JOHN RAWLINGS

ARENA EDITIONS

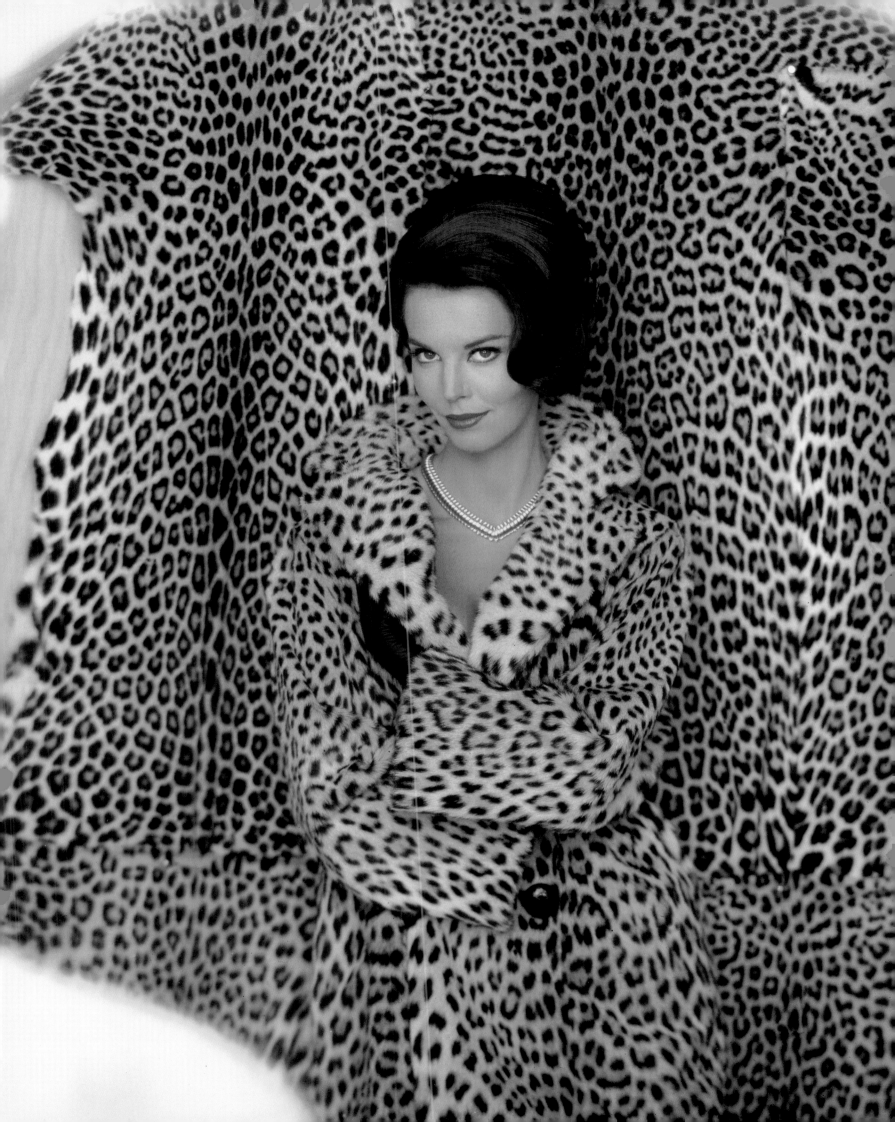

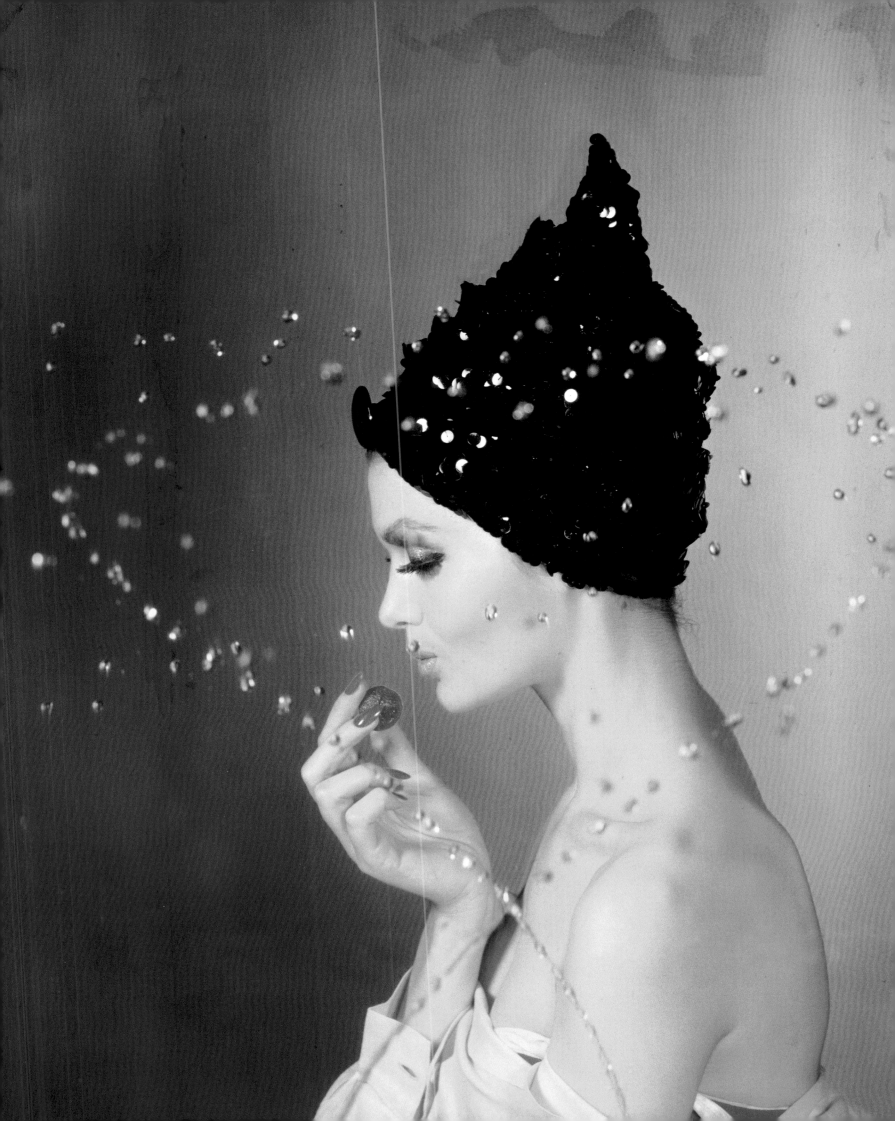

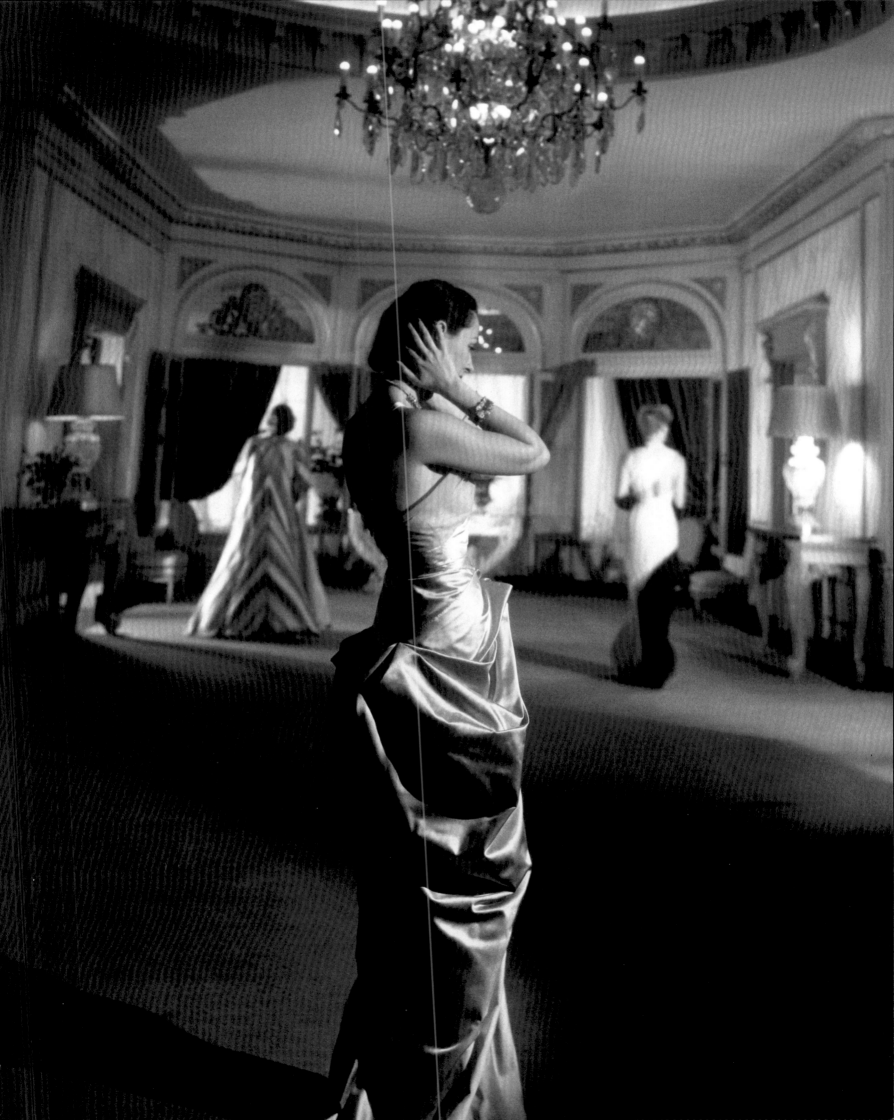

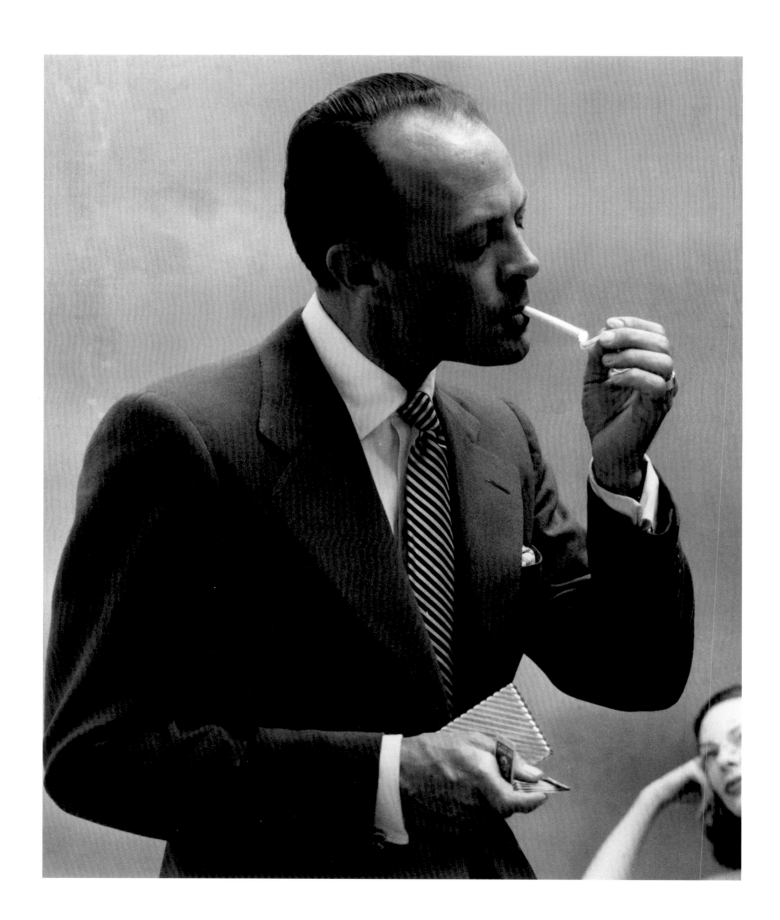

JOHN RAWLINGS

30 Years in Vogue

KOHLE YOHANNAN

For Adri

Contents

INTRODUCTION

Charles Dare Scheips Jr.

15

JOHN RAWLINGS: THIRTY YEARS IN VOGUE

Kohle Yohannan

19

THE PHOTOGRAPHS

44

ACKNOWLEDGMENTS

265

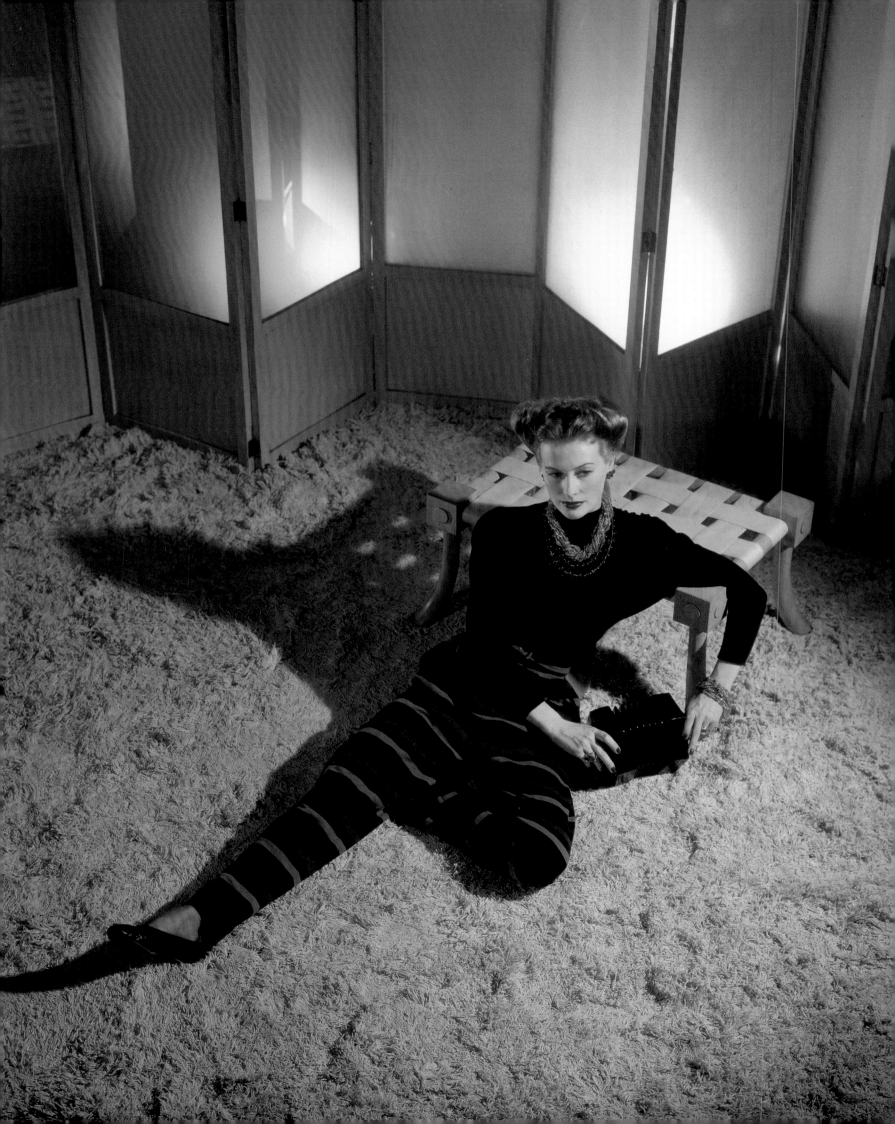

Transit

A woman I have never seen before
Steps from the darkness of her town-house door
At just that crux of time when she is made
So beautiful that she or time must fade

What use to claim that as she tugs her gloves
A phantom heraldry of all the loves
Blares from the lintel? That the staggered sun
Forgets, in his confusion, how to run?

Still, nothing changes as her perfect feet
Click down the walk that issues in the street,
Leaving the stations of her body there
As a whip maps the countries of the air.

—Richard Wilbur

This poem has always reminded me of photographer John Rawlings' distinctive and radiant work. Wilbur's "Transit" describes a stylish, gloved beauty emerging into the sunlight, with "perfect feet" that "click down the walk that issues in the street." As you will see in the following pages, Rawlings' photographs reveal a similar eye for chic sophistication, for the bold figure captured in a natural setting, for the confident, active urban woman enjoying modern life.

Rawlings is one of the twentieth century's most important photographers. But for too many years, his work has been all but forgotten by everyone but the most avid connoisseurs of fashion photography. In many ways, the timing of his career and life explains why Rawlings is at once a hidden and ubiquitous influence. On one hand, he had the great fortune to come to New York and begin working in the 1930s, just as photography became the dominant medium of the fashion magazine. During his fruitful thirty-year association with Condé Nast Publications, he also worked at times alongside such giants of photography as Edward Steichen, Cecil Beaton, Horst, and Irving Penn. In addition, he was

doubly blessed by America's emergence as a social, cultural, and economic center and the dynamic changes in women's lives in the years following World War II.

Unfortunately, Rawlings died at the relatively young age of fifty-eight in 1970, before the line between photography and the fine arts was forever obliterated, before today's photography profession—replete with magazines, agencies, galleries—became so crucial in shaping and sustaining a commercial photographer's career and reputation. While many of Condé Nast's photography masters such as Penn, Richard Avedon, and Horst saw their work become the subject of myriad museum exhibitions, catalogs, and monographs throughout the world, John Rawlings' remarkable career has remained almost completely undocumented. Until now.

I first became aware of Rawlings' extraordinary career while establishing the Condé Nast Archive in the early 1990s. Of course, with a collection that spans more than one hundred years, Condé Nast Publications, particularly *Vogue*, is inextricably connected with the history of photography. Simply put, *Vogue*'s stable of photographers is the pantheon of the great artists in photography. And now, looking at Rawlings' work at the beginning of a new century, it's important to at last give him the credit he deserves as a contributor to this medium. Besides its intrinsic beauty, Rawlings' work reveals itself as a cultural bridge between photography's European focus in the first half of the twentieth century and the growth of American cultural influence in the postwar era.

Rawlings came to the profession indirectly, through a general interest in the arts, as did many of his contemporaries. For instance, Horst (like Rawlings) began his career at Condé Nast building props in *Vogue*'s New York studio. He had studied with the architect and painter Le Corbusier in Paris and also benefited from the tutelage of *Vogue*'s principal photographer in Paris, George Hoyningen-Huene, before coming to the United States. In contrast, Rawlings' path was the classic American journey, from a small town in Ohio to the glamour of New York, at a time when Manhattan was becoming the world's leading center of culture.

John Rawlings was certainly the first major Condé Nast photographer to demonstrate a truly American eye. That's not to suggest that Rawlings' work is distinctly American because he worked only in the United States. As a matter of fact, he was able to travel and work abroad as well. *Vogue* studios were located in London and Paris as well as New York, and publisher Condé Nast, longtime *Vogue* editor Edna Woolman Chase, and legendary art director Dr. Agha believed in providing photographers with the money, artistic freedom, and facilities to produce work of unparalleled quality. They actively sought out the inventions, innovations, and equipment that would push the photography stars of *Vogue*'s future and simultaneously give them the edge in the always-competitive world of fashion publishing. It was in this forward-thinking environment that John Rawlings' intrinsic eye and youthful ambition grew and bore fruit, not just for Condé Nast but for the future of photography.

Taken in full measure, John Rawlings' work for *Vogue* allows us to see the transformations that took place visually and culturally at mid-century. The Louis XVI– or Elsie de Wolfe–inspired backdrops used by earlier *Vogue* photographers that suggest "the mode" of earlier fashion give way to modern spaces accented by Robsjohn-Gibbings furniture and the very American ready-to-wear clothing of Claire McCardell and Norman Norell. Rawlings' photography has a practical, no nonsense feeling, just as New York's Seagram Building by Mies van der Rohe reduces style to its bare, albeit elegant (and expensive), components. There is a good deal of breathing room and confidence in a Rawlings photograph. Unhindered by the cultural baggage of an earlier time, he focused his lens on the vibrant world surrounding him. Like a Frank Lloyd Wright masterpiece integrating space and environment, Rawlings' best photographs dissolve subject and background into a unified and stylish whole.

Kohle Yohannan has spent the past three years combing through the Condé Nast Archive and the Rawlings archive housed at the Fashion Institute of Technology. The book that follows is a seductive invitation to reassess Rawlings' accomplishments for a new generation. Today, with mid-twentieth-century modernism again in vogue, the time is ripe for Rawlings to at last take his place beside the great photographers of his era.

A great fashion photograph has at least two lives. The first is anchored in a particular issue, featuring garments available for purchase. The second life can be seen only from the distance of time: when the original subject of the photograph dissolves, and the image itself reveals the cultural world from which it came. In our own age, when postmodern mimicry is the currency of most fashion and photography, John Rawlings' work may serve to point us toward a more honest depiction of the world in which we live. His confident and unsentimental eye is a window into life stylishly lived at the middle of the last century, as well as a model for how we might see our own lives in the present. John Rawlings shot "the now" of his era. Perhaps his work will lead a new generation toward finding "the now" of its own time.

Carpe diem.

Charles Dare Scheips Jr.
Director, Condé Nast Archive
New York City, November 2000

John Rawlings Thirty Years in Vogue

Kohle Yohannan

John Rawlings was one of the most prolific commercial photographers of the twentieth century. During the course of a three-decade affiliation with Condé Nast Publications, from 1936 to 1966, Rawlings produced more than two hundred *Vogue* and *Glamour* covers, a staggering 11,000 pages of editorial fashion features and ad campaigns, and an impressive roster of television commercials. Rawlings' work, perhaps more than that of any other mid-century American fashion photographer, distinguishes itself as a veritable time capsule from the era in which American fashion and American style truly came into their own.

A contemporary of George Hoyningen-Huene, Horst P. Horst, Cecil Beaton, and Irving Penn, John Rawlings enjoyed a reputation during his lifetime as one of the world's most highly publicized and successful commercial fashion photographers. Despite this, Rawlings' work and career have received scarce attention by photo historians; to this day his name remains little known except among the fashion intelligentsia, often appearing as a mere footnote in the work of the countless journalists and fashion writers who continue to draw heavily on his images to illustrate the retelling of mid-century fashion. Key to understanding this oddly shadowed obscurity is realizing the significant ramifications of his death in 1970, at the young age of fifty-eight: Literally every one of Rawlings' professional and contemporary competitors (Horst, Penn, Louise Dahl-Wolfe, Richard Avedon, etc.) outlived him by at

least two if not three full decades of life and career achievement. Another and perhaps most surprising factor was the disappearance and long unknown whereabouts of John Rawlings' personal archive: a lifetime of newly rediscovered work comprising more than 25,000 negatives, extensive working notes, several annotated scrapbooks, and an invaluable cache of incomparably beautiful vintage prints. At the time of Rawlings' death, the entire contents of his private Manhattan studio were crated, stored, and later (unbeknown to all but a privileged few) quietly donated to New York's Fashion Institute of Technology, where the materials remained virtually untouched and uncataloged for thirty years—many now being seen for the first time since their original publication nearly half a century ago.

Born in Ohio in 1912, John Rawlings attended Ohio Wesleyan University before moving to New York in the early 1930s. There he worked as a freelance display artist for various Manhattan department and specialty stores. Eagerly caught up in the craze for the inexpensive 35-millimeter cameras that had then begun to flood the market, Rawlings initially used the camera to document his more successful window sets and in-house displays. Building, arranging, and then lighting to perfection all manner of vignettes around mannequins outfitted in the latest looks,

John Rawlings, circa 1937

Rawlings photographed his necessarily ephemeral masterpieces and later assembled the shots into a portfolio to showcase his display work for prospective clients. Enchanted by the often enhanced appearances inherent in the photographic medium, the visually adept young Rawlings was soon taking pictures of nearly everything in sight—including many of his employers' more stylish and socially prominent clients.

Against all odds, John Rawlings' official career as a photographer began on an unlikely note in 1936, when several of his candid shots of well-dressed society ladies and their preposterously over-groomed dogs found their way onto the desk of Condé Nast. The legendary publishing magnate clearly found Rawlings' informal snapshots more than impressive, as they immediately earned the fresh-faced twenty-four-year-old midwesterner not only an interview but also a job at the venerable *Vogue* studios. Like his contemporary, Horst P. Horst, Rawlings was first hired at Condé Nast as a prop builder and spare studio hand, later making his way around to the other side of the camera.

As an apprenticed assistant at the *Vogue* studios, Rawlings was afforded the coveted opportunity to train alongside many of the now-legendary figures of photographic history, Horst and Cecil Beaton among them. Hardworking and seemingly tireless, Rawlings spent his evenings and days off assisting on shoots and experimenting with lighting and camera techniques that he gleaned from the veritable giants of photography, for whom he built props and prepared sets during the week. Within only a few months, he was promoted to the status of full studio assistant and soon was receiving small, uncred-

Vogue, September 15, 1936

ited assignments for product photography and, later, event coverage. No small token of his employer's esteem, John Rawlings' first published photograph appeared in *Vogue* in 1936—the very same year he was hired.

During that first year at *Vogue*, Rawlings' superiors at Condé Nast not only recognized his potential for a stellar long-term career but also began to duly reward him. Impressed with his adaptable, refreshingly forthright photographic style, Edna Woolman Chase (editor in chief of American, French, and British *Vogue*) and Condé Nast personally presented

the then twenty-five-year-old photographer with an unprecedented offer: Rawlings was dispatched to England in 1937 to supervise and establish a fully operable, in-house photo studio at British *Vogue*. Combining raw talent with what he had learned during his brief but intense apprenticeship in New York, Rawlings worked avidly between the late 1930s and early 1940s to re-create and master the inaccessible and impossibly grand atmospheres of Huene, Beaton, and Horst—what for many years was the look of *Vogue*. Artfully intuitive and quick to adapt, Rawlings was soon working deftly and confidently within the aesthetic framework of this dramatic chiaroscuro play of otherworldly light and supple enveloping shadows.

Closer to the source than most, and being trained to carry the Condé Nast torch, John Rawlings naturally added to his own artistic sensibility what he most admired in his colleagues: His recently redis-covered scrapbooks (painstakingly compiled during his first years at Condé Nast) contain annotated tear sheets of the work of his favorite photographers, including Huene, Horst, George Platt Lynes, Beaton, Anton Bruehl, André Durst, and Dahl-Wolfe. In the margins, the up-and-coming young Amer-ican recorded what he found most inspiring and influential in the work of these celebrated image

makers. Scrutinizing, deducing, and reformulating lighting techniques; analyzing camera angles; mapping compositions—even noting the models' poses—Rawlings dissected and studied in minute detail all aspects of these artists' work. At times, the astute admirer merely added exclamation marks or circled a portion of a picture wherein some small detail intrigued him but somehow defied description. Invaluable documents when placed within the broader context of his mature style, these visually biographical scrapbooks provide a vital key to understanding and interpreting the early, formative years of John Rawlings' remarkable career.

In nearly four hundred pages (three volumes) of tear sheets and clippings, the work of one photographer, George Hoyningen-Huene, is markedly more prevalent than that of any other. With his restrained and austere classicist perfection, Huene was for Rawlings the unchallenged heavyweight of impenetrably seductive atmospheres and the master of superbly balanced, architectonic composition. Given his predilection for the work of Huene, it is not surprising to find that another of Rawlings' favorites was Horst P. Horst, with whom Rawlings had apprenticed at the *Vogue* studios. Horst had first modeled for Huene before becoming his understudy and protégé in Paris. Later, in 1935, he took over Huene's post as chief photographer for French *Vogue*, but by 1935 he was dividing his time fairly equally between the studios of French and American *Vogue*. Though Rawlings would have had very limited (if any) exposure to the aristocratically elegant Huene during his first year as an assistant at American *Vogue*, he no doubt encountered him upon returning from England later in the decade, when he became more familiar with Horst (his senior by only six years): Huene had relocated to New York to work for *Harper's Bazaar*, and he and Horst were to maintain an intimate lifelong association.

While much of what Rawlings admired about Huene was, admittedly, to be found in the work of Horst, throughout his life Rawlings maintained a singular esteem for Huene. When asked which photographers Rawlings most favored or were most influential on his career, New York fashion designer Adri, with whom Rawlings lived toward the end of his life, did not hesitate. "Oh, that's easy," she smiled knowingly. "The Four-H Club: Hoyningen-Huene, Horst, and Hiro. In that order." And despite the fact that Rawlings' early work at British *Vogue* is clearly modeled on the disciplined architectural purity of Huene and the studied theatrical lighting of Horst, it nevertheless remains less than slavishly derivative, at times revealing an unexpectedly frank and immediate atmosphere wholly unlike the prevailing tone of the era.

By the late 1930s, Rawlings was experimenting with psychologically dense and visually compelling atmospheres outside of the carefully controlled and artificially lit studio environment. An excellent example of this early inquiry is a photograph of Cora, a house model at British *Vogue*, taken on a London rooftop (page 53). While Herman Landshoff, Toni Frissell, Dahl-Wolfe, and others had photographed sportswear and junior styles outdoors in full sunlight, Rawlings' radically dynamic image of Cora—one of his earliest known works combining natural *and* artificial lighting—signifies the

young American's early dissatisfaction with the prevailing assumption that high fashion and high style were strictly an indoor sport. This occasional and early departure from the Huene/Horst standard in his 1938 work for British *Vogue* hints at Rawlings' later and most marked break with his training: a neo-pioneering return to daylight and a desire to free his subjects from the impenetrably staid and static environments of "glamour photography." In hindsight, and rather ironically, it seems that the closer John Rawlings got to the sources of his early inspiration, the more pronouncedly his experimental work began to veer from their examples.

The bulk of Rawlings' first months at British *Vogue* were spent photographing primarily British fashions for editorial features and creating portraits of society ladies and their thoroughbred daughters—photos that for the most part did not run in either French or American *Vogue*. Identifying the definitive separateness of the contents of the three *Vogue*s is vital in understanding not only the influences to which John Rawlings was exposed but also those from which he was temporarily removed. During the prewar era, while Eurocentrism was running rampant in America (and American *Vogue*), England was—and on the whole remained—stubbornly prone to sponsoring, promoting, and wearing the noticeably less elaborate, and therefore markedly less "French," fashions of its native designers. And though it would be inaccurate to suggest that the Parisian fashion market was in any way boycotted or conscientiously shunned by English high society, for the majority of British *Vogue*'s readership in the late 1930s, cutlines such as "chic" and "glamorous" were readily dispensed with in favor of "smart" and "sensible." Consequently, while the American marketplace remained unswervingly affixed to the Francophilic dictates of Parisian haute couture, England (given its geographical proximity and uneven social history with France) was markedly less inclined to share the awestruck American view of Paris as the veritable Mount Parnassus of style and taste. It was in large part this uniquely self-defining British marketplace that prompted the powers that be at Condé Nast to appoint and dispatch John Rawlings to his London post in 1937.

It would appear, however, that Rawlings' sudden departure from New York was quite possibly the result of other, somewhat more complex hierarchical factors: Given the vacuumlike environment of British *Vogue*'s content and circulation, along with its noticeable removal from the fashion pulse-points of Paris and New York, it is impossible not to wonder if the eager rookie was being "promoted" to night watch on the Siberian front as much as he was being rewarded for his precocious talent and unbridled enthusiasm. Though Chase and Nast's early recognition of Rawlings' potential cannot be called into question, one can scarcely imagine that the firmly established Horst or the socially ambitious Cecil Beaton (who at the time was traveling extensively) would have willingly given up his professional and social successes and freedom amid the whirl of New York and Paris to accept an overtly less glamorous startup position elsewhere. Rawlings, by contrast, was considerably younger, new on the job, and American. Quickly attracting attention from the executive offices in New York, he was understandably more enchanted by the prospects of advancement of *any* kind—perhaps even

more so if it meant being sent abroad. Speaking in later years about his "second big break" (the first, presumably, was his assistant job at *Vogue*), Rawlings told one friend at Condé Nast: "The day I left for London was the luckiest day of my life."

If John Rawlings was feeling lucky, it seems that Horst may have felt relieved: Interoffice memos dating from the first year of Rawlings' employment at Condé Nast expressed concern that the highly motivated and quickly advancing Rawlings might eventually cut in on Horst's generous portion of outside advertising work—one of the unique and highly profitable perks that Condé Nast made available to its star photographers and a situation that no one at *Vogue* was willing to risk. In a mutually favorable and deftly diplomatic maneuver aimed at keeping the reigning factions undisturbed while at the same time preventing another clearly remarkable talent from slipping through their fingers, Chase, Nast, and Dr. Agha (Condé Nast's artistic director) gave the eagerly receptive young Rawlings a chance to stake out his own professional terrain and, perhaps more importantly, an arena in which to develop his own instinctive eye beyond the shadows of his formidable and more established masters.

Reading between the political lines of *Vogue*'s delicate balance of power, another possible contributing factor in Rawlings' relocation suggests itself: Recognizing that Rawlings' engagingly simple, more *informative* approach to fashion photography was steadily aligning itself with increasingly common-sense attitudes toward dressing, Edna Woolman Chase may have cut Rawlings' apprenticeship in New York short to keep the impressionable young photographer from becoming over-steeped in the darkly theatrical floorshow of Horst's ubiquitous influence. By the mid-1930s, both Chase and Nast had already expressed concern about what Chase later called the "increasingly arty output of the New York and Paris studios." Practically astute, and often one very large step ahead of the game, Chase, Nast, and Agha may have seen a long-term solution in John Rawlings' innate lack of preciousness and instinctively pared-down aesthetic. The feasibility of this argument is helped along by even the most precursory glance at fashion magazines of the mid-1930s, which immediately confirms the extent to which the shadow-shrouded tone established by Huene (and by way of apprenticeship maintained by Horst) had been readily taken up—with radically varying degrees of success—by nearly every photo studio in the industry.

While *Vogue*'s competitors worked doggedly to re-create the seductive drama of Horst's personality portraits and editorial spreads, Rawlings' 1938 portrait of British starlet Vivien Leigh (page 51) clearly demonstrates that after less than one year of training under Horst, the newcomer to the *Vogue* studios had already identified and absorbed many of his past master's most readily identifiable atmospheres and signature lighting formulas. But it appears that the last thing Edna Woolman Chase wanted was another Horst. In a bulletin from Chase to Condé Nast staffers written in 1937 (the year Rawlings was dispatched to London), Chase recounts her mounting discontent:

I have been lecturing Horst about the lack of light in his photography. We have simply got to overcome the desire on the part of our photographers to shroud everything in deepest mystery I am sick and tired of having women say to me, "How is this dress made? What is it like."

Another bulletin, written in 1938 and later cited in Chase's memoirs, *Always in Vogue* (1954), was addressed mainly to the photographers but was circulated among the entire staff, stepping even further in its demand for more information and less "art":

Several of the photographs for September fifteenth are nothing but black smudges. . . . Concentrate completely on showing the *dress, light it for this purpose* and if that can't be done with art then art be damned. *Show the dress.* That is an order straight from the boss's mouth and will you please have it typed and hung in the studio.

By promoting and thereby removing *Vogue*'s newfound fledgling talent to where, over time, his instinctive clarity stood a chance to develop more or less independently, Chase and Nast provided a practical solution to a newly expanding market, while at the same time creating a semi-insulated training camp for what they rightfully suspected was their next rising star. Once installed at British *Vogue*, the young American rose fully to the challenge, taking thorough advantage of an indescribably rare opportunity to both prove his professional abilities and come into his artistic own. Enjoying an amount of autonomy he would never have been granted had he remained an assistant in New York, Rawlings produced such impressive work during his first few months in London that, in a break from the standing tradition, many of his British editorial pages found their way (with increasing regularity) into the international circulation of both French and American *Vogue*.

John Rawlings' career, beginning in the mid-1930s, coincided with a period of highly impacting technological advances and, as a result of World War II's material effect on fashion, a period of unforeseen aesthetic flux—the combined forces of which brought about a gradual but definitive changing of the guard in photographic style. By the time Rawlings had taken up his post at British *Vogue*, the long dying and inexplicable lingering of Baron Adolph de Meyer's sentiment-laden pictorialist style had been wholly obliterated by the sleek, hard-hitting blow of Edward Steichen's resounding modernism and Man Ray's seductive doses of surrealism—both of which, in effect, had left the commercial field increasingly wide open to new and innovative takes on fashion photography. While in the past, commercial photography had lagged behind art and design movements by a decade or so, by the late 1930s the pace was quickening. Suddenly, not only magazine editors but also the general public was looking for and expecting a more up-to-the-moment, even avant-garde, voice of authority on matters of taste and style.

Brought about in equal parts by *Vogue*'s increased annexing of artists and personalities from the modernist and surrealist movements and by a new breed of visionary fashion editors and art directors (including those employed by *Vogue*'s competition, such as Diana Vreeland and Alexey Brodovitch), this period fostered a keen awareness of the importance of documenting these overlapping cultural collaborations. Along the way it established the blueprint for a new and potent publishing fusion of art, fashion, and high society. Here was an era that witnessed Elsa Schiaparelli's work with Salvador Dali and Coco Chanel's joining ranks with Jean Cocteau and Pablo Picasso on *Le Train Bleu*—some of the century's most seminal artistic and cultural events—all of which were blazoned across the pages of *Vogue*. The resulting momentum of this art-driven media spin on fashion and popular culture effectively fueled and set into motion what has rightly come to be recognized as one of the most powerful vehicles of twentieth-century visual culture: the status-driven fashion magazine.

Another significant factor in not only the formation but also the possibility of John Rawlings' career was the far-reaching political and social effects of World War II. While his first years at British *Vogue* were rattled by political tremors that would later be felt full force around the globe, by the time the United States was actually poised to enter the war, Rawlings had been summoned to return to New York. Unlike his friend and colleague Irving Penn, Rawlings was passed over during the first wave of the draft call by what seems to be a mysterious intervention on the part of Condé Nast. A series of letters and interoffice communications between Agha, Chase, and Nast, which address but never fully explain the subject of "John Rawlings and his missing finger" (a condition that none of Rawlings's surviving photos support), reveals that John Rawlings was reclassified by the draft board and consequently was spared from active duty. Horst, however, was not so fortunate. Though German, Horst had become a naturalized American citizen and was drafted into two years of service as a sergeant in the United States Army. As veteran model Suzy Parker (now Mrs. Bradford Dillman) remembers it: "When Horst got drafted and Rawlings took over . . . well, let me tell you: there was more than just a little tension. In the end, though, when everyone came home and got back into the swing of things, it eventually blew over."

But while Rawlings' uninterrupted work from 1938 to 1945 does suggest that Condé Nast was successful in keeping at least one of its noticeably few major male American photographers off the front line (Louise Dahl-Wolfe, Toni Frissell, Lee Miller, and Kay Bell were all working at full capacity), given the political and social climate in the United States during the mid-1940s, remaining on the home front hardly meant escaping the war. Across the globe, fashion design and its supporting industries had already been profoundly affected by the mere threat of war. As if presaging the hardship of the years to come, the period immediately preceding World War II found the nation wrought with an intangible but pervasive mood of dis-ease and apprehension. "It's impossible to describe what it was like. . . . There was something in the air . . . a weight, a greyness—a sort of deafening uncertainty," remembers Mary Jane Russell, one of Rawlings's favorite models of the early 1950s. Whatever it was, for once people were sure glad not to be going to Paris.

On the fashion front, with France at peril, rumor and speculation flew that the fashion world would come to a halting end when the Paris couture officially shut its doors in 1944. But what transpired instead was a completely unexpected phenomenon that proved even more far-reaching and powerful than Eurocentrism had ever been: the unforeseen emergence of American style. With the onset of World War II, gone were the days of excessive, conspicuously expensive dresses whose effect depended upon dozens of yards of fabric. Virtually overnight, the European fashion market was given a crash course in the "less is more" aesthetic that had long been an inherent part of the American mind frame. When the American war council passed Limitation Order L-85 (restricting the amount and type

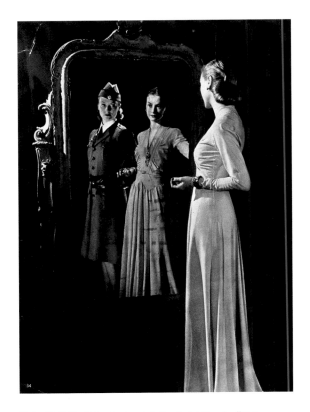

During World War II, Rawlings' work deftly reflected *Vogue*'s effort to promote a sort of visual "can-do-ism" among American women, presenting fashion as an empowering force as opposed to solely decorative.

of fabric used in civilian fashions), American designers responded with beautifully cut, pared-down modern clothes, which in their stark simplicity seemed to suggest a more minimalist, less pretentious style of photography. With the turning of political events and the resulting social segue into the wartime lifestyle, fashion was in for a change, and John Rawlings' instinctive, no-frills fashion photography was coming into its own.

The extent to which Rawlings' career was affected by the social and stylistic changes brought about by the war cannot be overstressed. As women around the world were entering into the workforce in unprecedented numbers, just how relevant were the passively glamorous, sumptuously decorated styles that had been so popular in the prewar years? At virtually every level of society, the "American Look" was taking root. Facing the reduced circumstances of wartime rationing, American women actually welcomed the more practical, less conspicuous new sportswear—clothes that would have seemed wildly out of place amid the luxury-laden photo spreads of prewar *Vogue*. Almost overnight, even the most fashionable women were proudly outfitted in the so-called Victory Suits: spare, undecorated man-tailored jackets cut from somber-colored woolens and worn over plain, mid-calf skirts. Encouraging a marked resistance to opulence, and thereby establishing a kind of "patriotic chic" all their own, women around the world took pride in their visible support for the war effort. Suddenly, the glamorous confections of the French couture and the lush, languid environments in which they were characteristically photographed seemed something of an outmoded memory, even somehow inappropriate. Even the U.S. government began to realize the extent to which women were affected by style magazines, officially requesting that Hollywood starlet Veronica Lake stop wearing her long flowing hair cascading forward over one eye—for fear that female

factory workers who imitated her would find themselves at peril on gear-driven assembly lines. Fashion editor Bettina Ballard, who remained in Paris after the onset of the war, remembers being publicly snubbed at a chic eatery by a couple who later chastised her for her "too *Vogue*-like appearance in times such as these."

In the midst of mounting international disdain for self-indulgent excess, John Rawlings' freshly uncluttered, partially sunlit approach was quickly gaining favor with *Vogue*'s readership. As fashion editors worked to promote a kind of visual "can-do-ism" that American women could immediately relate to, Rawlings' wartime and postwar work began to evince a more believable, and therefore somehow more empowering, atmosphere. From the late 1940s on, Rawlings moved steadily and definitively away from the Horst-inspired formula of artfully incorporated props and airtight inaccessibility that so readily distinguishes his earlier work. Shifting the focus away from the more rarified, status-conscious European aesthetic, Rawlings moved headlong toward a fresher, more American, lifestyle-driven look.

John Rawlings returned to America around 1940 with newfound confidence and a well-deserved reputation as one of Condé Nast's rising stars. While in the past *Vogue* had proudly wielded the social clout of its aristocratically titled European editors and photographers (Hoyningen-Huene was a Balkan baron, and de Meyer assiduously *claimed* to be), with the successful U.S. intervention in Europe, being an American suddenly acquired a previously unimaginable chic all its own. Once back on native soil, and one step further removed from Paris fashion, Rawlings began almost instinctively to realign himself with the markedly less-labored glamour of the American ideal of beauty—what Christian Dior had offhandedly termed "Le Look Sportif" when describing American women of the 1940s.

In hindsight, Dior's impression of American style seems less of a quality in and of itself and is perhaps better understood as the essential absence of theatricality and the forbidding chic so popular among the designers and patrons of the haute couture. An American through and through—despite his high-styled European hiatus—John Rawlings knew and understood this elusive American appeal. Unlike many of his peers, once freed from the yoke of Eurocentrism he did not waste time trying to reclaim the fussy trappings of a look and an era gone bye. Apparently Rawlings' peers applauded his adamant refusal to look back. In an interview with longtime *Vogue* art director Alexander Liberman, cited in *Appearances: Fashion Photography Since 1945*, Martin Harrison notes that Liberman recognized in Rawlings's postwar works "a very American clarity," asserting further that "there is no European chi-chi about them." Newly ensconced in a glass-roofed studio on East Fifty-fourth Street, where he further developed his modernistic approach to the combined effects of natural and studio lighting, John Rawlings set about formulating a new, more dynamic photographic idiom to better express this uniquely American quality of casual elegance and relaxed style—an emerging phenomenon that even Paris could neither explain nor deny.

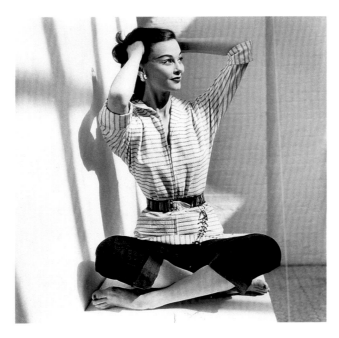

Tina Leser separates, *Vogue*, May 15, 1951

In one of his typically unpretentious but eminently quotable moments, legendary *Vogue* editor Leo Lehrmann once characterized the genius of Condé Nast's most successful early photographers as "necessarily schizophrenic." Lehrmann further explained that unlike other visual artists, such as painters or illustrators (who conceive of and execute their work more or less autonomously), fashion photographers of the early twentieth century were generally the well-honed products of meticulously supervised in-house apprenticeships. And though Steichen, Man Ray, and later Martin Munkacsi present visible exceptions to this rule, for the most part those who made their way up the ranks at *Vogue* were in fact laboriously trained in manifesting and reaffirming the reigning mood and the overall vision of the magazine (and more precisely the editor) for which they worked. Without calling into question the remarkable talents of the world's great commercial photographers, a more accurate, more objectively informed look back at, say, the flawless cover girl glamour of a Horst spread from *Vogue* or the vibrant dynamism of a Munkacsi beach shot from the same era at *Harper's Bazaar* reveals as much the shrewd and discerning editorial eye of Edna Woolman Chase or the prescient, modernist departure of Alexy Brodovitch and Carmel Snow as it does the photographer's artistic and technical genius.

Viewed through this wholly unartistic lens of corporate identity, the mid-century high-fashion magazine trade begins to resemble a veritable showdown/battleground where the world's most powerful editors and their squadrons of carefully appointed stylists, writers, pet designers, illustrators, and photographers vied for cultural authority as the herald of fashionable living and the last word in matters of taste and style. At the heart of this battle, poised at the crossroads of art and commerce, was the fashion photographer. With this interdependent process in mind, it becomes increasingly clear that what varied each magazine's slant and won over its readership was not solely the personal tastes of the legendary leading ladies of editorial fame. In view of the fact that all reigning and competing editorial factions (*Vogue*, *Harper's*, etc.) necessarily drew from the exact same couturiers—indeed the very same collections—just as important was the photographer's distinctive manner of styling and photographing what often turned out to be the very same dress.

Not surprisingly, major publishers, in their ongoing battle to increase readership and lure advertisers, quickly realized that the fashion photographer was by far one of their most potent and valuable

weapons. This new awareness resulted in the mounting status of what had once been merely the "staff photographer" and naturally brought with it the expectation of more competitive salaries and additional professional perks. In the final analysis, while the editors might have had the last word, the photographer remained the voice by which it was ultimately spoken. This notion lends credence to the rumor, circulated in 1935, that when Carmel Snow (who had defected to Hearst Publications in 1932 to take over as editor in chief of *Harper's Bazaar*) finally succeeded in luring away Huene (at the time *Vogue*'s principal photographer in Paris), it was with an offer to pay him *three times* his current salary at *Vogue*.

Though it is tempting to see this early shifting of status as the infant-stage prototype of high-profile fashion photographers as we know them today, it must be remembered that the imperiously grand, often domineering magazine editors of the 1930s and 1940s were no more prone to turning over unedited free rein to a photographer than publishing mavens would be today—perhaps even less so. Instead, as Leo Lehrmann pointed out, what was expected was a closely synergistic relationship that, ideally, unified the magazine's established identity, the forecasting vision of the editors and stylists, and the creative and technical excellence of the photographer. As it happened, this uniquely interconnected, even symbiotic relationship between photographer and editorial staff found its nearperfect manifestation in the life and career of John Rawlings, who in 1942 met and married fashion editor Babs Willaumez—a self-created Americanized Brit—herself working for Condé Nast.

Slick, quick-witted, and renowned for her severe chic, acid wit, and deadpan humor, Babs Willaumez had been a longtime resident of Paris before World War II. Spending her young adult life as an art student in France and England, she later made her way up through the ranks at Condé Nast, landing a much-coveted position as fashion editor at French *Vogue*. Respected for her considerable design and illustration talents, Babs was also a regular style contributor to several Condé Nast magazines. A tall, good-looking blond with ice-blue eyes and a punishing jawline, Babs Willaumez personified the glaringly chic ideal of the mid-century fashion editor. At once inventive and unconventional, she had perfected the seemingly effortless blasé elegance that even the most refined European women were fain to attempt. But while surviving photos of Babs undoubtedly suggest an unimpeachably well-

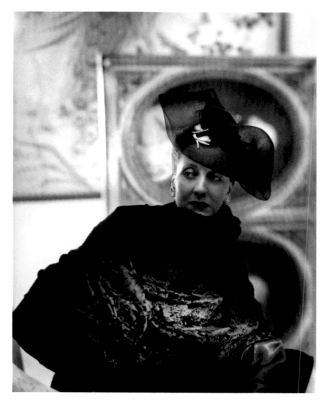

Babs Rawlings, circa 1947

put-together style maven perfectly in sync with her time, it seems she had another, somewhat more rebellious side. Despina Messinesi, an editor in various departments at *Vogue* for more than fifty years, remembers that Babs would show up at the office "with two dogs in tow, wearing the kinds of looks other people only talked about—the ones artists sketched in our magazine—but no one but Babs *actually wore*." Messinesi went on to recall: "shocking colors, bare feet with sandals in town—*in the winter*, blouses unbuttoned *down to there*. . . . Babs was, you know, rather outrageous."

It would appear that it was just this flair for the unpredictable that lent Babs Willaumez part of her sparkle. Evoking the image of an oracle in a cave, Messinesi remembers, "One just *knew* that Babs was on to what was next, but you were sometimes afraid to ask!" It seems that Babs Willaumez and Edna Woolman Chase held each other in a sort of mutual awe, so much so that one insider felt certain that Babs may have held sway with Chase in the machinations that kept John Rawlings at Condé Nast during the war. And though it never came to pass, documents in the Condé Nast archive suggest that Edna Woolman Chase may have been grooming Babs Willaumez as heir apparent to the position of editor in chief of American *Vogue*.

Not surprisingly, Babs enjoyed a noticeably privileged pick of editorial pages and style bylines, many of which included her own designs and fashion forecasts. Additionally, throughout her career at Condé Nast, Babs freelanced as a designer for several wholesale houses and even launched her own line of day-into-evening separates. Partial to long, sweeping, sarong-knotted evening skirts, jeweled gauntlet bracelets, and boldly colored string-tied halter tops, Babs was as well known for her style sense as she was for being "tough as nails." Though it was true that "Babs Rawlings meant business" as an editor, Suzy Parker also insists that "Babs really was an *amazing* designer." Parker remembers that her internationally acclaimed sister, model Dorian Leigh, was married in "a sleek, silver-grey gown, sewn up from one of Babs Rawlings' sketches." The bridesmaids? None other than Suzy Parker and the still-reigning Carmen Dell'Orefice.

As a couple, the high-profile newlyweds worked incredibly well together, producing a seemingly inexhaustible stream of eye-popping, glamorous editorial pages and enjoying a generous amount of personal publicity along the way. The new Mrs. John Rawlings' carefully measured throwaway chic and blasé superiority, coupled with her much younger husband's straightforward and unaffectedly fresh vision of American style, proved to be the perfect creative and social formula—effectively ushering the highly sought-after couple well past the jealously guarded velvet ropes of New York's most exalted art and social scenes. "They were both so good-looking and so talented," remembers one woman who knew the couple. "And between them, they knew *everyone*." By the late 1940s, it was not at all unusual to see an issue of *House and Garden*, *Vogue*, or *Glamour* featuring editorial spreads by Mr. and Mrs. John Rawlings alongside profiles and personality pages *about* Mr. and Mrs. John Rawlings, spotlighting to everyone's advantage their highly successful, glitteringly attractive, and undeniably cross-pollinated professional and social lives.

Despite what proved to be a long but not entirely successful marriage, Babs' attraction to Rawlings was certainly in keeping with her past: She had an eye for talented, well-mannered, artistic men and had previously been married to fashion illustrator René Bouet-Willaumez. While her soft-spoken new husband was reserved and prone to slowly developing friendships, Babs Rawlings (an ex-countess by her earlier marriage) was by all accounts a formidable contender at the office and the cocktail party alike. One socialite acquainted with the new Mrs. John Rawlings characterized the couple as "complete and total opposites . . . I'm not talking just night and day, but *high noon* and *midnight*." Exhibiting all of the bulletproof grandeur to which women of her era aspired, Babs Rawlings nevertheless worried that her new younger husband's easygoing, openly casual attitude might somehow be misinterpreted by her rivals as a sign of social disarmament. Soon after their marriage, she informed the entire staff at Condé Nast that from then on the quietly elegant and wholly unpretentious young man who had always insisted on being called "John" was to be addressed as "Mr. Rawlings." She may very well have been willing to dispense with the swanky title of "Countess" by marrying John Rawlings, but no studio hand or editorial assistant was going to call her "Babs." The absolute personification of hard-edged style and omnivorous social ambition, Babs Rawlings once coolly informed a young stylist, who had politely refused an invitation to join her for an after-work drink because she was expected at home, that "home is for changing one's clothes." (page 118)

By the early 1950s, Mr. and Mrs. John Rawlings' combined social and professional success found them hosting A-list cocktail and dinner parties at a rather grand and beautifully appointed Sutton Place apartment decorated in an eclectic and much-talked-about mix of eighteenth-century French antiques, offset by the strikingly modern neo-Greek designs of their mutual friend T. H. Robsjohn-Gibbings. Their silk-jacquard-upholstered salon was modernistically punctuated with paintings by Amedeo Modigliani, Rufino Tamayo, and Pavel Tchelitchev. By sharp contrast, at the couple's converted boathouse (situated on Long Island's Oyster Bay—where both Horst and Edna Woolman Chase also kept summer homes), a casual, more overtly relaxed atmosphere prevailed. There, in addition to a regular stream of weekend guests, neighbors Ilka Chase (daughter of *Vogue*'s editor in chief) and her husband, Dr. Norton Brown, formed the inner circle of John and Babs's infrequent downtime. Remembering the endless stream of models, photographers, stylists, and designers who came and went during the long weekends and summer months in Oyster Bay, Peter Brown (Norton Brown's son and stepson to Ilka) pointed out that "it was almost certainly amid the whirl of those fast-paced conversations and general creative think-tanking that Rawlings-the-photographer learned to think like an editor."

The relationship between John Rawlings and Mr. and Mrs. Norton Brown is complex and requires some explanation. Ilka Chase was an accomplished radio star, actress, and author, whose forward-thinking and somewhat "bohemian" lifestyle often made for uneven relations with her famously elitist mother. While Edna Woolman Chase and Babs Rawlings shared a longstanding mutual admiration and affinity for artful living and carefully crafted personae, both Ilka and Norton Brown were

altogether intolerant of artifice and snobbery of any kind. Not surprisingly, they found themselves more naturally drawn to the unforced, unaffected personality of the *other half* of the Rawlings clan—a situation that occasionally made for strained cocktail chat where Ilka and Babs were concerned. As Peter Brown (who was nonetheless fond of the "always on" Babs Rawlings) summed it up, "Ilka and Babs got along because they chose to get along." At any rate, what is decidedly clear by all accounts is that the real bond was between John, Norton, and Ilka. As a result of this organic simpatico, Mr. and Mrs. Brown (both separately and as a couple) remained John Rawlings' closest personal friends throughout his life.

Despite her hard edge—perhaps even because of it—Babs Rawlings deserved her international renown as a stylist and her reputation for possessing a truly extraordinary flair for clothes: In Paris and New York alike, Babs Rawlings was hailed for decades as one of the most stylishly dressed women around. And as a direct result of the couple's collaboration, John Rawlings' reputation among socialites and starlets was effectively bolstered. Among the art and café society circles it became common knowledge that in the capable hands of Mr. and Mrs. John Rawlings, some of the more socially prominent but least physically likely candidates were being transformed into unimaginably flattering portrait pages. A remarkably talented and wickedly perceptive fashion editor, Babs Rawlings was as instrumental in her husband's professional success as she was in moving the couple up and well beyond the social ladder at Condé Nast.

The seemingly obvious relevance of this overlapping contextual relationship between a fashion photographer and his social/professional milieu has long been treated (when acknowledged at all) as a mere detail in biographical works on applied photographers. Rather inexplicably, the prevailing trend has been to ignore contextual issues and to gauge a photographer's historic importance solely in terms of his or her technical or aesthetic contribution to the field—a flawed proposition in this author's opinion, for reasons rarely taken into consideration. While few photo historians would disagree that integral to the assessment of period fashion photography is the objective and separate consideration of technical innovation ("the new" where applicable) and artistic merit ("the beautiful" where warranted), fewer still have raised the point that with only rare exception those individuals credited with groundbreaking technical advances in the field of commercial photography were not always those who produced consistently beautiful, highly desirable pictures.

Perhaps more telling is the fact that by mid-century, the majority of commercial photographers were happily working within the established borders of the medium—only adopting or taking up new innovations as they became available. And while commercial photographers at the upper echelons of the fashion and advertising industries were expected to implement, or at the very least acknowledge, any given technological advances (faster films, color emulsions, strobe lights, etc.), relatively few had the inclination or the necessary free time to set about reinventing the wheel. In spite of this, pedantic

academics, grasping for philosophical straws in the wake of postmodern art criticism, have persistently rallied to establish some sort of prerequisite of technological innovation on the milestone map toward determining great photography. Worse yet (and exponentially weakening the chain of photographic history) have been the hero-worship tendencies of overzealous art critics and biographers, who in their well-intentioned enthusiasm to meet this arbitrary "requirement" often end up blurring the lines between photographers who adopted or promoted new technologies (and therefore became most readily associated with them) and those who *actually invented them*.

A glaring example of this paradigm is the reputation of Louise Dahl-Wolfe, a wonderfully talented photographer who is nearly always cited (and rightfully respected) for her precise, well-honed color work. Taking tribute to the threshold of idolatry, however, more than one photo history text renders Dahl-Wolfe as single-handedly ushering in color photography and heroically convincing her panic-stricken peers of the mid-1930s that color negative film wasn't such a bad thing after all. Though Dahl-Wolfe unarguably achieved accurate and beautiful results from a newly developing and often unwieldy medium, color fashion photography would have progressed on its own—with or without Dahl-Wolfe's avid application and devoted early campaigning for its cause. The same cannot be said of the innovative color work of Anton Bruehl, who, in addition to producing countless memorable pages of editorial work for all three *Vogues*, collaborated with Fernand Bourges in reformulating and perfecting the color engraving process used by Condé Nast Publications in the physical production of its magazines. Consider, even, the undeniably innovative (if technologically bastardized) explorations of the German-born Erwin Blumenfeld or American artist-cum-photographer Man Ray, both of whom expressed irreverent disavowal of all preconceived notions of traditional darkroom procedure, creating some of the most important and unforgettable images of the early twentieth century—along with more than a few near-hysterical lab assistants and darkroom fires between them.

For many image makers, however, and certainly for John Rawlings, seeking to redefine and extend the technological reaches of photography seemed markedly less important than capturing the fleeting, often elusive, up-to-the-minute expressions of the times. Though Rawlings avidly joined his colleagues in cheering the arrival of Kodak's groundbreaking high-speed films and personally modified his fixed-lens Rolleiflex with a newly engineered lens mount—thereby enabling it to accept interchangeable lenses that he had engineered and built—he nevertheless maintained a longstanding appreciation for a bulky, outdated, nearly immovable 8 × 10 Deardorff and a roller-mounted Ansco studio camera, both of which he continued to use throughout his lifetime. Further, unlike many photo purists, Rawlings moved somewhat unpredictably from format to format, thinking nothing of transporting large-format, wet-plate studio cameras onto locations where many would have opted for the handheld convenience and portability of the Rolleiflex or Hasselblad (which he favored toward the latter half of his career). Interested as much in methodology as technology, Rawlings expressed discord not with the tools of the industry but rather with photographers themselves, who he felt overlooked

the most basic aspects of photography. At various points in his career he exclaimed that "People don't crop enough!" and "Sunlight is *grossly underestimated*!"

In truth, Rawlings' infatuation with sunlight was as multifaceted as the body of work that came about as the result of it. In his custom-built top-floor studio on the Upper East Side, Rawlings designed a glass-roofed ceiling structure, fitted on the inside with an elaborate system of pulley-drawn shades in varying degrees of opacity. A circular swivel-mounted subfloor enabled the photographer to position his subject at virtually any angle in relation to the falling light. This remarkably advanced concept is as important as it is fascinating, and by the late 1940s Rawlings' experimentation with filtered and direct sunlight was already yielding some truly forward-looking images. The signature slashes of

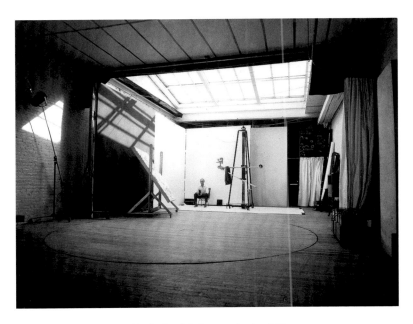

John Rawlings' Manhattan studio, circa 1947

downward falling sunlight, so recognizable throughout Rawlings' pages in *Vogue*, correspond precisely to the metal-framed skylights that made up the transparent matrix of John Rawlings' glass-roofed ivory tower. (page 197) By way of an increasingly elaborate overhead system of gauze, films, and other semi-translucent materials, John Rawlings ingeniously coaxed in and deftly manipulated the one element that for the majority of studio photographers was a wildcard not to be trusted: the sun.

Despite his custom-rigged Rollei and his innovative return to the controlled use of sunlight, Rawlings was ahead of his time not solely in the *practical* use of his camera but also in his clear and determined conception of the photographer as a highly attuned chronicler of the moment—capturing and preserving the intangible but undeniable zeitgeist of his era. Rawlings' longtime companion Adri, who inherited and preserved the entire John Rawlings archive and donated it to FIT, feels certain that the photographer's fascination with change was as much part of his work as it was his personality: "John was an Aquarius; he was the epitome of fluidity. He loved to watch *everything* change right before his eyes; light, moods, fashion—even the weather. I think that's why the camera fascinated him his entire life. It held each point in time as a still moment; the process of change, proof of the present becoming the past." In truth, it seems that Rawlings was instinctively aware that he was living in a period that would later be hailed as the high point of style and fashion. Be it the wry, barely upturned half-smile of the imperiously haughty Suzy Parker or scads of ermine

and Harry Winston jewels tossed nonchalantly onto the shoulders of a coolly dismissive Sunny Harnett, John Rawlings captured some of the twentieth century's most unforgettable moments in fashion history with the dedication and passion of a modern-day Audubon—recording the incomparably glamorous last impressions of what he rightfully suspected was a dying breed.

Approaching his work with the mind frame and sensitivity of an artist but the uncomplicated level-headedness of a craftsman, Rawlings remained wary throughout his life of his colleagues who took themselves too seriously. Speaking in the early 1950s about the state of commercial photography at an awards ceremony for the Art Director's Club, John Rawlings expressed none of the now-revered "push the envelope" posturing when he addressed his peers with the plain and clear message that "the onus is on us. The tools are there, they have been for years. . . . What is uppermost is the photographer's ability to put today in front of the camera." This unaffected, self-challenging attitude toward the fiercely competitive high-stakes field of commercial photography reveals the unique character of what essentially was a modest man working at the top of the vanity industry. Understanding and embracing the necessarily ephemeral nature of fashion photography, John Rawlings, who was awarded literally dozens of the industry's top honors and went on to become the president of the Society of Photographic Illustrators, evinced none of the grandiose seriousness so readily apparent in both the work and personalities of photographers such as Cecil Beaton (who sometimes arrived at the studio dressed in a beret and floor-length cape—which he kept on while working!) or George Hoyningen-Huene, who required a reverent silence and formality at all times while he worked or was merely setting up his shot.

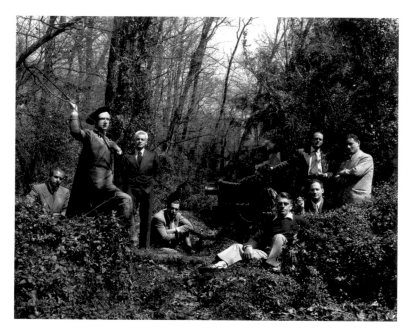

Group portrait of *Vogue* photographers with Dorian Leigh, Oyster Bay, Long Island, New York, 1946 by Irving Penn. Copyright © 1946 (renewed 1974) by Irving Penn, courtesy *Vogue*.

In a 1947 cover story in *Commercial Camera*, John Rawlings (who proudly referred to himself as a commercial photographer and rarely mounted exhibitions of his work for sale) made a definitive stand about the technical-versus-creative merits of great photography. "The question of whether or not photography is art strikes me as pretty much academic. But if it is or can be, it will show itself by more than a mere manipulation through a bag of tricks," he said, leaving nothing to question regarding his opinion of overtly arty, acrobatically technical photography. In his distinctively lithe and lively hand-

writing, this same man once penned onto the back of a contact print of a darkly exotic young woman, draped in the Grecian manner and seated in a Robsjohn-Gibbings Klismos chair, that great photography was the result of "simplicity . . . keeping the photographer out of the picture." Though he was trained by the masters of opulent excess and untouchable otherworldly glamour, by the 1940s John Rawlings' innate minimalist nature was already making itself known.

At once prescient and practical, Rawlings was quick to recognize the newly emerging omnipotence of the Hollywood glamour machine. As a result of his suggestion in 1942 that Hollywood personalities and society figures would prove more visible and effective vehicles of editorial fashion than models, *Vogue* increased its focus on New York's glittering café society and the stars of the silver screen. In a truly prophetic three-page interoffice memo (which not only documents Rawlings' idea but also offers insight into the young photographer's social and business savvy), Rawlings specifically pointed out that Condé Nast could trade on its magazine's international circulation in exchange for unpaid cameos by glamorous personalities. The implications and resulting phenomenon of this seemingly simple communication are nothing short of mind-boggling. Who knew that after a relatively brief time on the job, an unknown midwestern display artist would so profoundly affect the cultural under-pinnings of what was unarguably the most powerful and influential fashion magazine of its era? Beyond this, and proof of Rawlings' and *Vogue*'s long-term impact, nearly fifty years later one can scarcely even conceive of fashion beyond the realm of its respective film and media stars—all forms of media and advertising having been virtually subsumed by the celebrity-saturated fashion industry, now fueled almost entirely by star power. From the point of view of cultural history, Rawlings' role in effecting this change is without question one of the most highly impacting achievements of his career and is more resoundingly influential and formative than any contribution to twentieth-century pop culture made by any photographer since.

To the credit of Edna Woolman Chase and Condé Nast, John Rawlings' insightful suggestion was met with unanimous praise, and it quickly paid off to an extent that no one could ever have predicted. Soon the unassuming young man from Ohio was photographing nearly every stage, screen, and society star of the mid-twentieth century, including Marlene Dietrich (pages 57,85), Joan Crawford, Brooke Astor, Montgomery Clift (page 92), Millicent Rogers (page 102), Bette Davis, the Duchess of Windsor, Lauren Bacall, Truman Capote (page 243), Pavel Tchelitchev (page 75), Gene Tierney (pages 112, 144–145), Mona Bismarck, Salvador Dali (pages 72–73), Babe Paley (pages 105, 113, 115), and Veronica Lake (page 67), to name but a fraction.

In addition to recruiting celebrities and socialites for the editorial pages, Rawlings also helped launch the careers of several of the most prominent mannequins of the mid-twentieth century. His early discovery, for example, of model-turned-actress Meg Mundy in the waiting room of the CBS studios had far-reaching effect: Mundy (a trained singer whose father managed the orchestra at New York's

Metropolitan Opera) went on to enjoy a decade-long career as one of the most successful American mannequins of the 1940s, with a string of Broadway successes close on its heels. In a published interview that coincided with her acclaimed lead in Jean-Paul Sartre's *The Respectable Prostitute*, Mundy forthrightly attributed her sparkling success to John Rawlings. She remembered him patiently teaching her the importance of relaxation in front of the camera and (not so patiently) ordering her to "Get rid of that pimple, girl!" At a time when magazines and photo studios were making it their business to lure away the competition's hot new talent, Mundy remained unflaggingly loyal to Condé Nast, largely because of Rawlings.

Like many photographers, Rawlings had his own running list of favorite models, those sylphlike muses with whom the photographer and his camera, in fleetingly glamorous moments, somehow transcended their

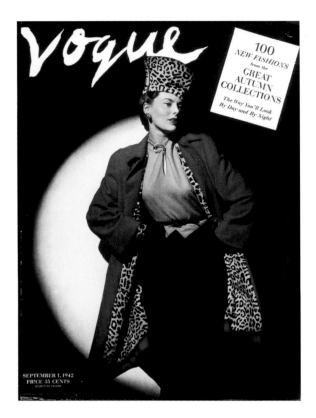

Meg Mundy, *Vogue* cover, September 1, 1942

medium. Showing a marked favor for Meg Mundy, Dana Jenney, Helen Bennett, and Betty McLauchlen during the late 1930s and early 1940s, Rawlings was also among the first to feature the fourteen-year-old marvel Carmen Dell'Orefice, who in later years went on to do nudes with him. In a recent interview, Carmen proudly defined Rawlings as "another breed. And underline that!" she insisted. "He was highly intelligent, sensitive to a point one can hardly imagine. Whether I was dressed, half-dressed, or not dressed at all, I trusted him implicitly. He made me feel so comfortable, so relaxed. Looking back, I remember thinking it was the first time I ever felt so beautiful!"

Later, in the early 1950s, Rawlings came under the spell of Marylander Jean Patchett and the bewitchingly beautiful Sunny Harnett. With her long-legged American physique, pristine blond good looks, and broad open-eyed glance (page 211), Harnett had an immediacy and an in-your-face quality that Rawlings just adored. But John Rawlings' most noticeable fascination was for the incomparable Texan Suzy Parker. Parker had begun her career at the encouragement of her eldest sister, famed model Dorian Leigh. (Leigh's agency represented both Suzy and Carmen.) With her renowned sense of humor and famous mane of flaming russet red hair, Suzy Parker was widely envied for her internationally celebrated American beauty and an immeasurably successful career, both in America and abroad. In 1953, when *Vogue* sent Rawlings to Paris to cover the haute couture collections, there was Suzy Parker, as much the toast of the town as the new collections themselves. In fact, the 1953 fall edition of French *Vogue* dedicated an entire Rawlings spread to her, proudly touted on its cover as "Collections— Suzy Parker!"

In the mid-1960s, long after Parker had begun working as a photographer for Magnum—shooting fashion features for *Elle* and French *Vogue*—and had scored several Hollywood successes, she was featured in a celebrity profile in *Vogue* along with her first child, Georgia. It was Rawlings she welcomed into her Manhattan home for the accompanying photos. In a recent interview, Suzy Parker remembered the man she said she could never forget: "John Rawlings was the perfect gentleman! So handsome, so polite. But good fun, too." Contrasting Rawlings to other photographers of the time, Parker remembered that while some were "so serious, grave even, Rawlings always made you feel like what you were doing, or the way you were interacting was just what the camera wanted." She also pointed out that Rawlings let a model work her own magic: "He never posed you like a doll: none of those vague, front-facing staring-into-the-camera shots. He understood movement and the beauty of naturalness, even humor."

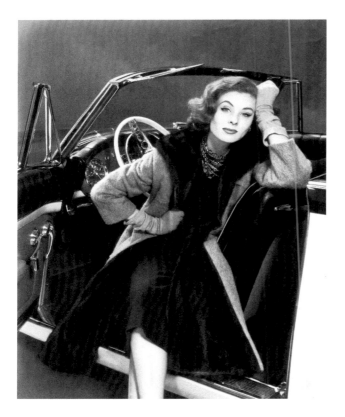

Suzy Parker, *Vogue*, September 15, 1952

By the second quarter of the twentieth century, fashion magazines had evolved from publications that merely reported on the latest looks into veritable "how to" lifestyle manuals. And as the fashion press was growing into its newly expanding role as the most powerful vehicle of commercial endorsement—suggesting a more precisely targeted opportunity for advertisers to reach American women—John Rawlings' commercial career took on bounding momentum. A veritable pioneer of the lifestyle-based ad campaigns that have since become the mainstay of modern-day advertising, Rawlings was quick to recognize the potential mass appeal of the pointedly elitist high fashion aesthetic. Garnering commercial advertising accounts from some of the nation's biggest corporate names, Rawlings produced ad work in the mid-1950s and 1960s that was light-years ahead of its time. From ketchup to couture, perfume to pantyhose, John Rawlings fused the high culture sensibility of the haute couture with the workaday products of the American housewife.

Excited by the output of America's postwar boom in industrial design, Rawlings incorporated everything from housewares to convertibles into both his editorial and ad campaigns. Whether displayed in a Chevrolet ad with the dauntingly glamorous Suzy Parker cast as a wholesome midwestern housewife or an ultra-chic showdown wherein two couture-clad femmes fatales meet at the local supermarket to

buy Hunt's ketchup, Rawlings' amusingly accessible style and un-arty atmospheres were a natural choice for American manufacturers. (pages 208–9) By the mid 1950s, the sleek, bulletproof styling sense that Rawlings had gleaned from years of experience in the world of high fashion, combined with his early years as a display artist, made him a world-class photographer well versed in the presentation and arrangement of products with the sale in mind. In a flashback to his early days in New York, the excruciatingly modest Rawlings once downplayed his industry-acclaimed product advertisements by saying that the genre came easy to him because it was "basically high-end window dressing."

Spirited, clever, sometimes wonderfully kitsch, Rawlings' award-winning ads for Coca-Cola, Viceroy Cigarettes, and General Motors from the mid-1950s are veritable icons of mid-century American popular culture. Featured on buses and billboards across rural America, then later on television, these images of the newly polished postwar American lifestyle reached well beyond the pages of the New York–based fashion magazines, leaving us some of the twentieth century's most compelling scenes of Americana. (page 225)

John Rawlings once wrote that "the mirror actually sees what the camera sees: a compressed, two-dimensional view of reality behind glass." Whether hastily copied from another source or jotted down in an inspired moment, this oddly provocative thesis, written on a work-order envelope amid columns of film costs, models' fees, and travel expenses, put into words what so many of Rawlings' pictures reveal: an ongoing visual dialogue with mirrors and reflective surfaces of all kinds. Characterizing the camera as an eye seeing through glass, Rawlings experimented with glass surfaces and treated semi-transparent materials—work that yielded some truly innovative and remarkably beautiful results. Sandblasted glass, pattern-scratched Plexi, a car's rear-view mirror—even the view from a model's compact—were of interest to John Rawlings, who grappled throughout his career with his conceptual hierarchy of the mirror, the lens, and the human eye. (page 250)

Rawlings' use of mirrors and other reflective surfaces eventually developed into a quest to redefine and ultimately call into question the accuracy of the photographic medium. In his history-making 1946 image of socialite and *Vogue* editor Babe Paley (page 113)—the first color photograph ever transmitted by radio—Rawlings positioned the arrestingly chic American blue blood in front of a floor-to-ceiling sheet of polished metal, creating a shimmering but not exacting visual echo of Paley's commanding physique and imposingly regal Lucien Lelong evening ensemble. While Rawlings' camera (the onlooker's point of view) ostensibly sees the subject clearly, is the half-accurate reflection (or mirror) facing the sitter meant to suggest the age-old maxim that we do not see ourselves as clearly as others do? Or are we to read Paley's looking into the camera as disregard for the warped likeness that stands before her—an acknowledgement that Vanity is ultimately, and at best, an unreliable ally? A frequently encountered symbol of both Truth and Vanity, the mirror in fashion photography would appear at first to need no explanation whatsoever. But what of Rawlings' replicated visions, subtle

distortions, and hints of inaccuracy? For Rawlings, the polemic revolved around one central thesis: The lens and the mirror shared a vision that the human eye could never conjure on its own—"a compressed, two-dimensional view of reality behind glass."

Referring to the mirror in his technical notes as "the third eye," Rawlings was most fascinated by its potential for depicting varied and shifting points of view within a single pictorial field—a multiplicity of viewpoints that ironically reinforced his assertion that photography yielded essentially just one more of an unlimited number of inaccurate points of view. Unlike the work of Erwin Blumenfeld, who was prone to mask or partially obscure his subjects with glass or mirrors, or that of Horst, whose witty use of mirrors yielded a picture-within-a-picture effect, Rawlings' use of optical mirroring and reflective surface refraction was not deconstructive but rather *expansive*, leaving the original (or "real") subject fully intact while offering or suggesting simultaneous optical fields of perception. (page 81)

Far from searching for realism through these inquiries into "the camera's lie," Rawlings sought to further expound upon the creative potential of this seductively deceptive relationship between three-dimensional subject matter and a two-dimensional medium. What occurs over time, however, is not what might be expected: Instead of merely incorporating the mirror into his compositions, Rawlings eventually imposes the perfectly balanced symmetry that only a mirror can give directly onto the raw material of his work—manipulating contact sheets and negatives alike in his pursuit of the ideal image. (pages 148–149)

More than a mere carryover from his early days as a display artist, this keen, almost instinctive awareness of the subject/object relationship led Rawlings to synthesize over time his own point of departure vis-à-vis the human figure within an overall composition. Remembering that for many years Rawlings' first employable talents (as a display artist, then as a prop builder) were expressed in three-dimensional form is crucial to an accurate understanding of this seemingly straightforward American image maker. Today John Rawlings is remembered almost exclusively for his sleek, pared-down editorial work, yet a closer, more informed look at the output of Rawlings' career reveals instead a more complex thematic evolution. In his later more mature work, the result of this visual inquiry becomes apparent: a photographic narrative in which three-dimensional objects (mirrors, paintings, sculpture, and period furniture) come to play equally important roles in coaxing out and rendering the psychological character and mood of Rawlings' subjects, in portraiture, commercial ad work, and editorial shoots alike.

During his lifetime, Rawlings produced two volumes of collected studies of the nude figure. The first, *100 Studies of the Figure* (1951), was an artfully presented selection of black-and-white images of the truly extraordinary American beauty Evelyn Frey, with whom Rawlings maintained a romantic relationship in the early 1950s. Frey (who was godmother to one of Dorian Leigh's children), with her

timeless features and imposing cheekbones, bore a striking resemblance to Rawlings' first major discovery, Meg Mundy, a similarity that did not escape the notice of Rawlings' contemporaries. Combining studio and location shots, the book features uncharacteristic experiments with severe film grain, along with daringly cropped, forward-looking studies of the human body that even by today's standards bear the mark of the avant-garde. (page 157)

Rawlings' second book, *The Photographer and His Model*, published in 1966, follows the same format as the first (one model throughout), this time featuring top model Betty Biehn, with whom Rawlings remained romantically linked for many years. Evincing a more immediate and overtly erotic atmosphere than the first book, the second collection of nudes somehow lacks the unity and timelessness that so readily distinguishes the first. This fact may be attributed in large part to Rawlings' inclusion of color work alongside his black and whites, but perhaps it is better explained by the nine years that it took to complete the project (despite what is written in the book's introduction). Strongly opinionated about the nature and practice of nude photography, Rawlings returned repeatedly to his sessions with Frey and Biehn, approaching each shoot as a natural starting point for technical perfection and compositional innovation. On occasion, Rawlings licensed and sold outtakes from his nude sittings for use as advertisements or editorial illustration, sometimes as much as a decade after the pictures were shot. Bold, seductive, and at times arrestingly beautiful, Rawlings' nudes provided the remarkably prolific commercial photographer with a creative respite from the dressed up and necessarily superficial world of fashion photography—a rare opportunity to contemplate the beauty that lay beneath—and he commented once that the work offered him "an escape from the rut of specialization." In 1957 Rawlings' nudes were featured along with those of Edward Weston in an edition of *Great Photography*—dedicated exclusively to the work of the two American image makers.

By the mid-1950s, Rawlings' representation in American and international magazines achieved an unprecedented ubiquity, with as many as twenty-six pages of his editorial, advertising, and feature layouts appearing once in a single issue of *Vogue*. Two lucrative book contracts for his nudes, as well as national campaigns for such corporate clients as Chrysler, Revlon, Clairol, Ivory Soap, Jaguar, and Volkswagen, eventually earned Rawlings commissions for an impressive roster of television commercials. His mid-1960s Clairol ads featuring athletic American girls running along windswept beaches, then emerging in slow-motion close-ups from the sea, were widely imitated well into the next decade. By the late 1960s, Rawlings' advertising work had begun to command fees as high as $10,000 a day—a staggering sum when seen in retrospect. Rawlings was equally active in print work and television alike at the end of his career, and his work conscientiously paralleled and fully interfaced with the twentieth century's ongoing fascination with technology and its long-standing love of glamour. John Rawlings remained at the top of his field throughout his lifetime, and by the time of his death in 1970 he had achieved a reputation as one of the most successful commercial photographers of the twentieth century.

Rawlings treated each genre of his work as carefully as the next. His soft-spoken but adamant belief that excellent images involved "keeping the photographer out of the picture" resulted in a career and body of work that offer pristine, unfiltered freeze-frame glimpses of the twentieth century's most dynamically charged era of art, fashion, politics, and industrial design. A quiet giant in the history of the Condé Nast empire, the unaffectedly elegant Rawlings, with his unassuming demeanor and Fred Astaire gait, was nevertheless known for his unstoppable determination to "get the shot"—he once strapped himself to the out-rigging of a swooping helicopter to better capture the dynamism and effect he envisioned. When asked to what length he would go to achieve the ideal photograph, John Rawlings gave an answer that was aglow with the optimism and assurance of the all-American mindset that had formed, promoted, and shared in his success: "Whatever it takes."

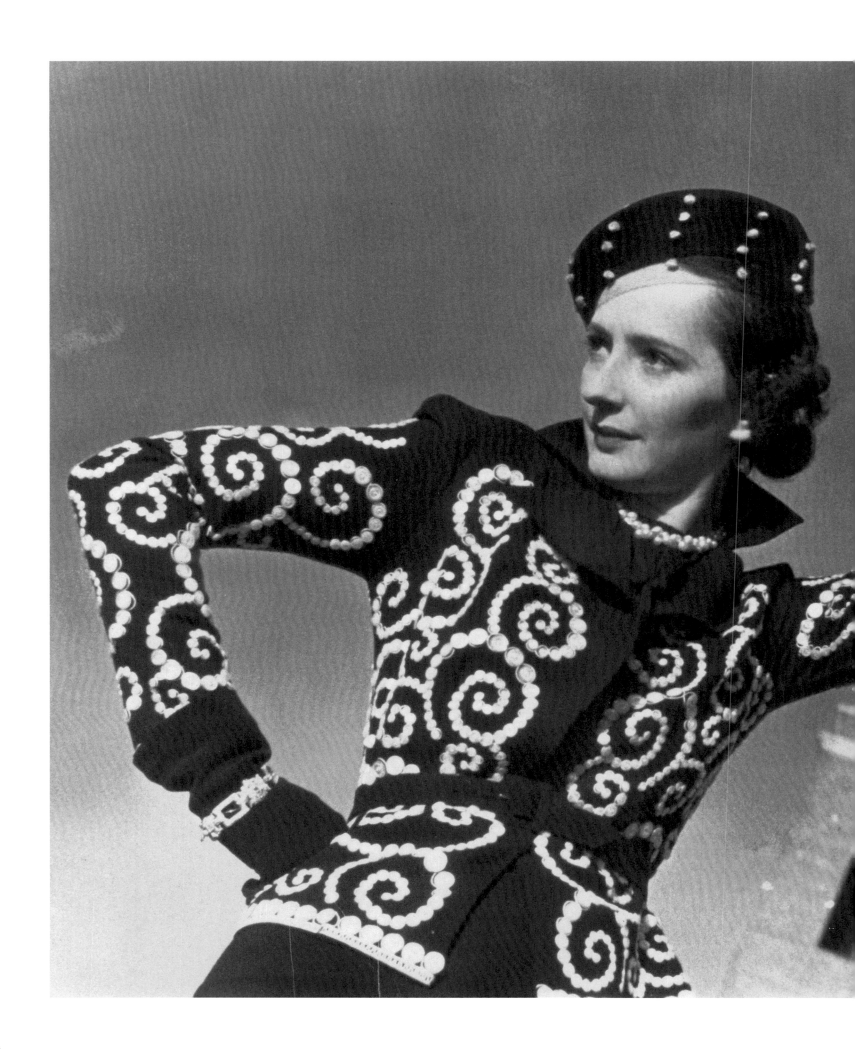

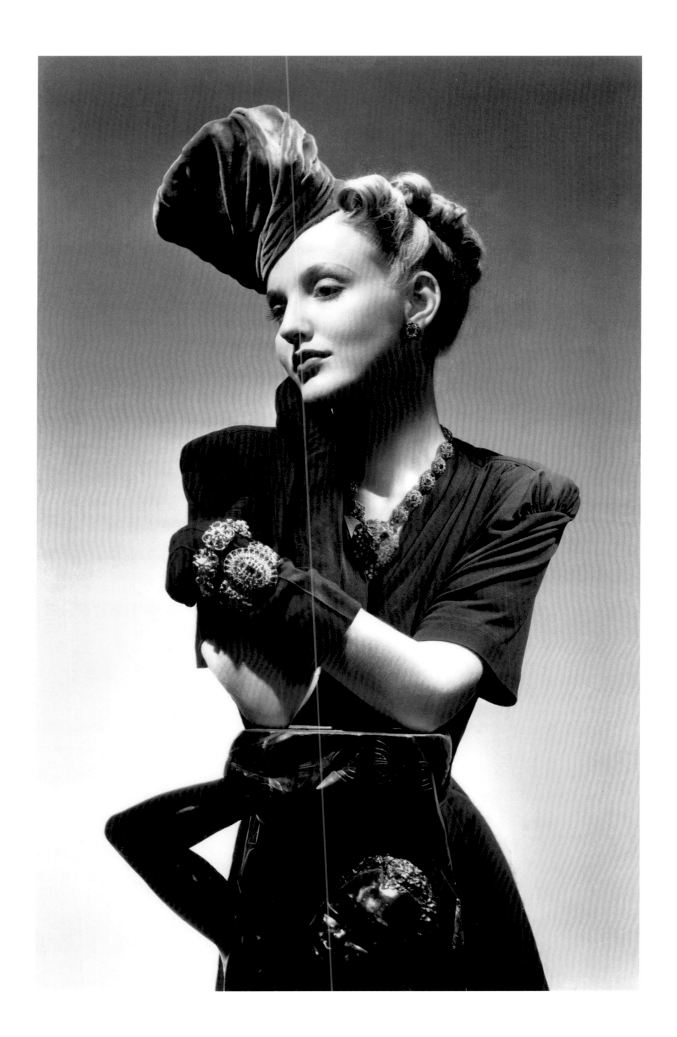

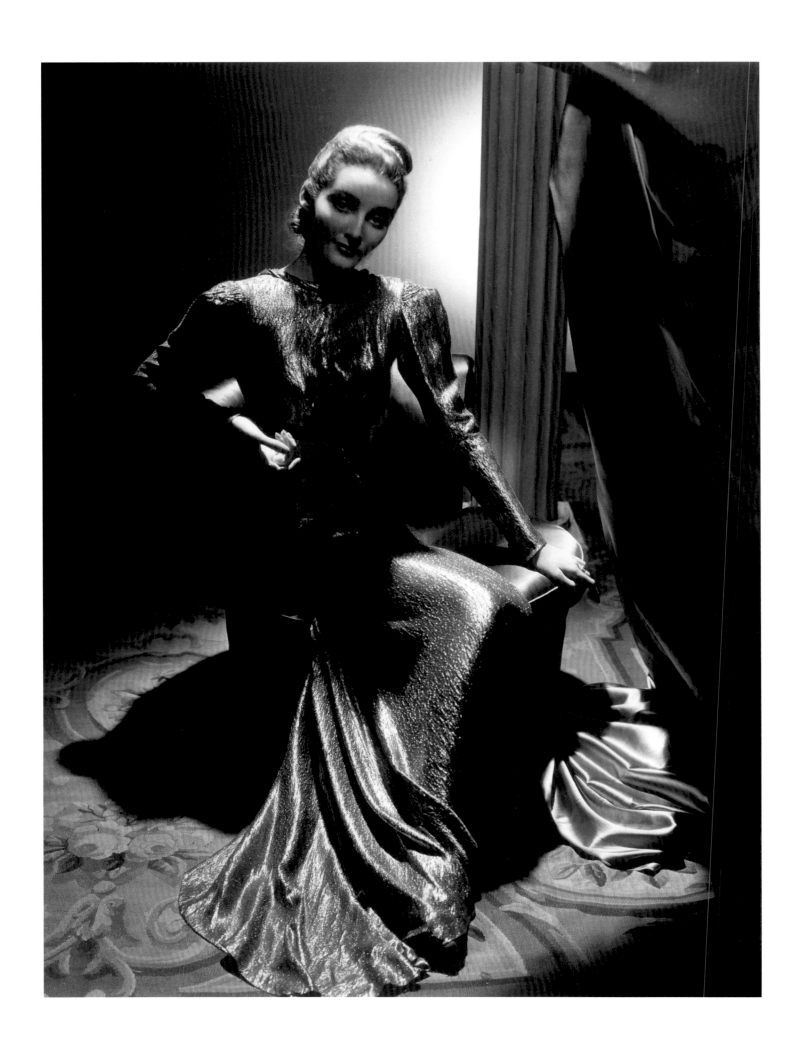

Vogue, May 15, 1938

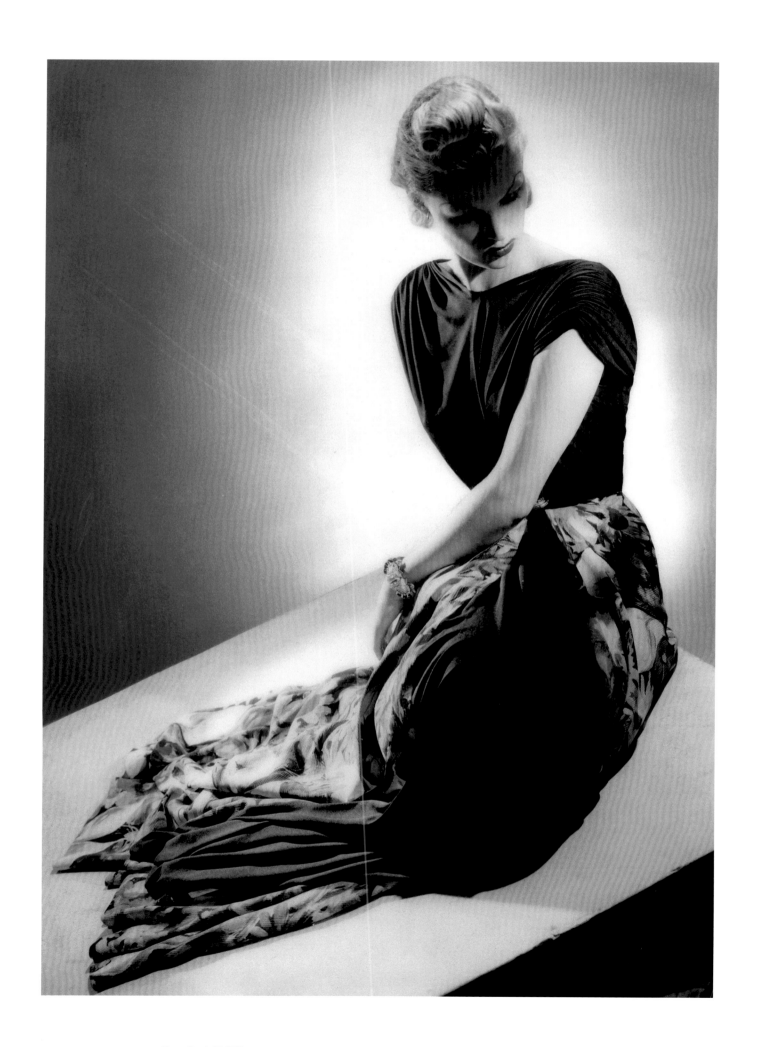

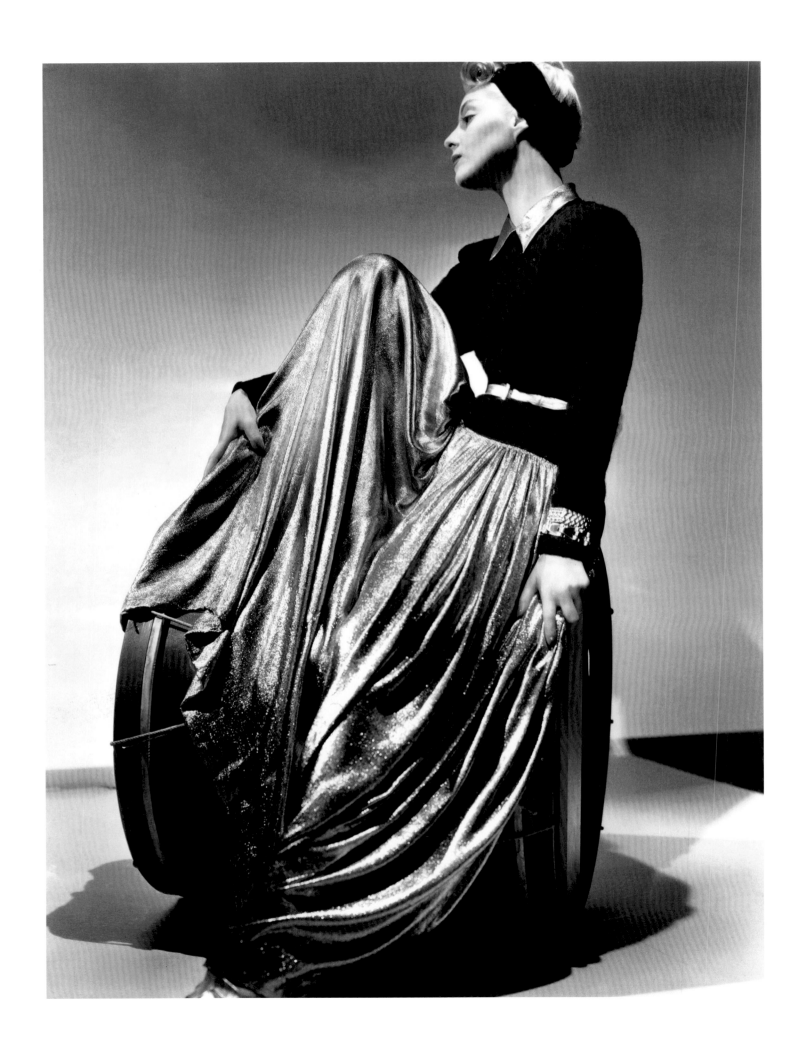

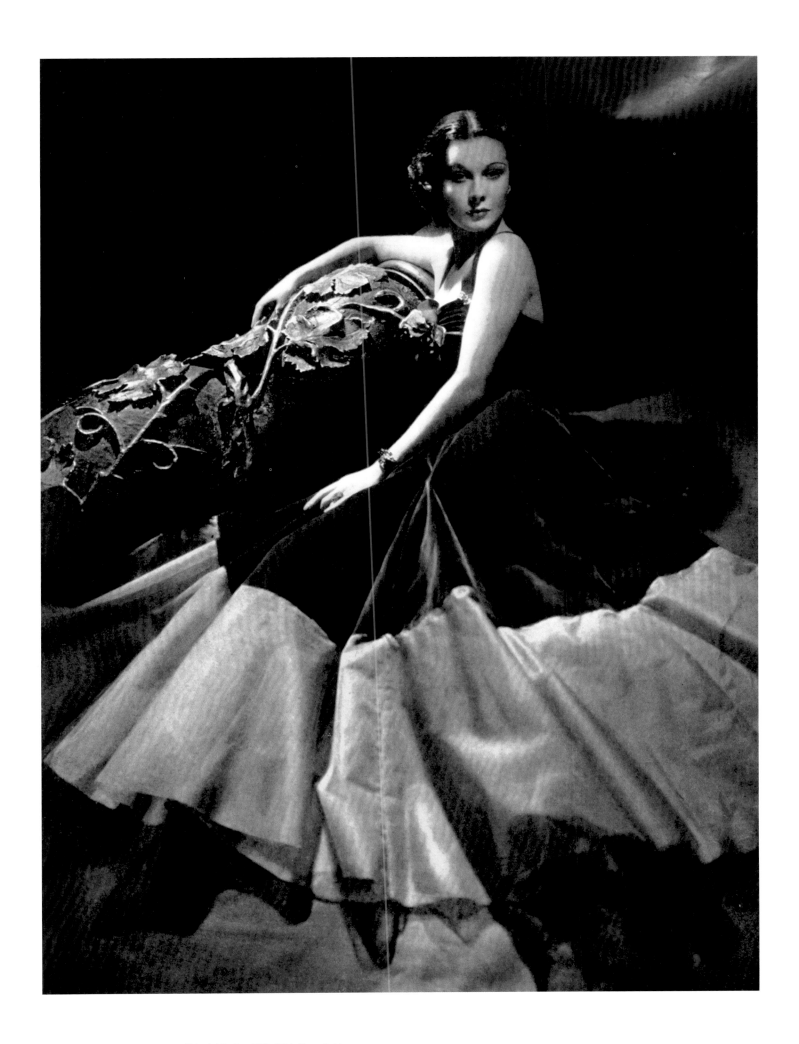

Vivien Leigh, circa 1938, British *Vogue* Archive

British *Vogue*, circa 1938

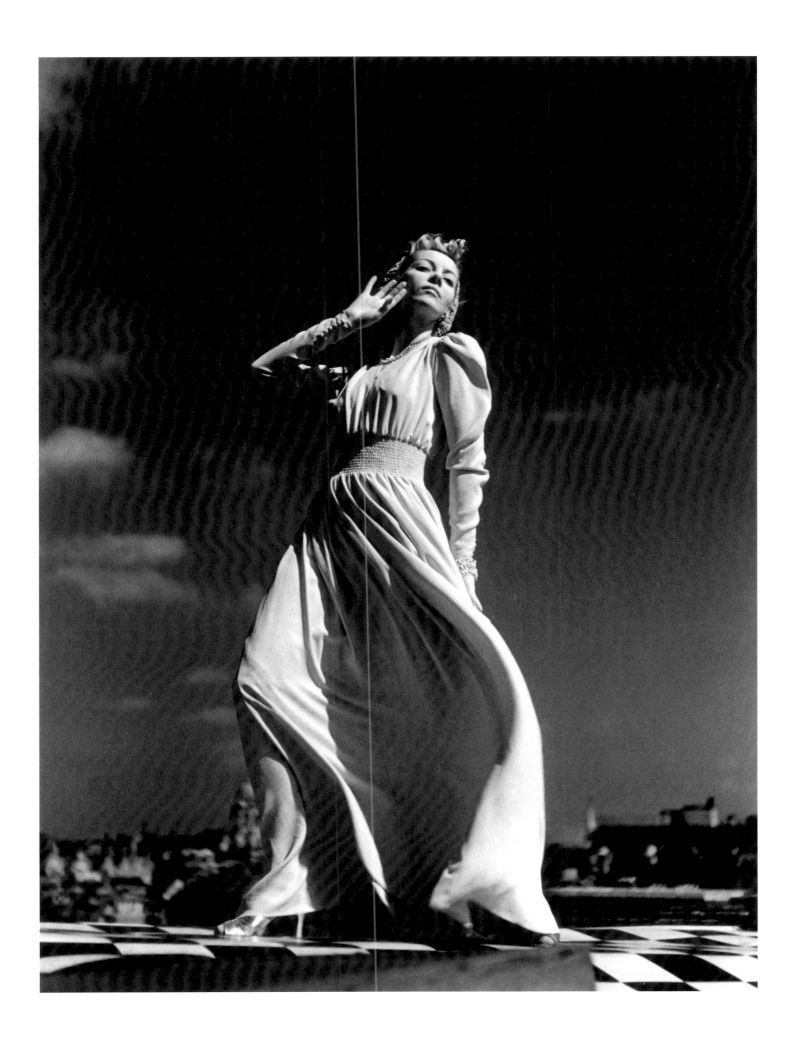

British *Vogue*, circa 1938

Hat by Madame Pauline, *Vogue,* September 1, 1938

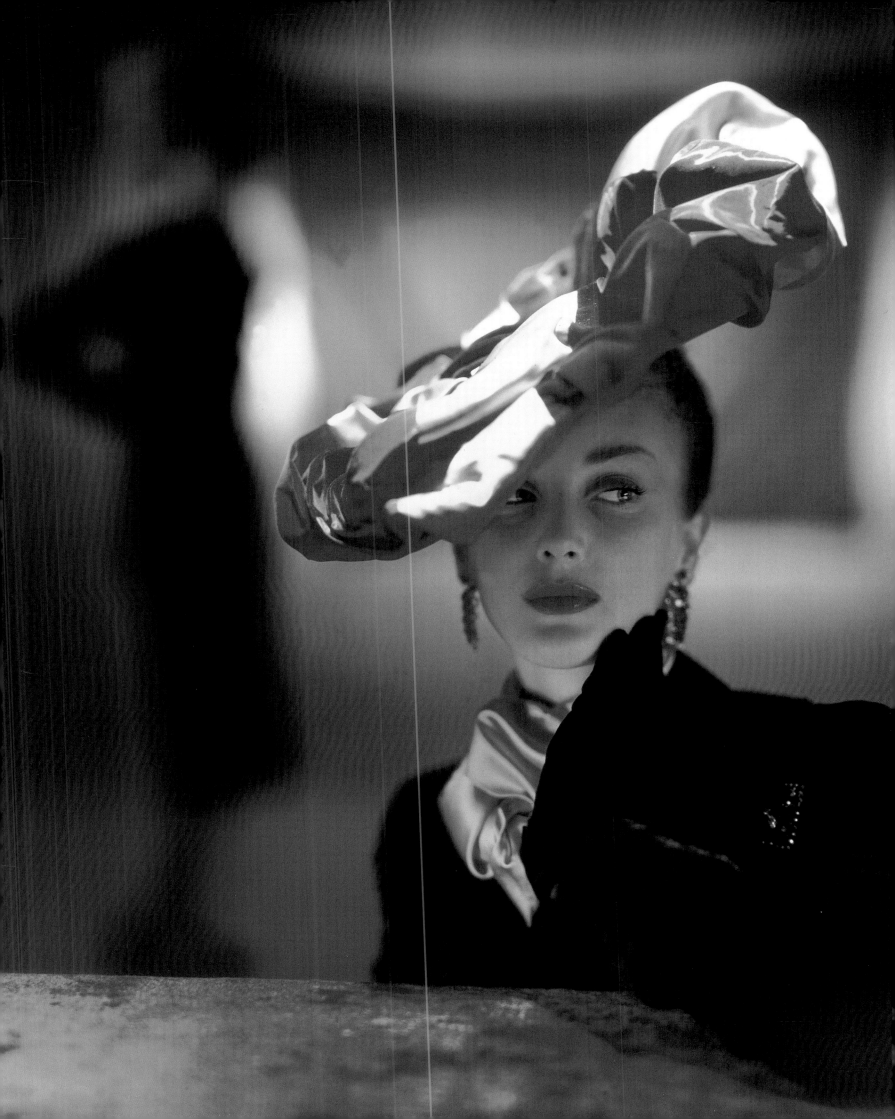

Marlene Dietrich, circa 1940

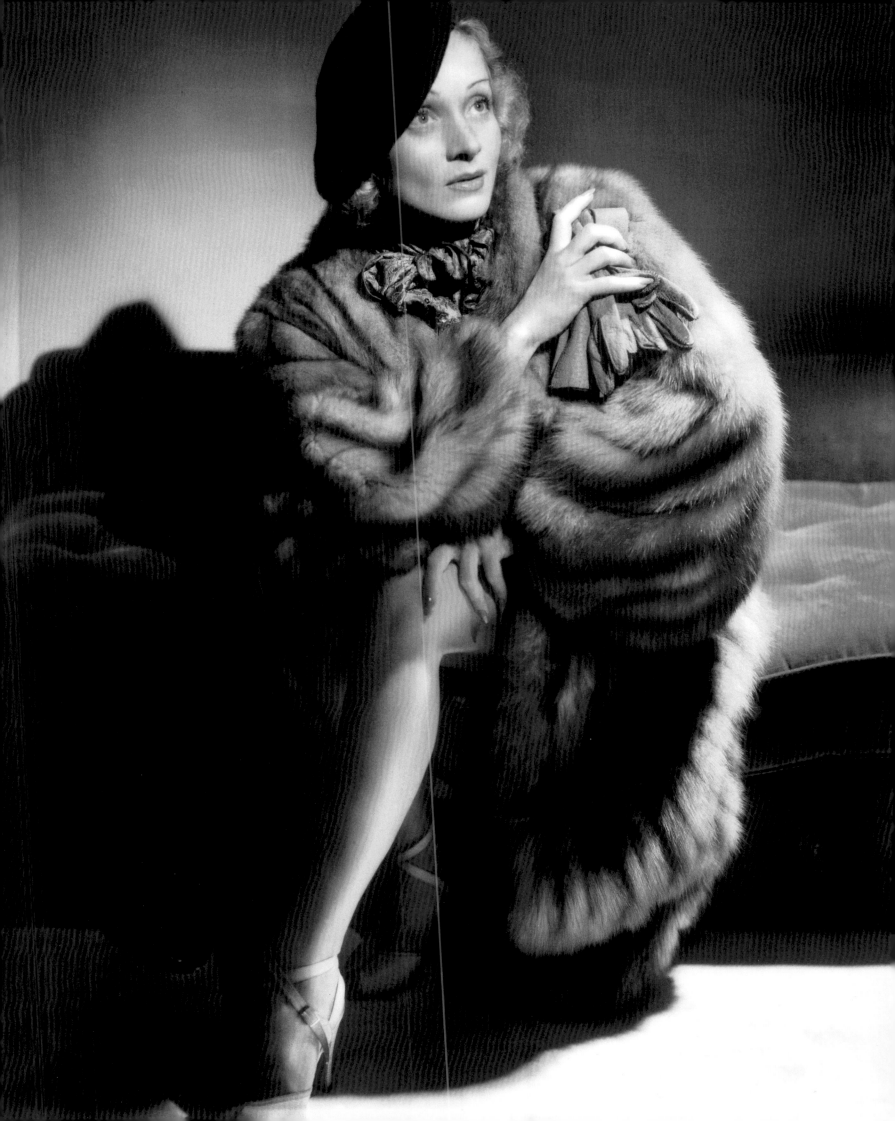

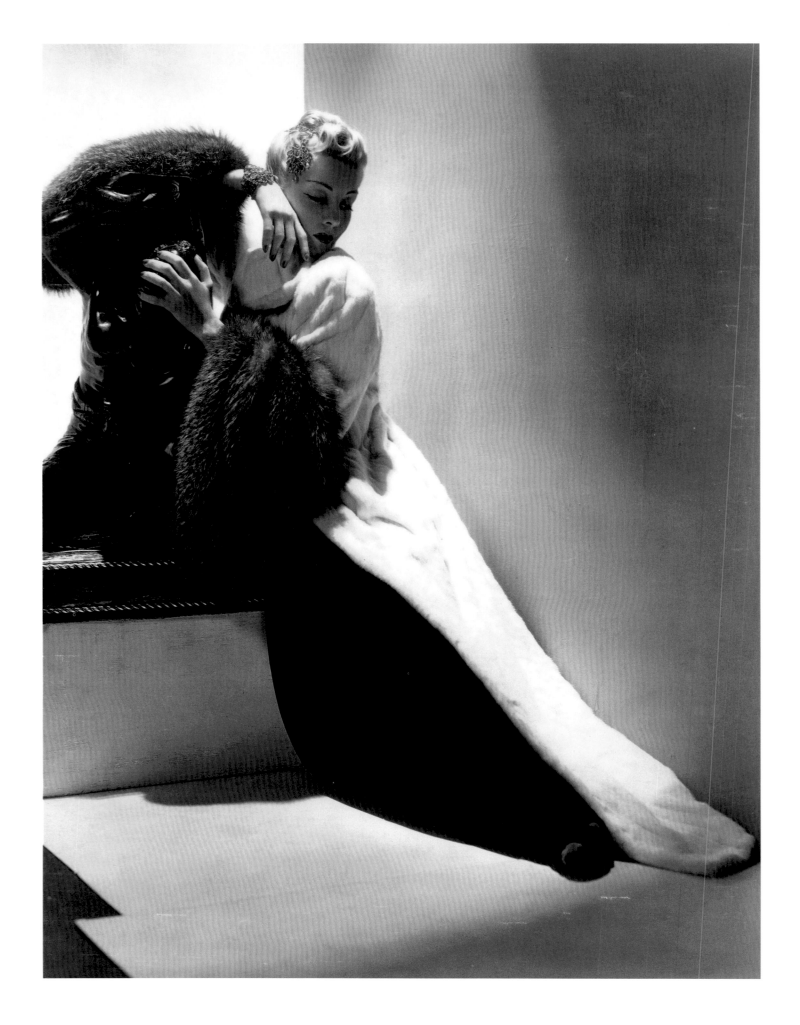

British *Vogue*, circa 1940

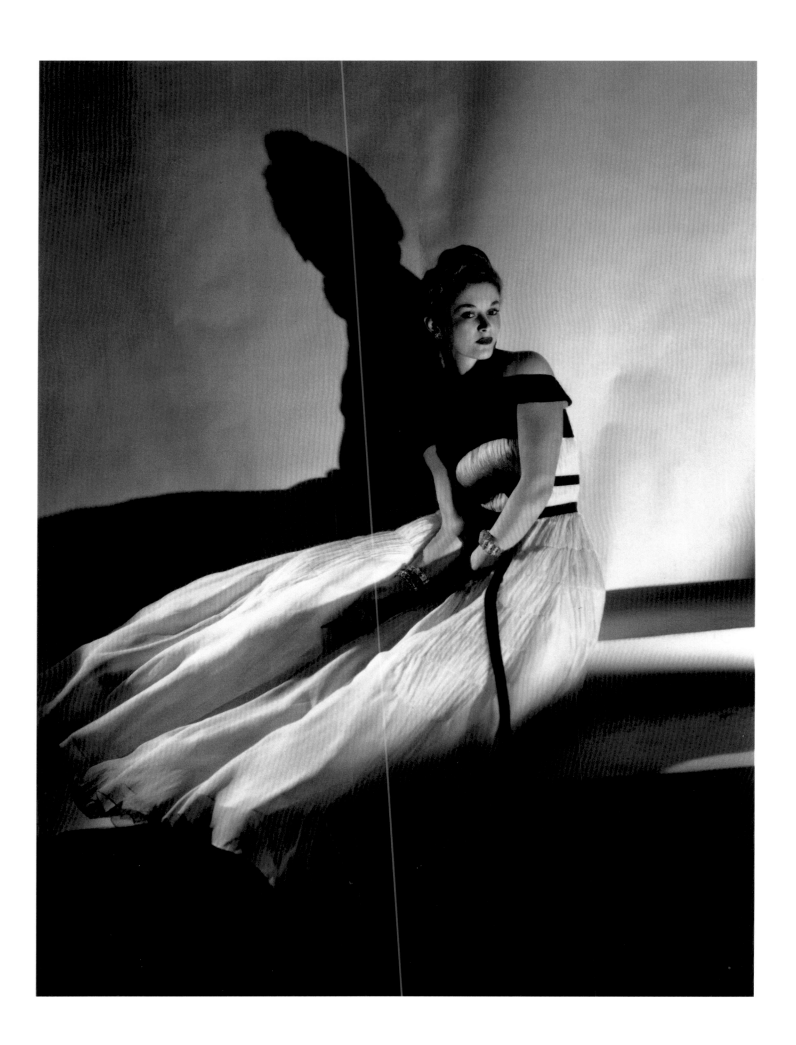

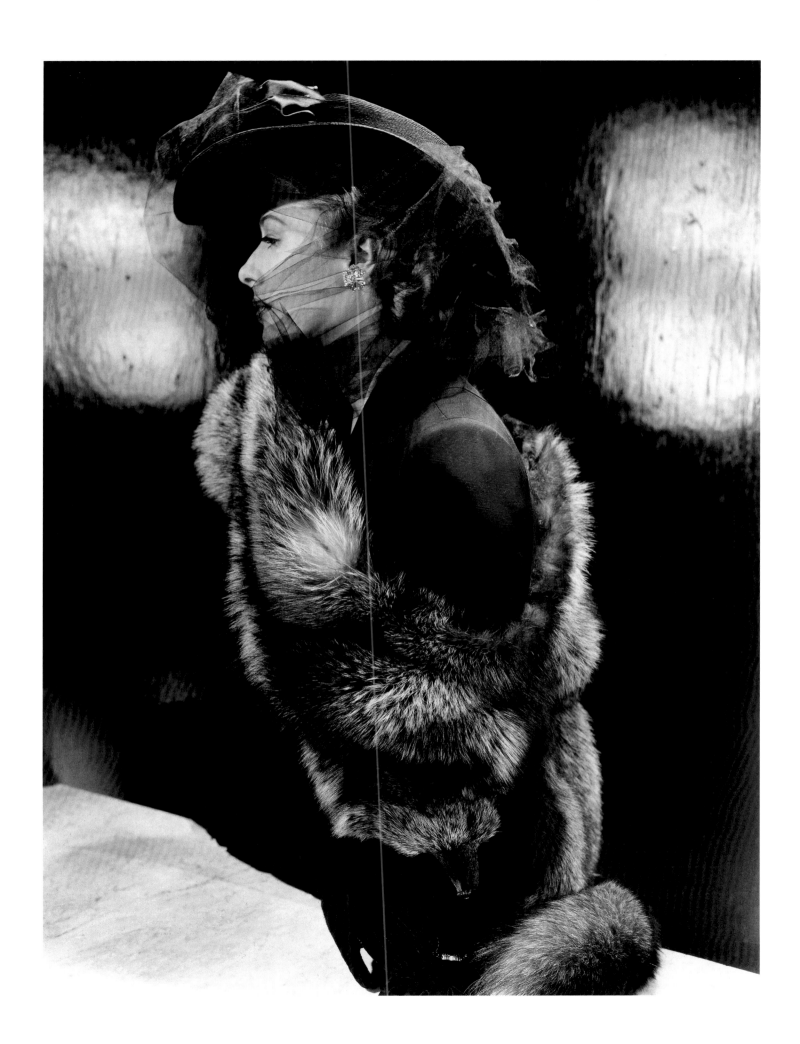

Maurine Zollman, *Vogue*, May 1, 1941

Meg Mundy in Cartier jewels, *Vogue*, October 15, 1940

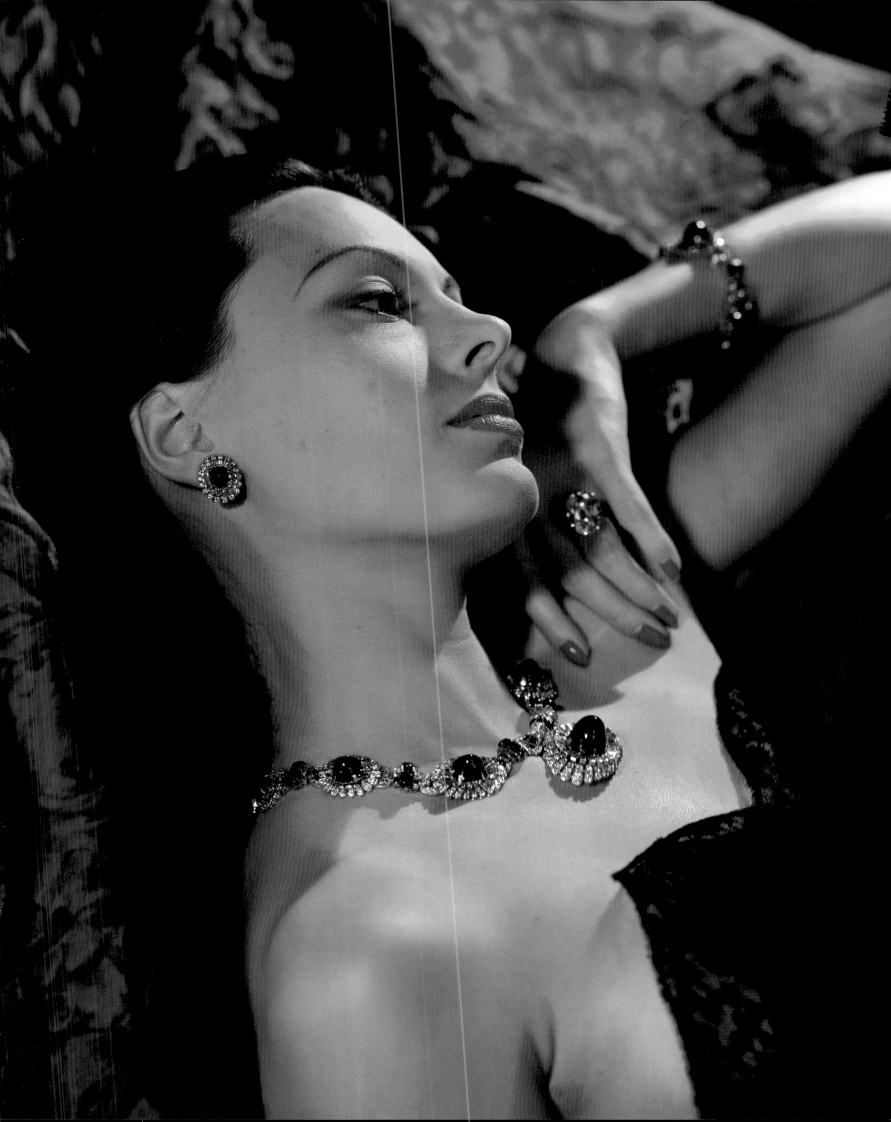

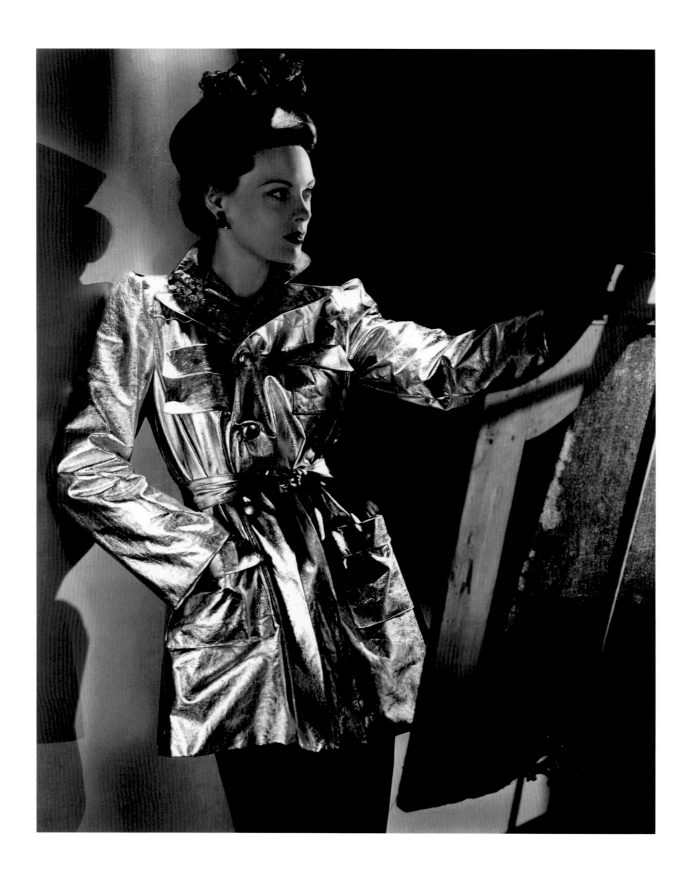

Meg Mundy in a 22-carat-gold-washed kid Mainbocher trench coat, *Vogue,* September 15, 1940

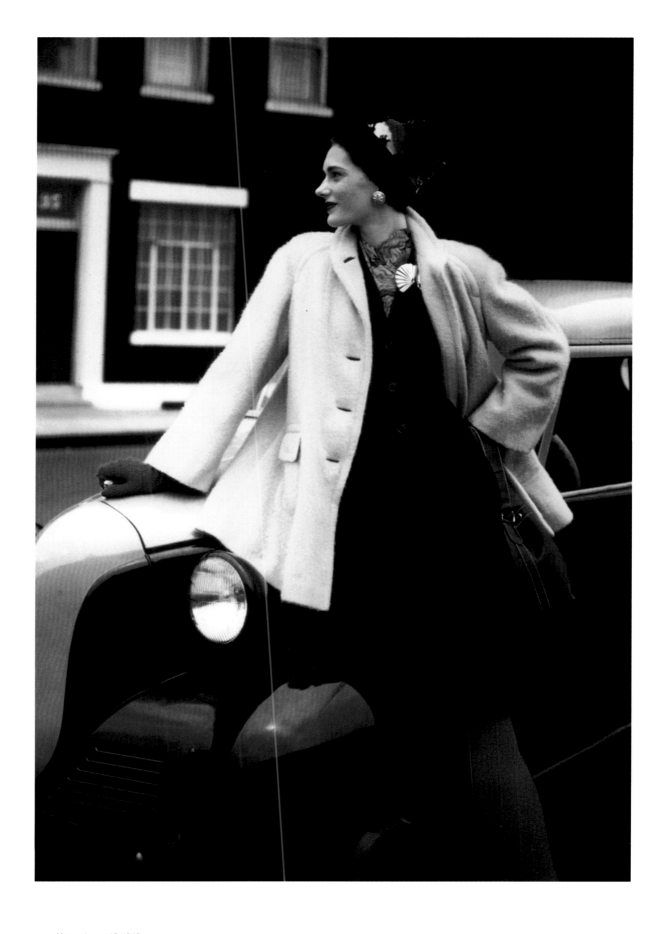

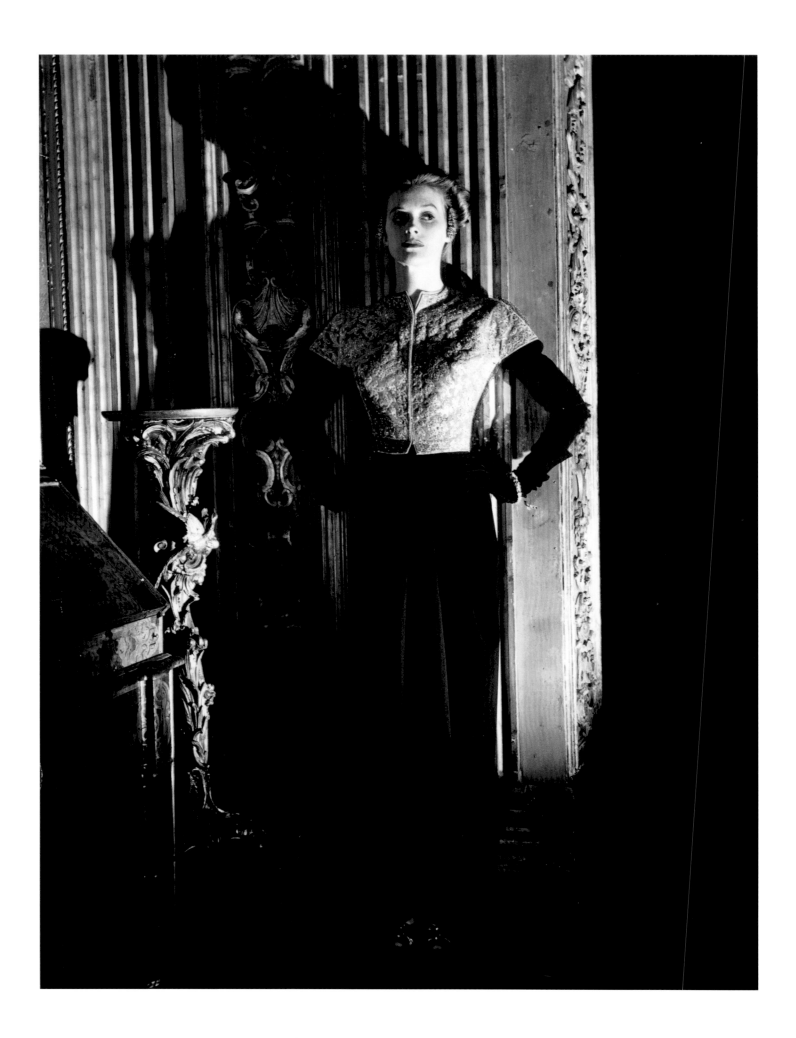

Germaine Monteil ensemble, *Vogue*, June 1, 1942

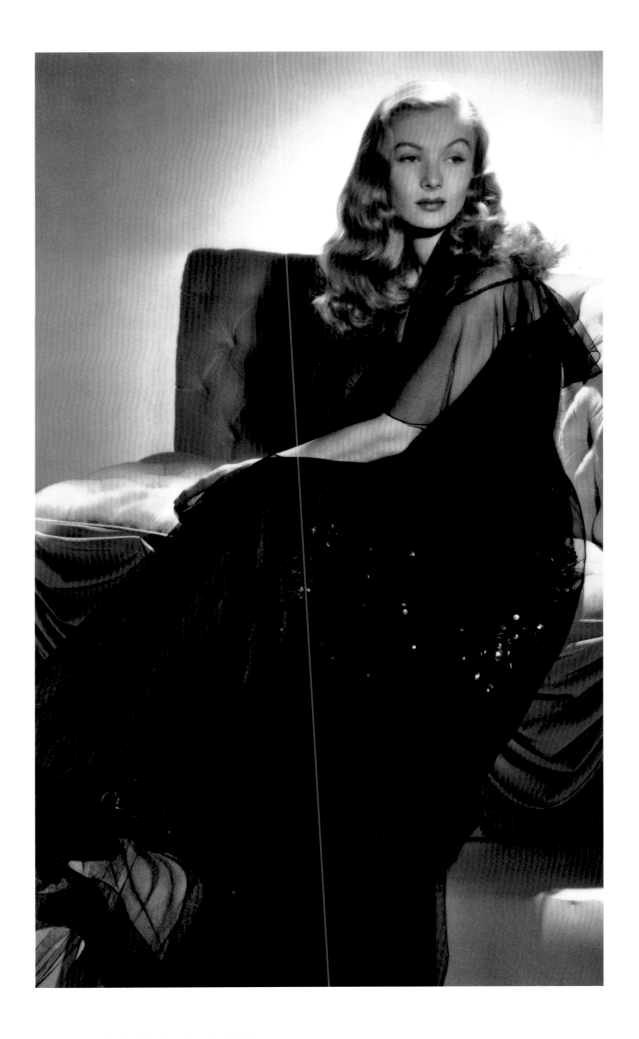

Veronica Lake, *Vogue*, November 15, 1942

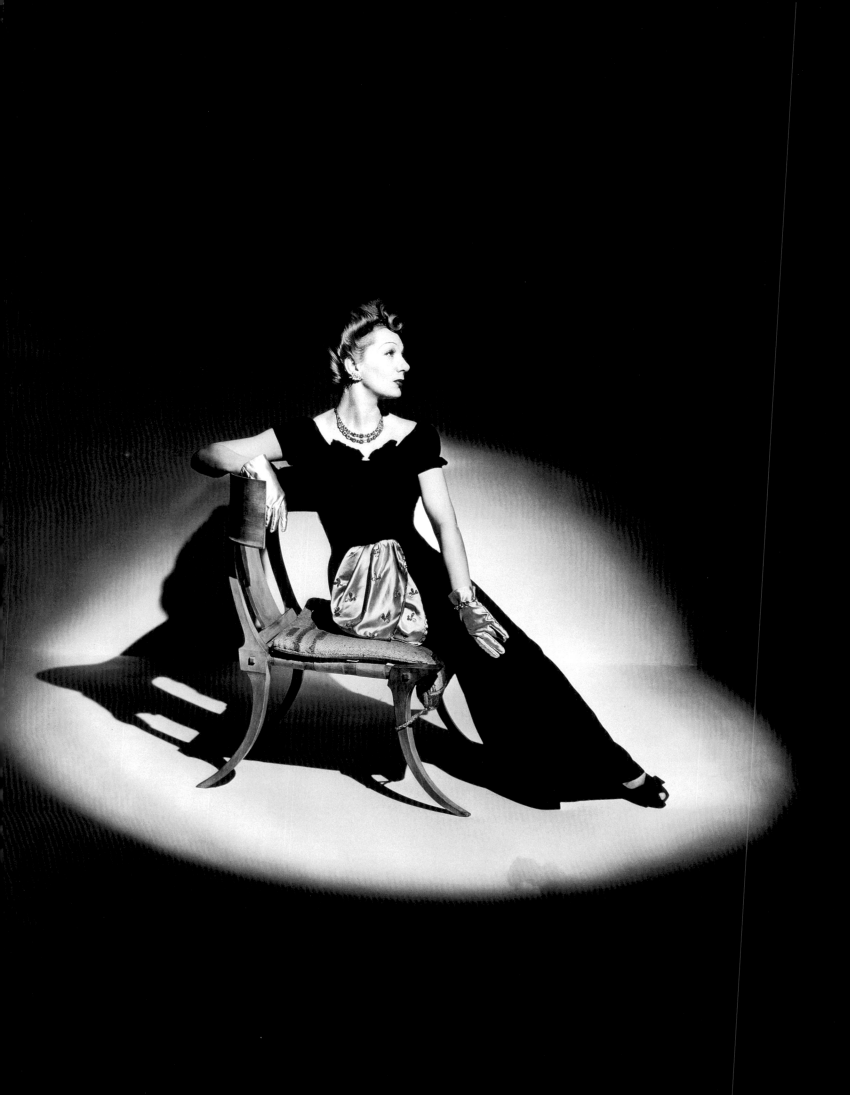

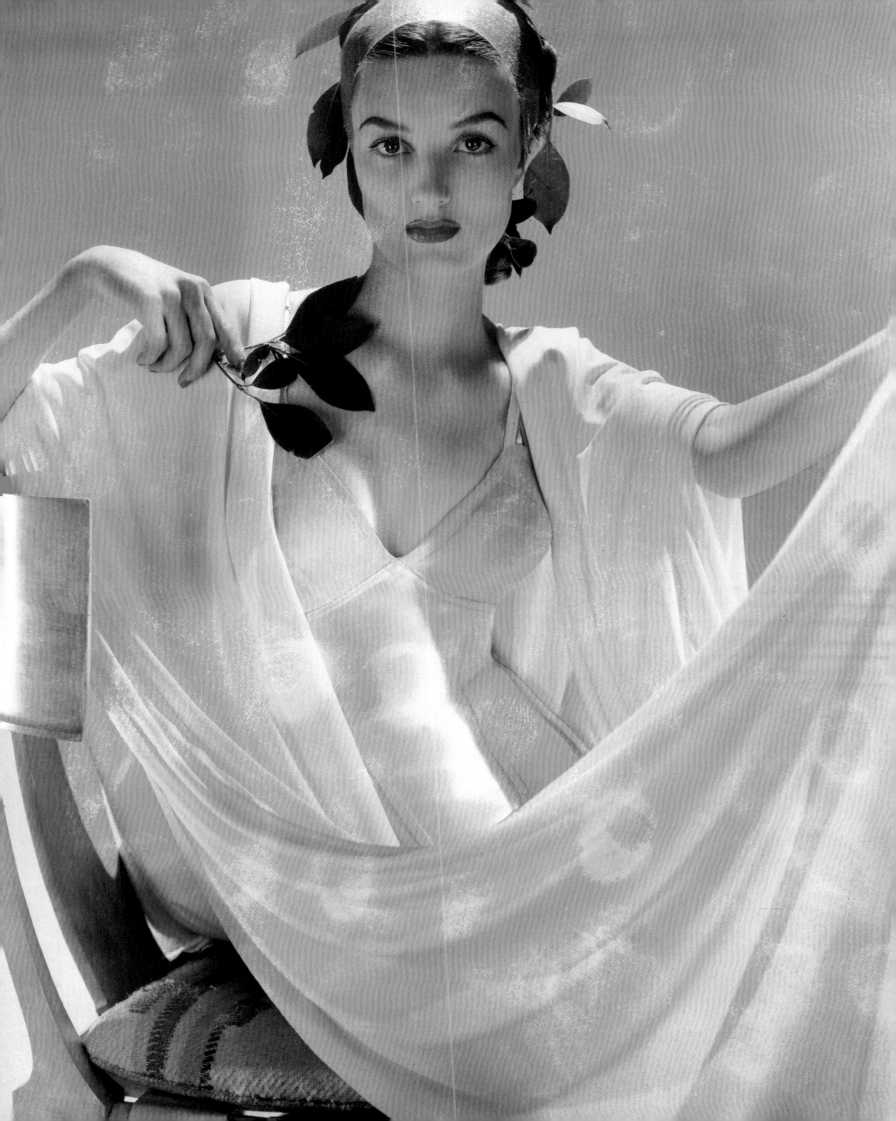

Salvador Dali, November 1943

Pavel Tchelitchev, studio sitting, circa 1942

75

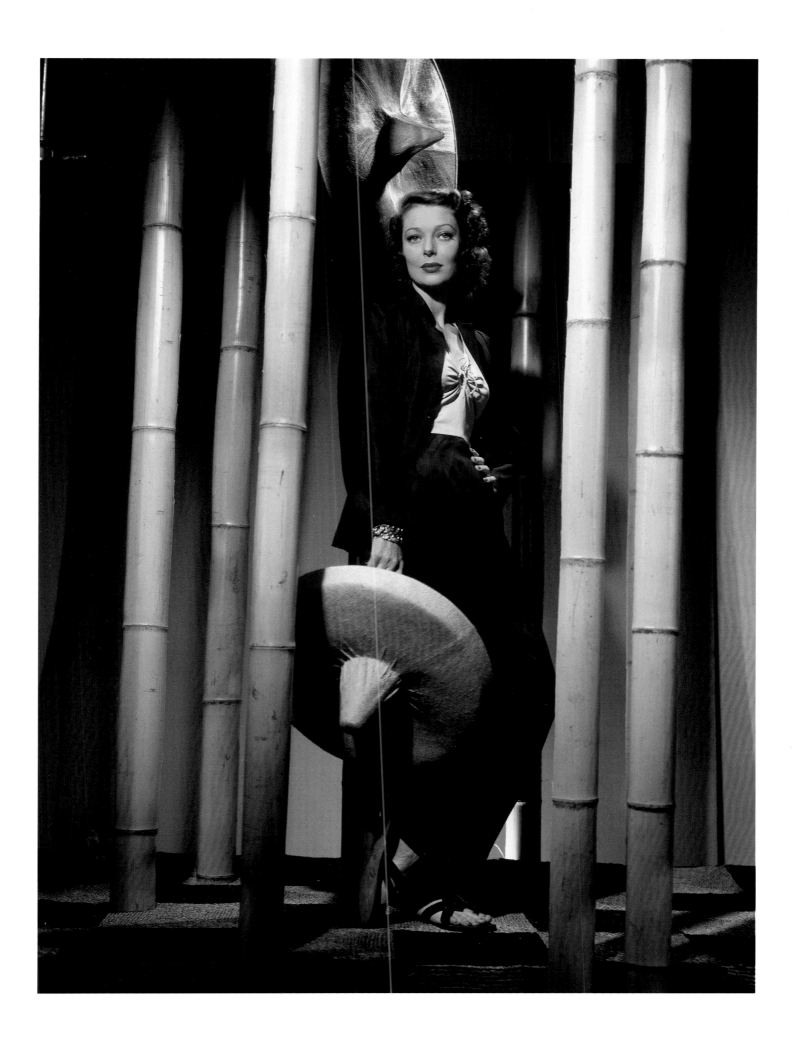

Loretta Young, *Vogue*, January 15, 1941 Opposite: *Vogue* cover image, September 1, 1943 77

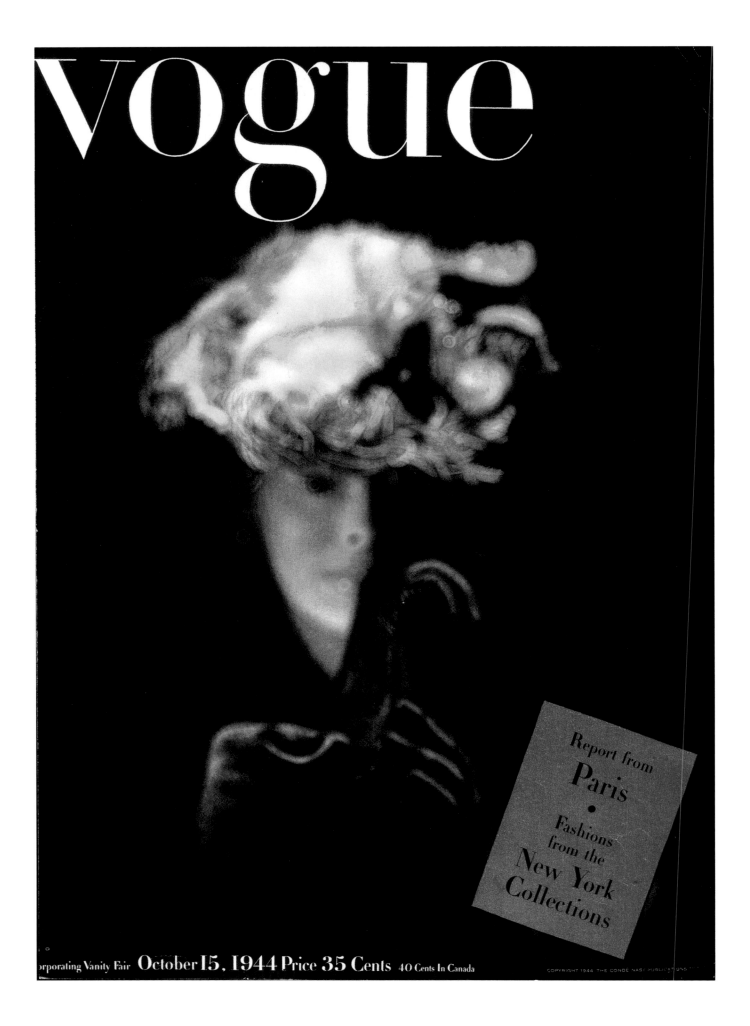

Vogue cover, October 15, 1944

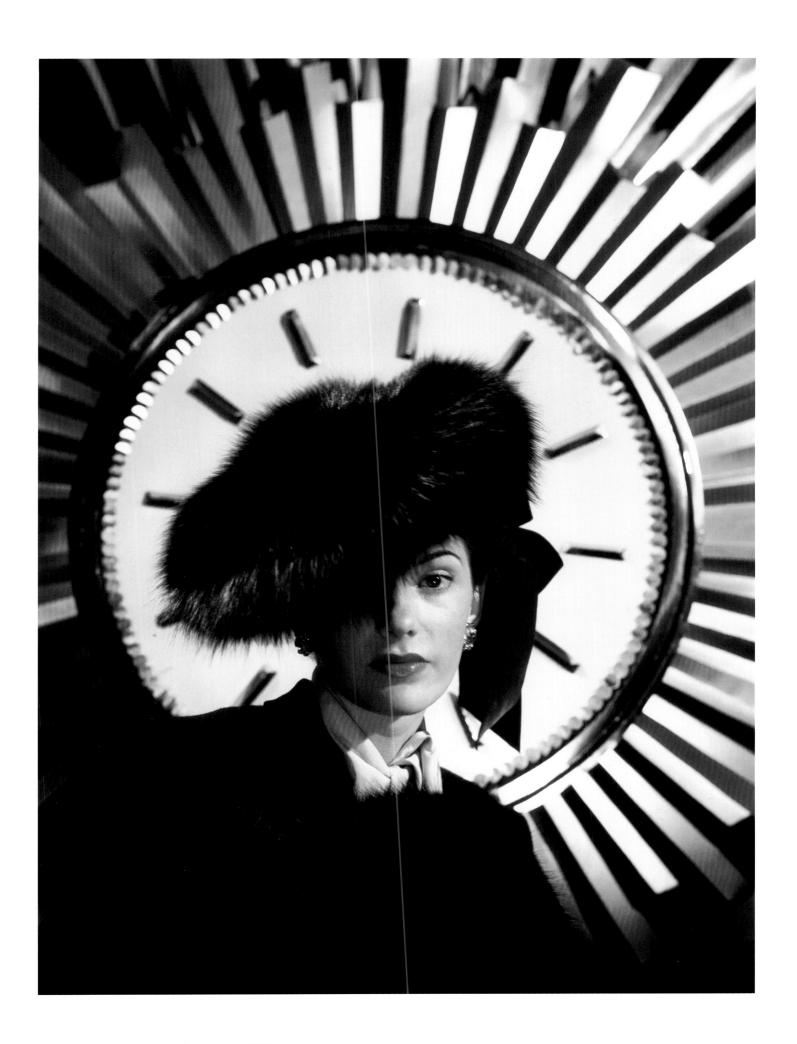

Mirror refracted image used for *Vogue* cover, January 1944

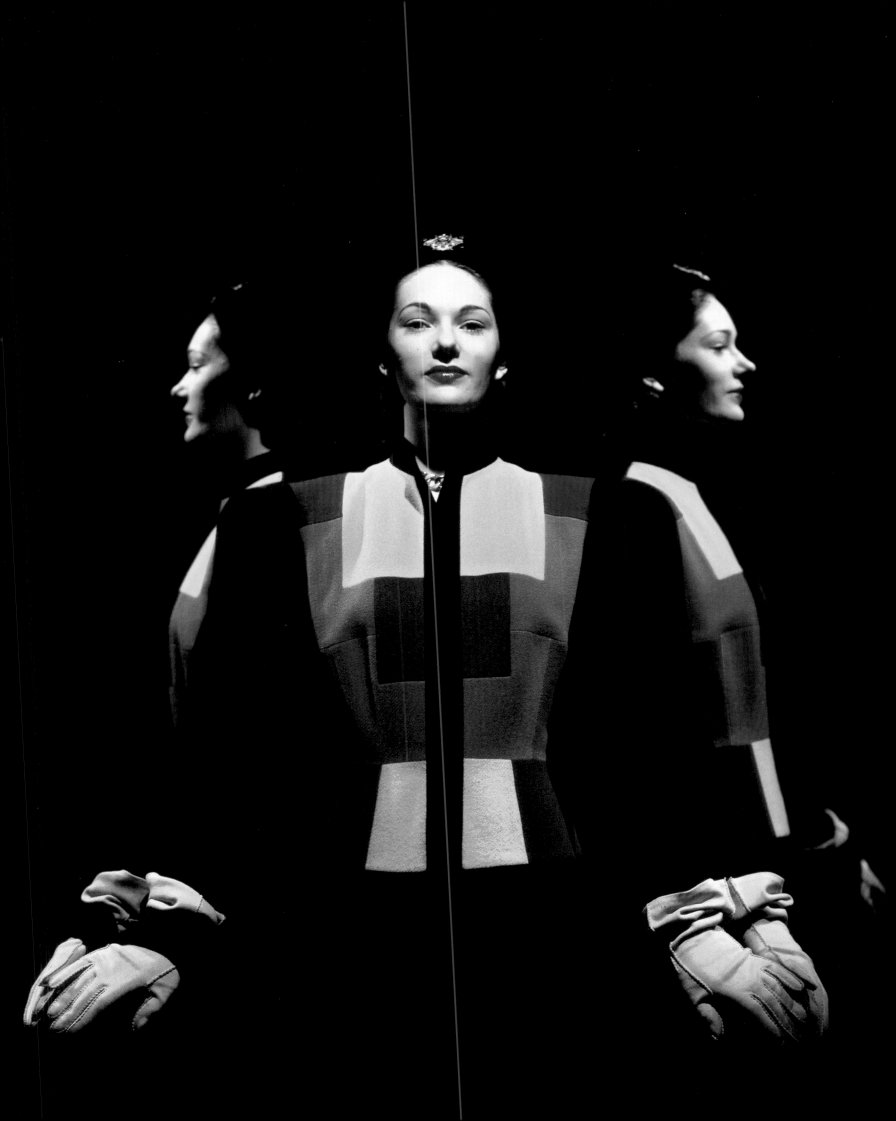

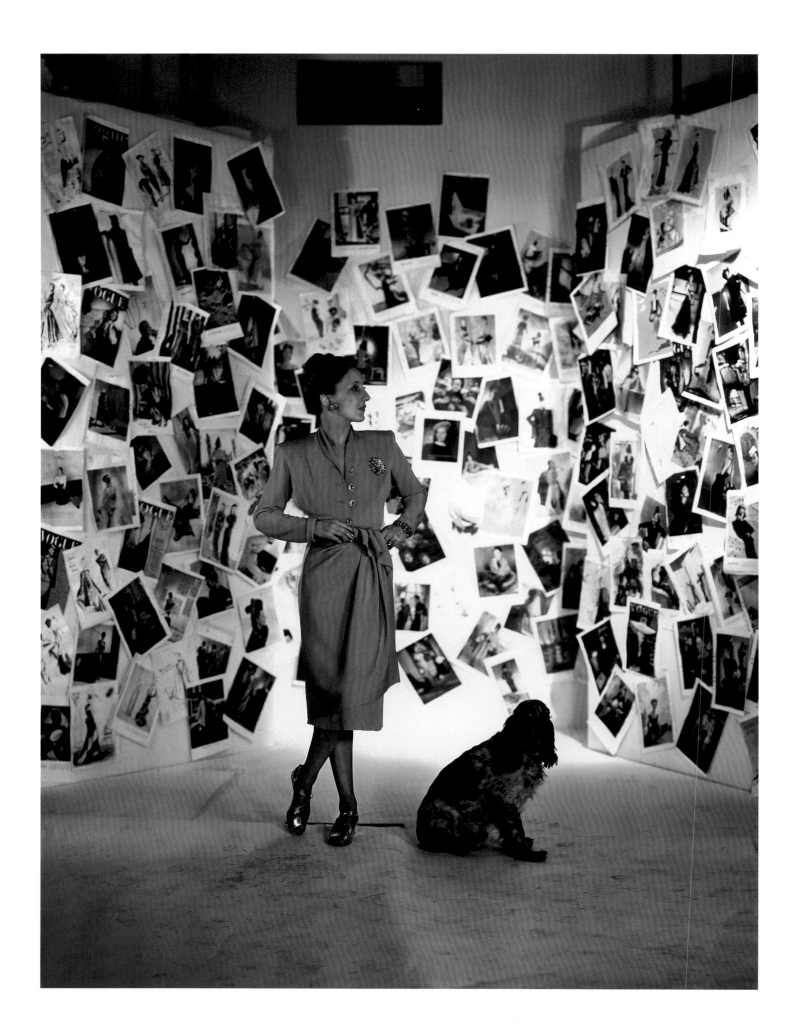

Babs Rawlings, *Vogue*, April 15, 1944

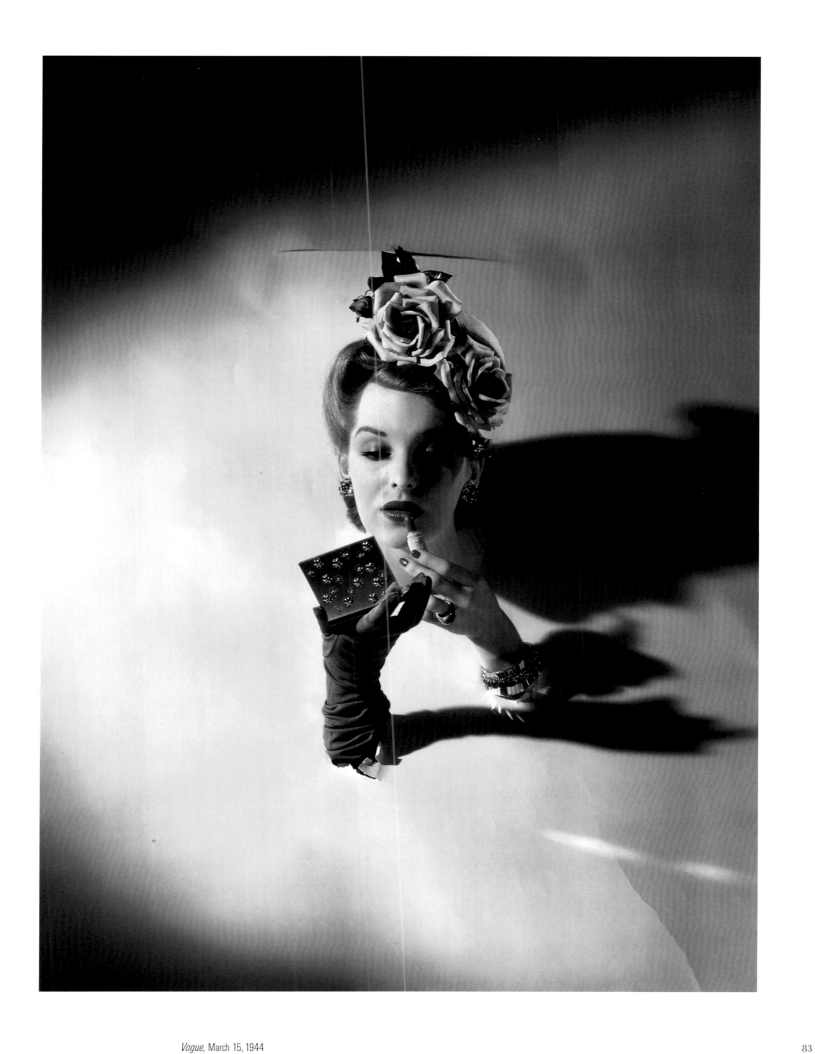

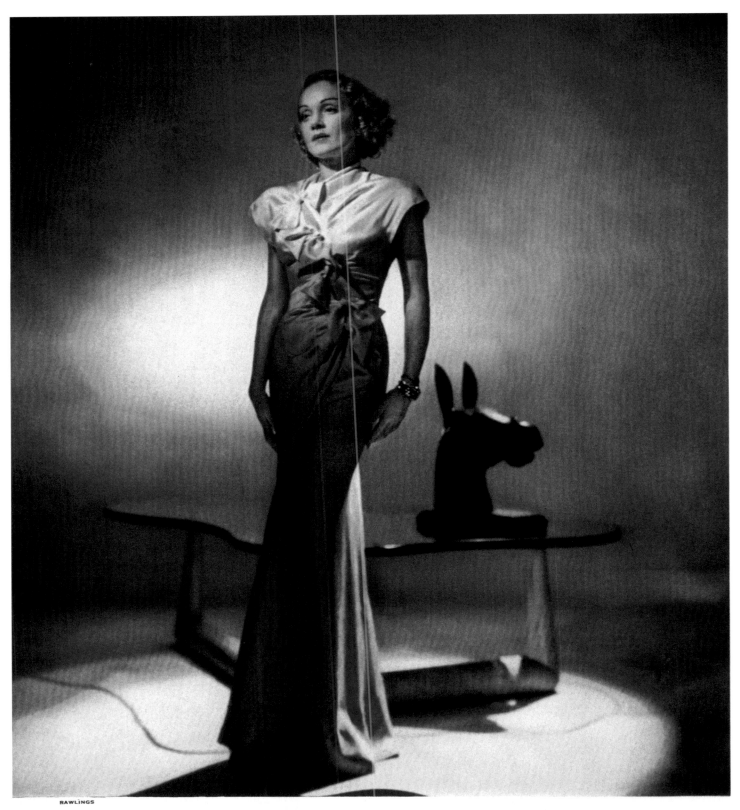

RAWLINGS

Marlene Dietrich

Currently spangling the film, "Kismet"—Miss Dietrich wears a satin dinner sheath, asymmetrically slit to the skin from shoulder to hip, and tied with bows. Characteristic Charles James original, at Elizabeth Arden.

Marlene Dietrich in Charles James; table by T. H. Robsjohn-Gibbings, *Vogue*, October 1, 1944

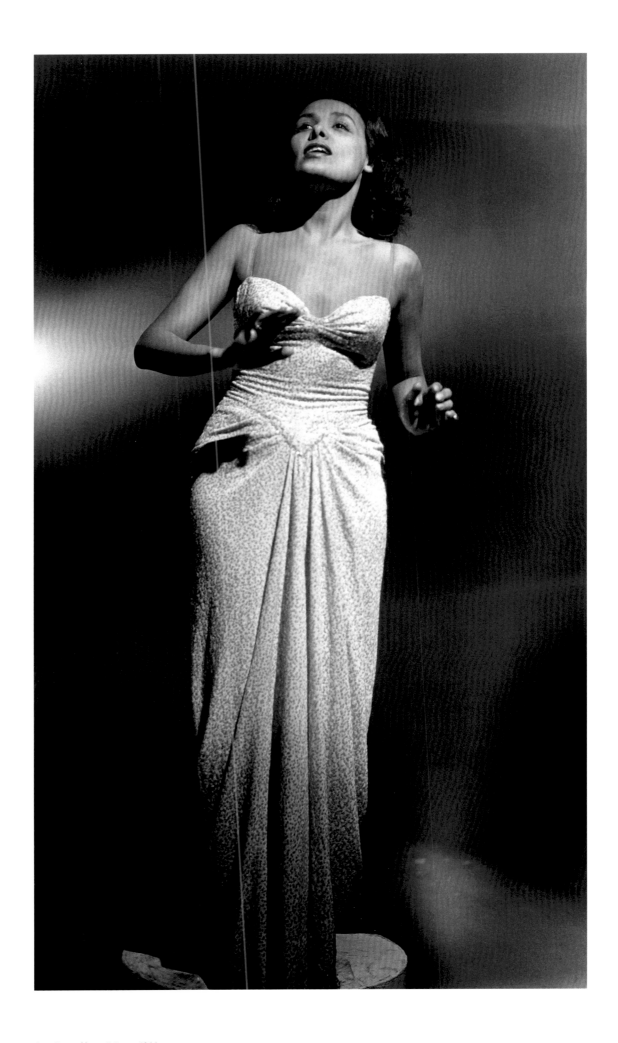

Lena Horne, *Vogue*, February 1944

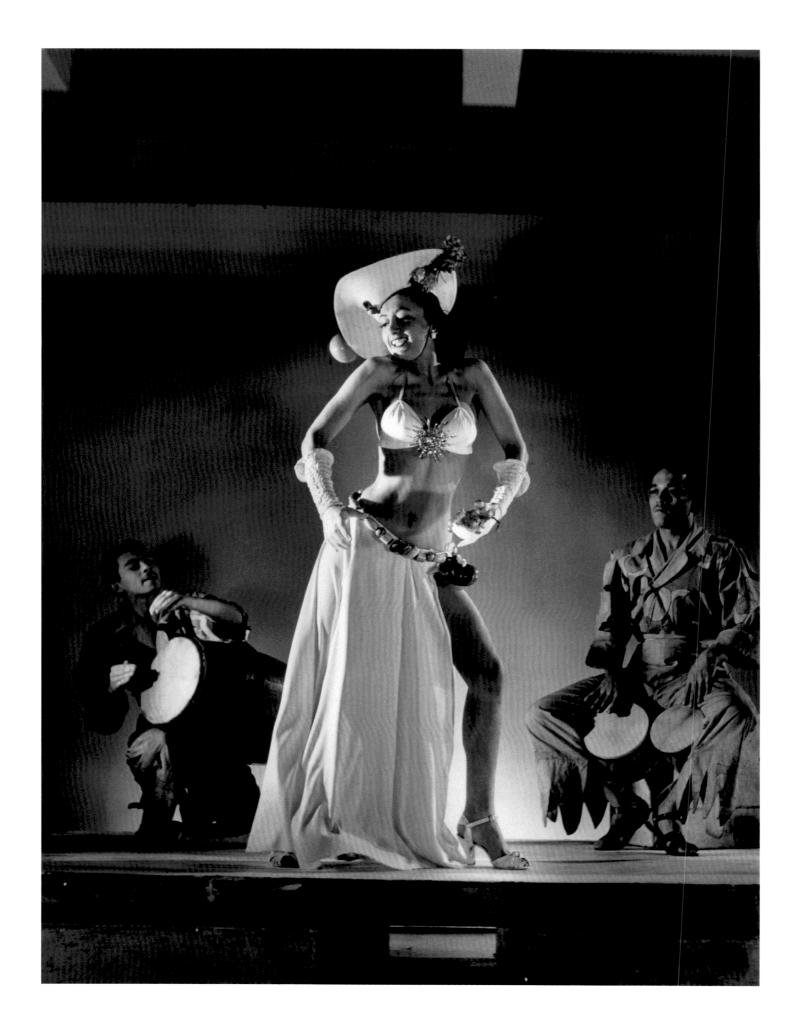

Carmen D'Antonio on the set of *Panama Hattie*, *Vogue*, February 15, 1944

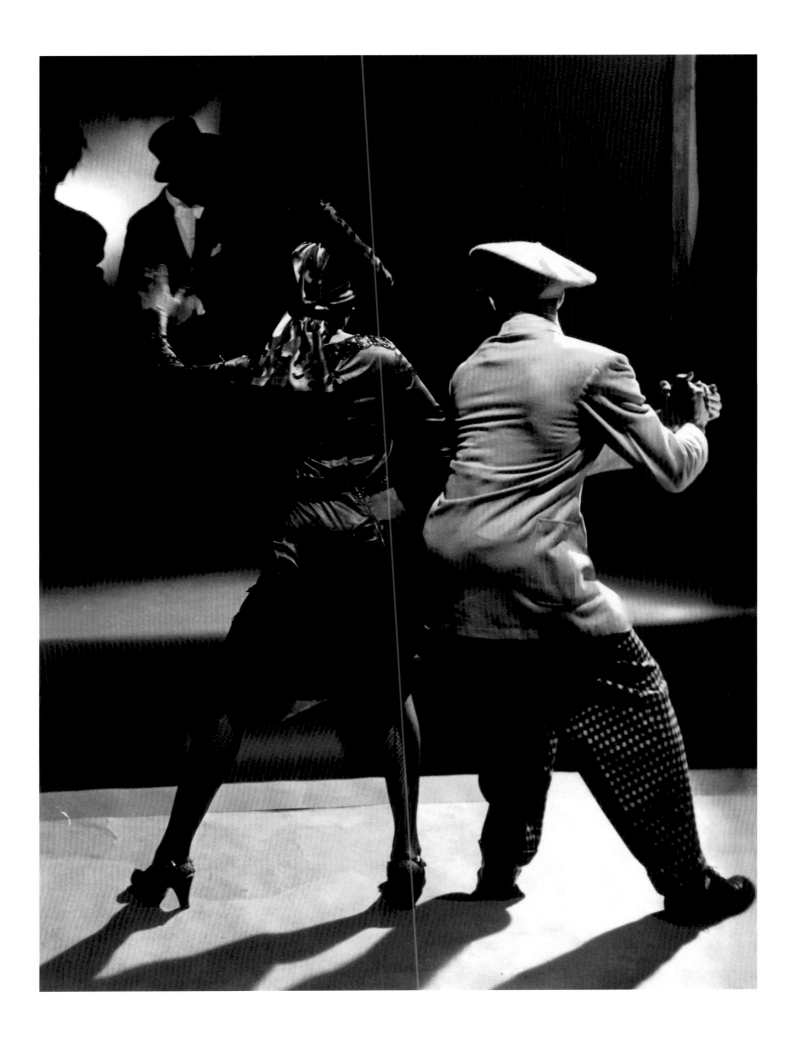

Katherine Dunham in *Tropical Revue*, *Vogue*, February 15, 1944

Jarmila Novotna, Metropolitan Opera soprano, *Vogue*, July 1, 1944

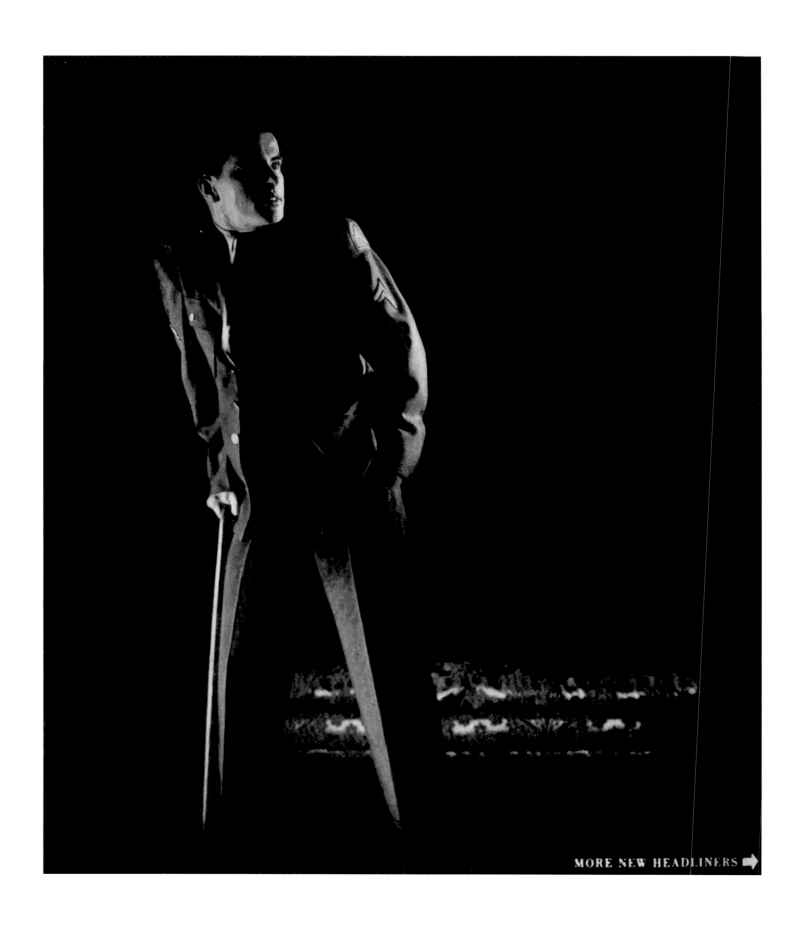

MORE NEW HEADLINERS ➡

Montgomery Clift, *Vogue*, July 1944

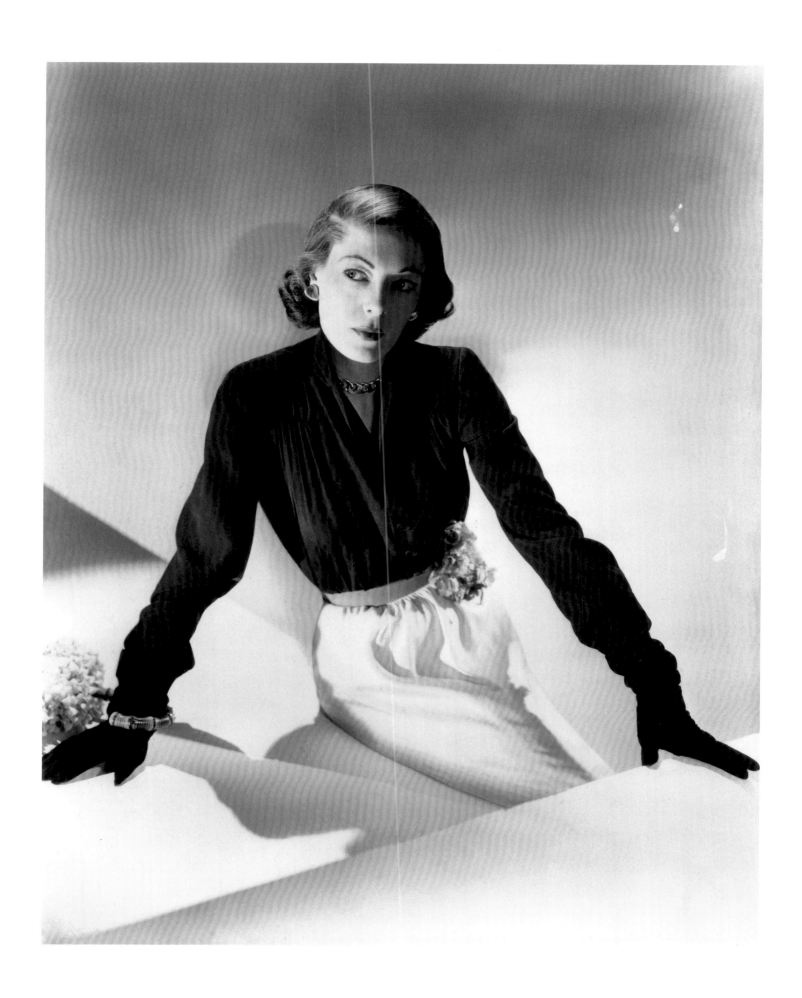

Muriel Maxwell, *Vogue*, April 15, 1944

93

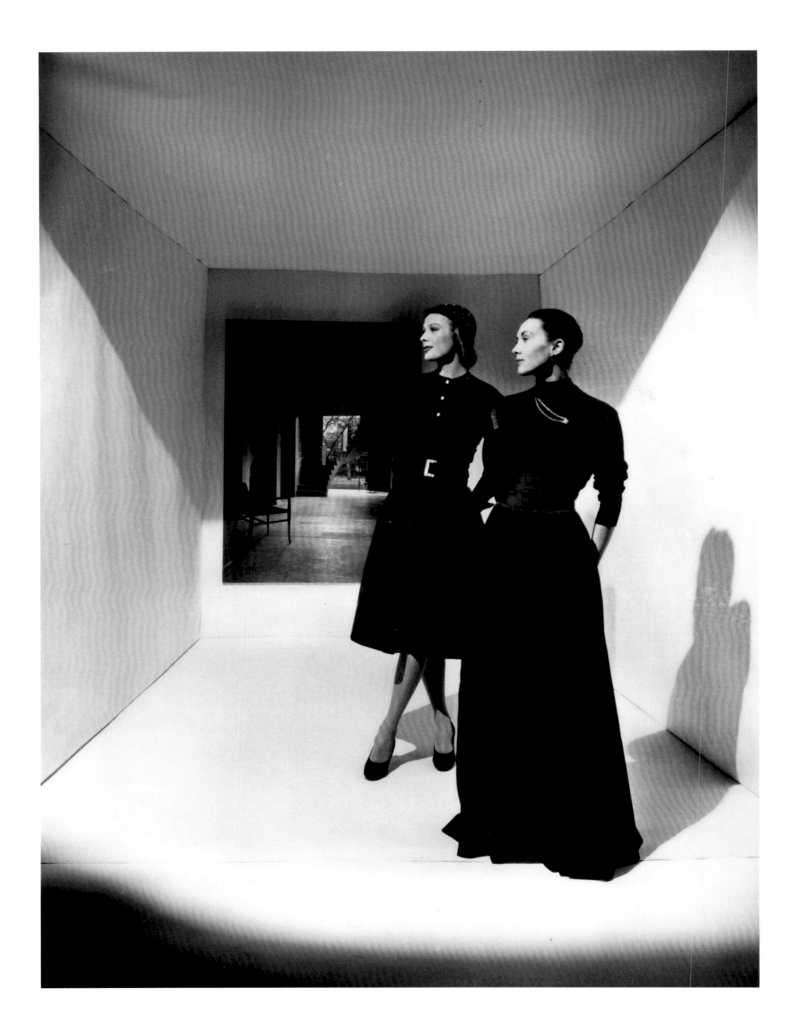

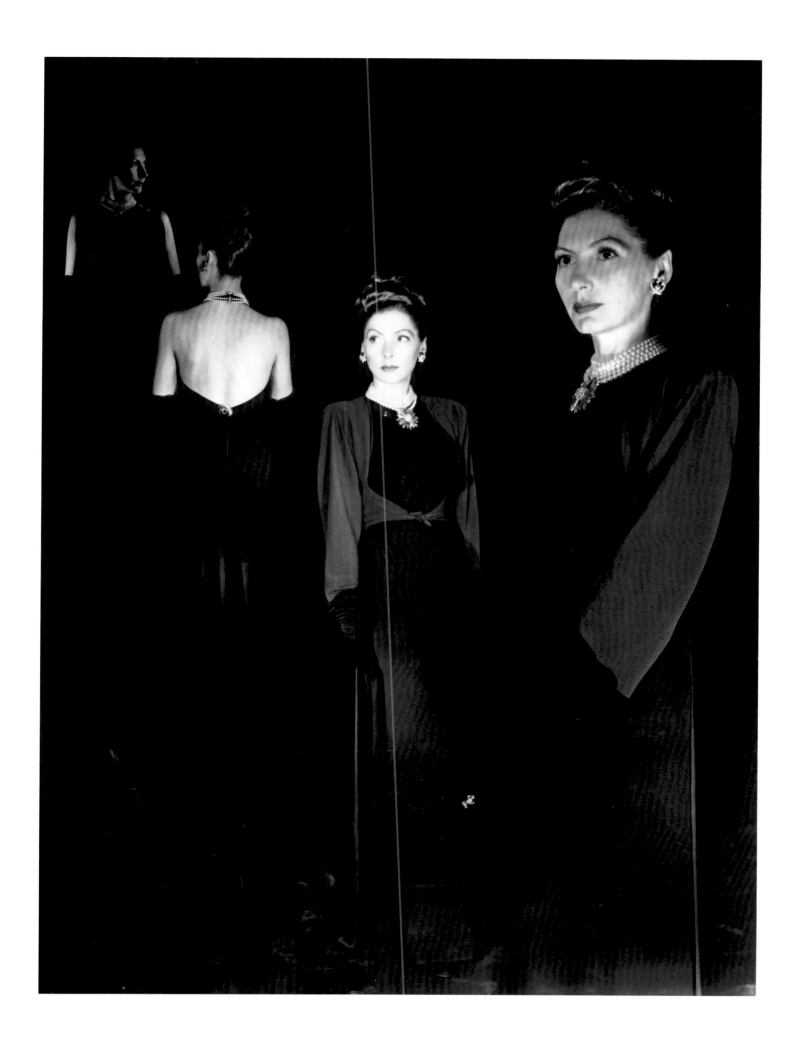

Madame Valentina, *Vogue,* November 1, 1944

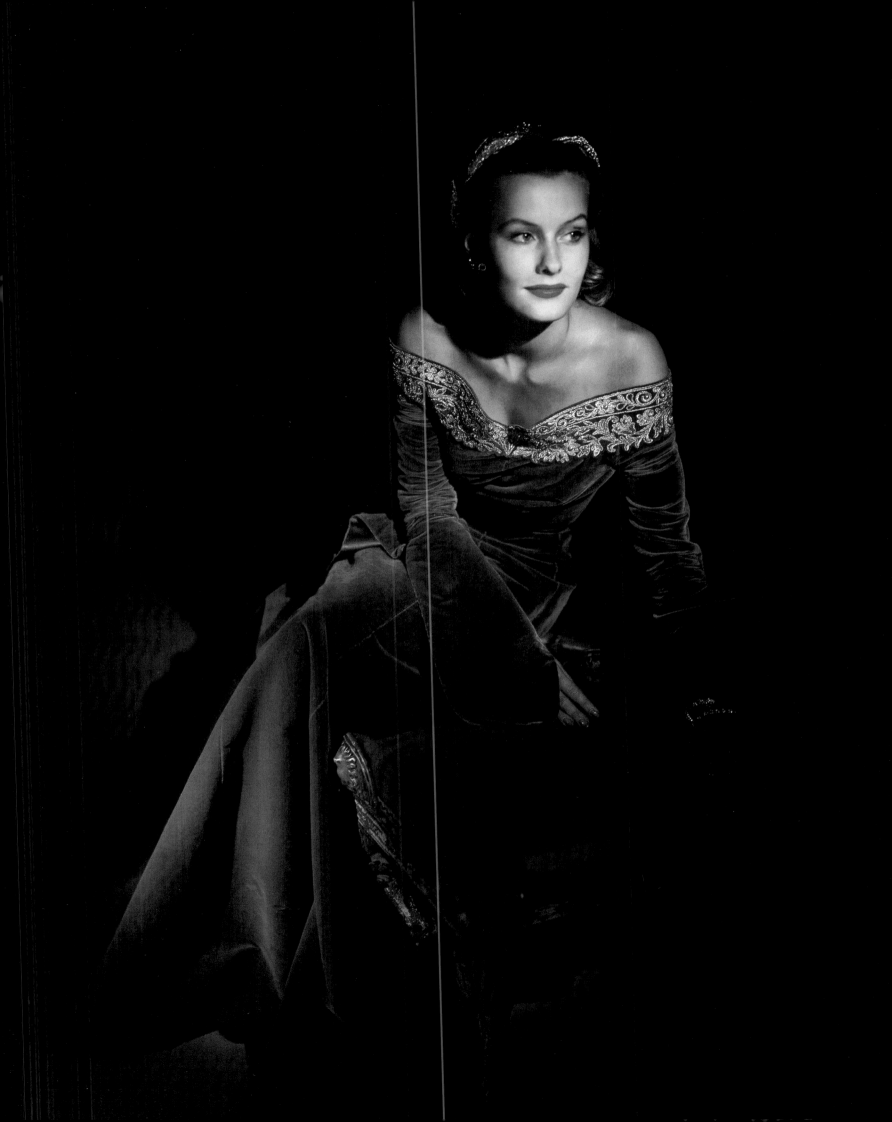

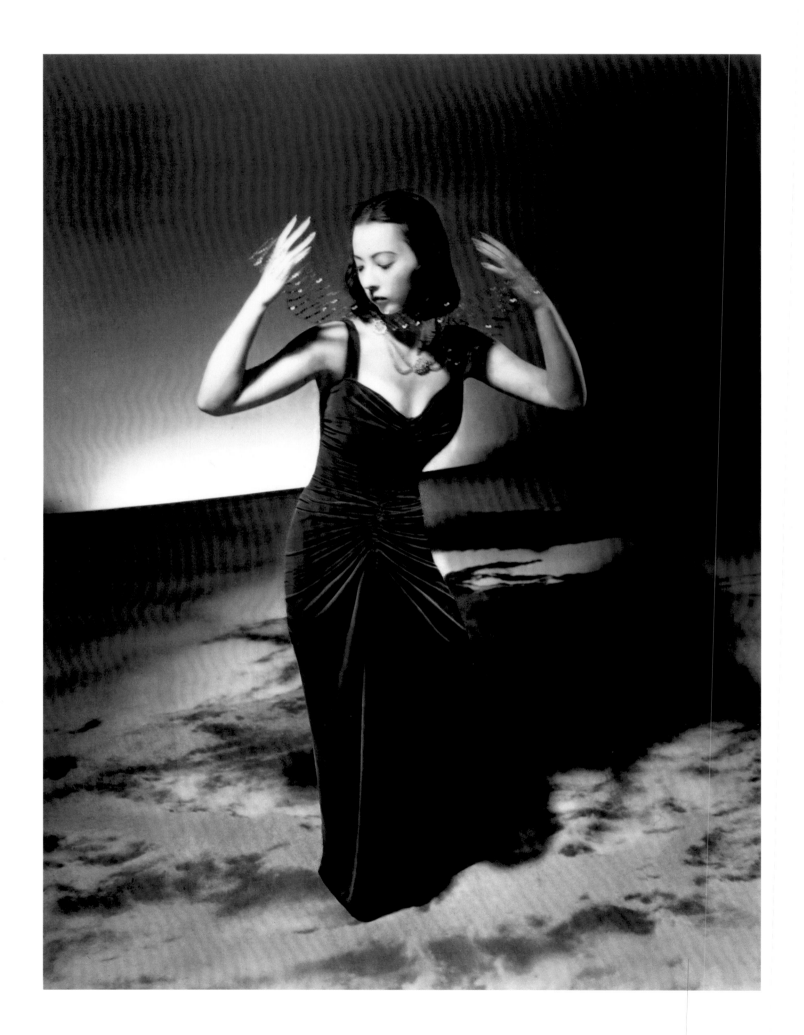

Sono Osato, *Vogue*, circa 1945

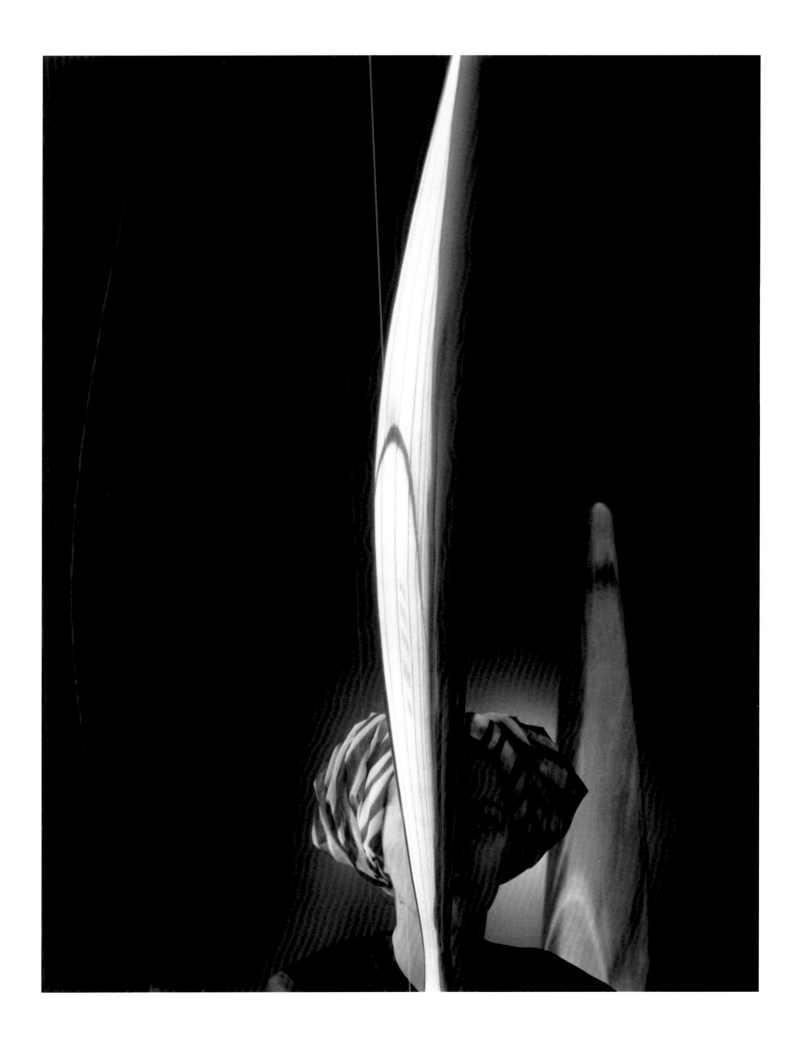

Constantin Brancusi's *Bird in Space*, *Vogue,* July 1944

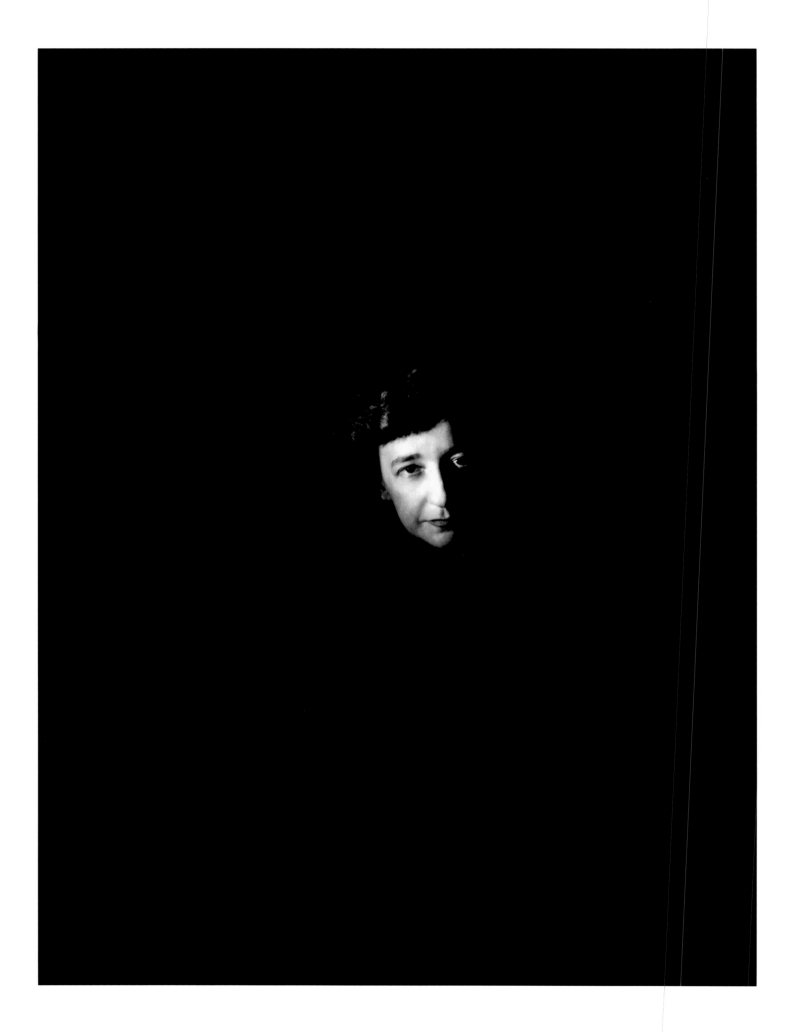

Lillian Hellman, *Vogue*, June 1, 1944

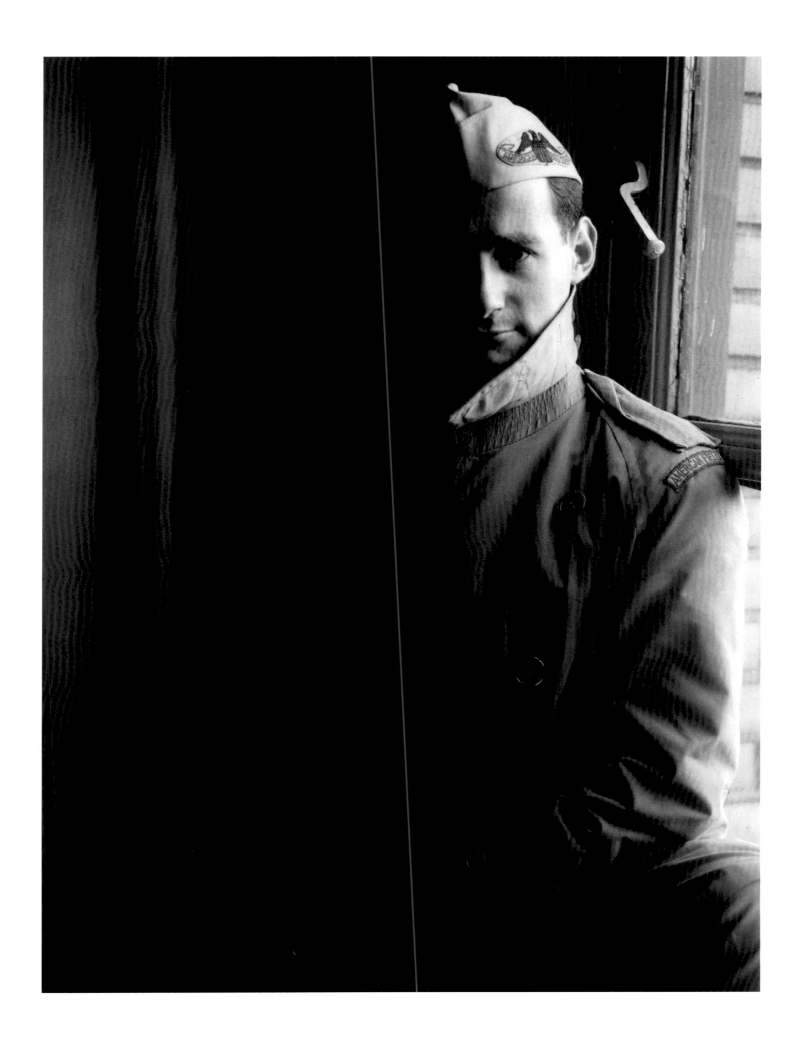

Irving Penn, *Vogue*, March 1, 1945

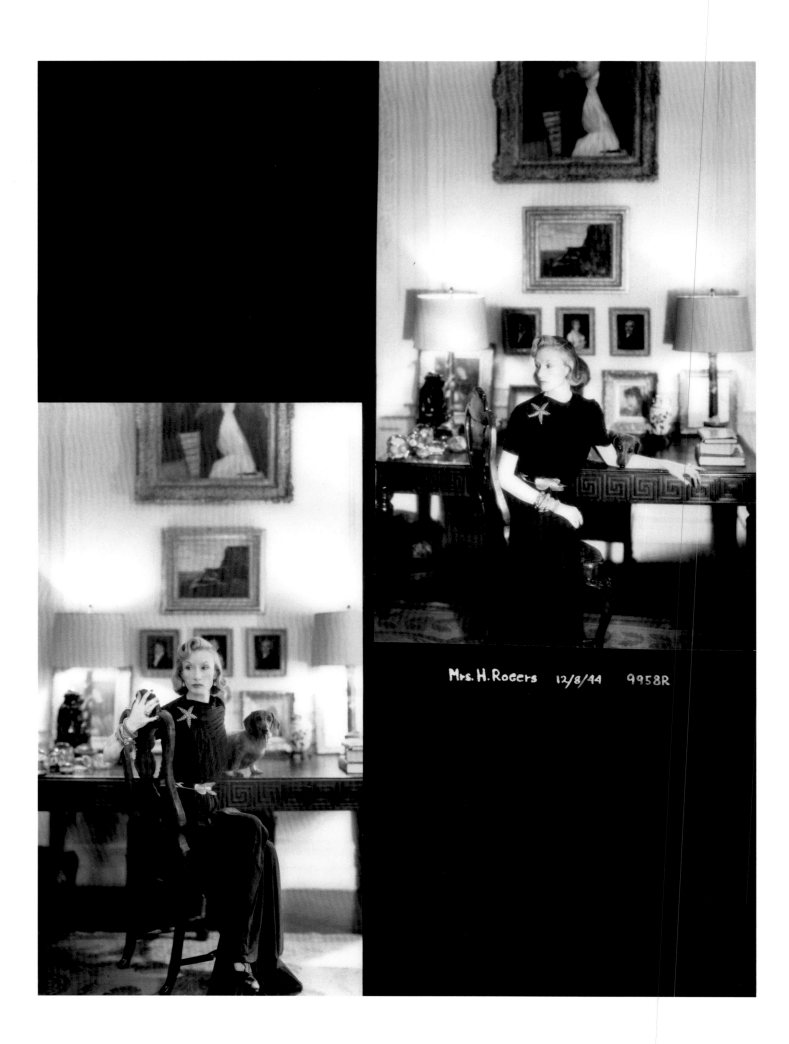

Mrs. H. Rogers 12/8/44 9958R

Millicent Rogers, *Vogue*, March 15, 1945

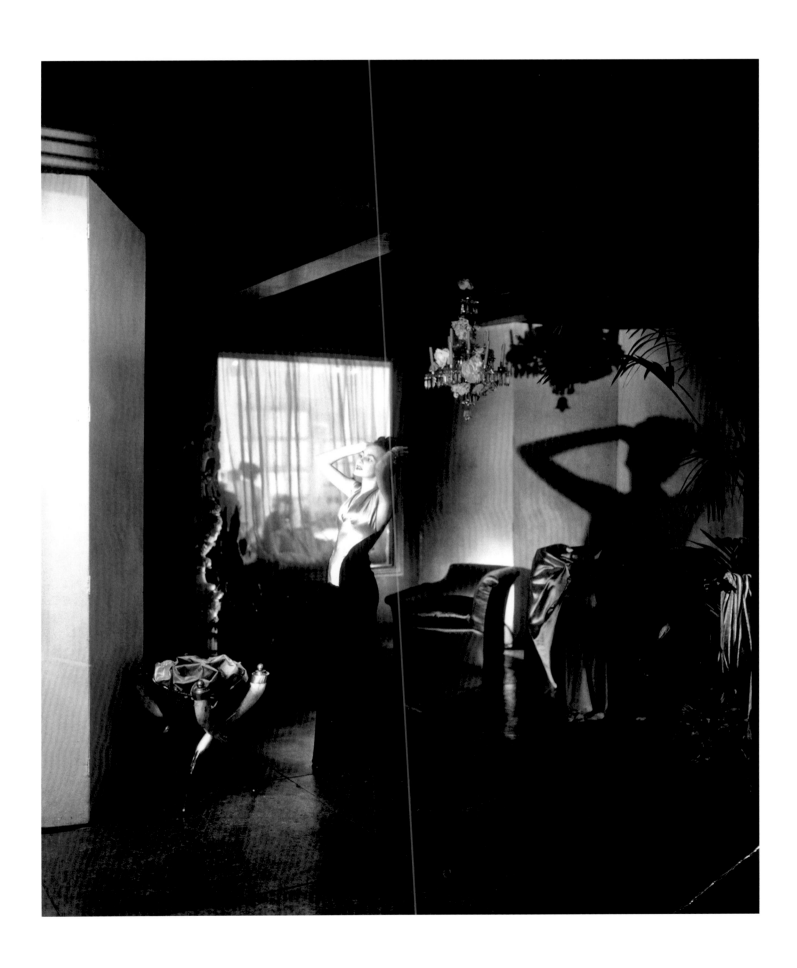

Countess Igor Cassini in Charles James, *Vogue*, December 1, 1945

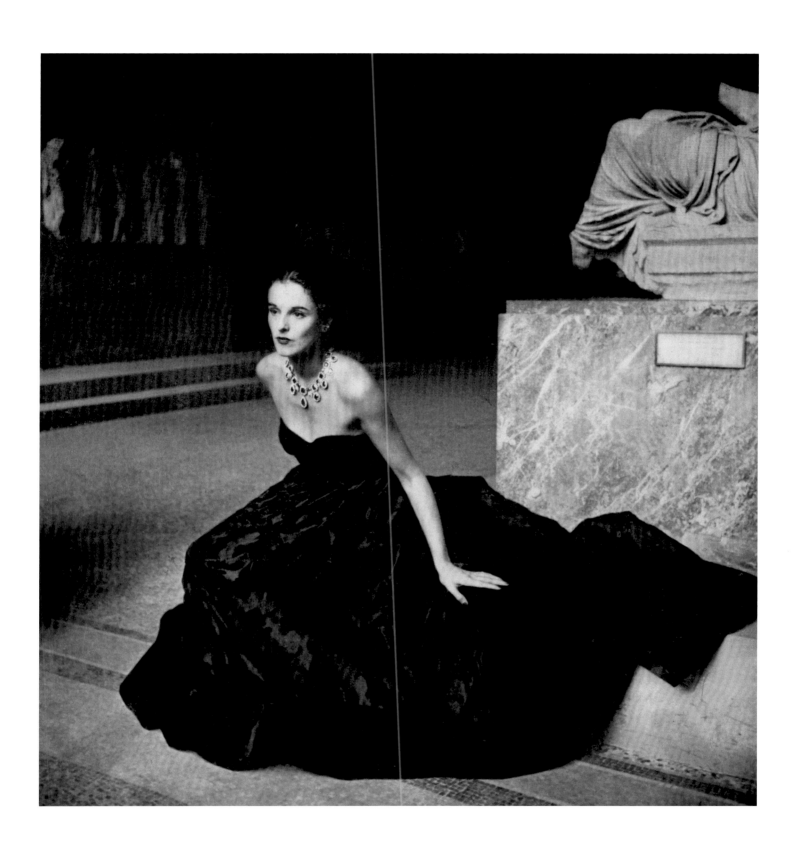

Babe Paley in Pacquin; jewels by Van Cleef and Arpels, *Vogue*, November 15, 1946

Gloria Vanderbilt, Pond's makeup advertisement, 1945

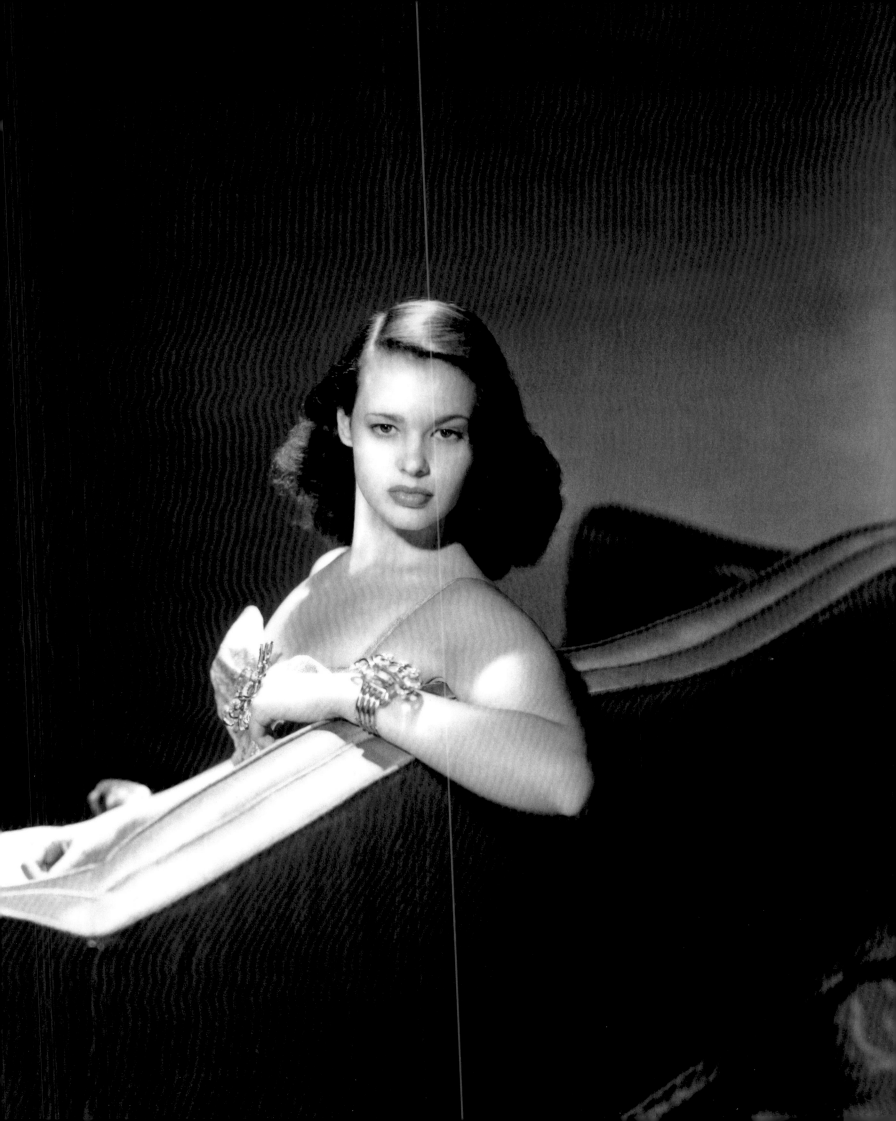

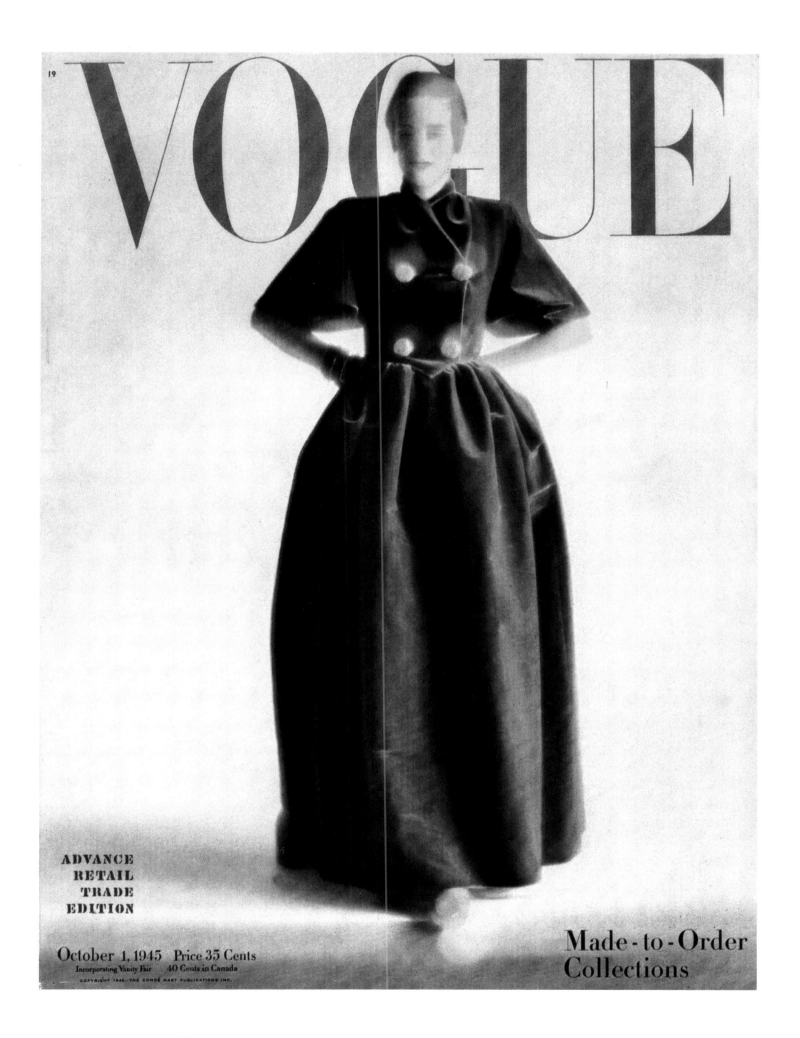

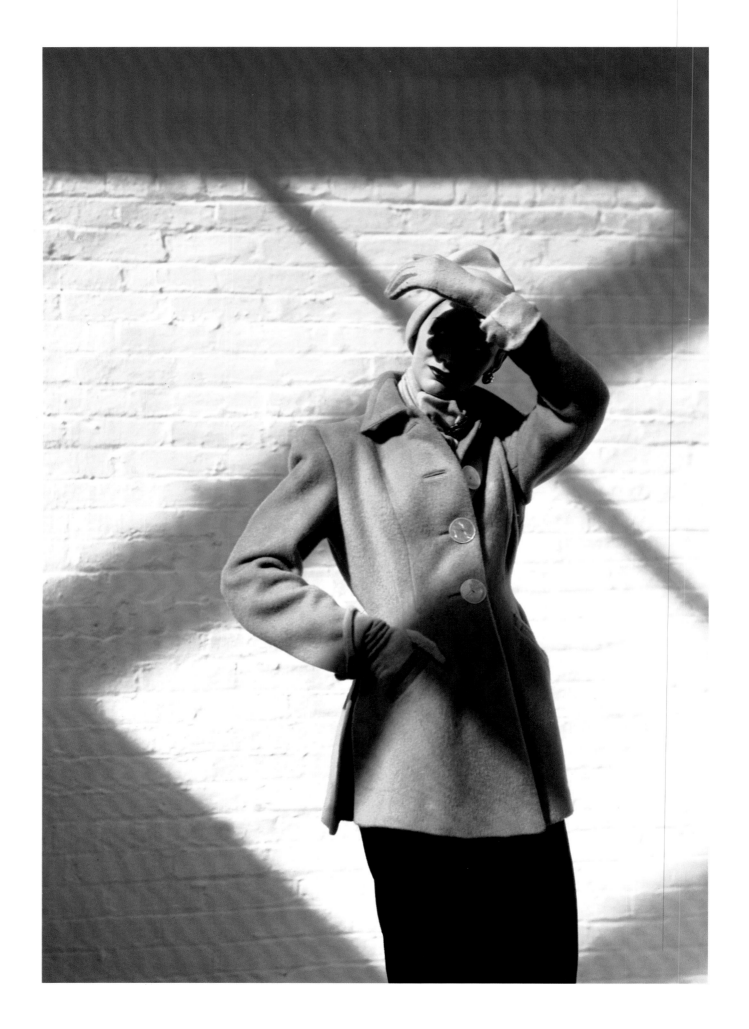

Vogue cover, January 1, 1946

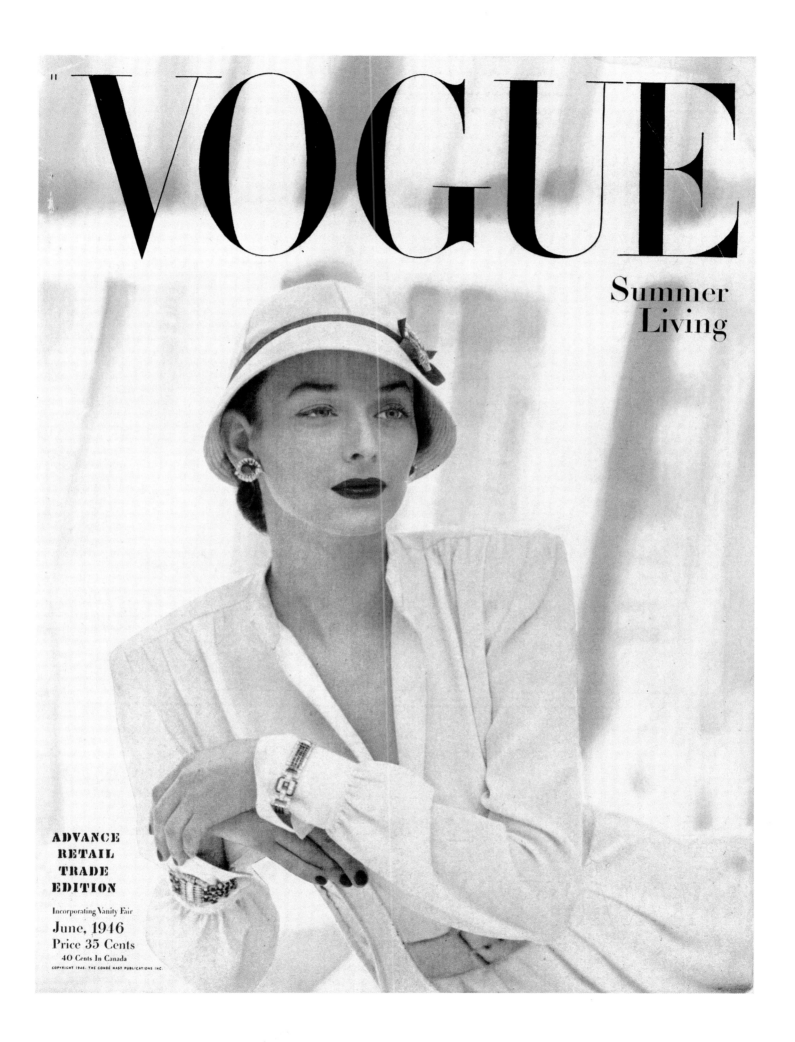

Dorian Leigh, *Vogue* cover, June 1946

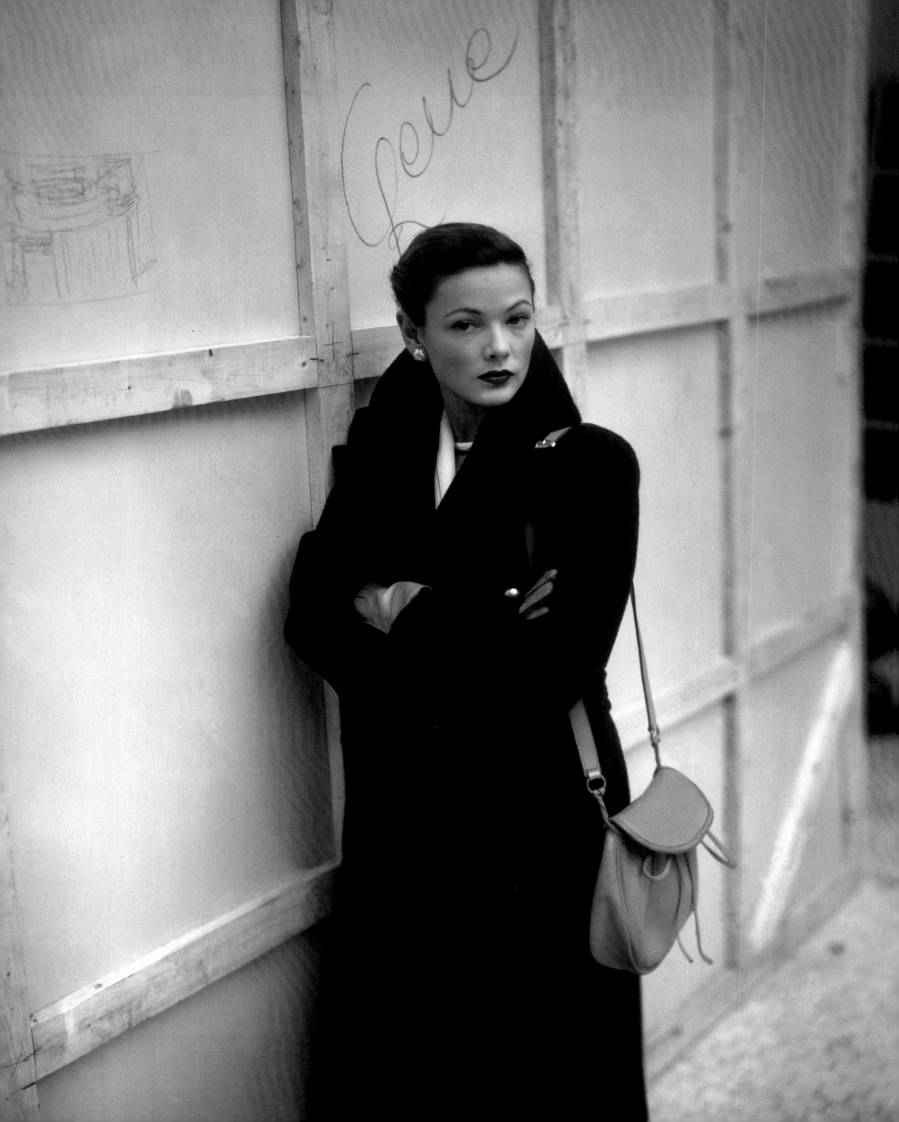

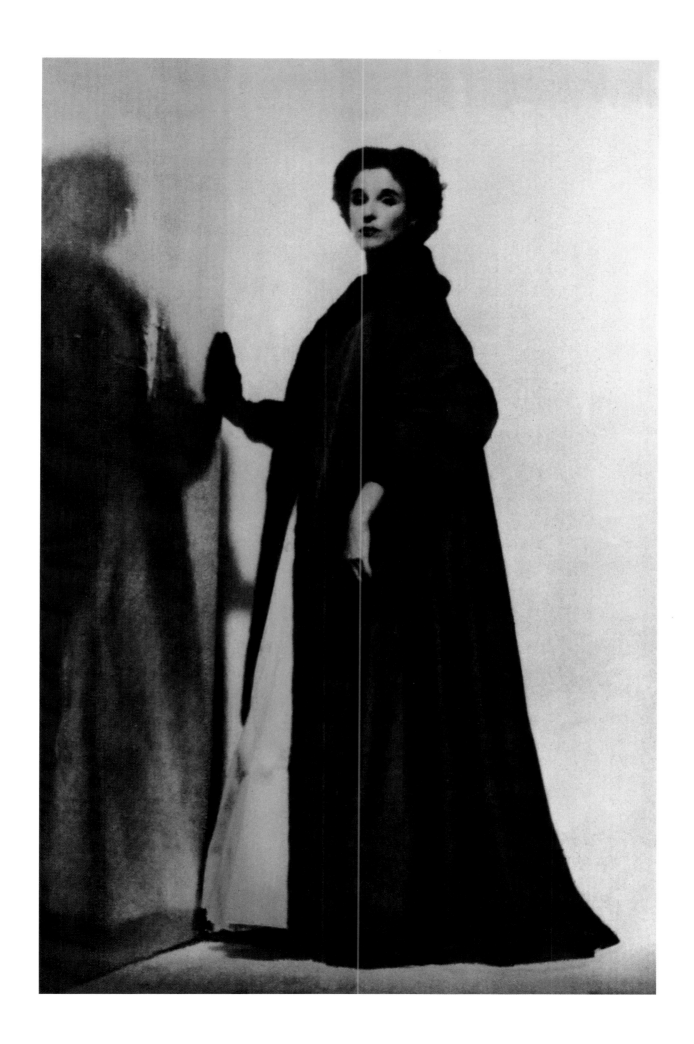

The first color photograph transmitted by wire; Babe Paley in Lucien Lelong, *Vogue*, October 1, 1946 Opposite: Gene Tierney, *Vogue*, March 11, 1946

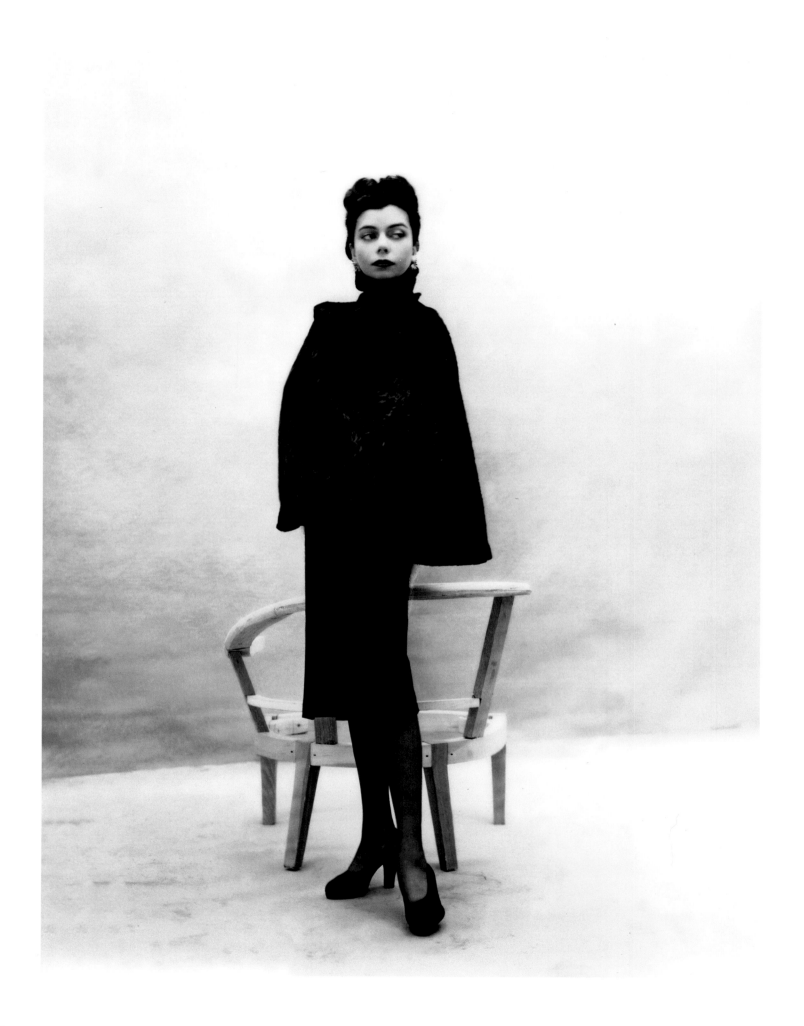

Madame Perla Smilovici, *Vogue*, April 15, 1946

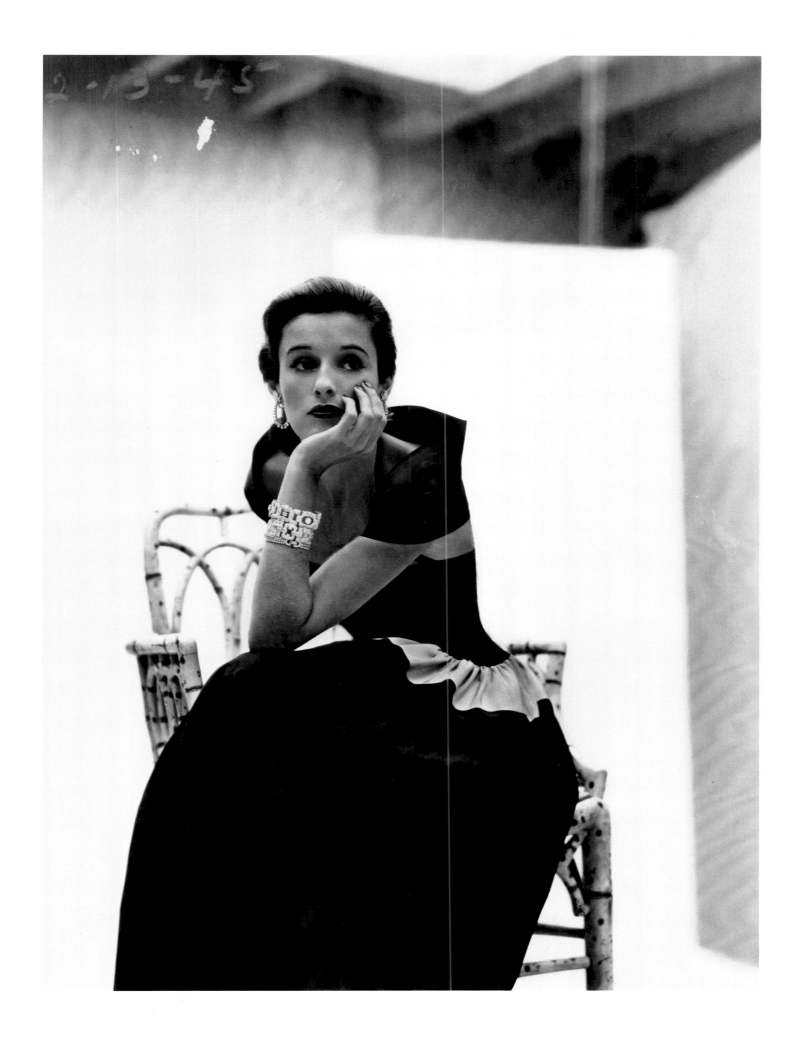

Babe Paley, *Vogue*, February 1, 1946

Rufino Tamayo, January 12, 1946

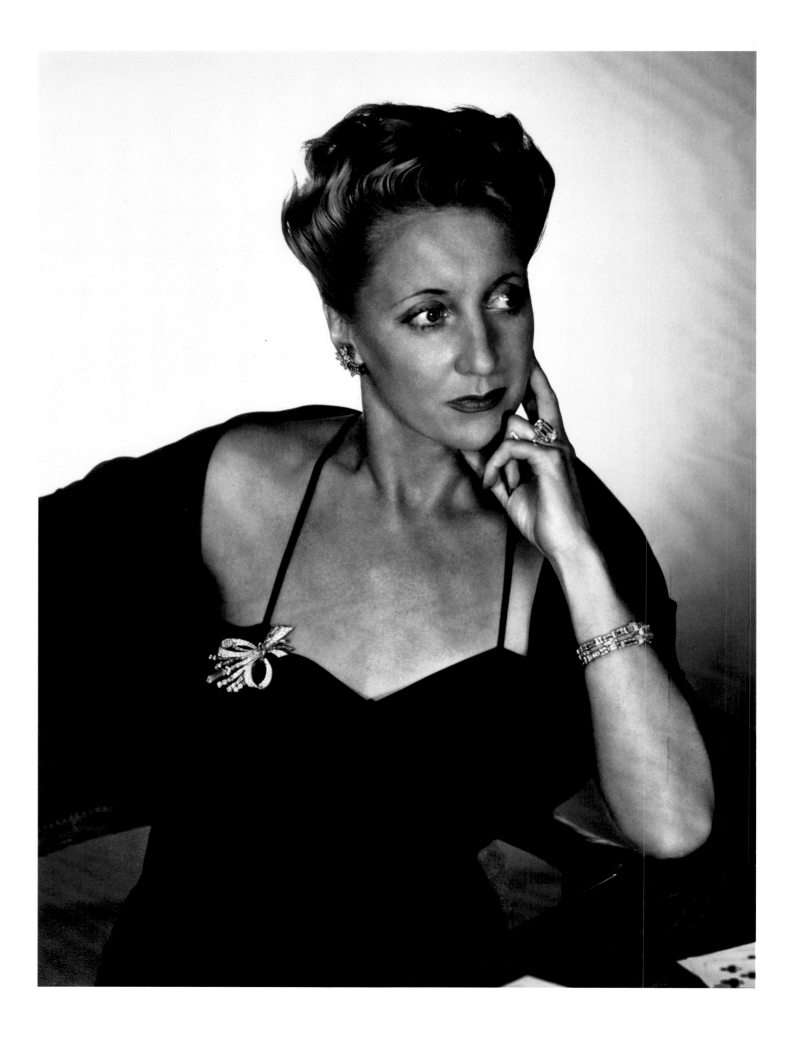

Above and opposite: Babs Rawlings, circa 1947

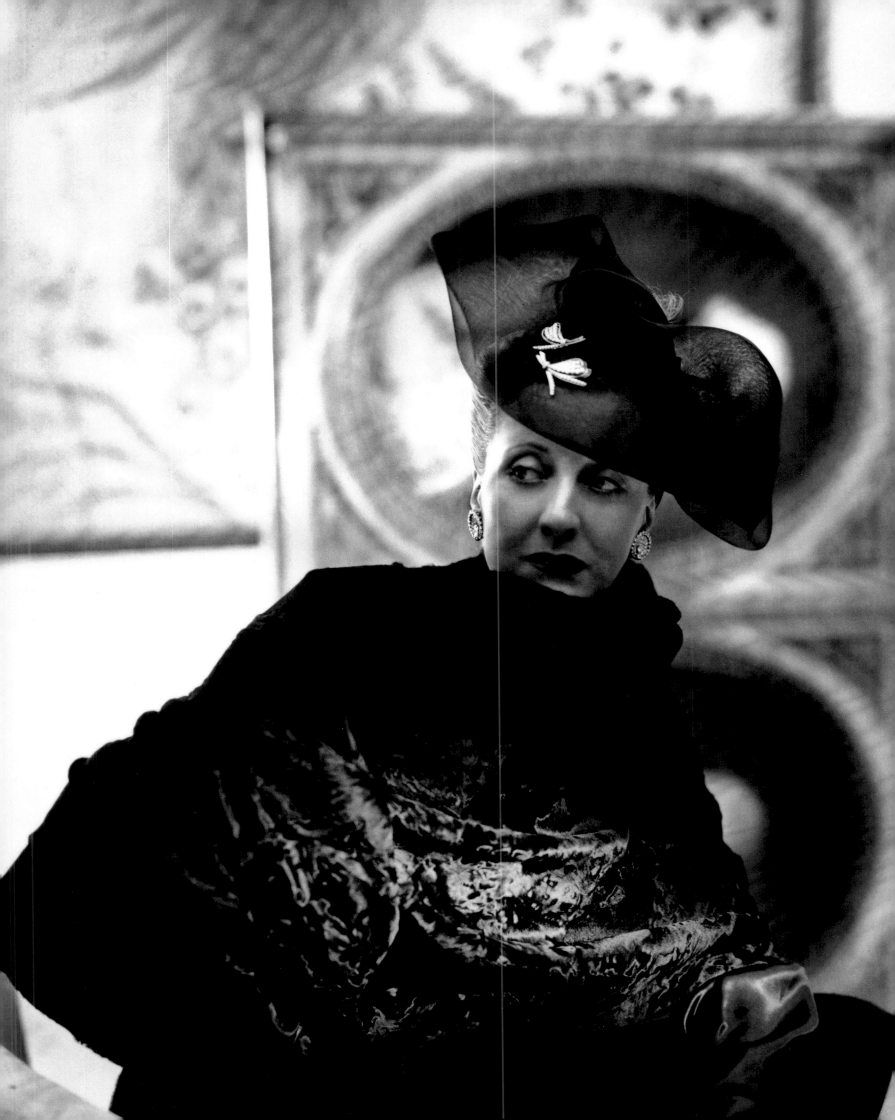

Frank Crowninshield, *Vogue*, 1947

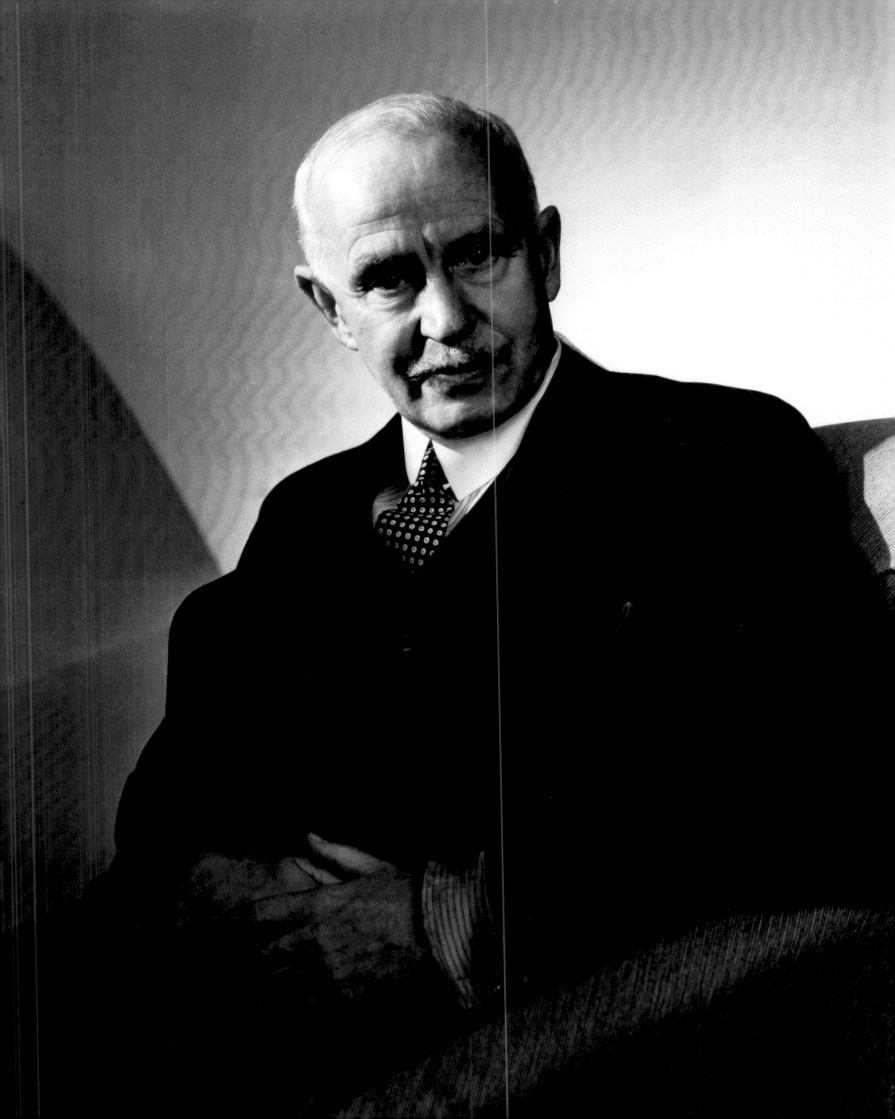

Mr. and Mrs. Alexander Liberman, circa 1947

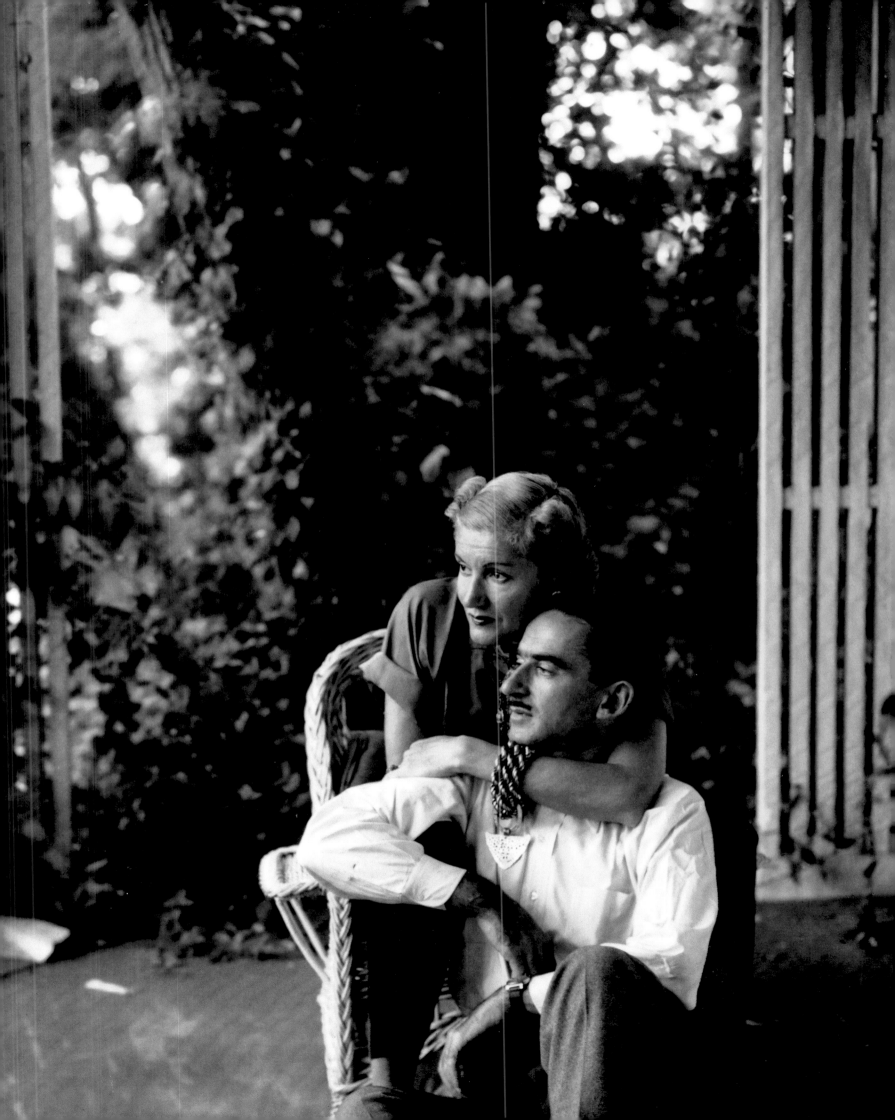

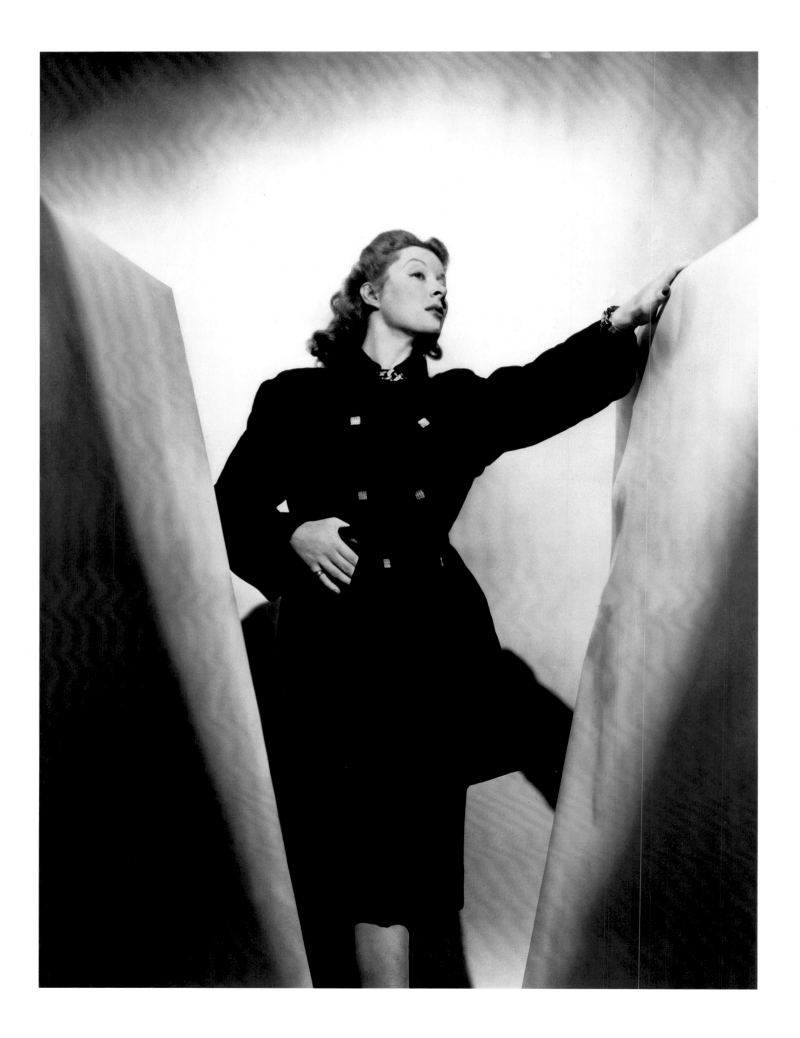

Greer Garson, *Vogue*, December 1, 1943

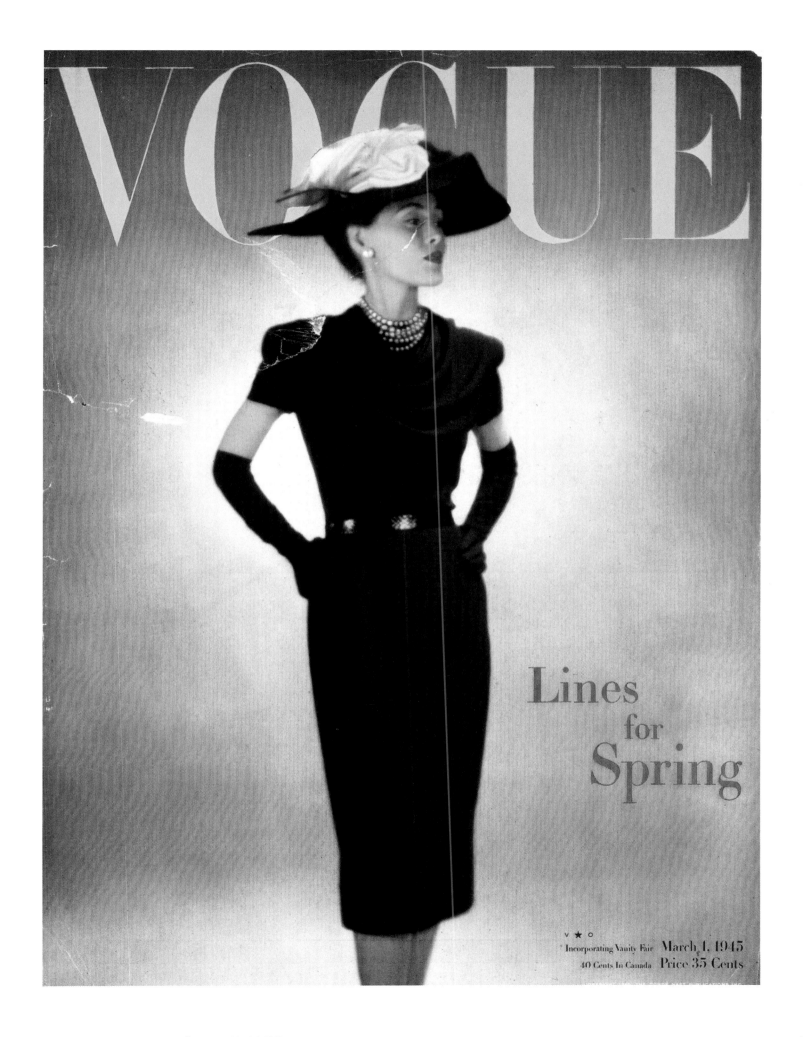

VOGUE

Lines
for
Spring

v ★ o
Incorporating Vanity Fair March 1, 1945
40 Cents In Canada Price 35 Cents

Vogue cover, March 1, 1945

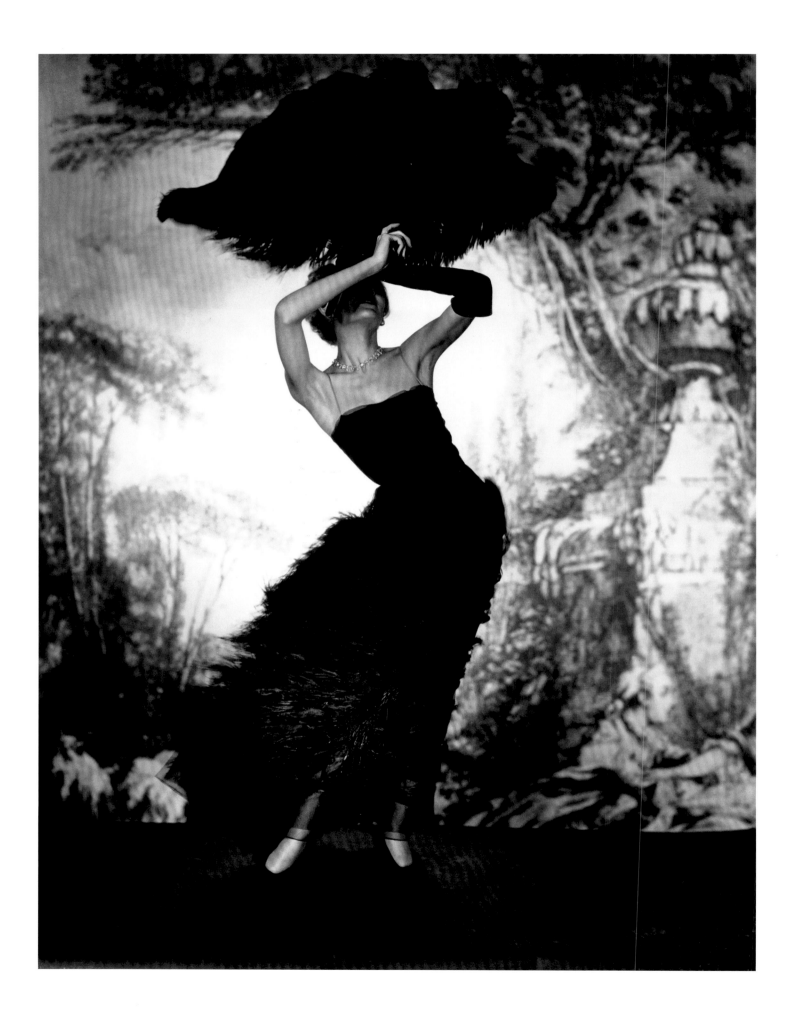

Traina-Norell, *Vogue*, March 1, 1947

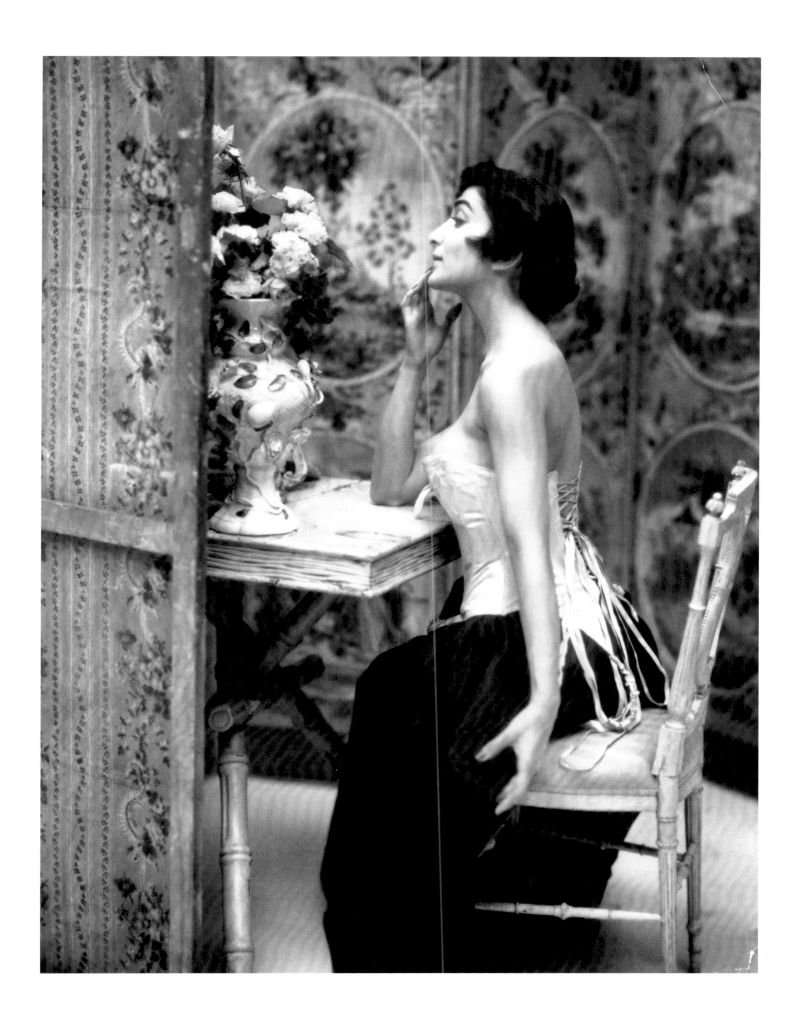

Carmen Dell'Orefice, *Vogue*, October 15, 1947

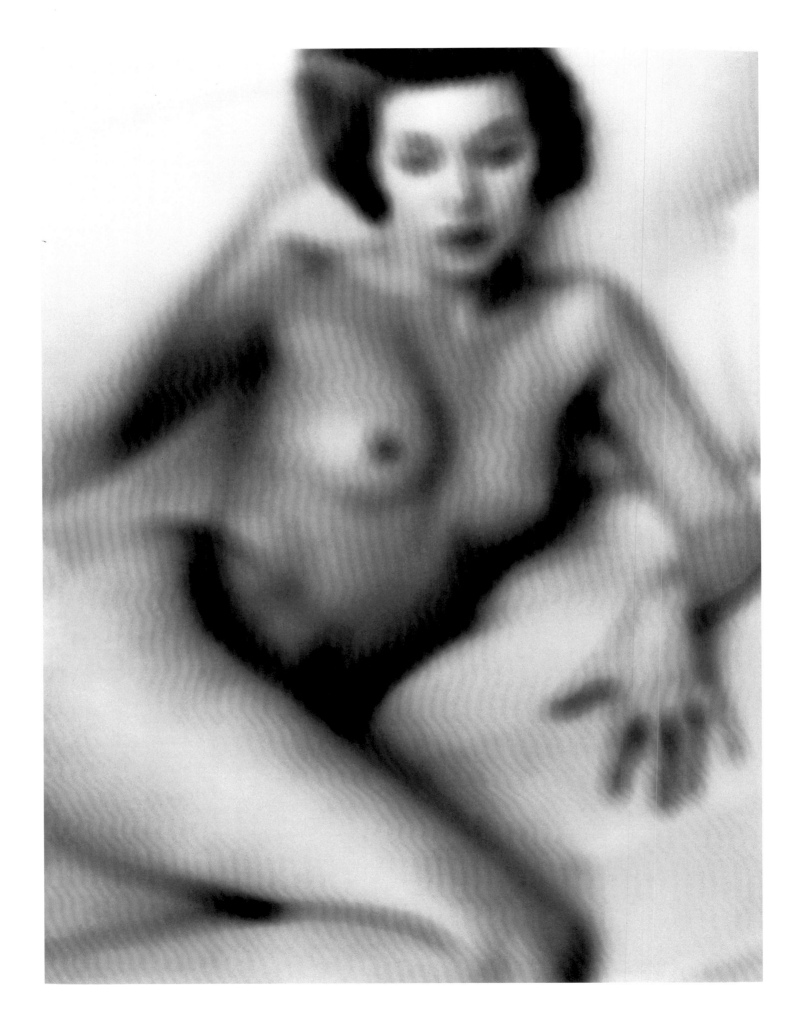

circa 1947

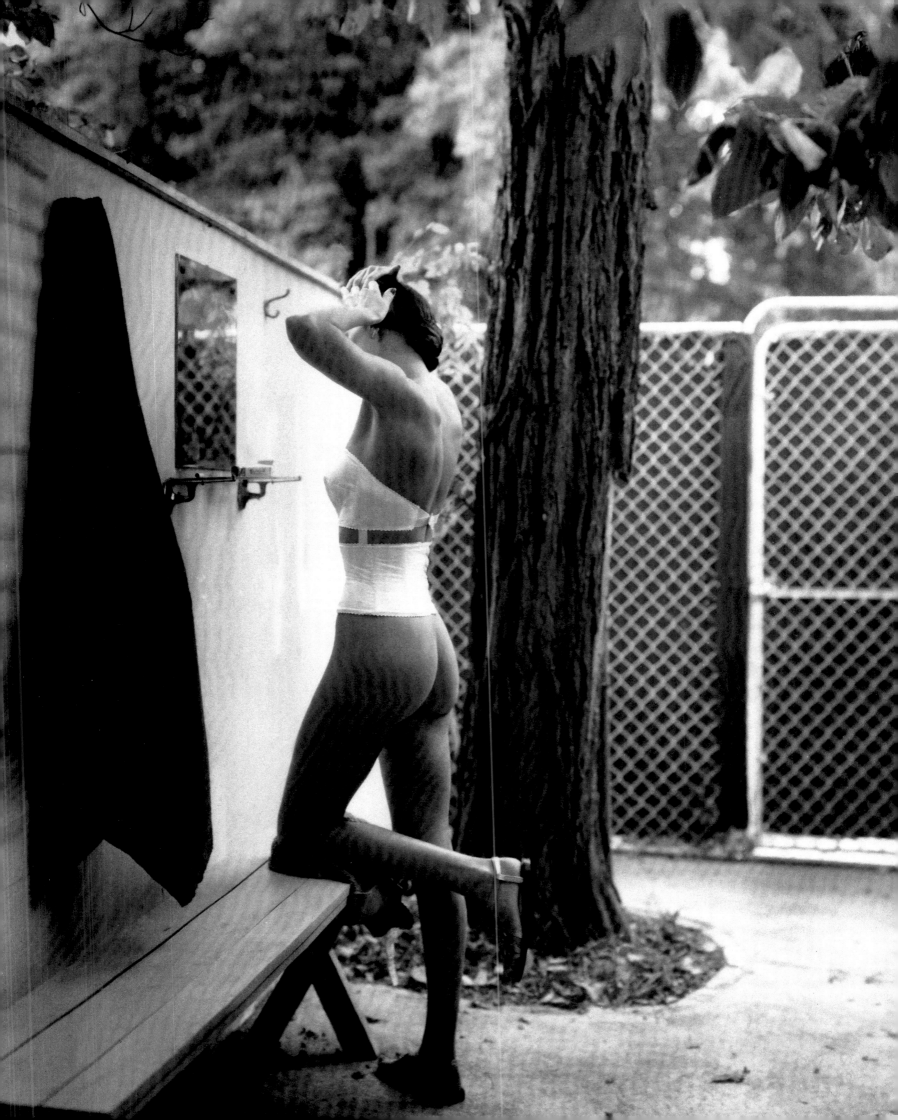

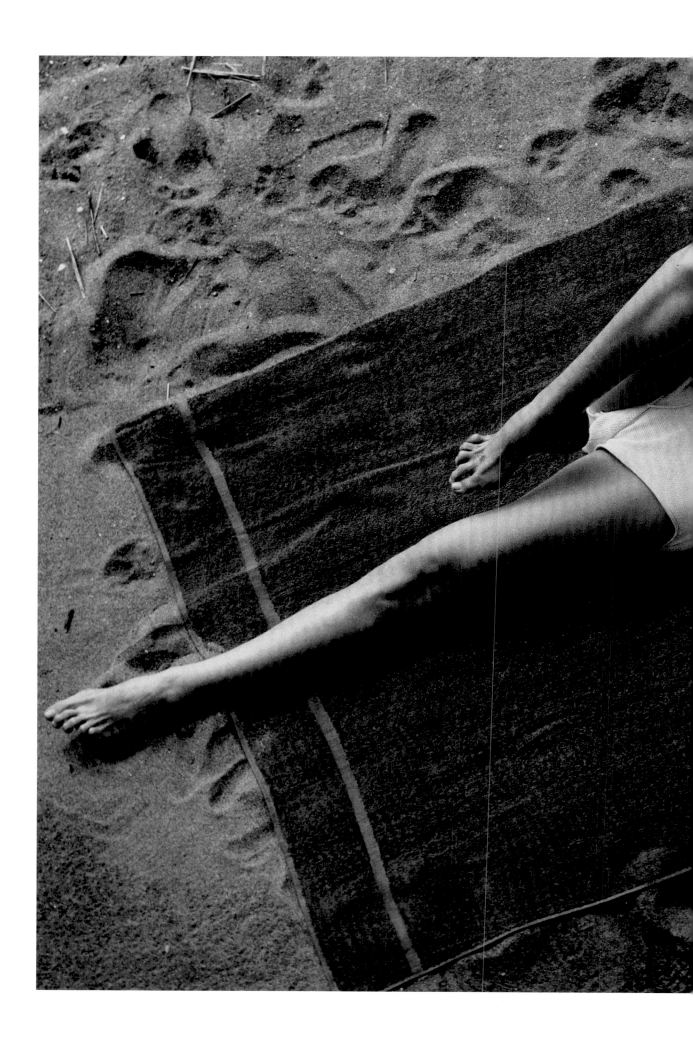

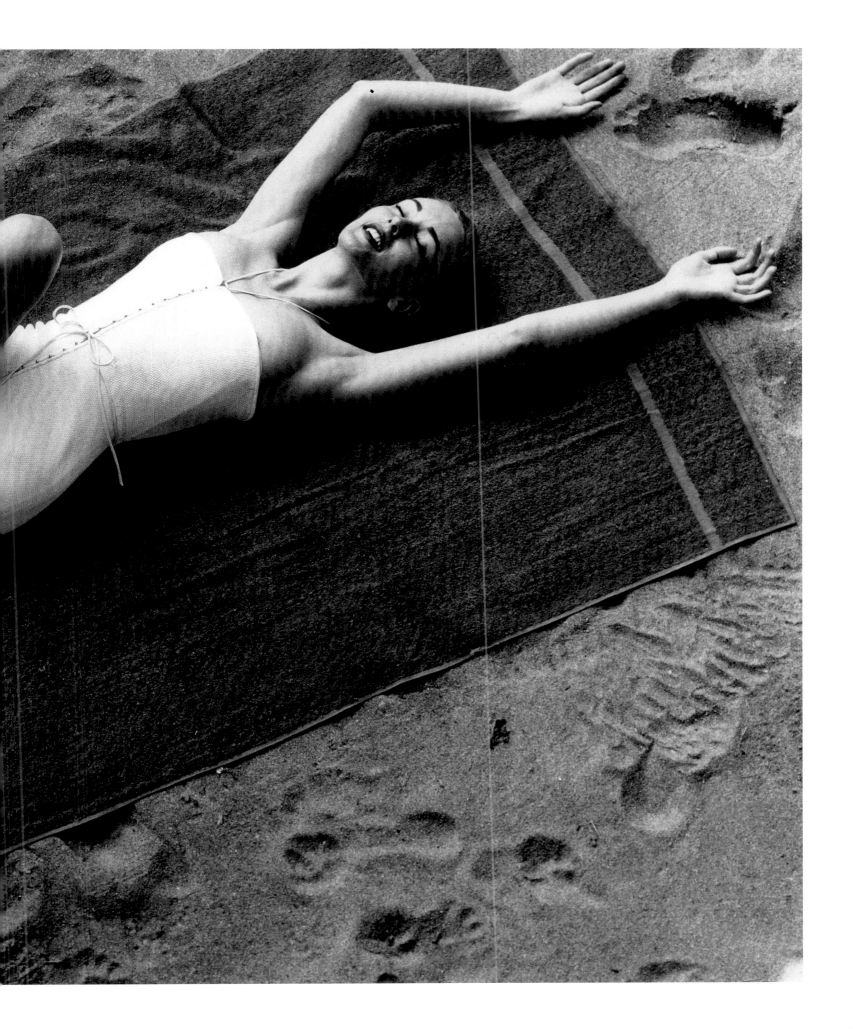

circa 1947

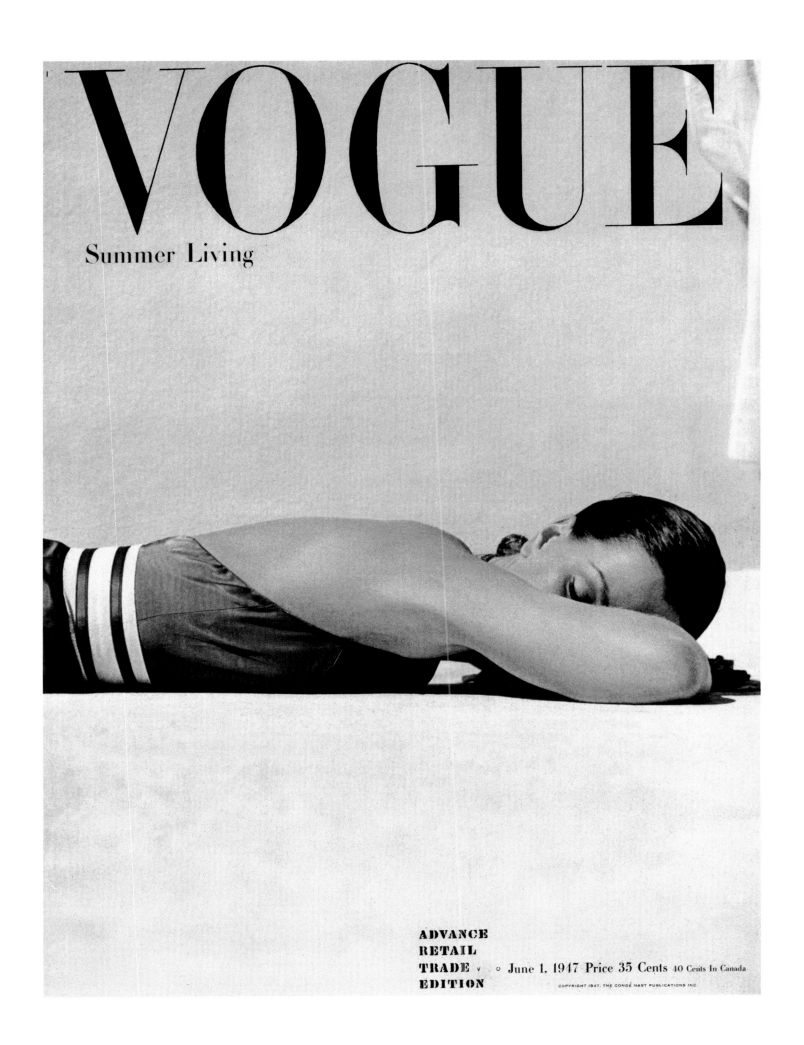

Vogue cover, June 1, 1947

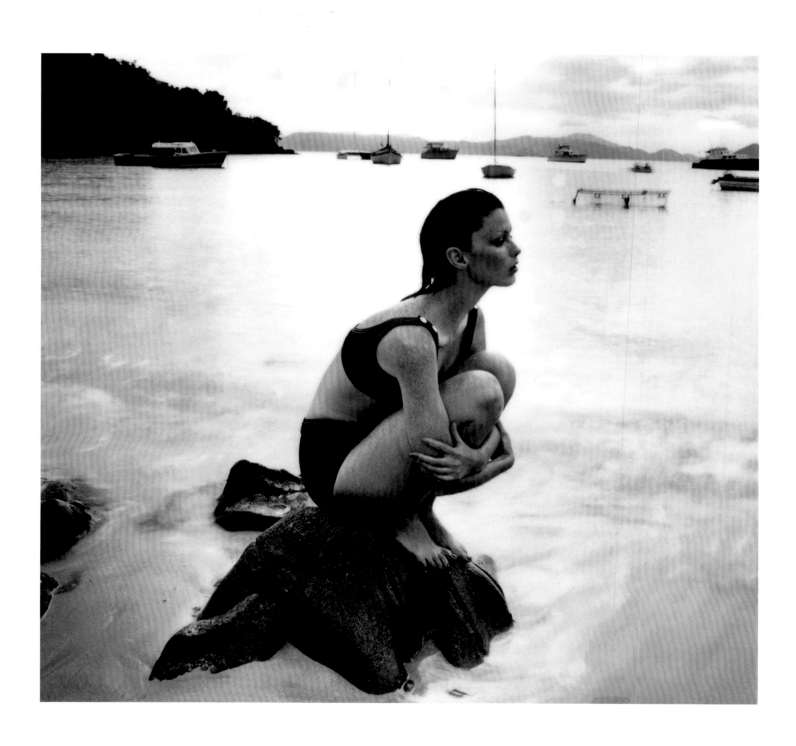

circa 1950

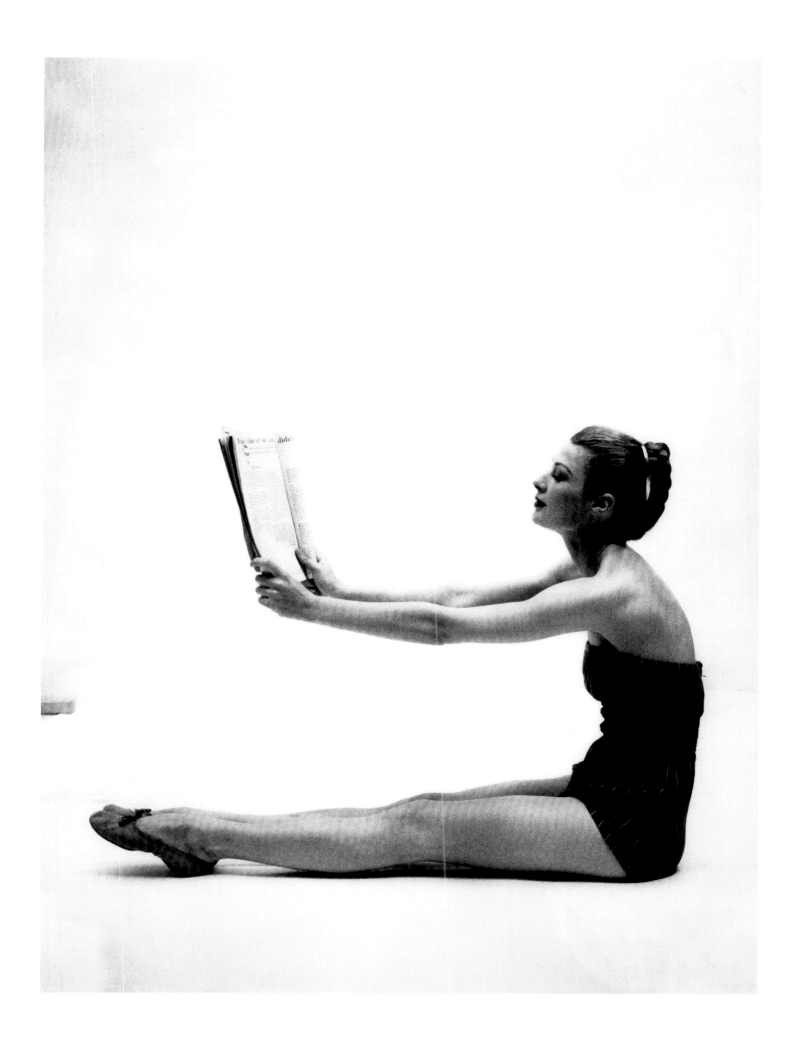

Claire McCardell bathing suit, circa 1950

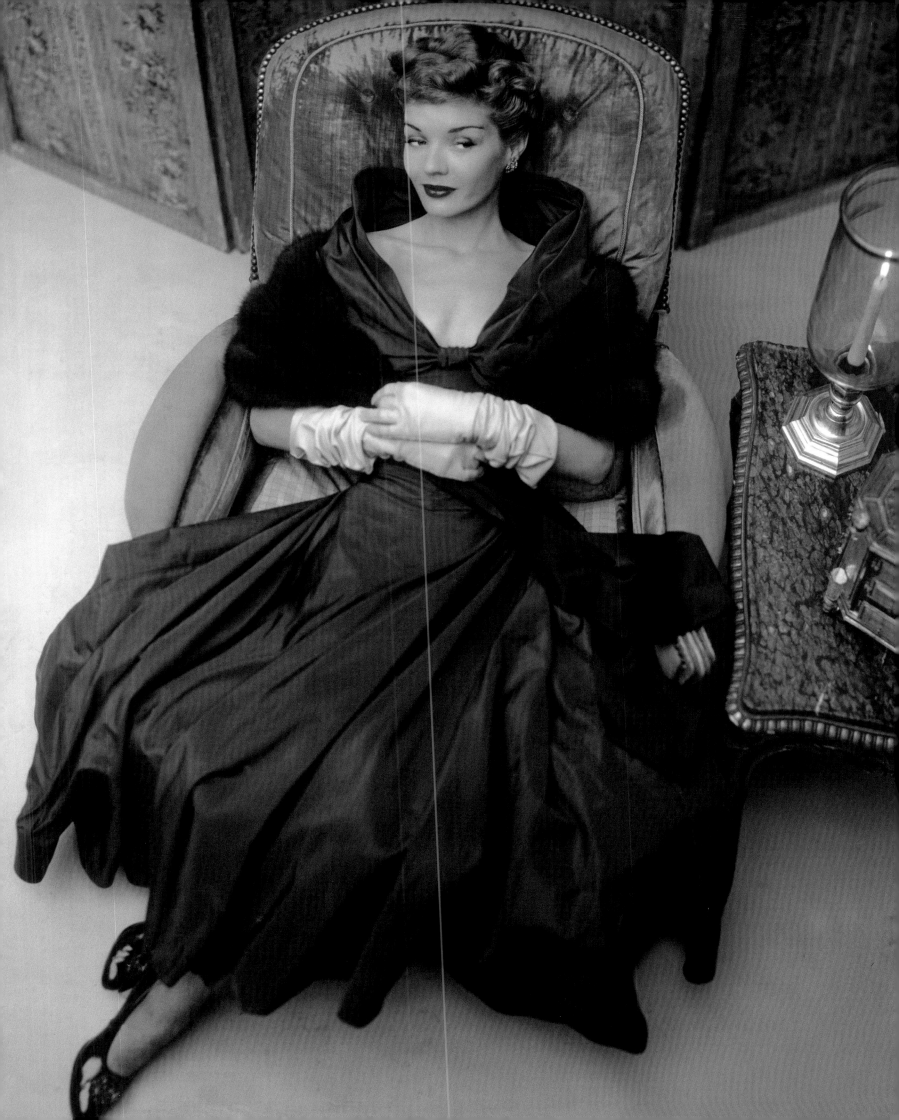

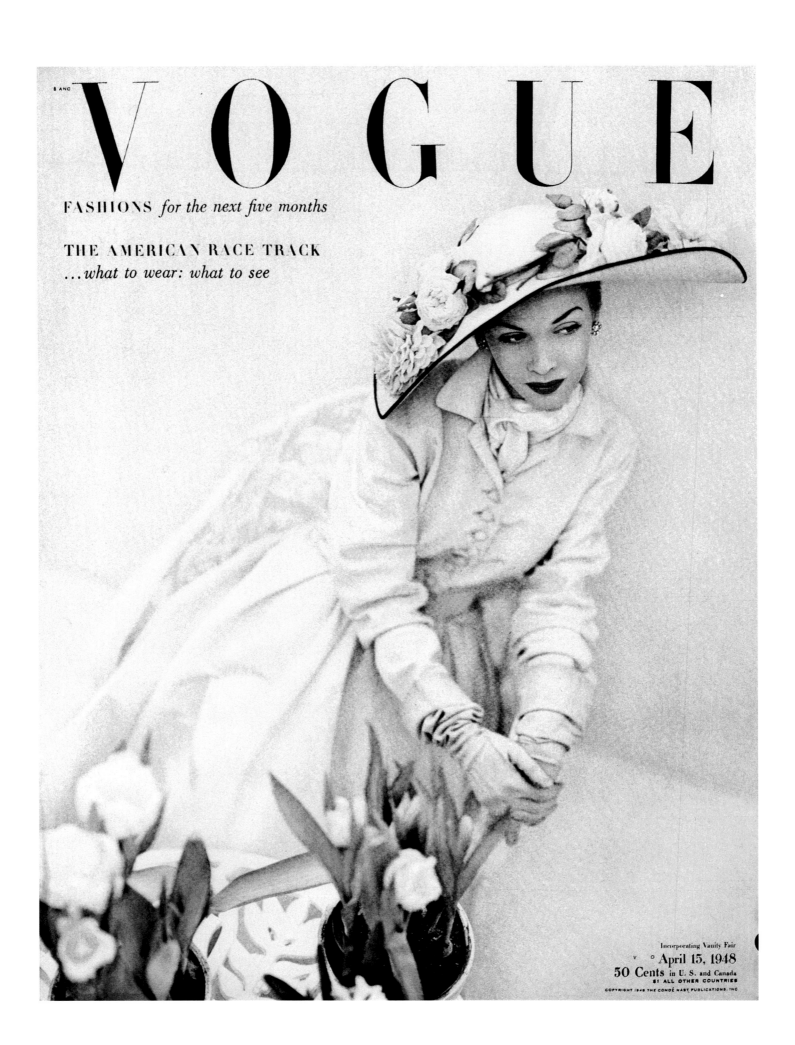

VOGUE

FASHIONS *for the next five months*

THE AMERICAN RACE TRACK
...what to wear: what to see

Incorporating Vanity Fair
April 15, 1948
50 Cents in U. S. and Canada
$1 ALL OTHER COUNTRIES
COPYRIGHT 1948 THE CONDÉ NAST PUBLICATIONS, INC

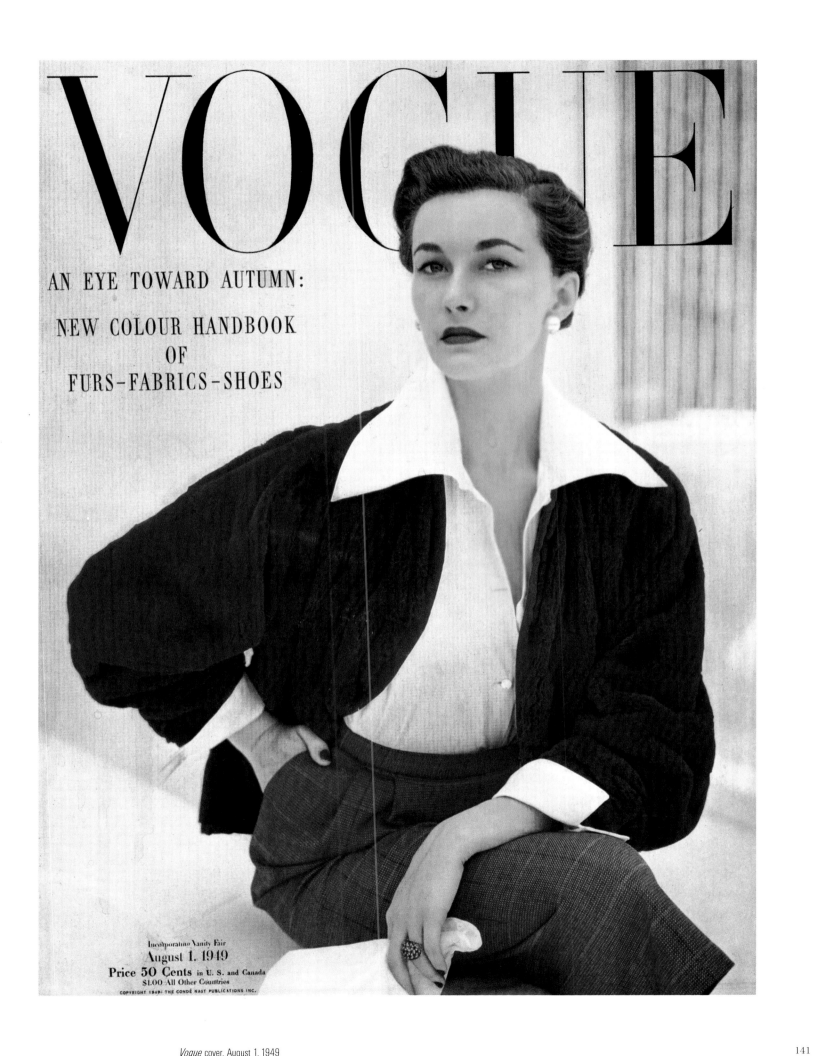

VOGUE

AN EYE TOWARD AUTUMN:

NEW COLOUR HANDBOOK
OF
FURS-FABRICS-SHOES

Incorporating Vanity Fair
August 1, 1949
Price **50 Cents** in U. S. and Canada
$1.00 All Other Countries
COPYRIGHT 1949: THE CONDÉ NAST PUBLICATIONS INC.

Vogue cover, August 1, 1949

Traina-Norell advertisement, January 1950

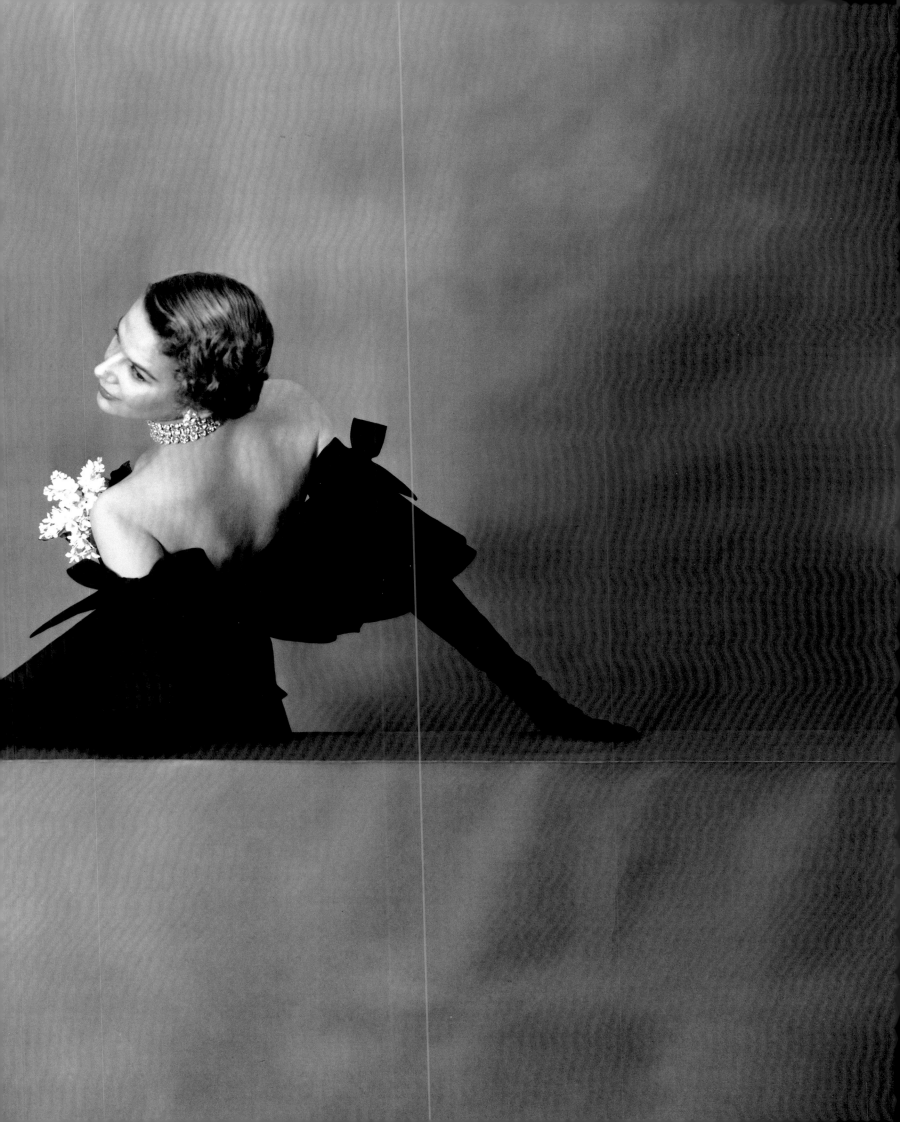

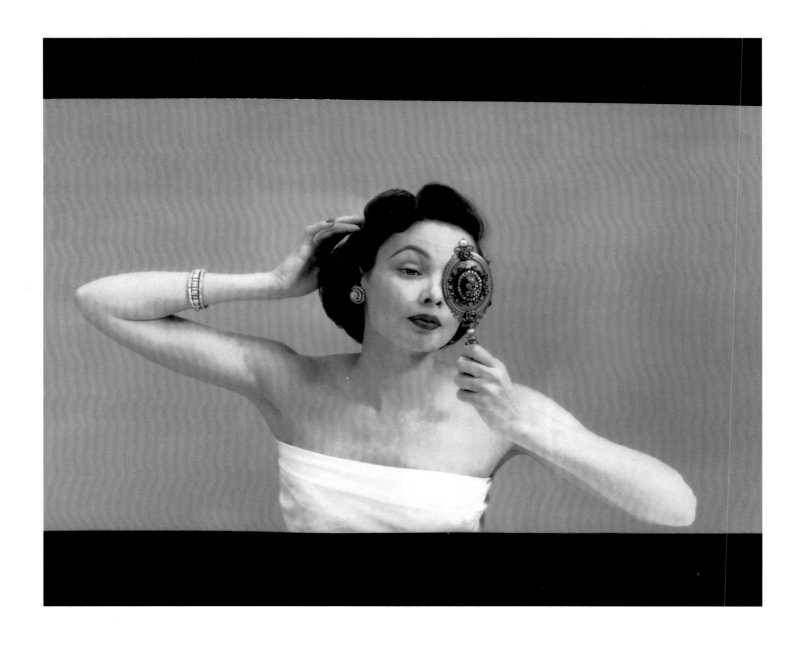

Gene Tierney, 1950

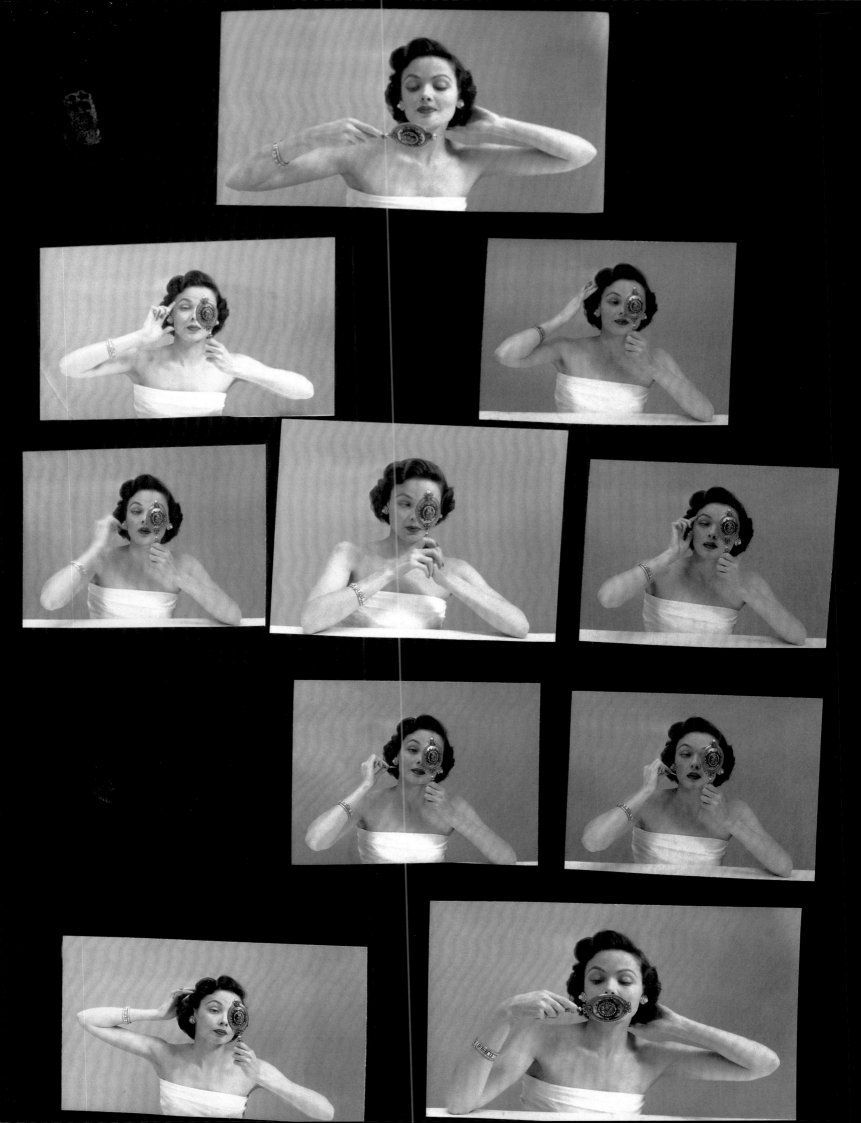

"One Cigarette, Two Lights"; dress by Mildred Orrick, *Vogue*, April 15, 1950

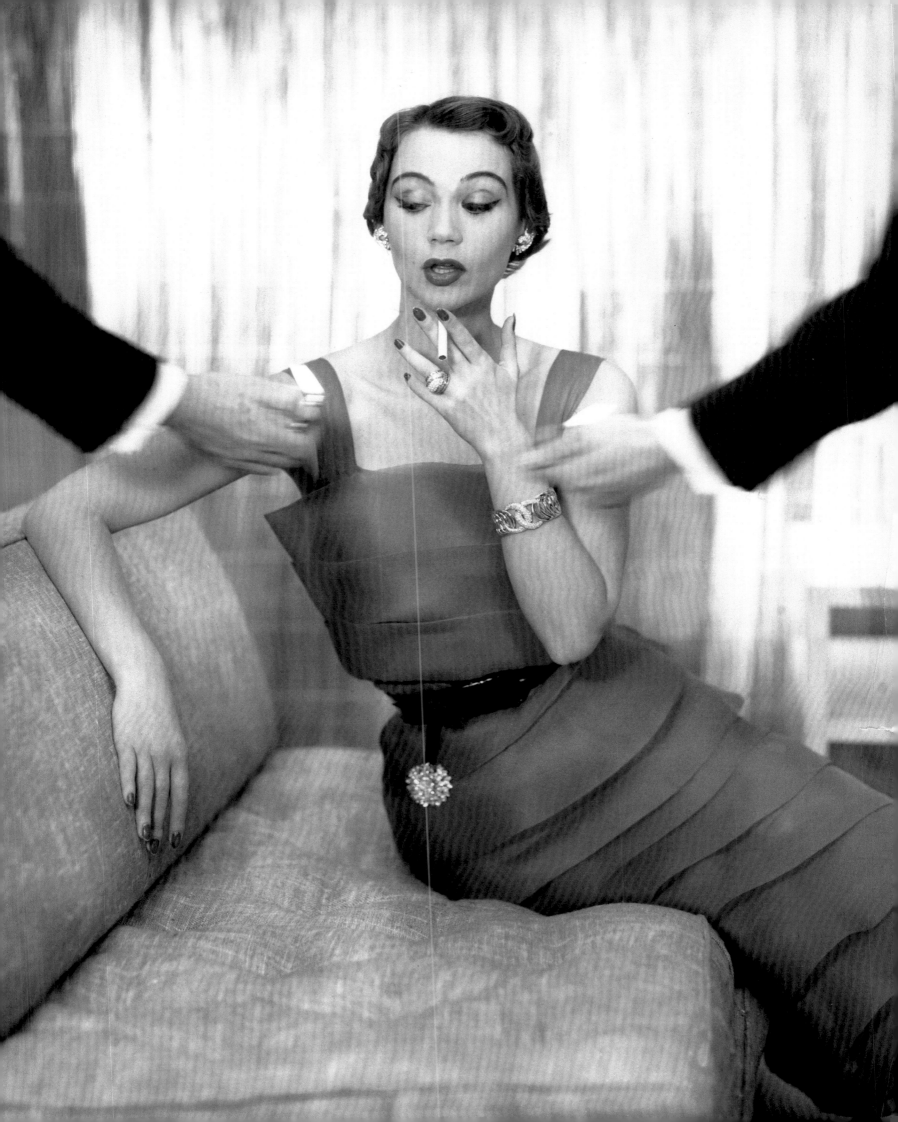

Manipulated contact print for Hanes advertisement, August 1964

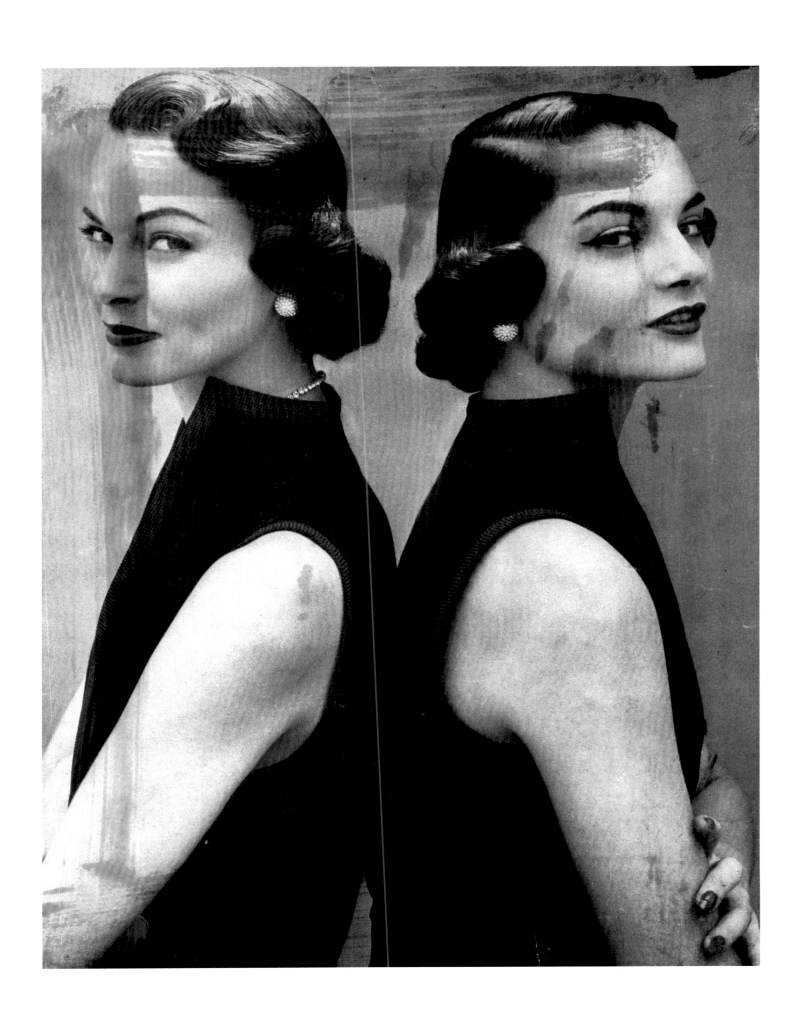

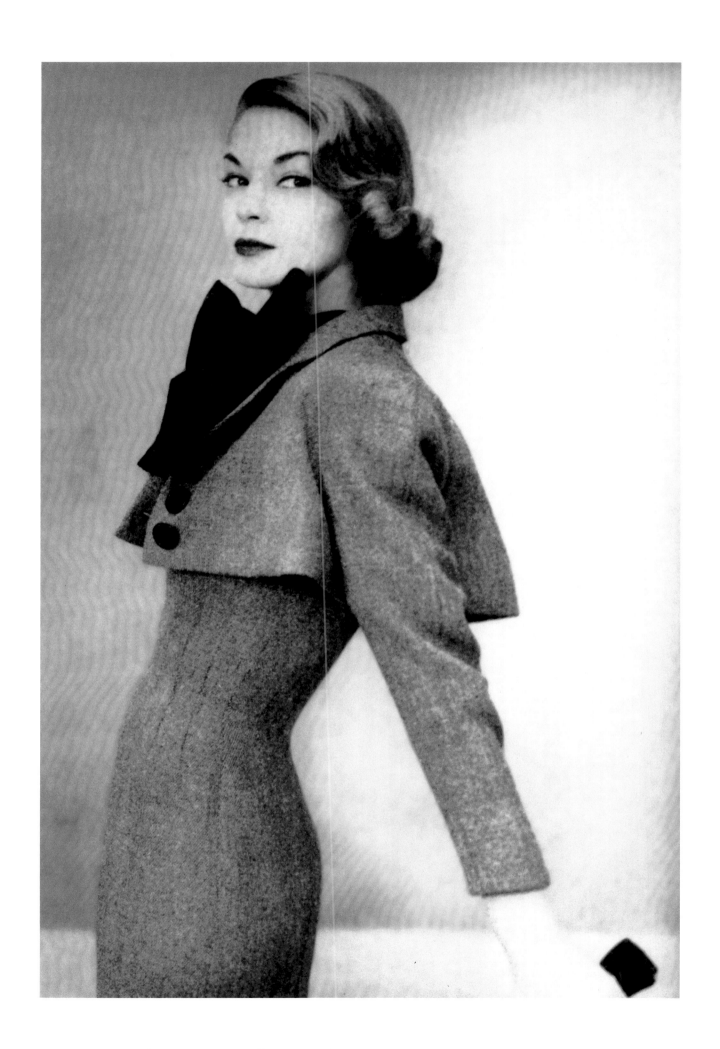

Jean Patchett in Norman Norell, *Vogue*, February 1, 1951

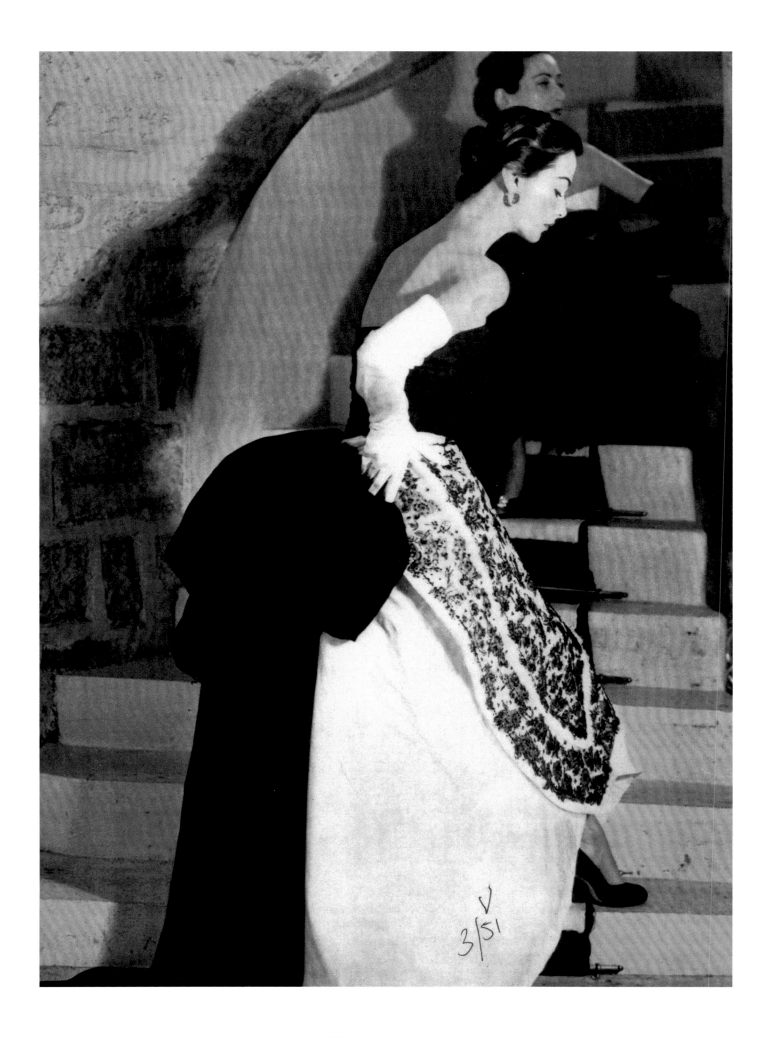

Vogue, Balenciaga apron dress, March 15, 1951

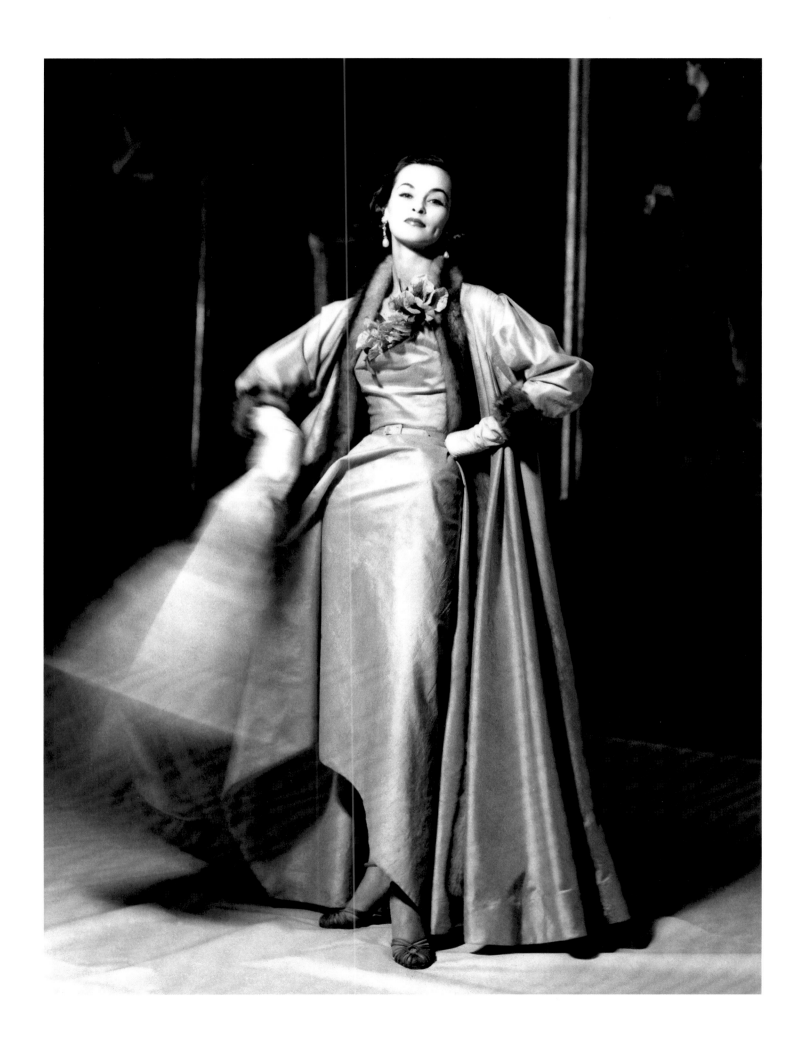

Jean Dessés ensemble, outtake, April 1951

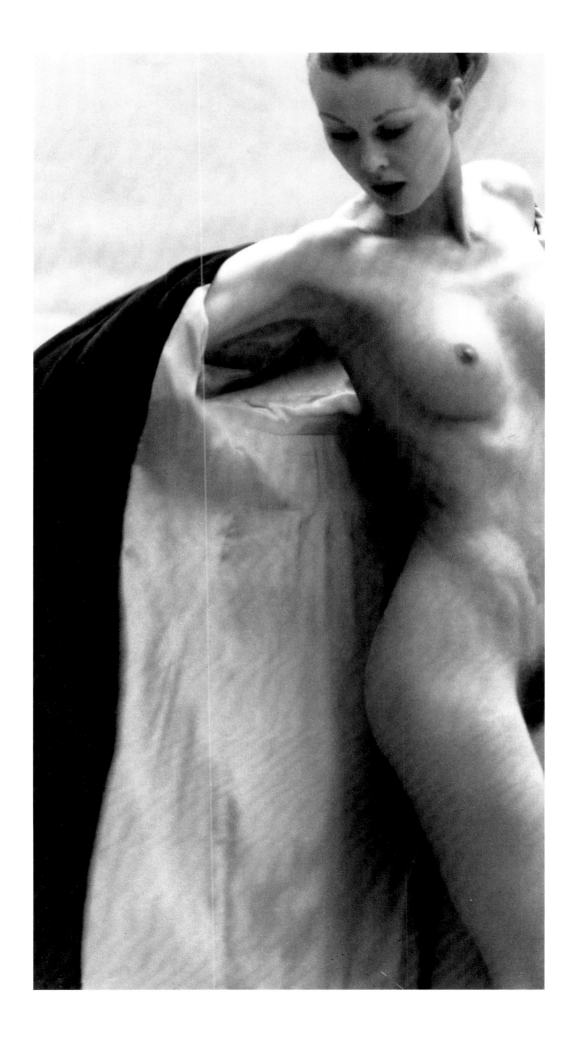

Evelyn Frey, from *100 Studies of the Figure*, 1951

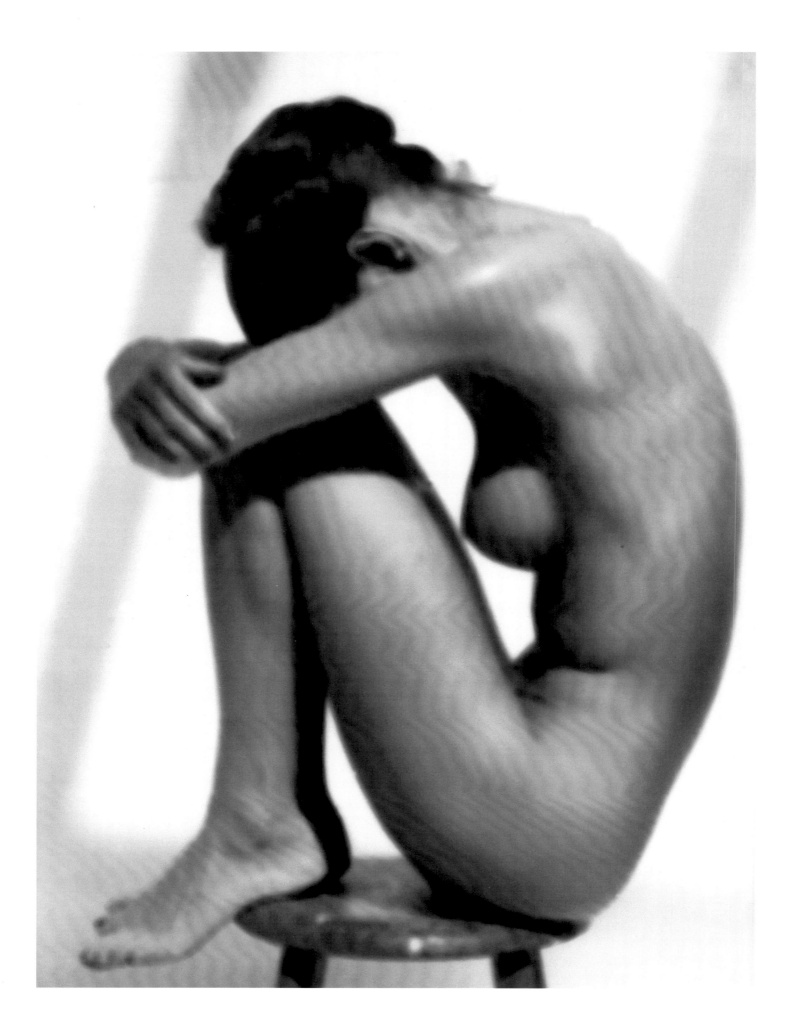

Evelyn Frey, from *100 Studies of the Figure*, 1951

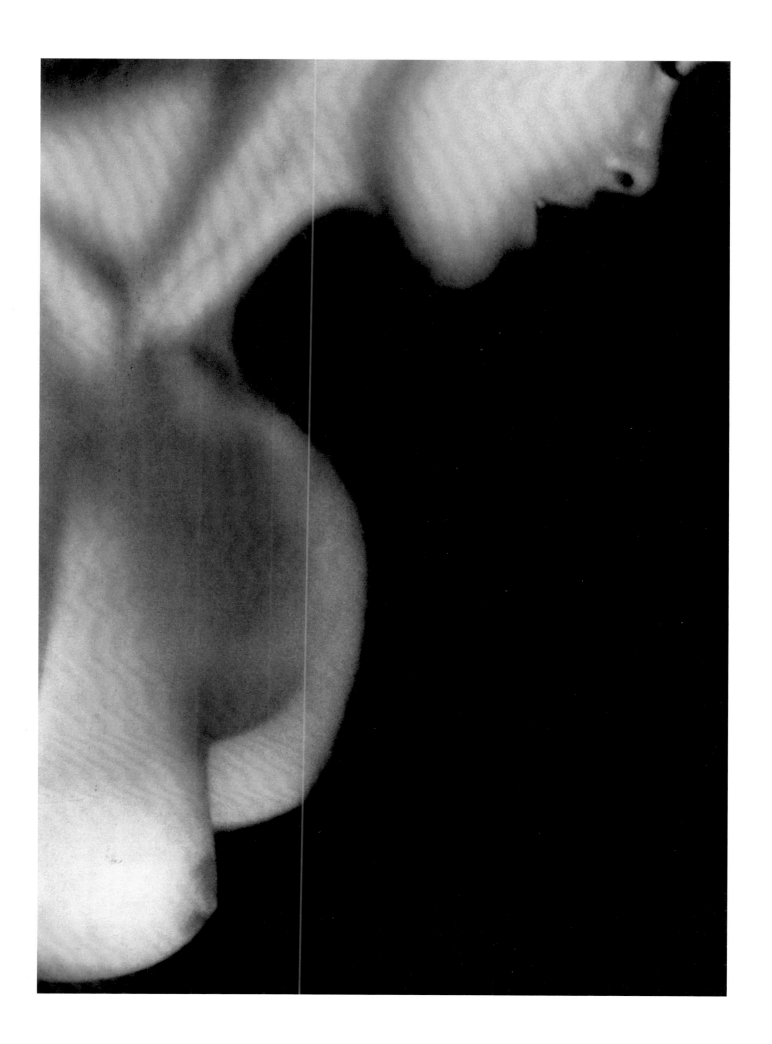

Evelyn Frey, from *100 Studies of the Figure*, 1951

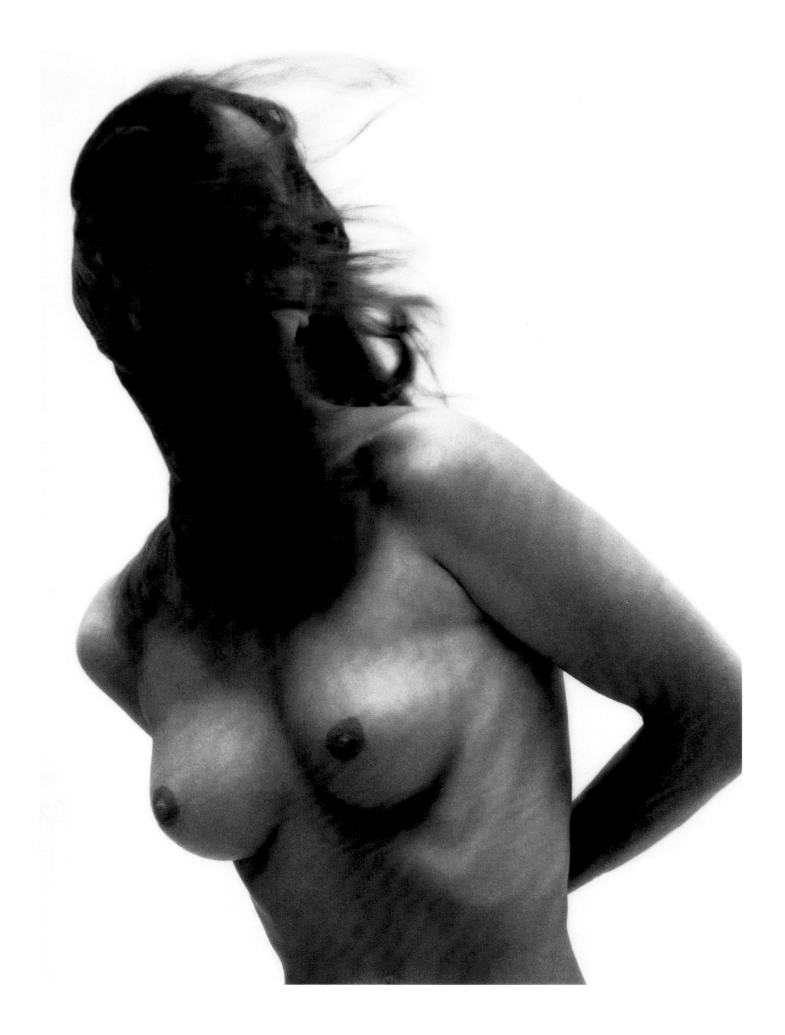

Evelyn Frey, from *100 Studies of the Figure*, 1951

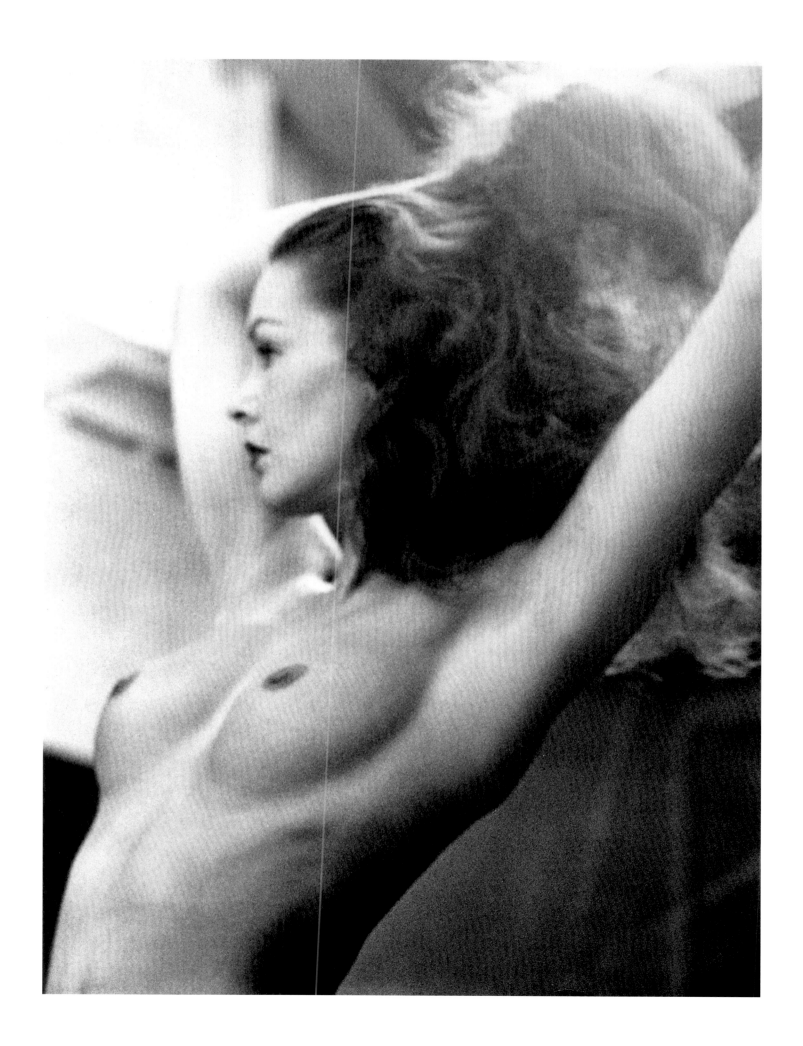

Evelyn Frey, from *100 Studies of the Figure*, 1951

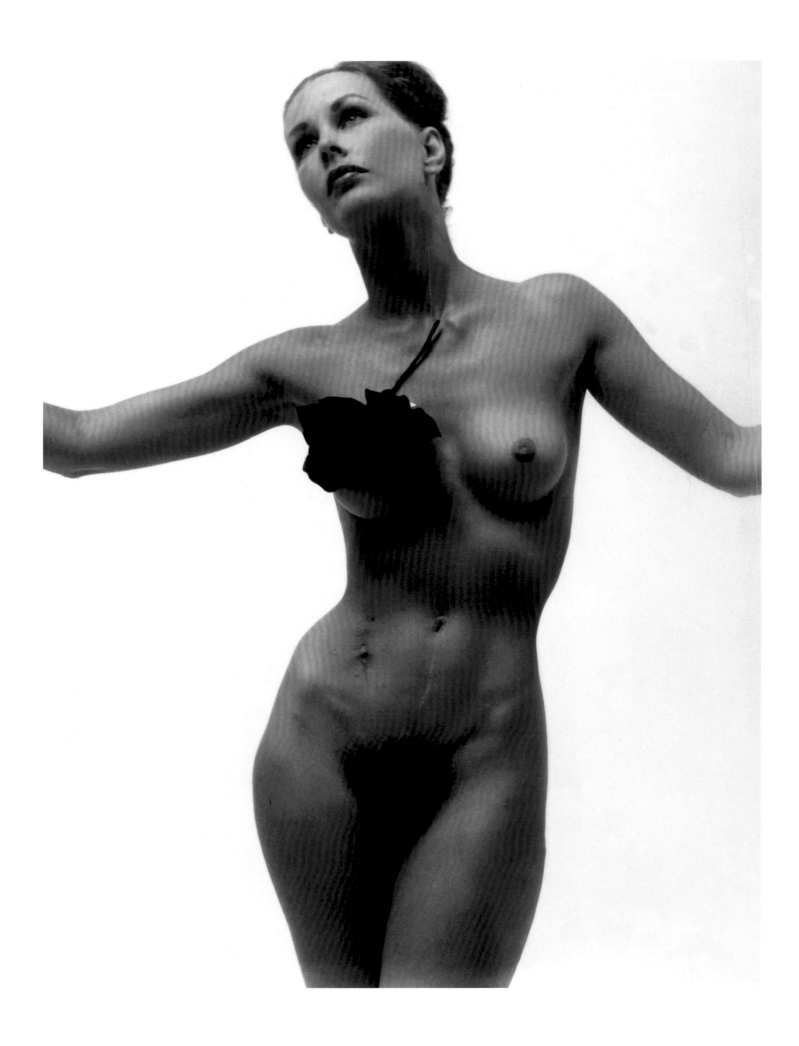

Evelyn Frey, unretouched print, 1951

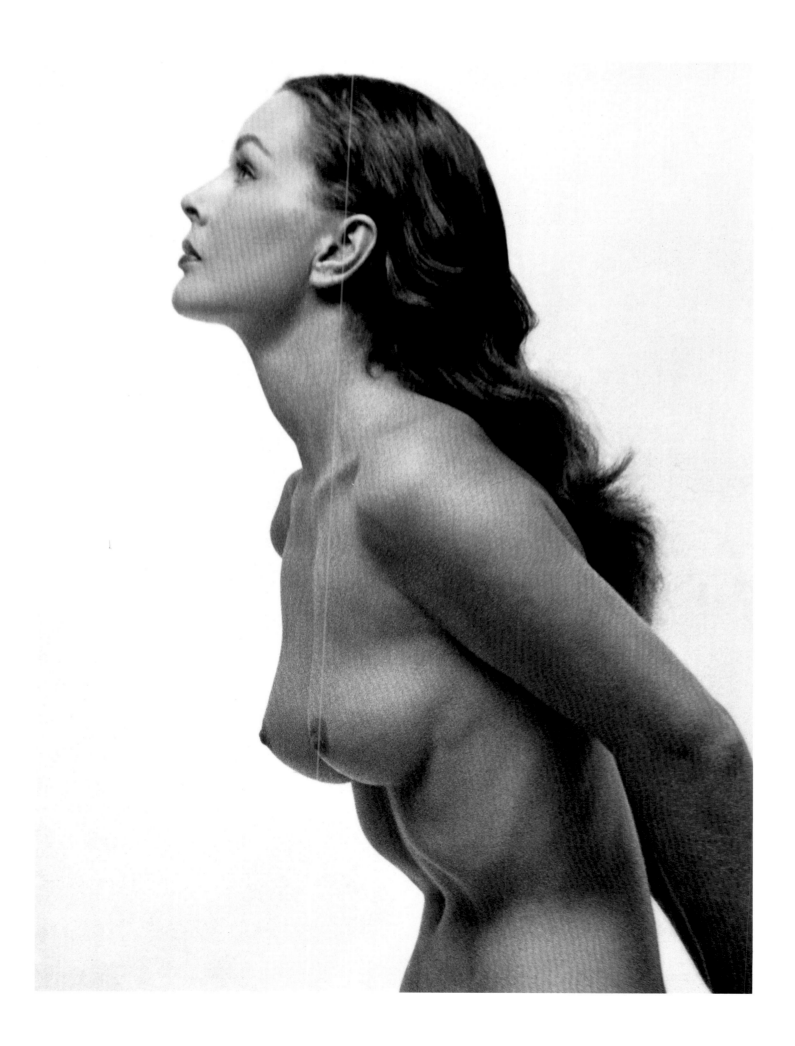

Evelyn Frey, from *100 Studies of the Figure*, 1951

Evelyn Frey, from *100 Studies of the Figure*, 1951

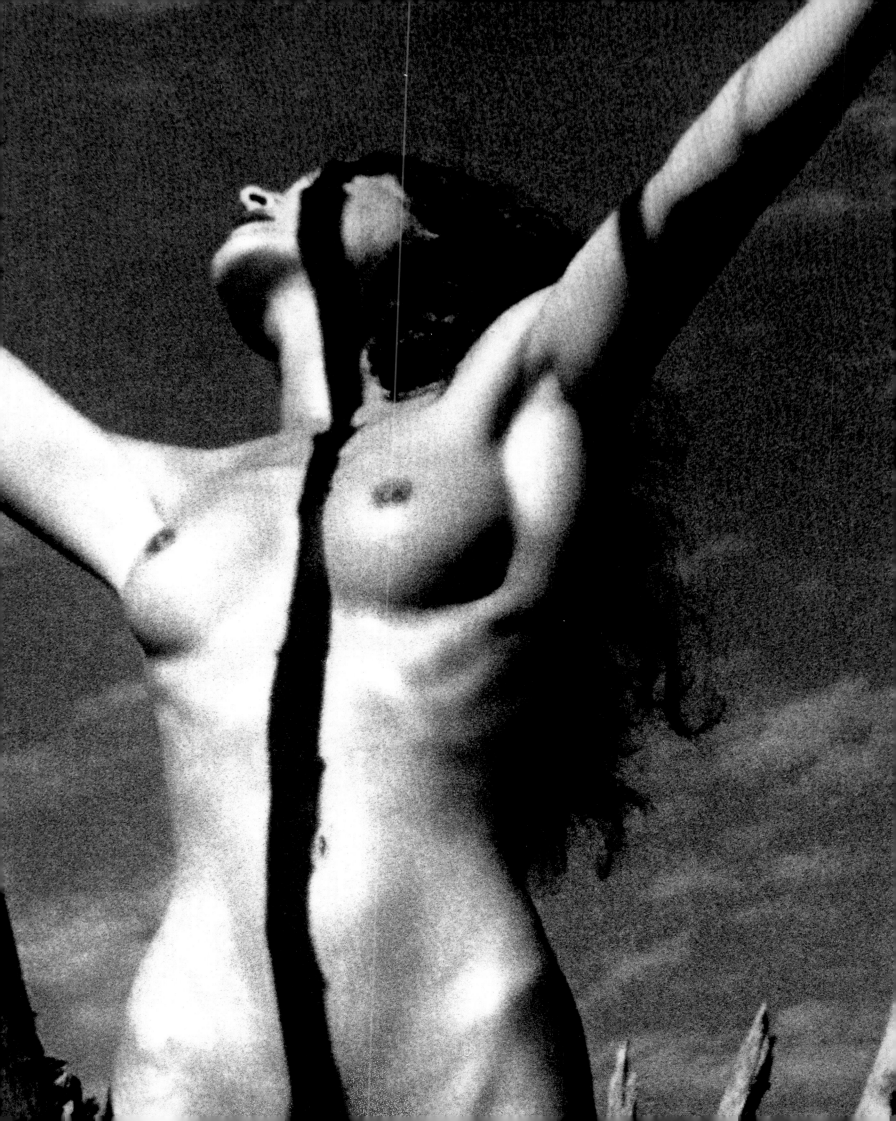

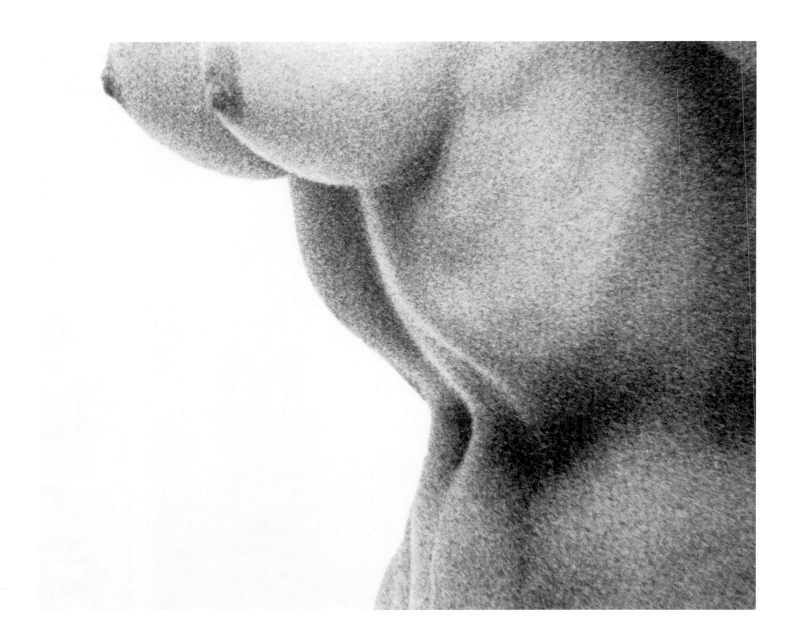

Evelyn Frey, from *100 Studies of the Figure*, 1951

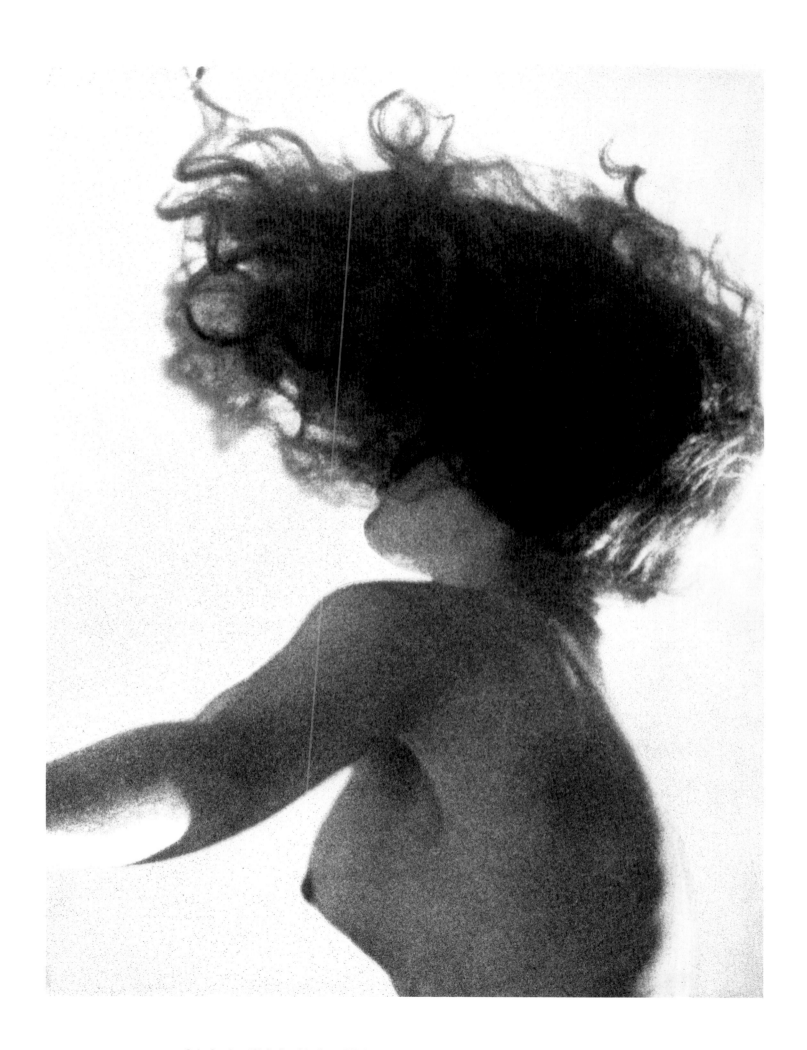

Evelyn Frey, from *100 Studies of the Figure*, 1951. Private collection.

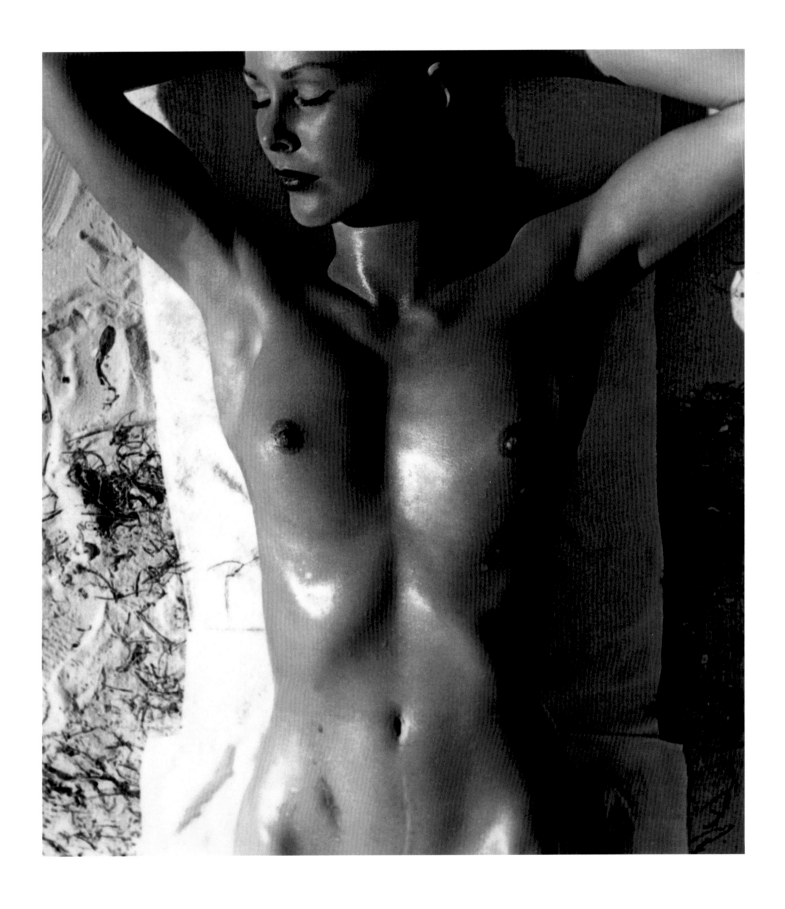

Evelyn Frey, from *100 Studies of the Figure*, 1951 Opposite: Evelyn Frey with Babe Paley in the background, 1951

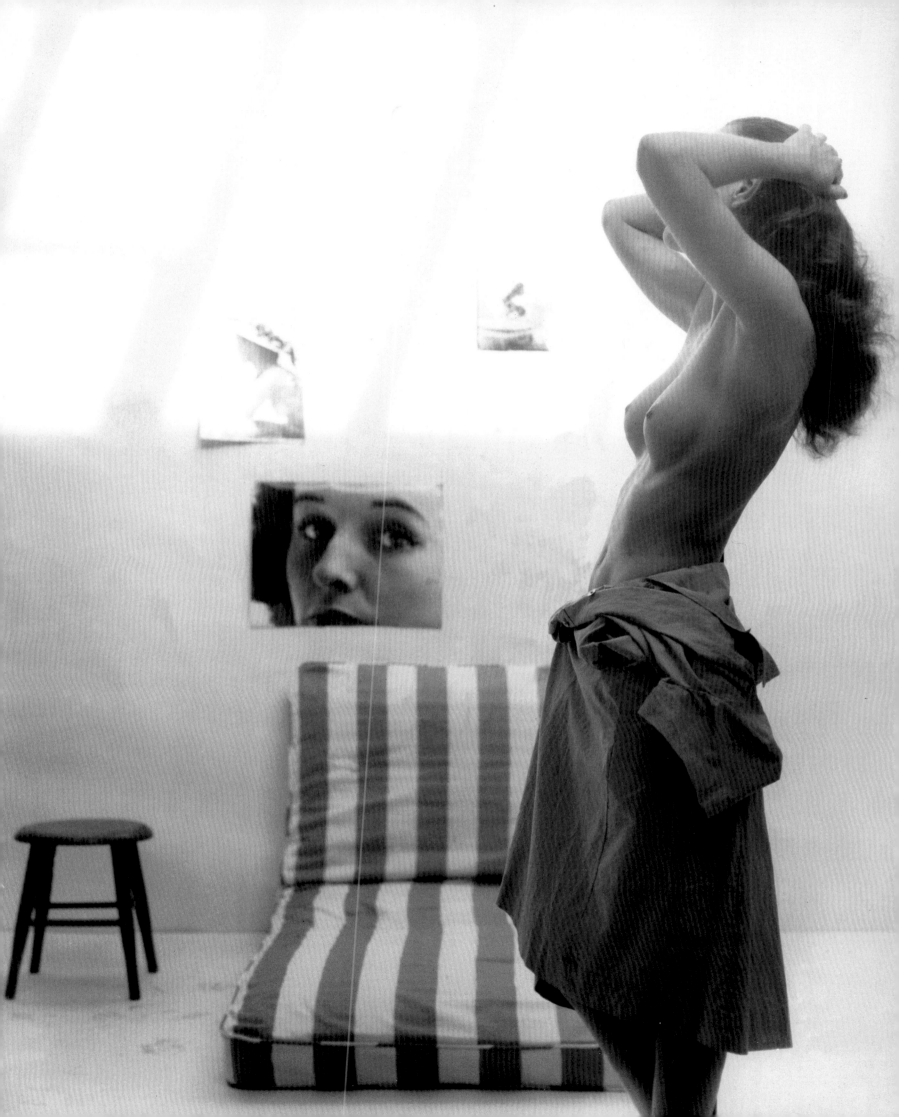

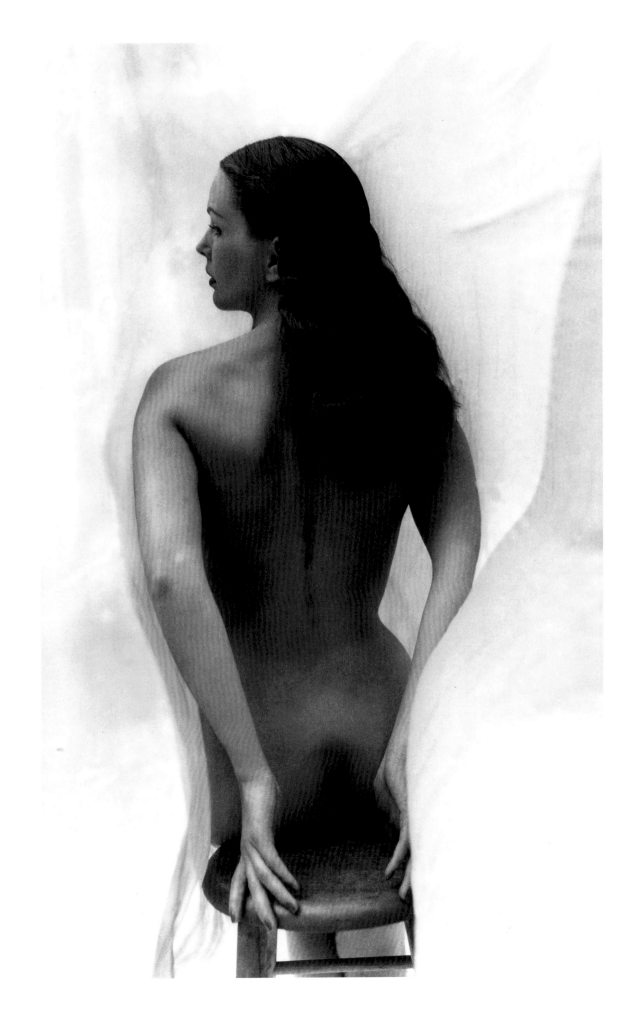

Evelyn Frey, from *100 Studies of the Figure*, 1951

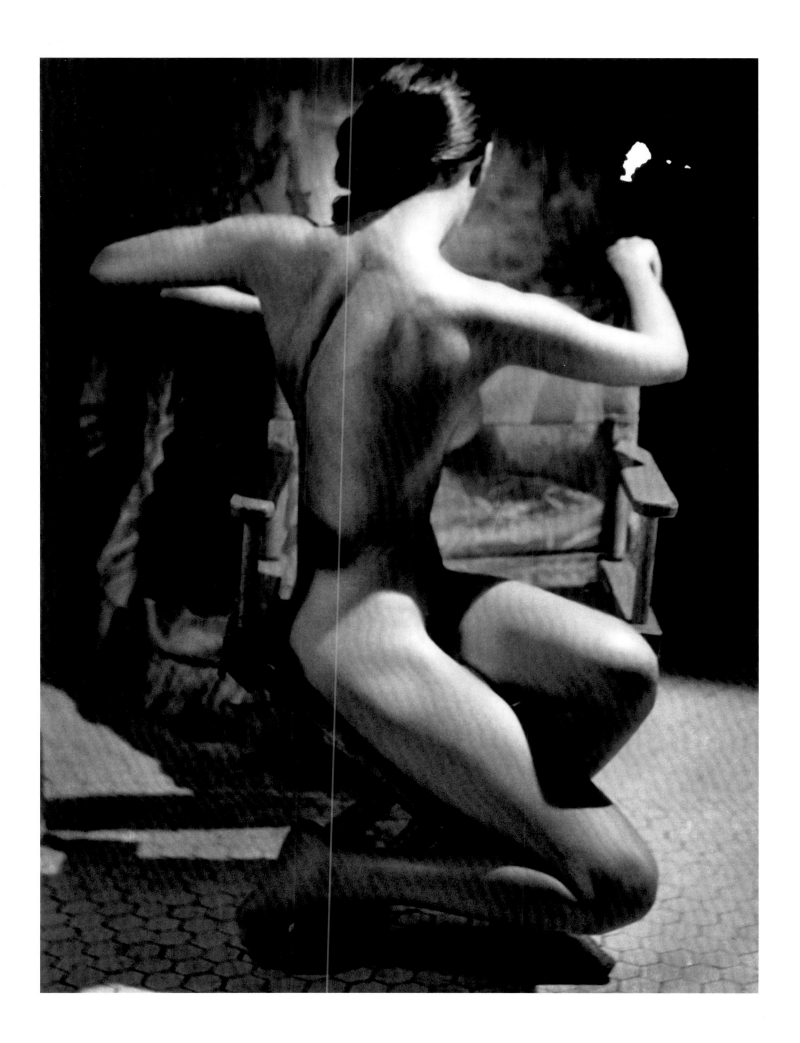

Evelyn Frey, from *100 Studies of the Figure*, 1951

Evelyn Frey, from *100 Studies of the Figure*, 1951

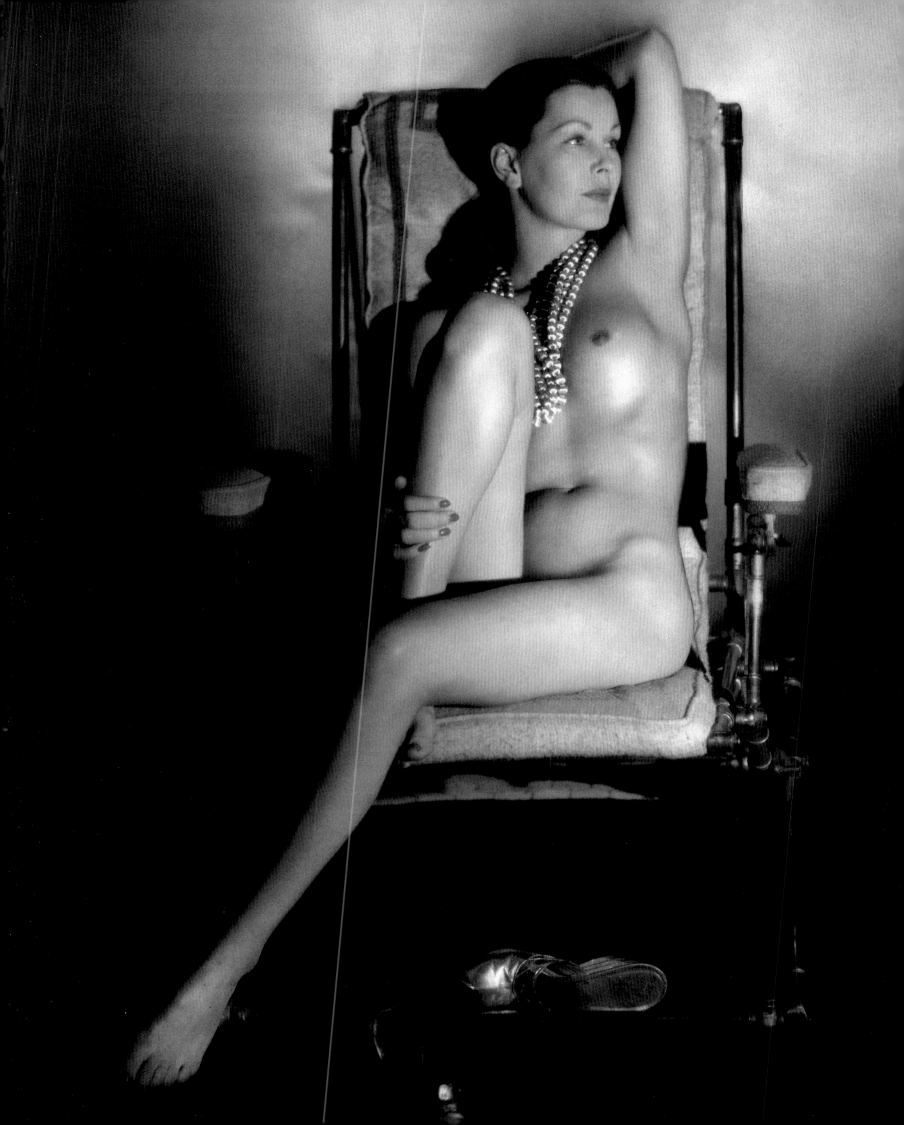

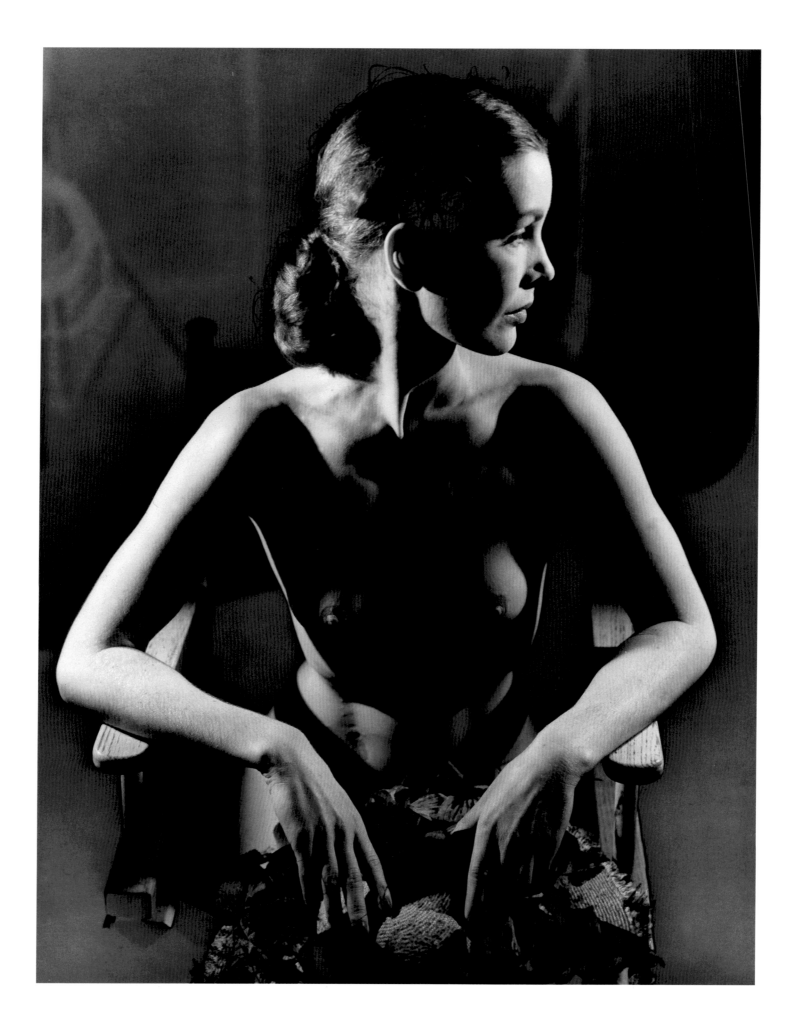

Evelyn Frey, 1951

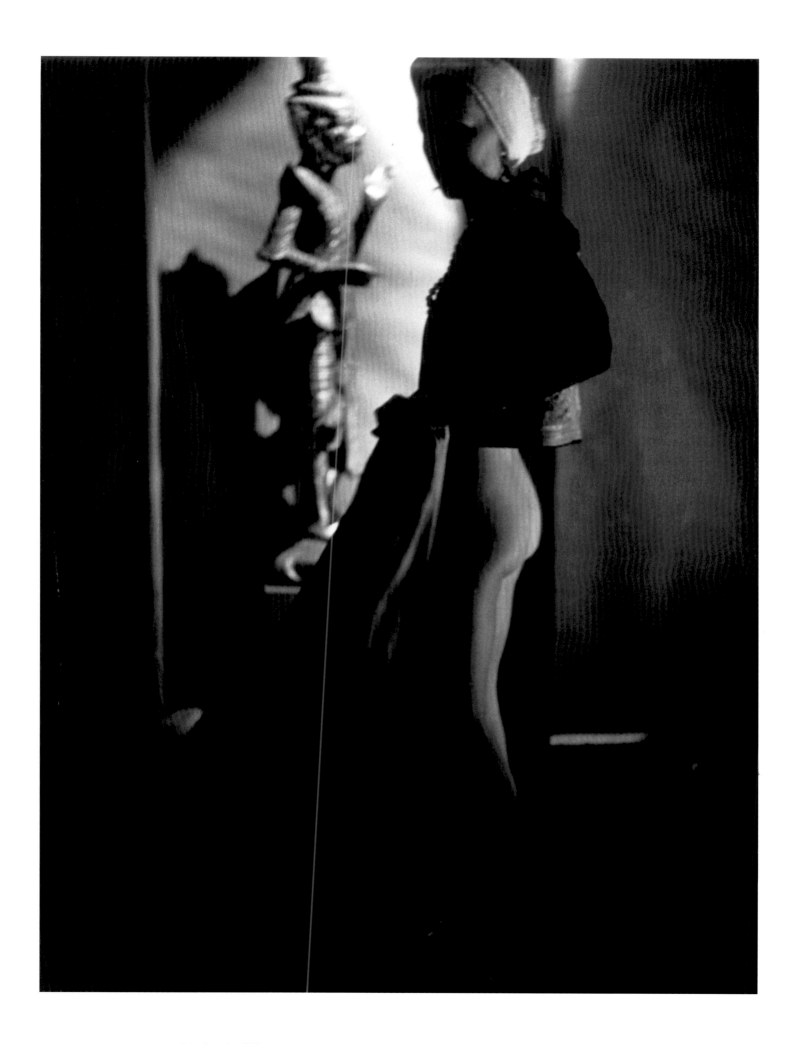

Evelyn Frey, circa 1951

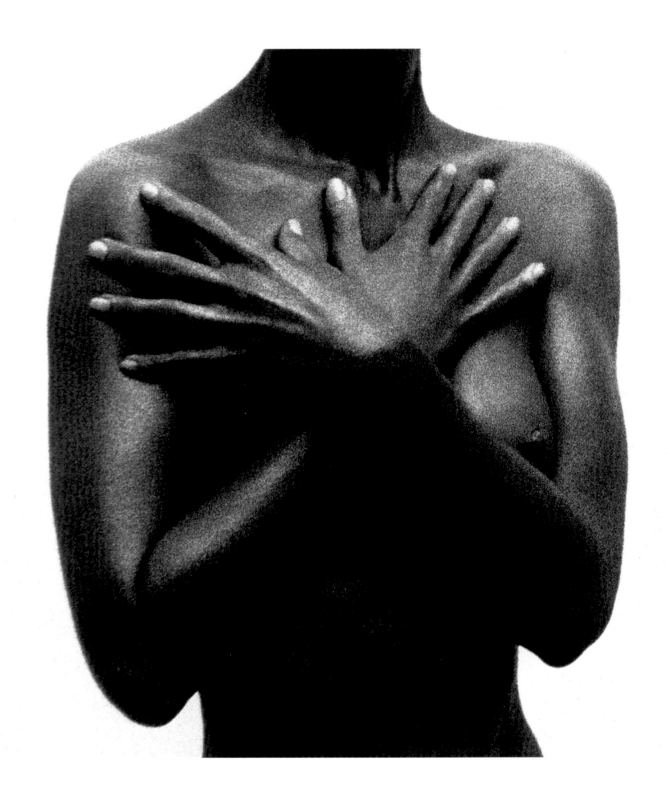

from *100 Studies of the Figure*, 1951

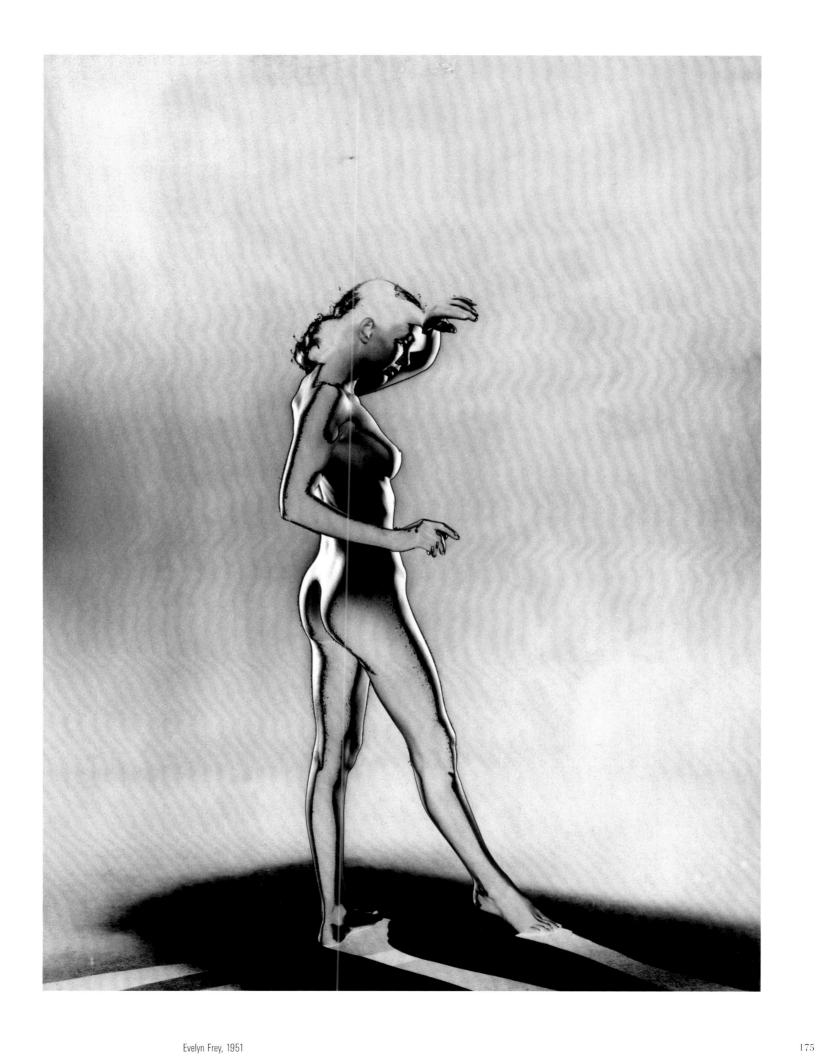

Evelyn Frey, 1951

Sunny Harnett, *Vogue*, October 15, 1951

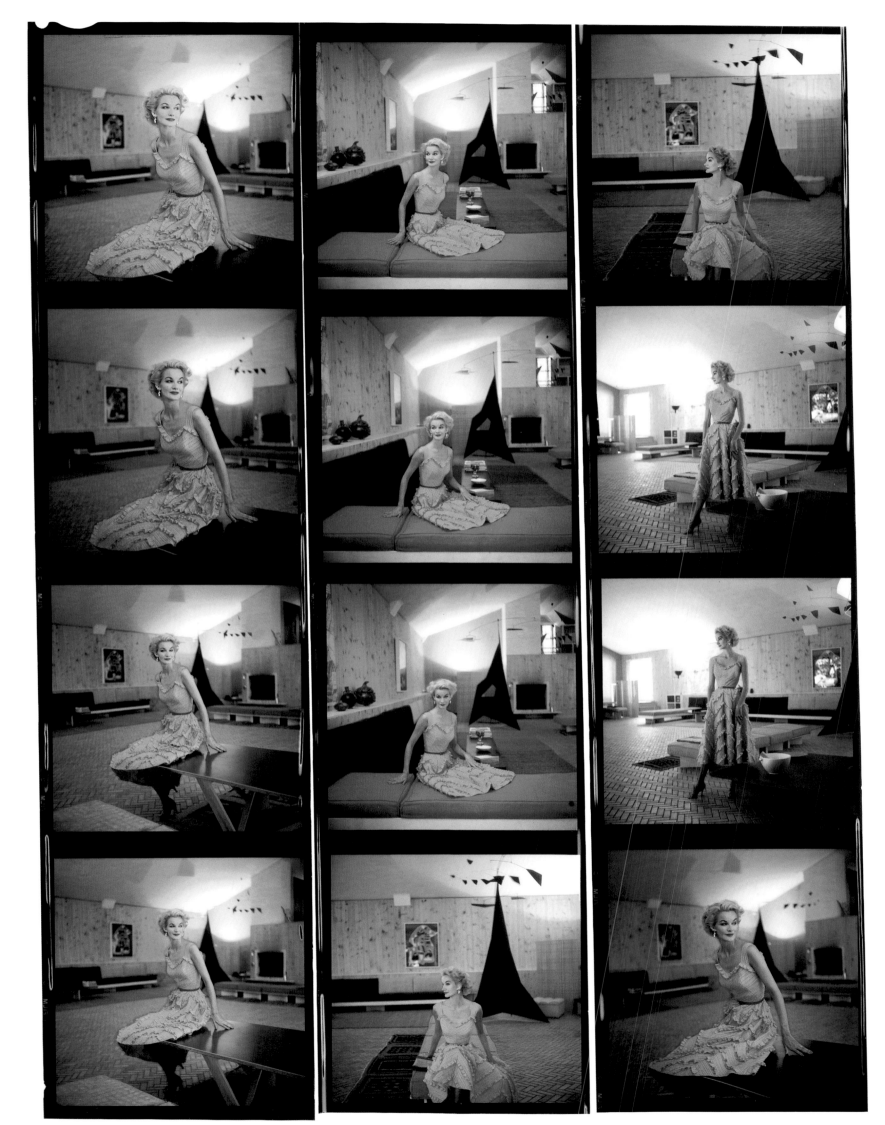

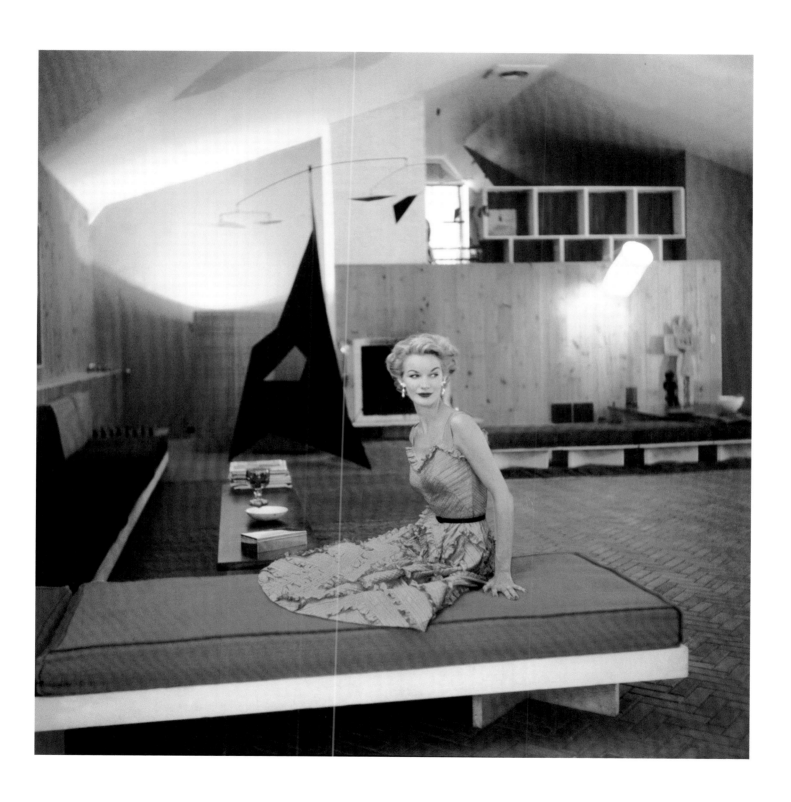

Sunny Harnett in the apartment of architect José-Luis Sert, *Vogue*, November 15, 1952

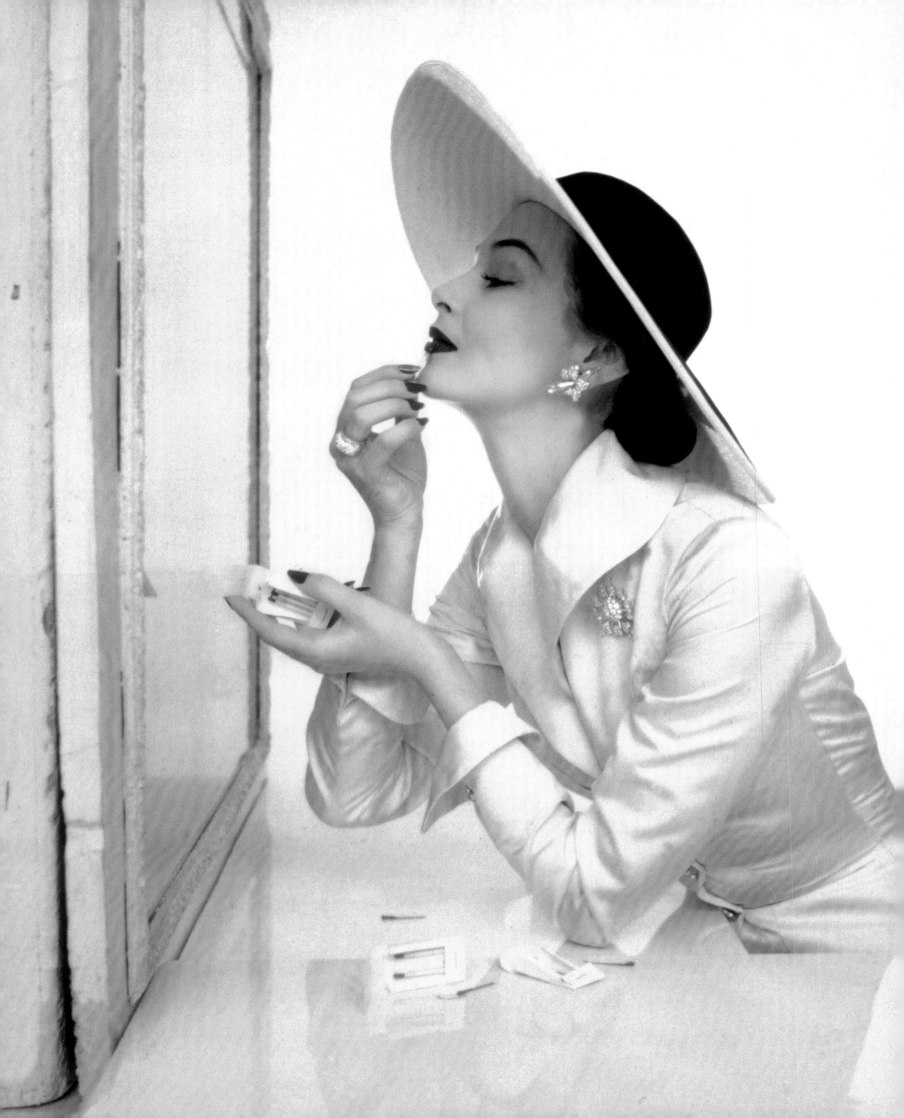

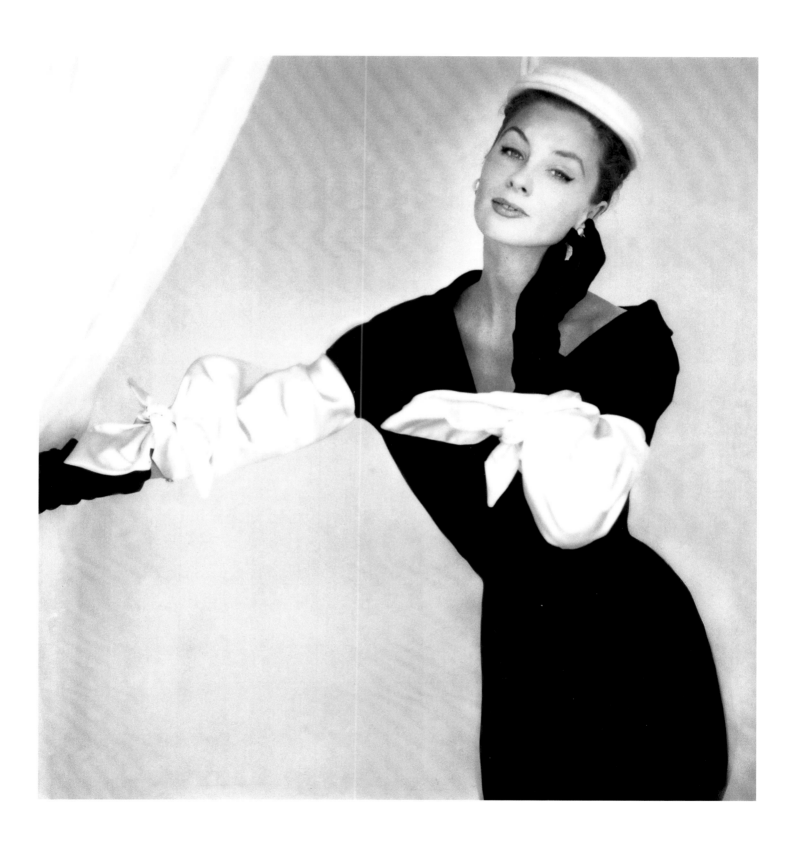

Suzy Parker in Balenciaga; hat by Hattie Carnegie, September 15, 1953

Suzy Parker, *Vogue*, September 15, 1952

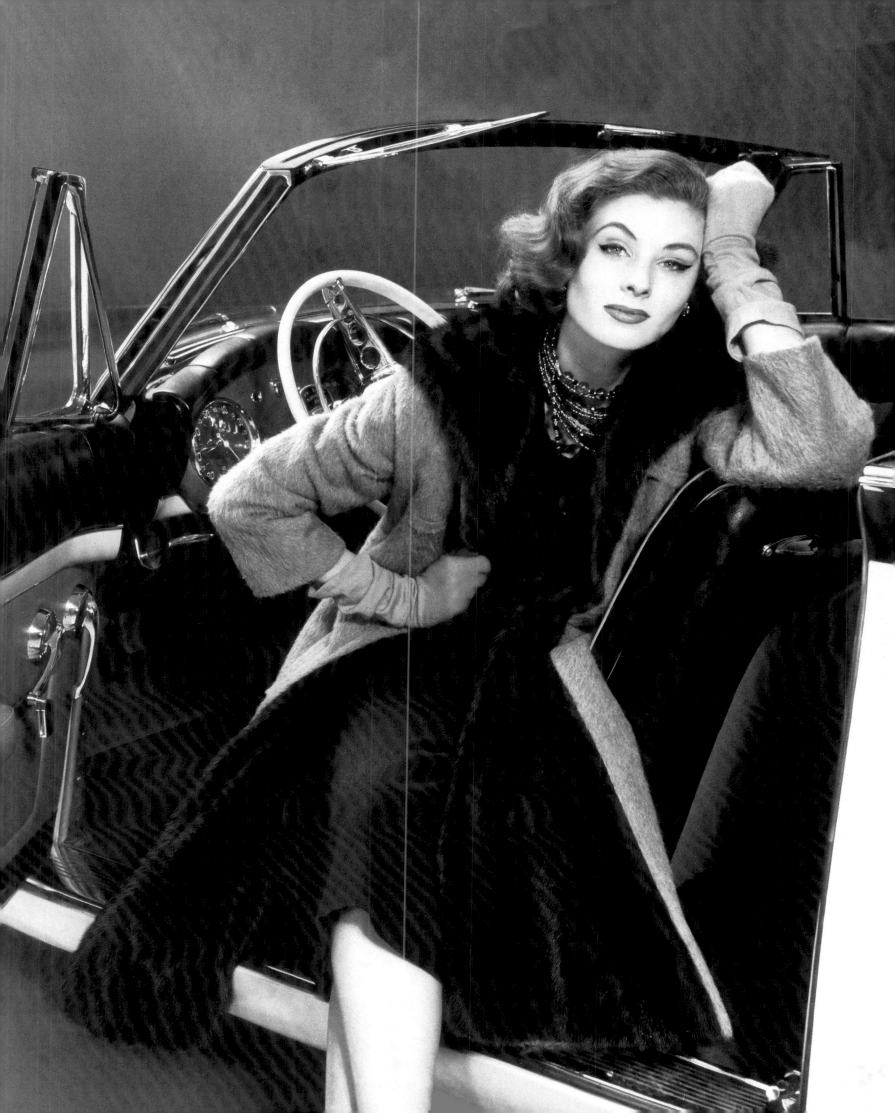

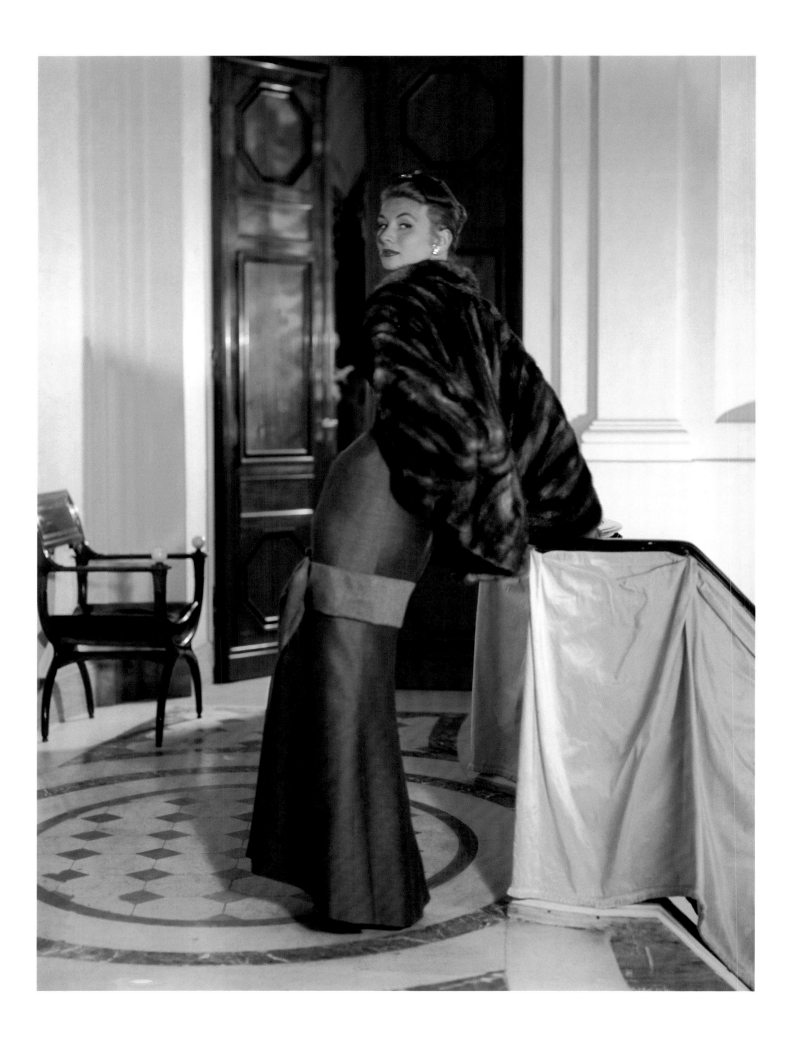

Suzy Parker in Christian Dior, *Vogue*, October 15, 1953

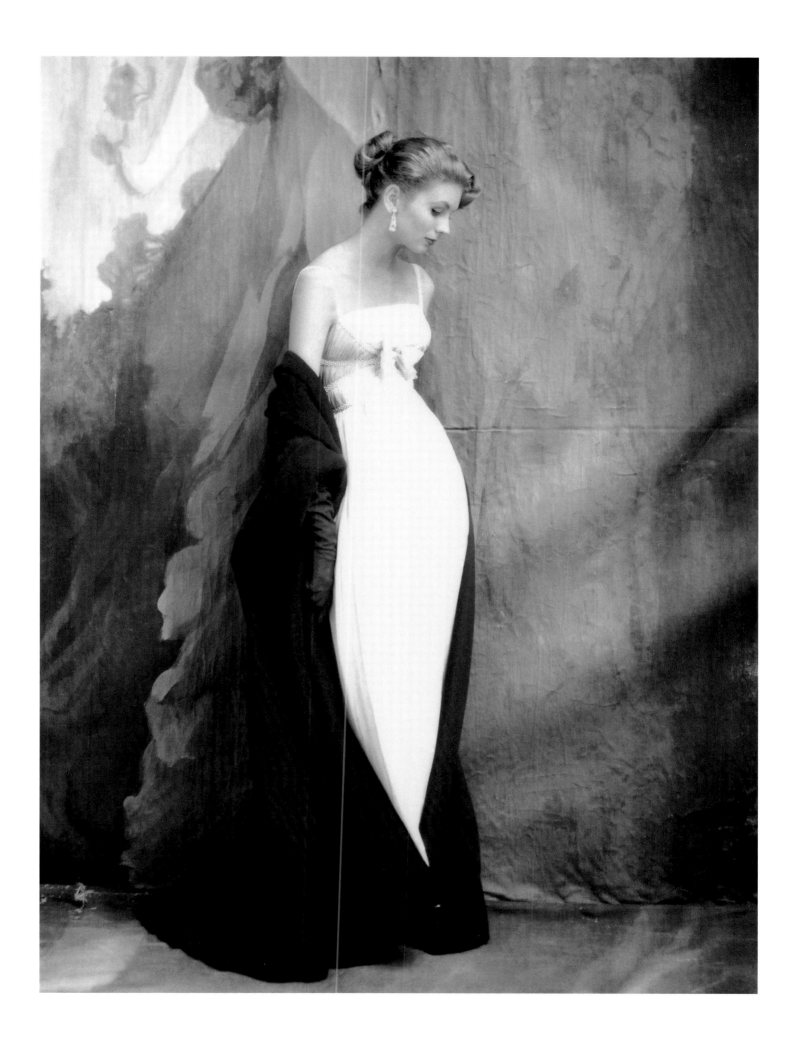

Suzy Parker in Jacques Griffe, *Vogue*, October 15, 1953

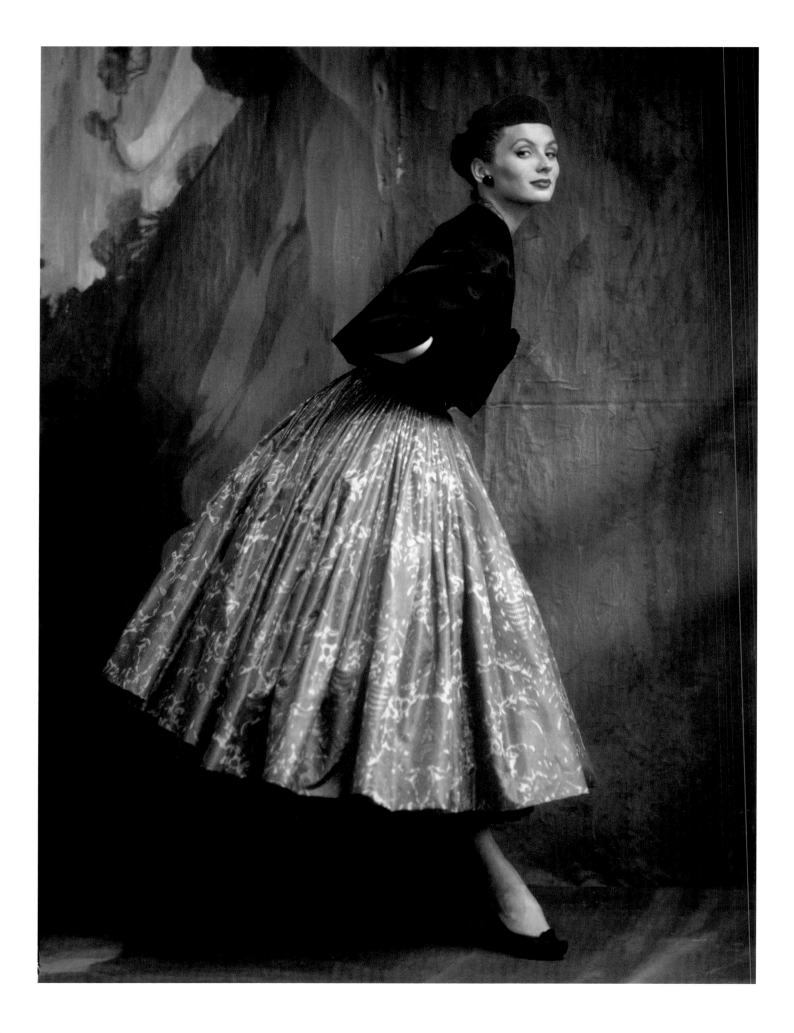

Suzy Parker in Givenchy, *Vogue*, October 1953

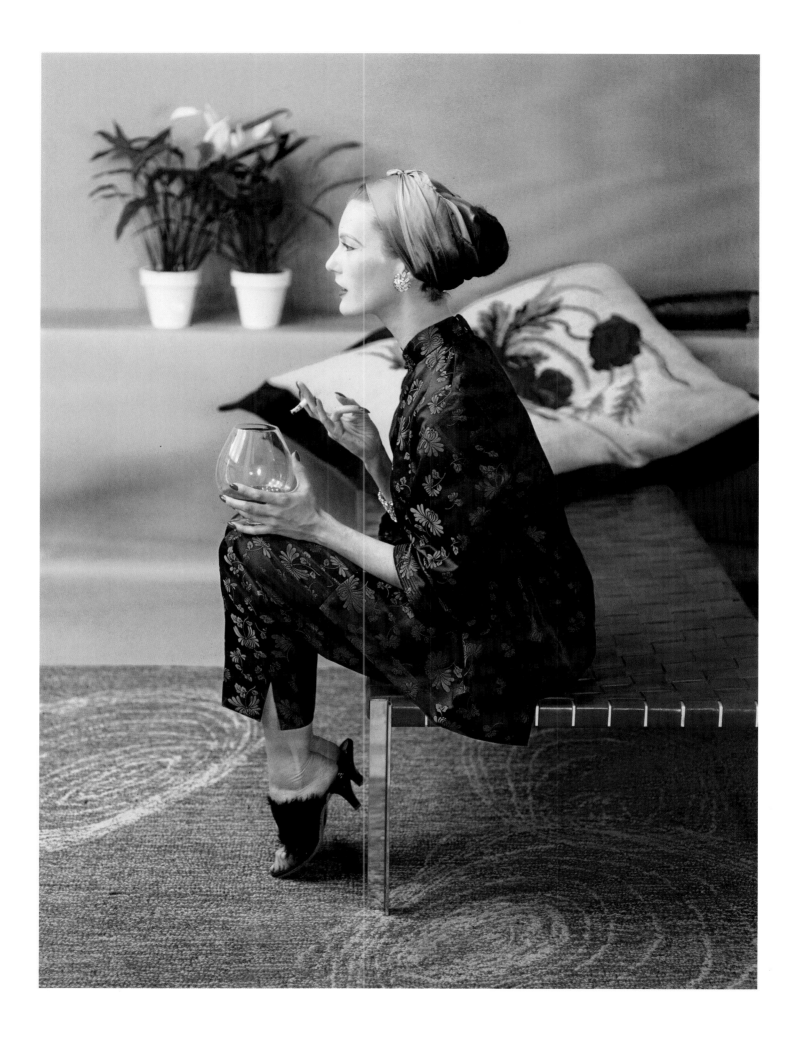

Mary Jane Russell, *Vogue*, December 1953

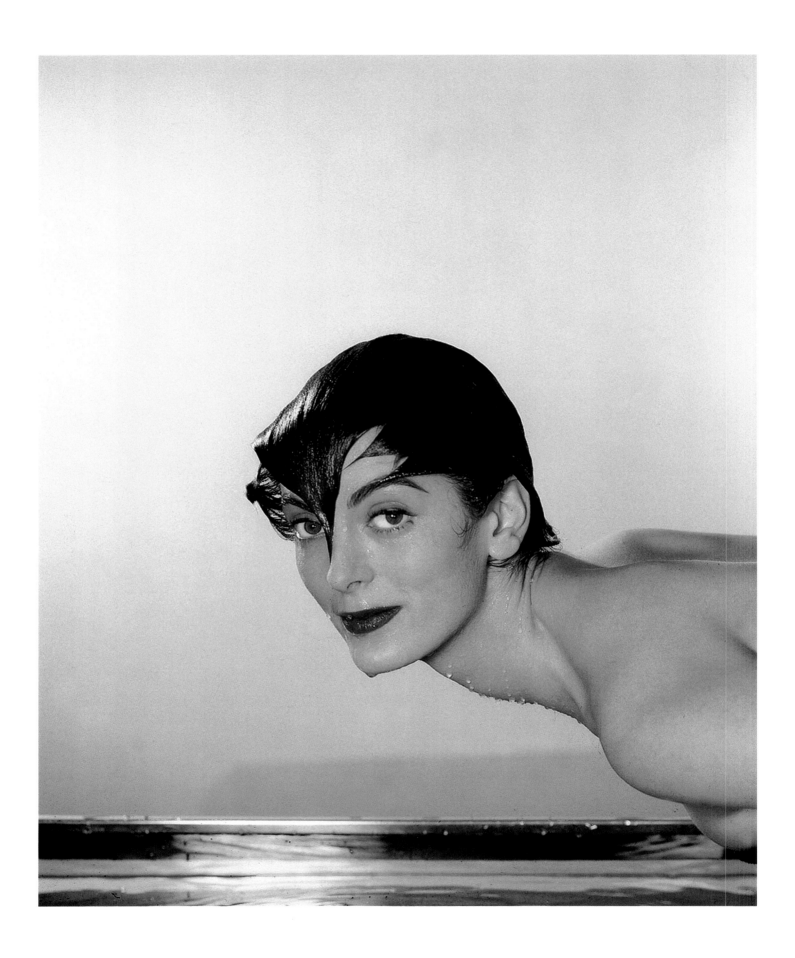

Carmen Dell'Orefice, *Vogue*, 1955

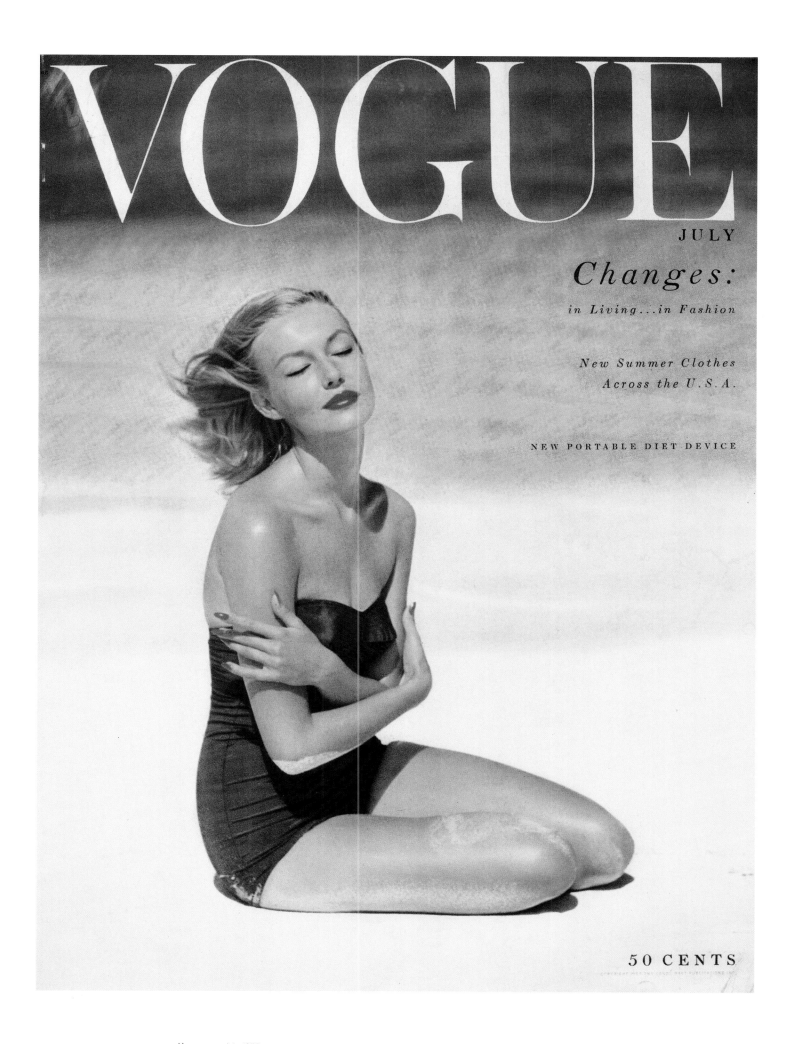

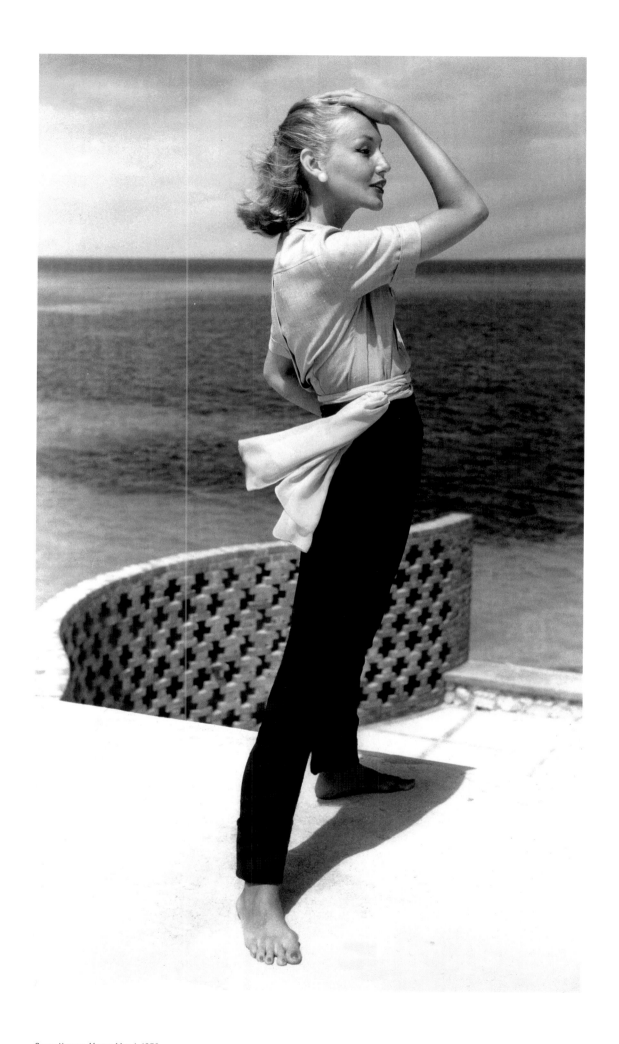

Sunny Harnett, *Vogue*, May 1, 1953

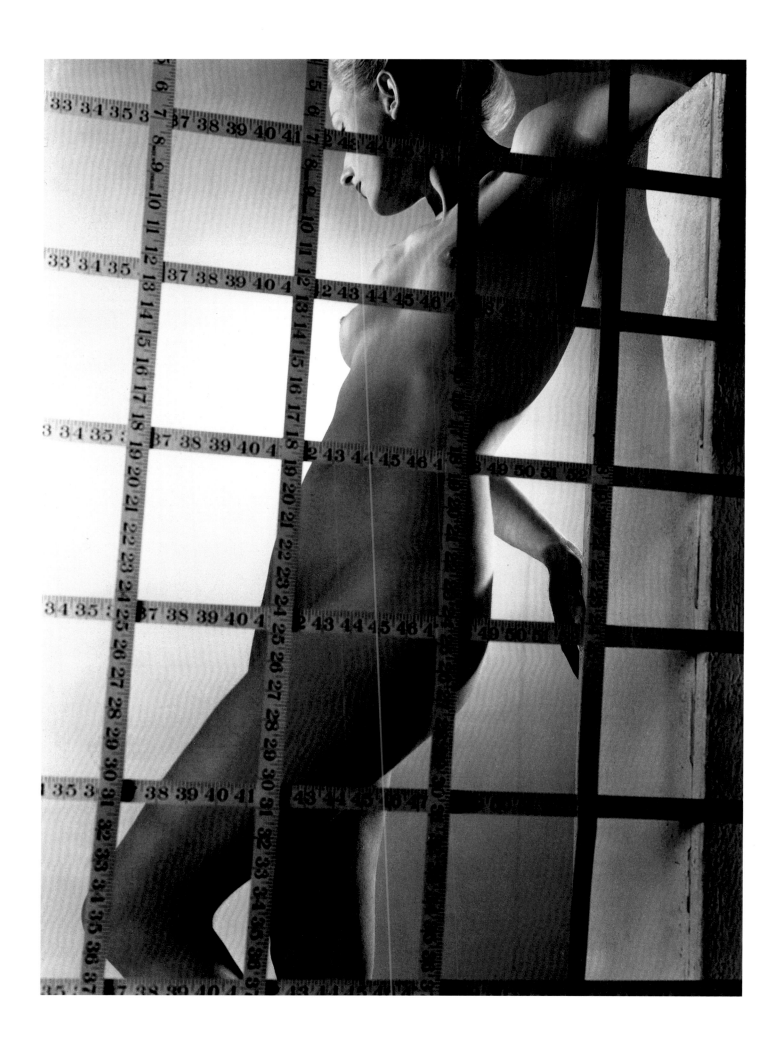

Mary Jane Russell, *Vogue*, December 1954

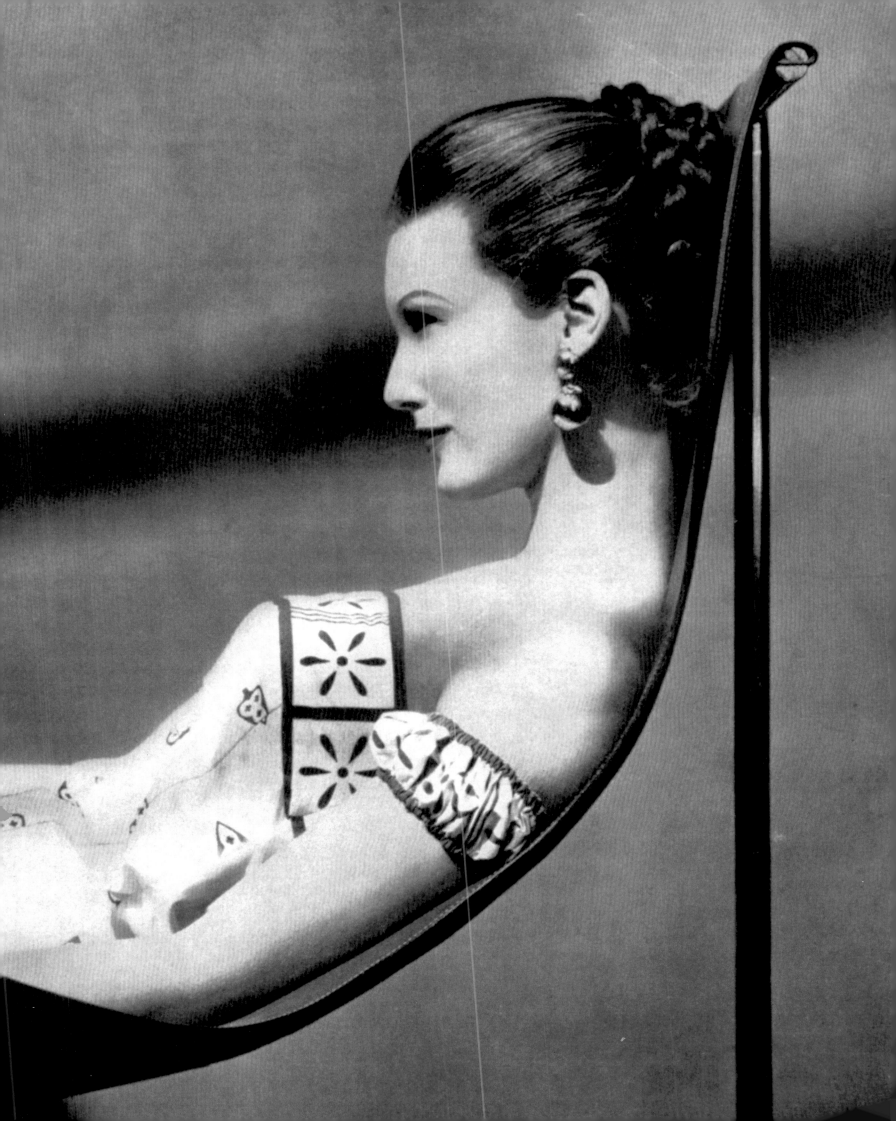

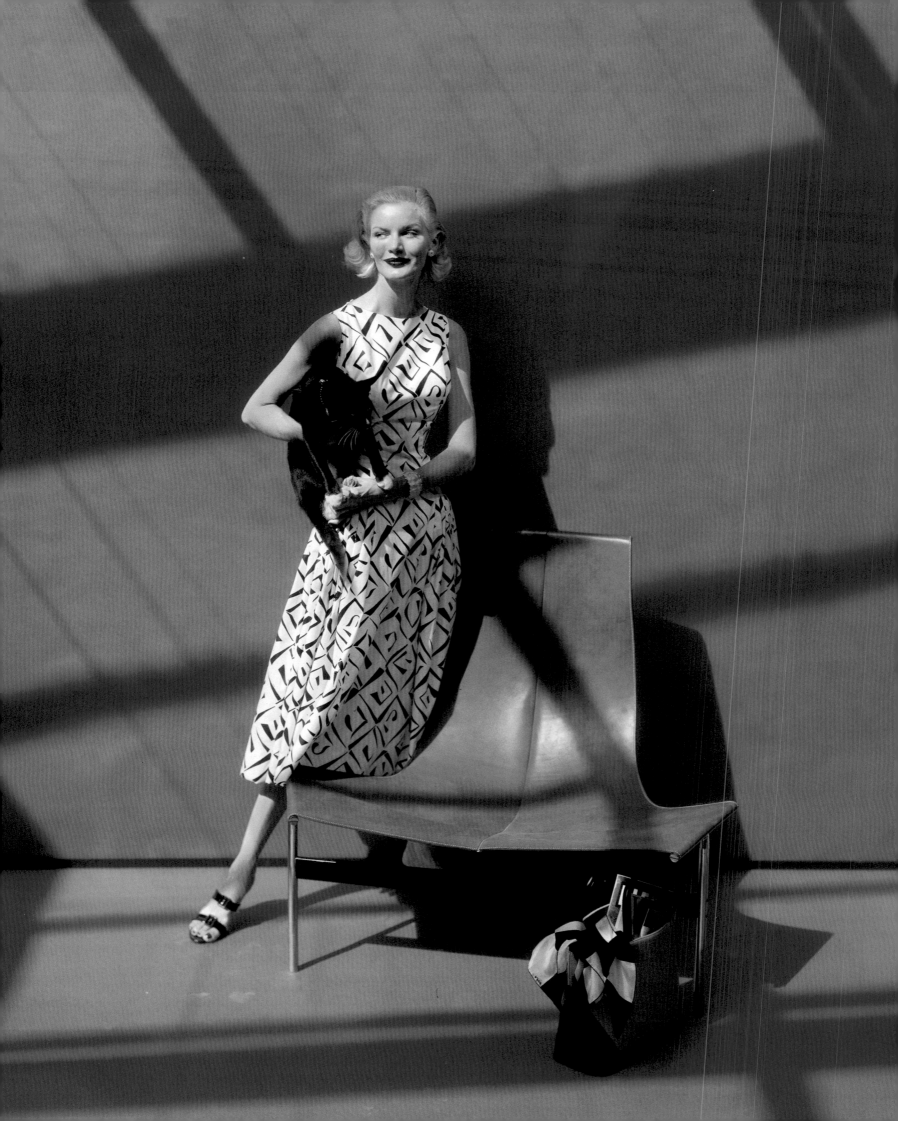

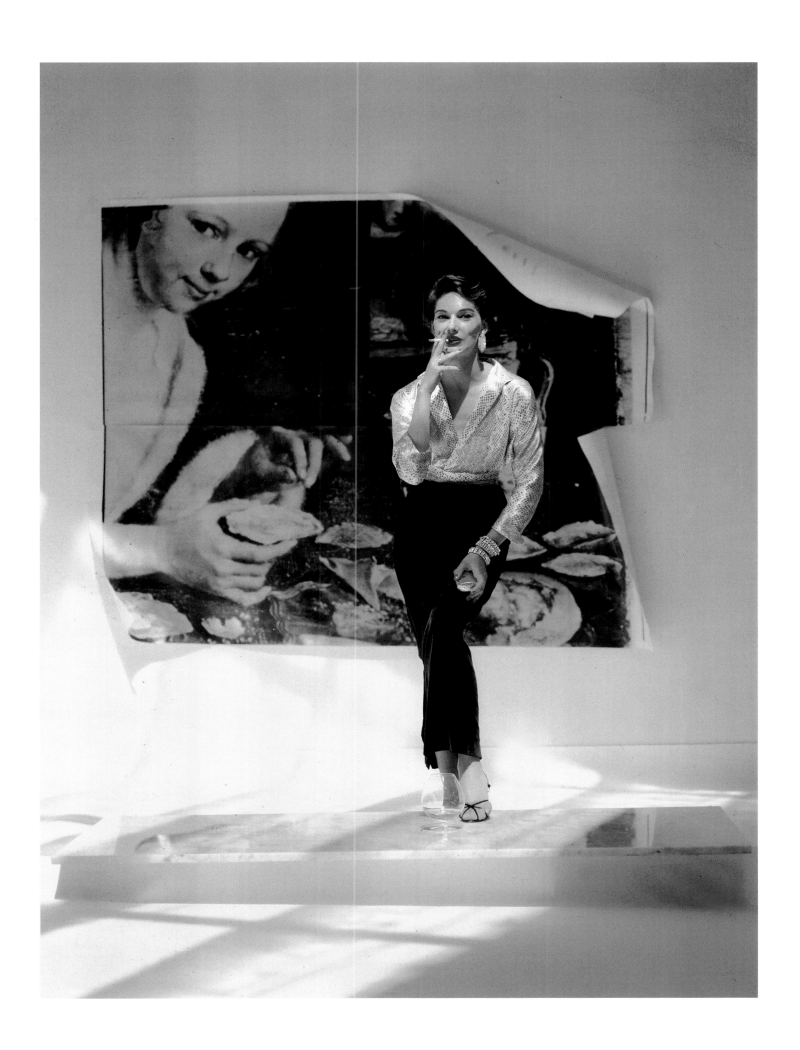

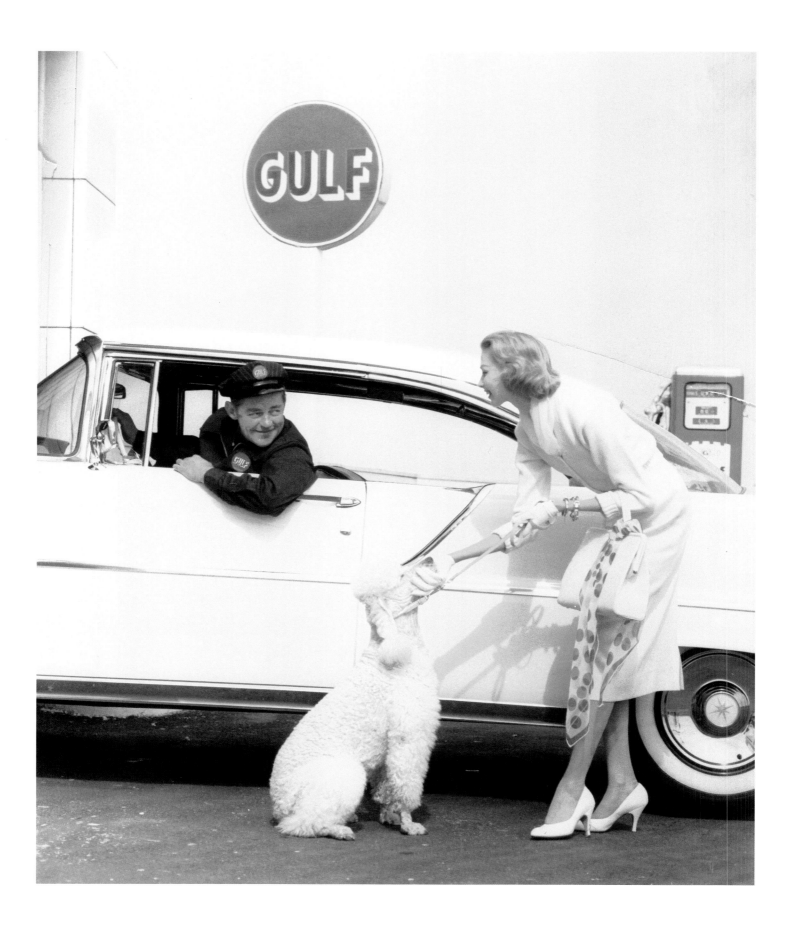

Gulf advertisement, circa 1955

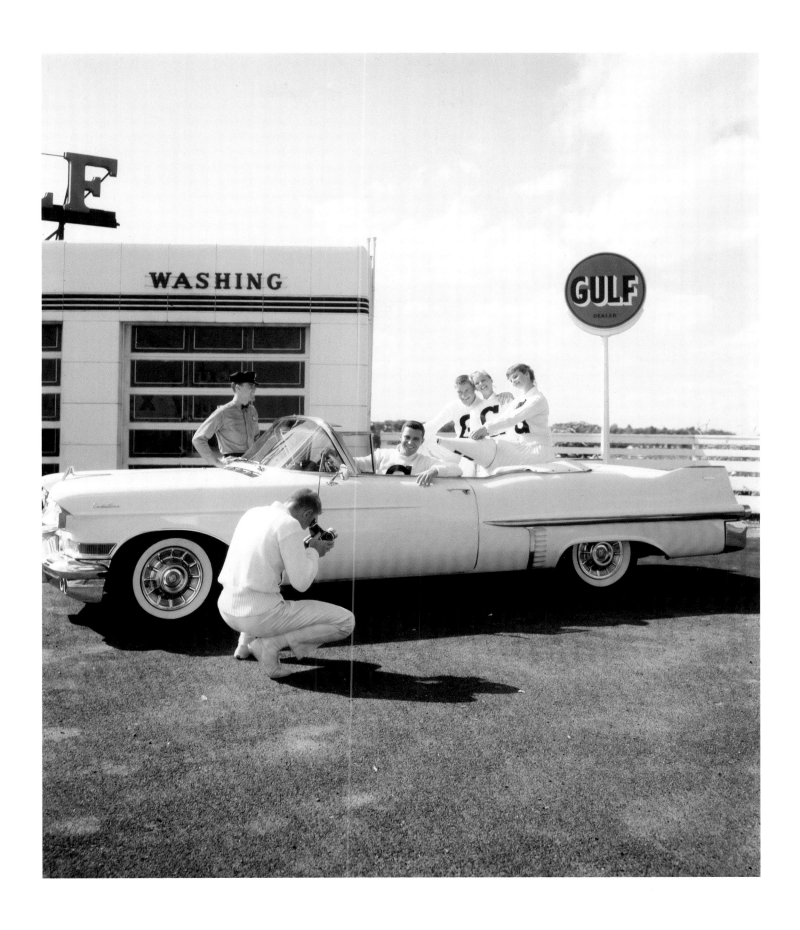

Gulf advertisement, circa 1955

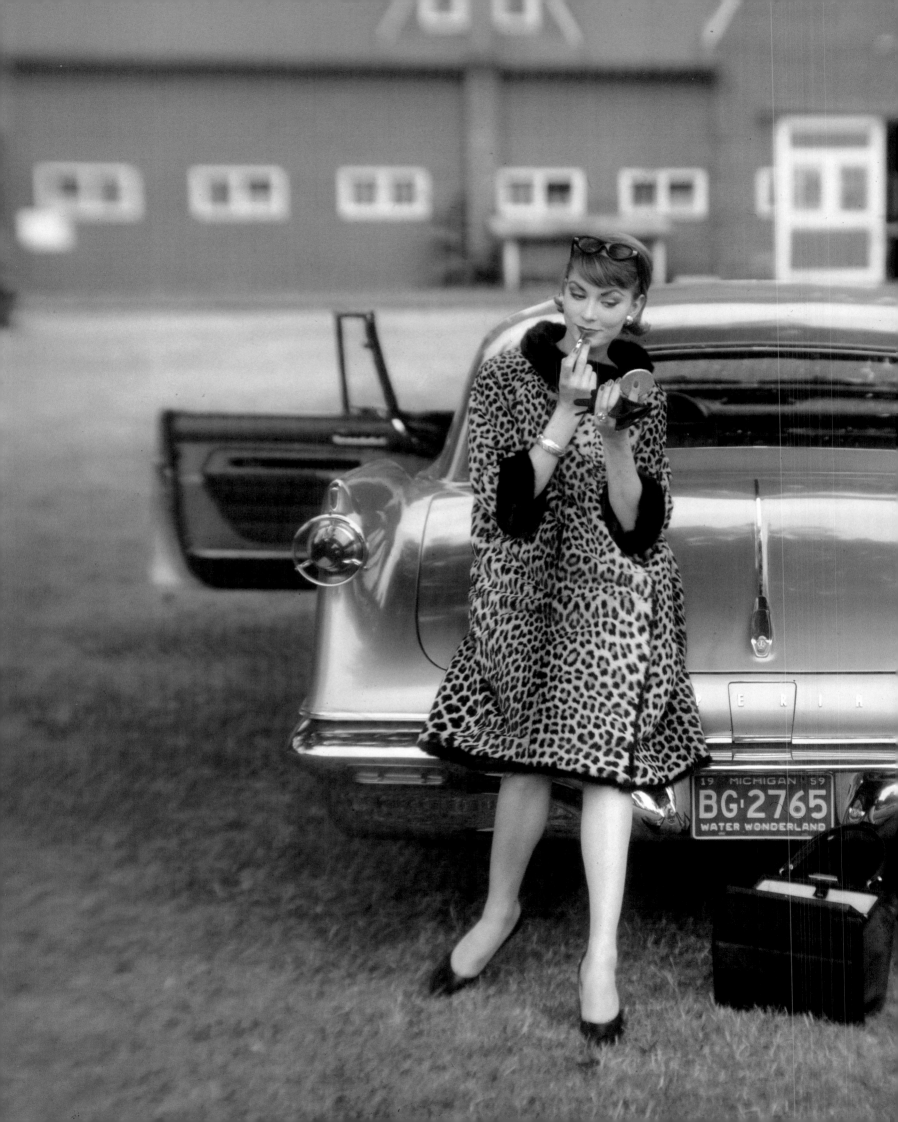

Mrs. Amory Carhart, *Vogue*, May 15, 1954

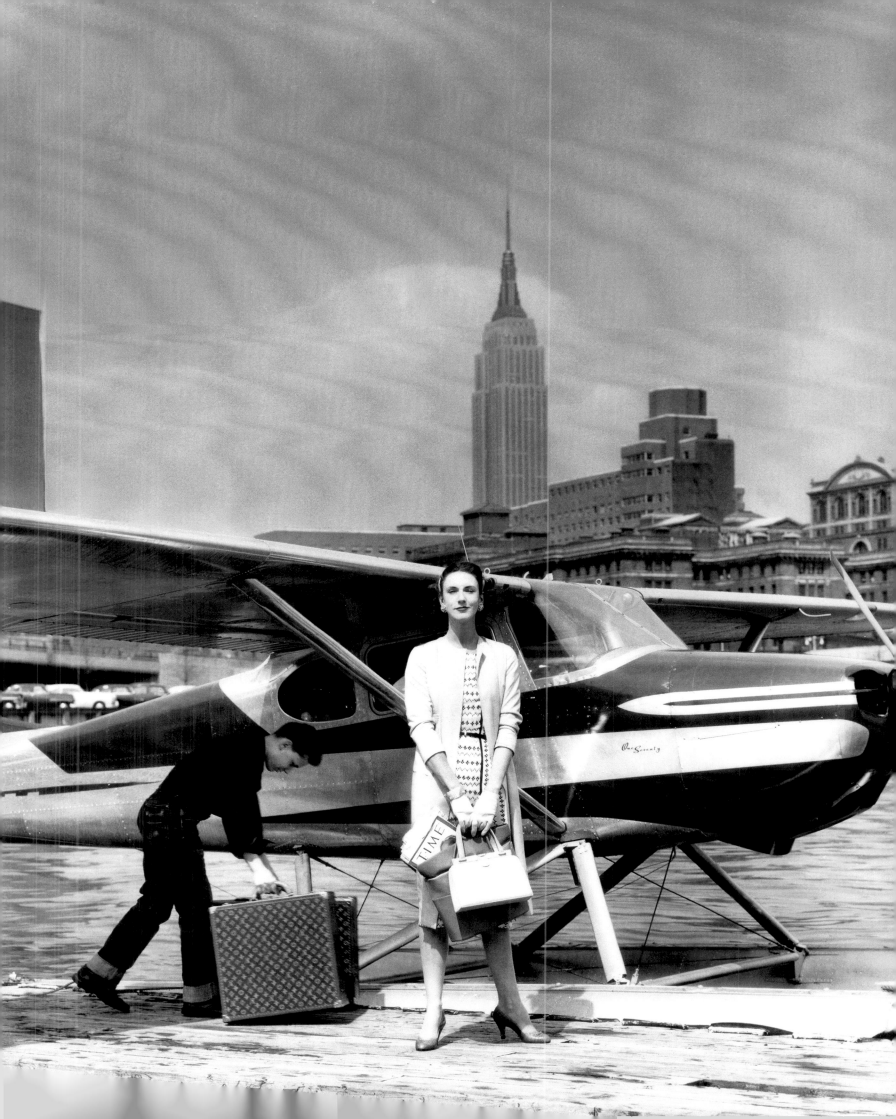

circa 1955

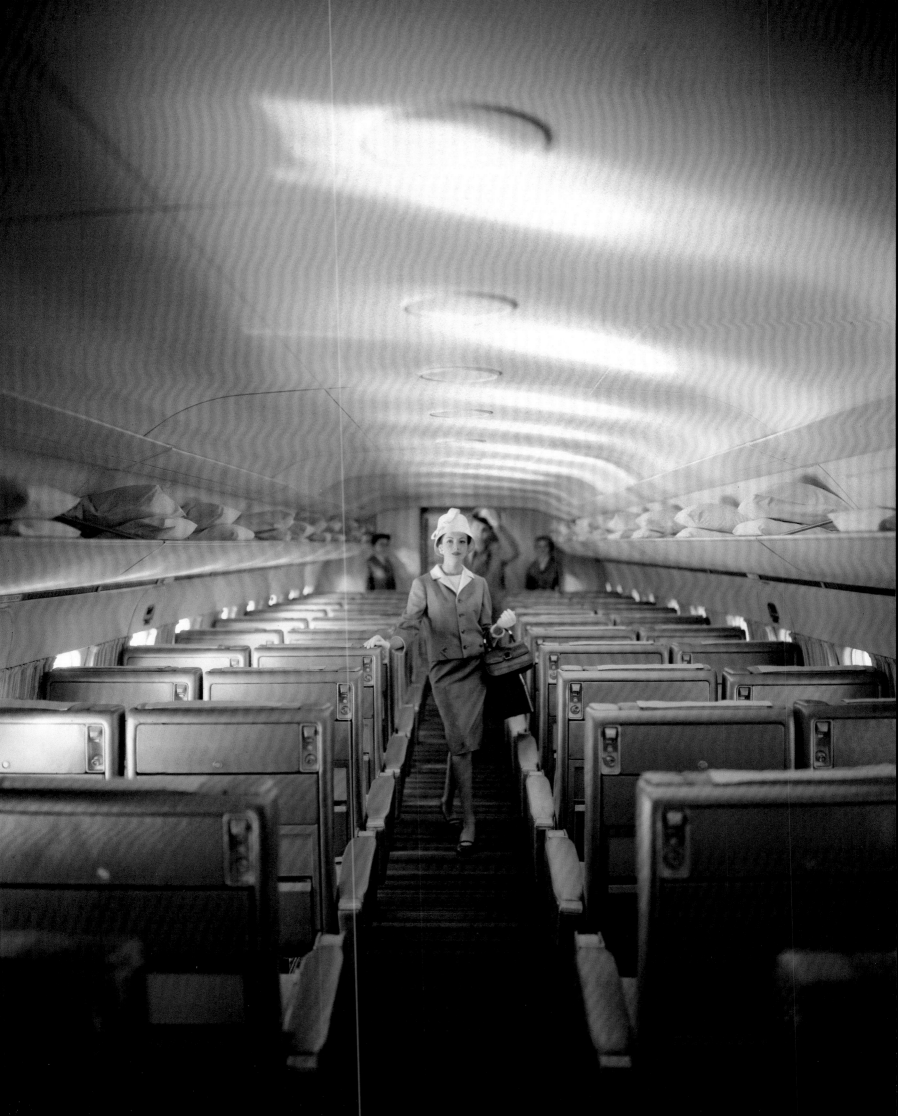

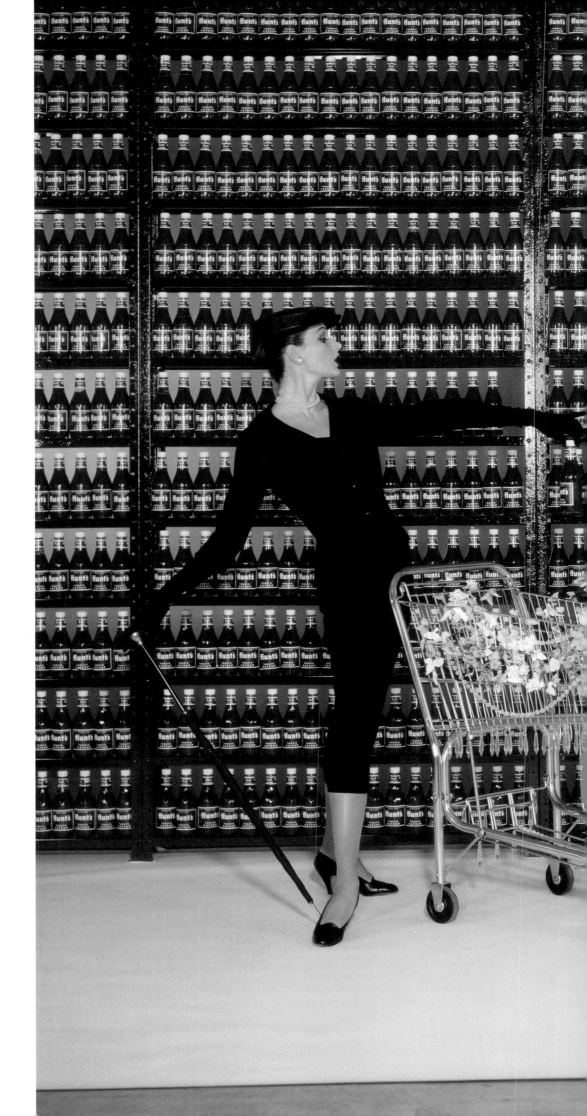

Suzy Parker and Dovima, Hunt's ketchup
advertisement, *Vogue*, August 1, 1956

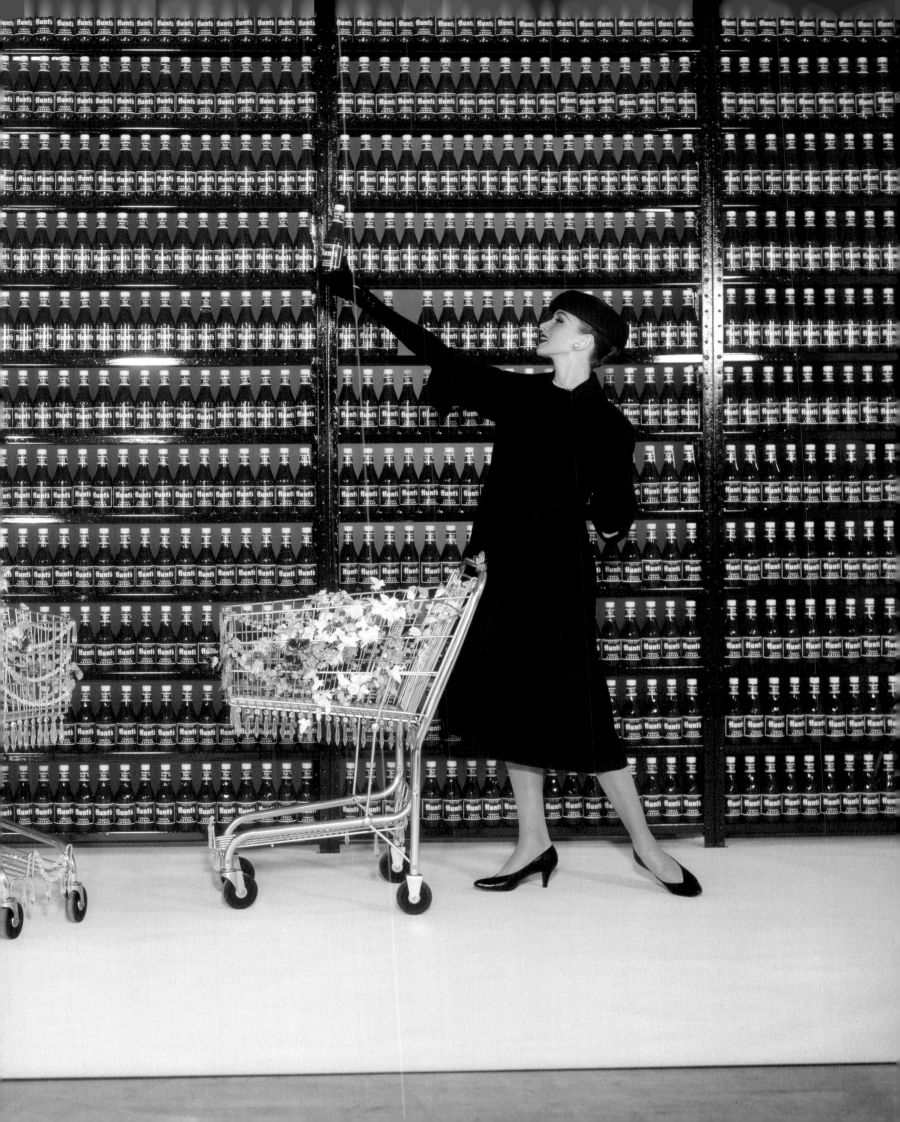

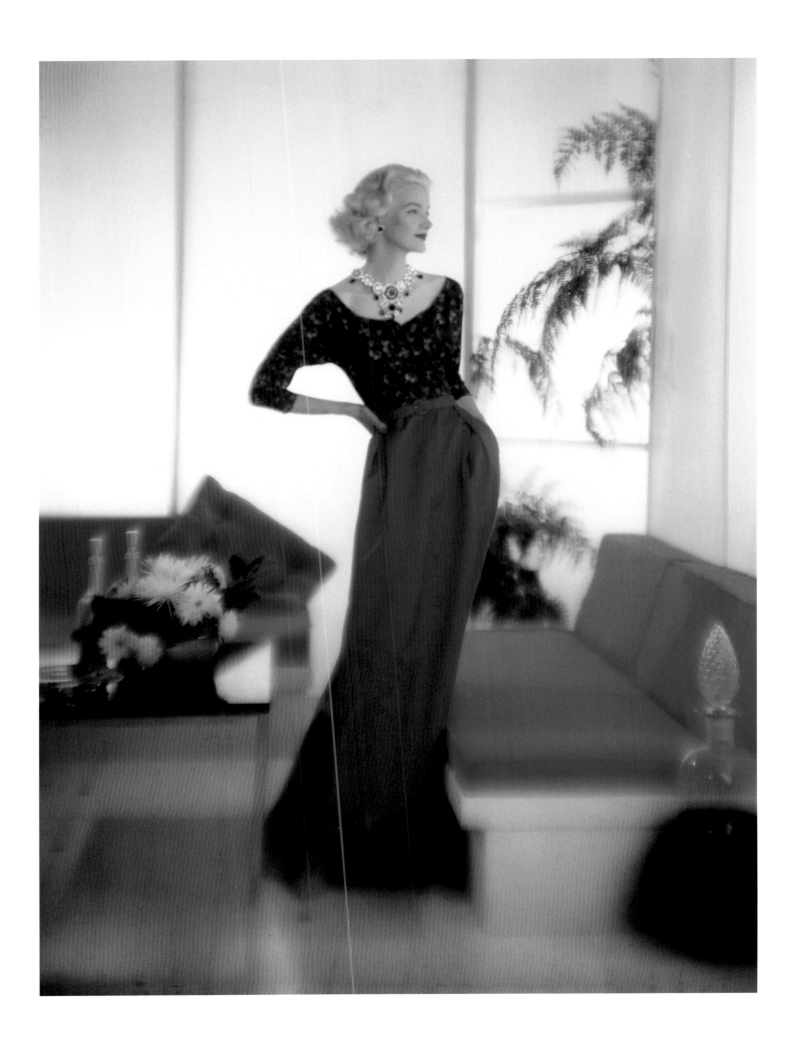

Sunny Harnett, circa 1955

VOGUE

SEPTEMBER 15.

The New Way:
to be in fashion
and stay
an individual

Mary Jane Russell, *Vogue* cover, September 15, 1955

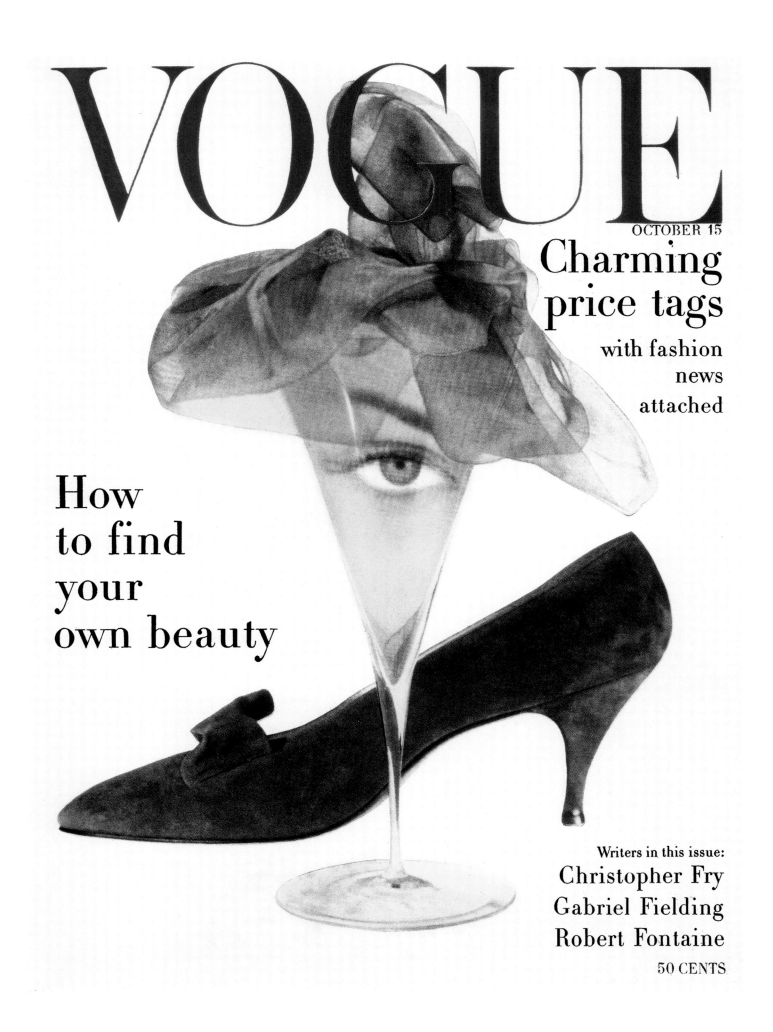

VOGUE

OCTOBER 15

Charming
price tags

with fashion
news
attached

How
to find
your
own beauty

Writers in this issue:
Christopher Fry
Gabriel Fielding
Robert Fontaine

50 CENTS

Vogue cover, October 15, 1957 · Opposite: Revlon advertisement, 1956

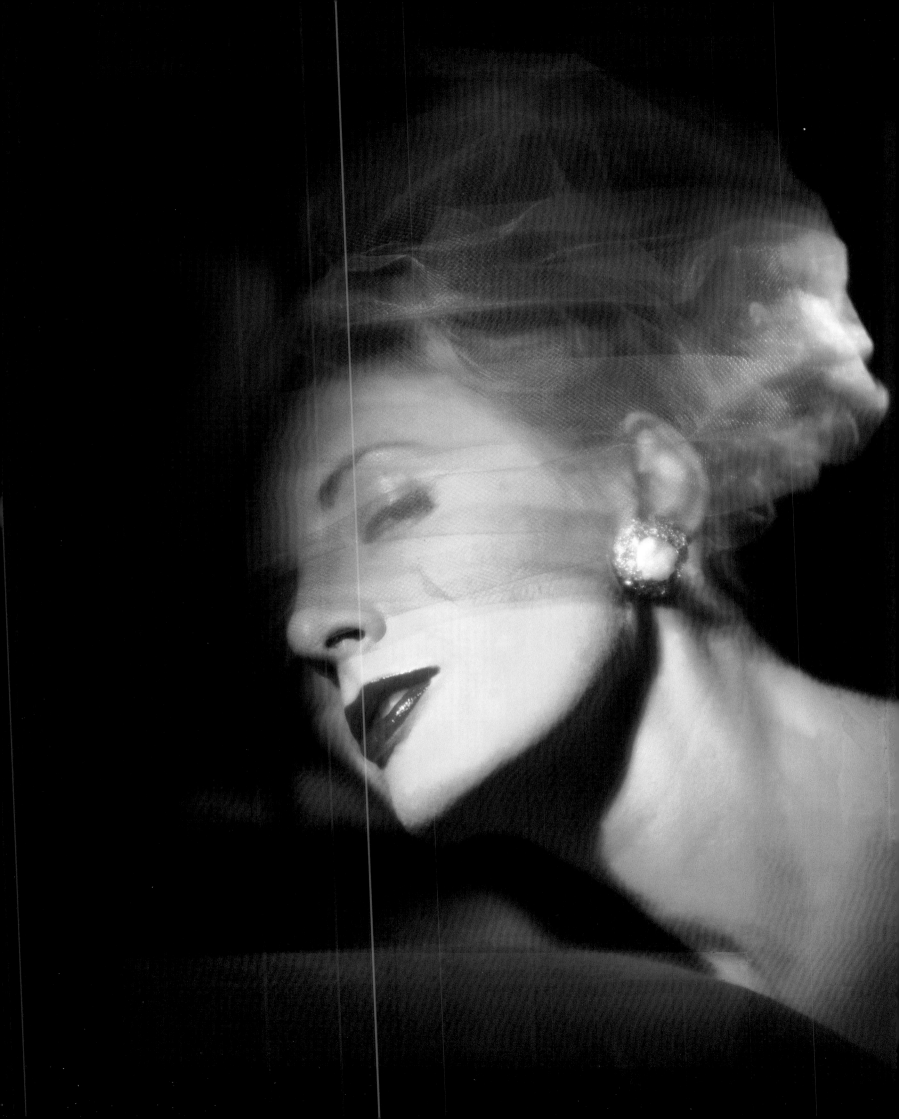

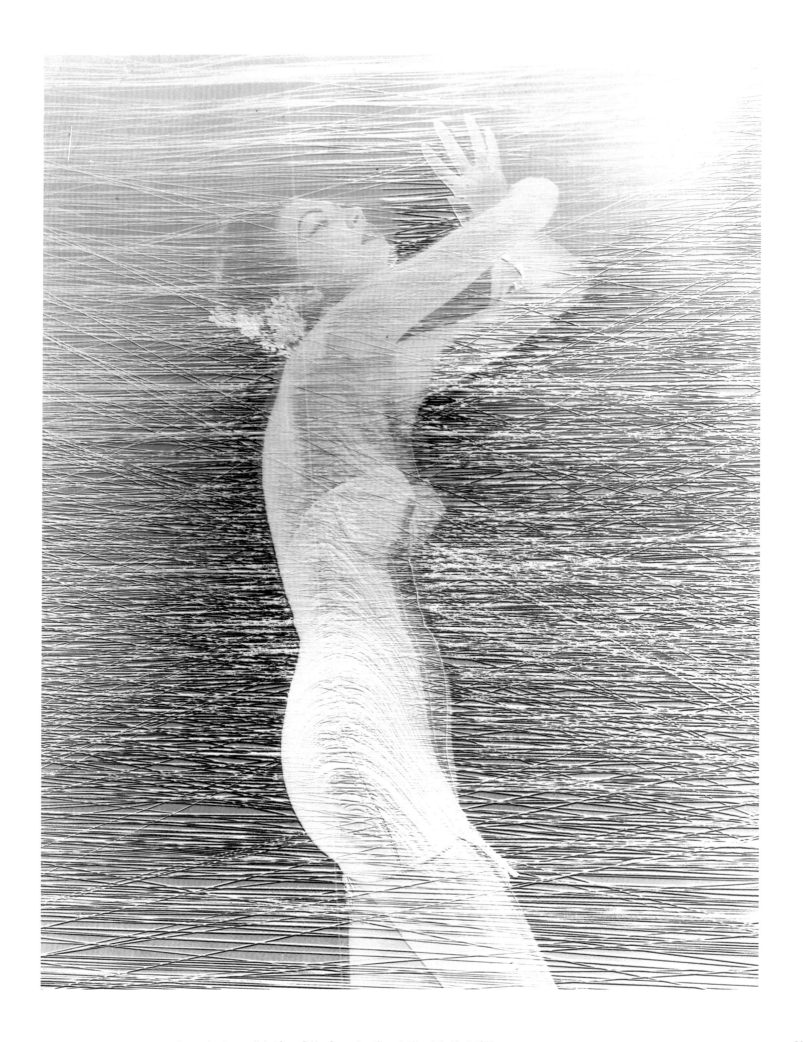

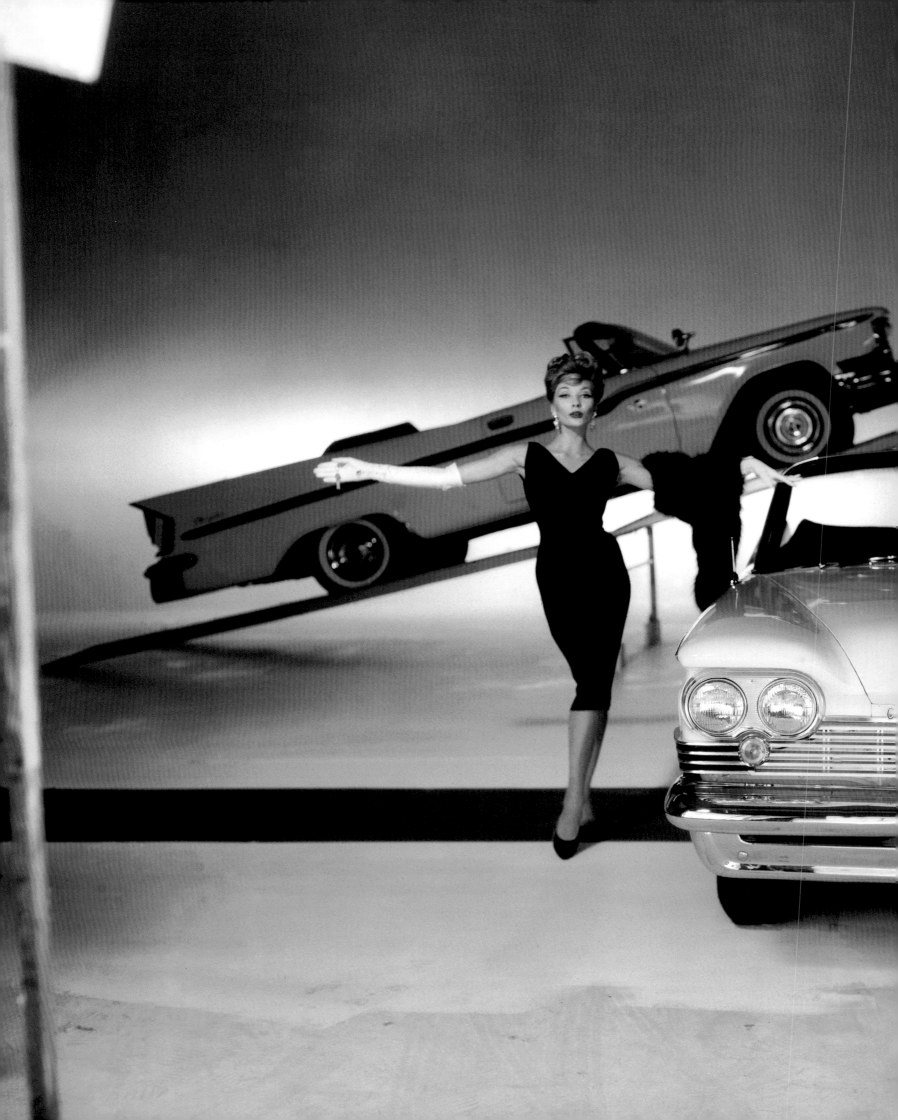

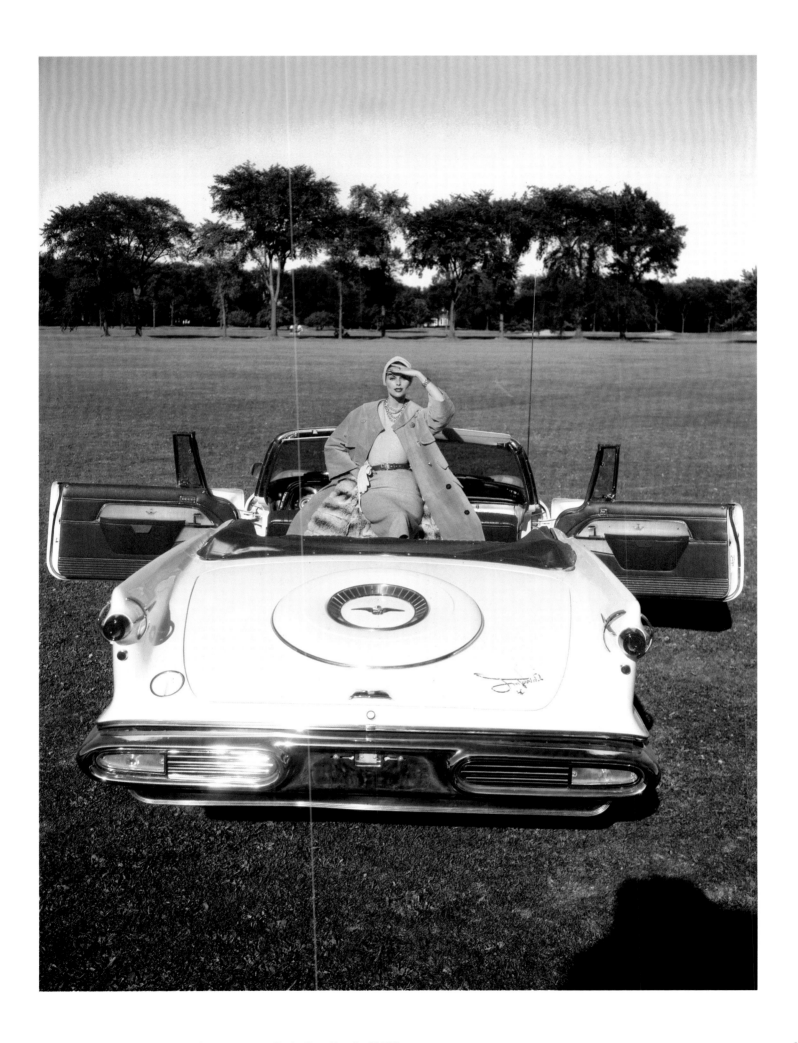

Anne Saint-Marie in Maximillian fur, *Vogue*, November 15, 1957

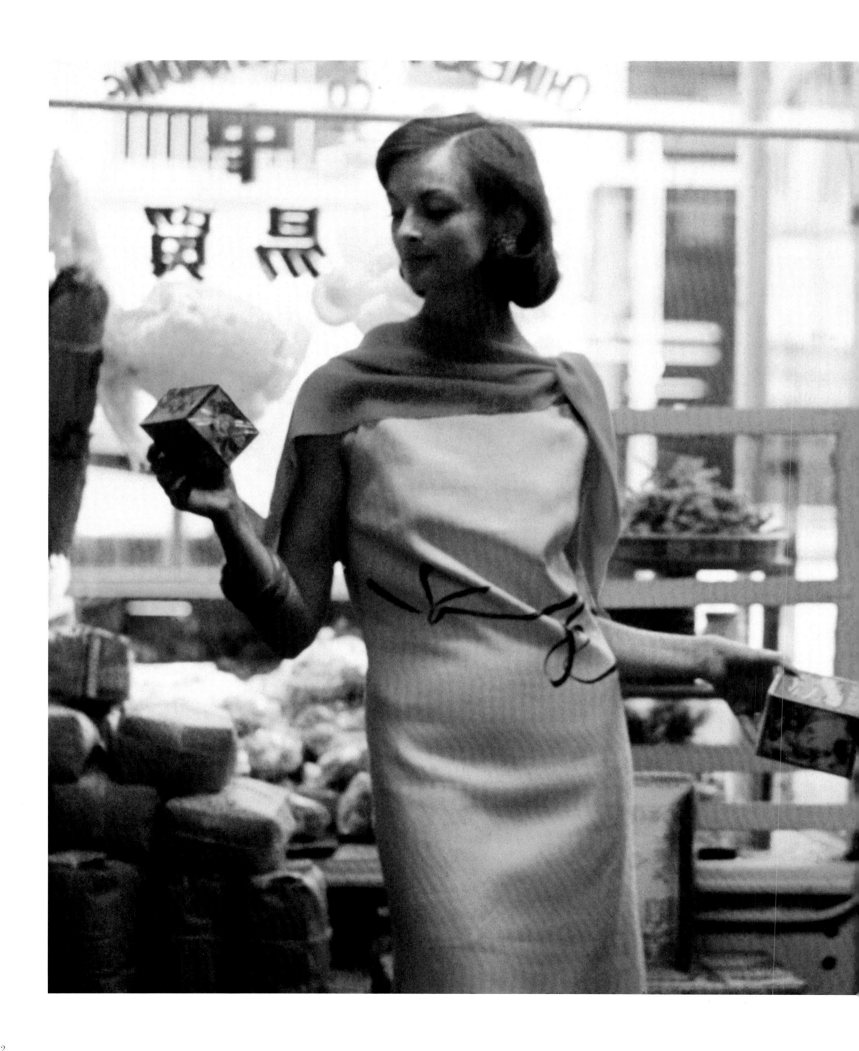

circa 1957

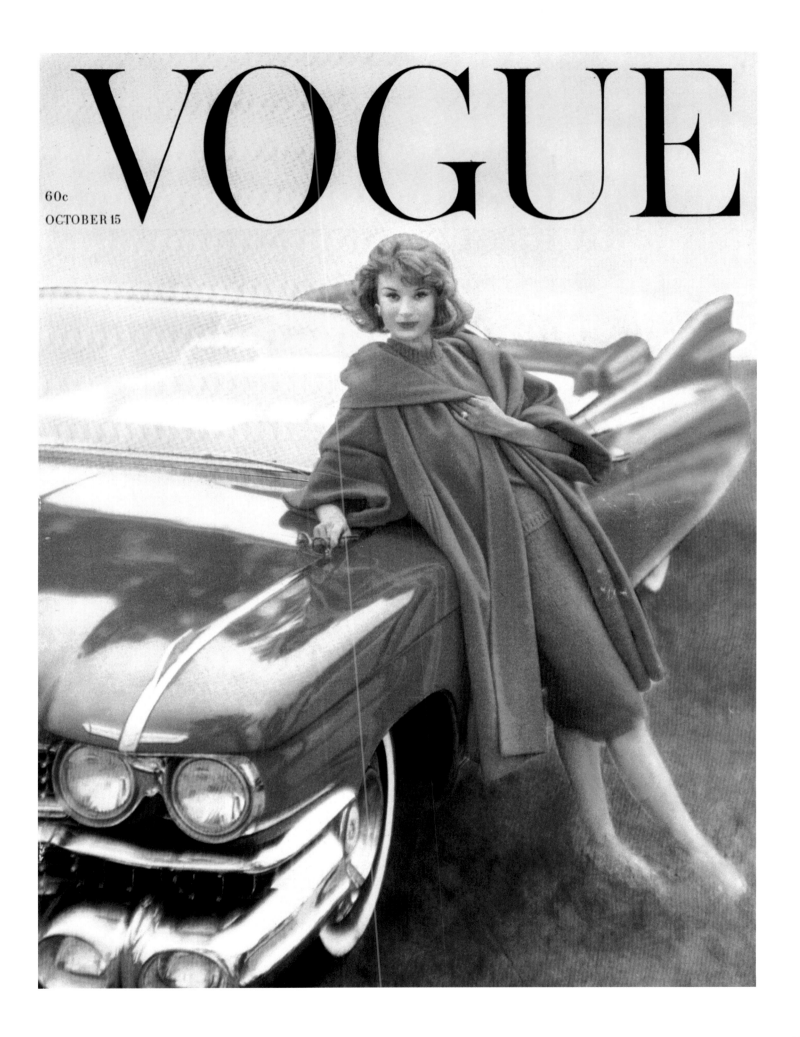

VOGUE

60c
OCTOBER 15

Vogue cover, October 15, 1958

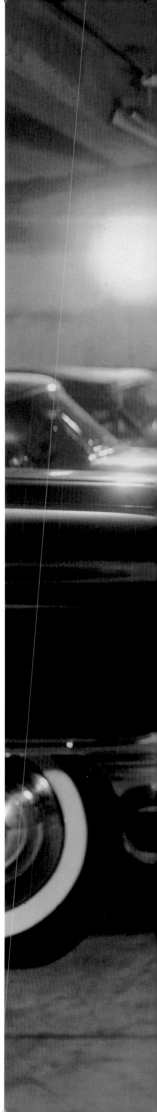

circa 1958

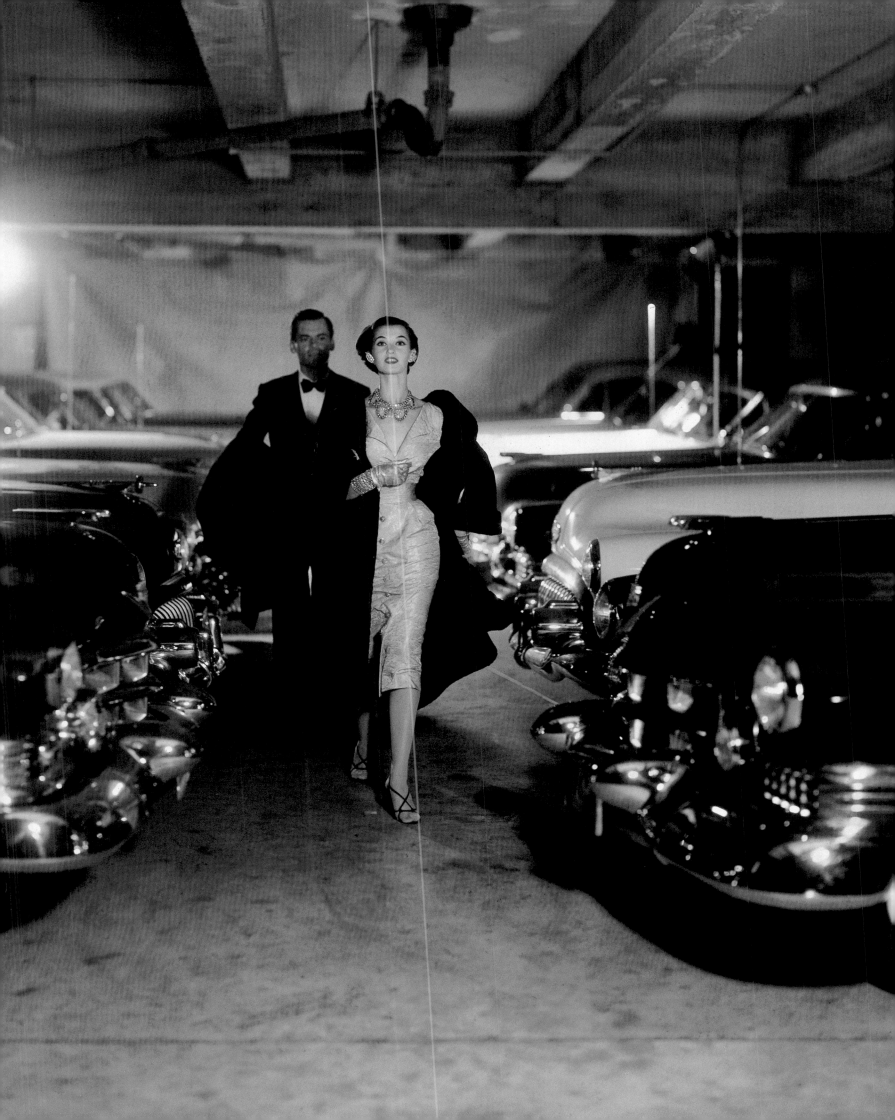

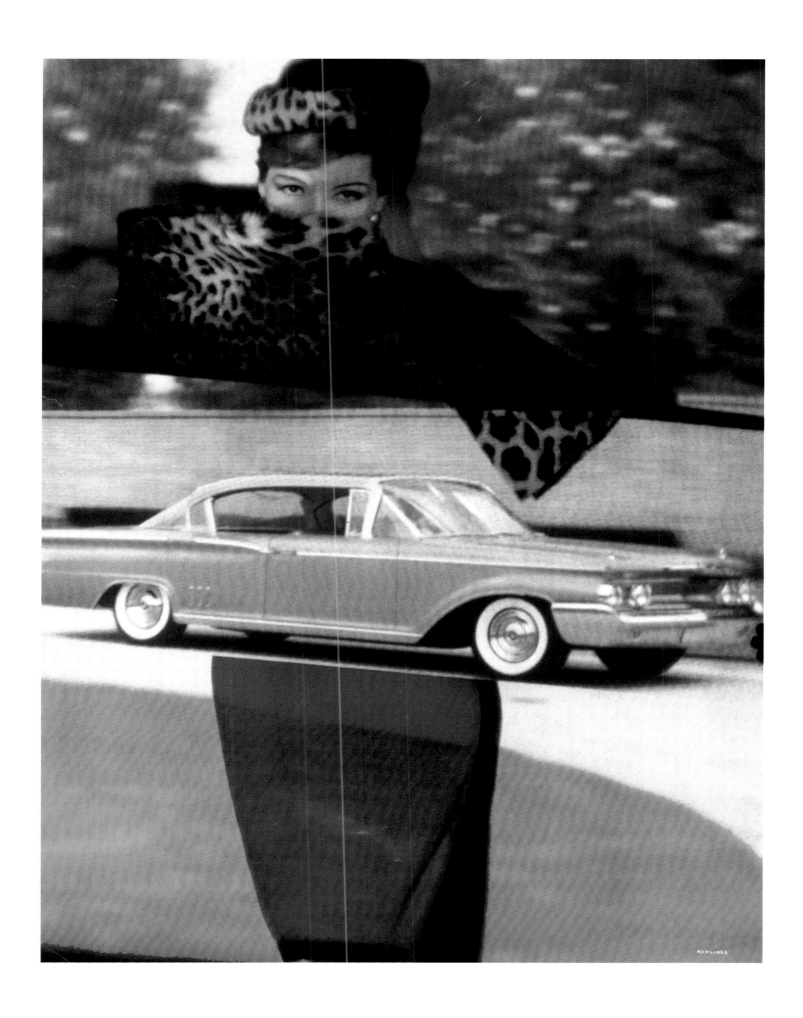

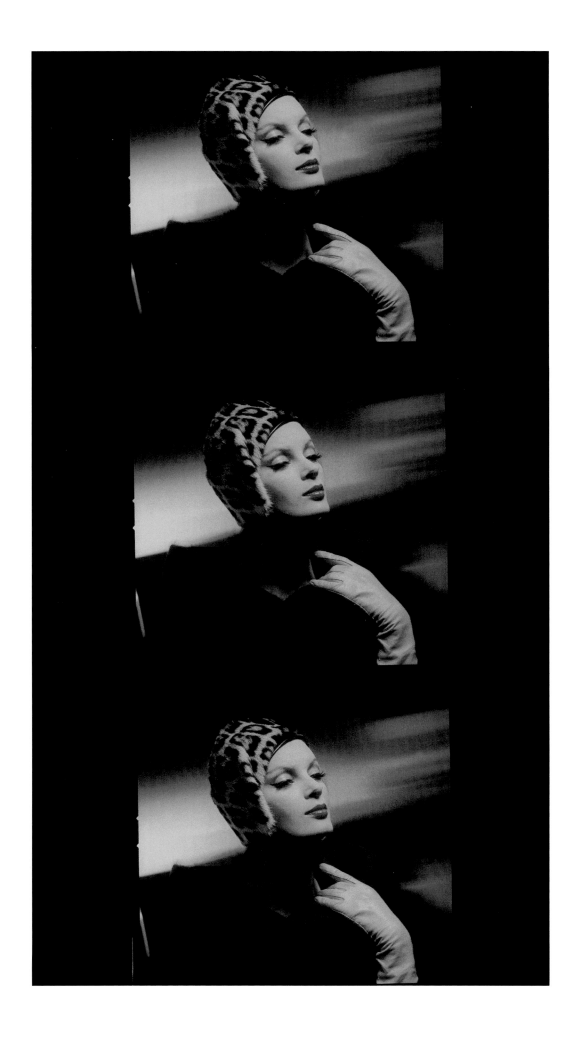

Nena von Schlebrügge, circa 1960

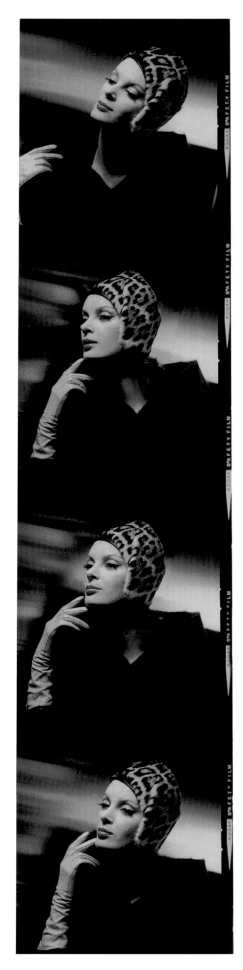
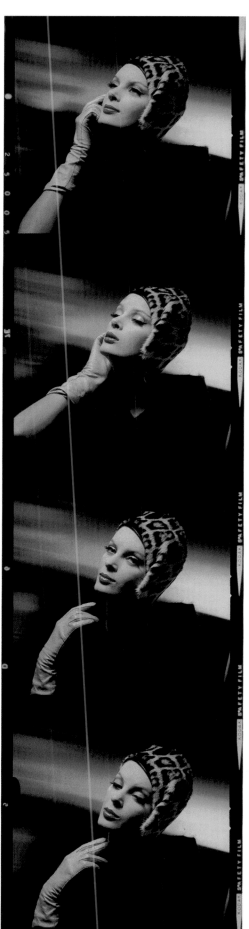
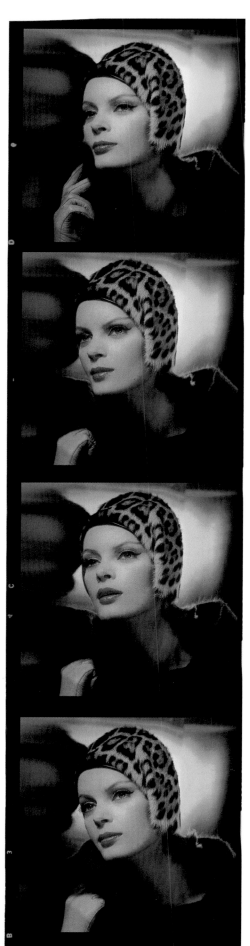

Nena von Schlebrügge, circa 1960

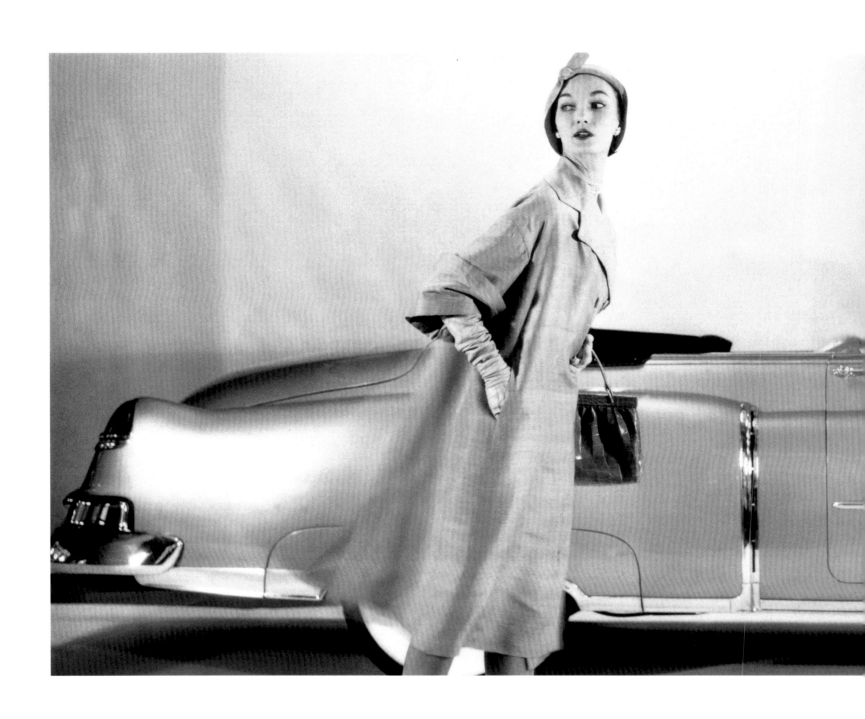

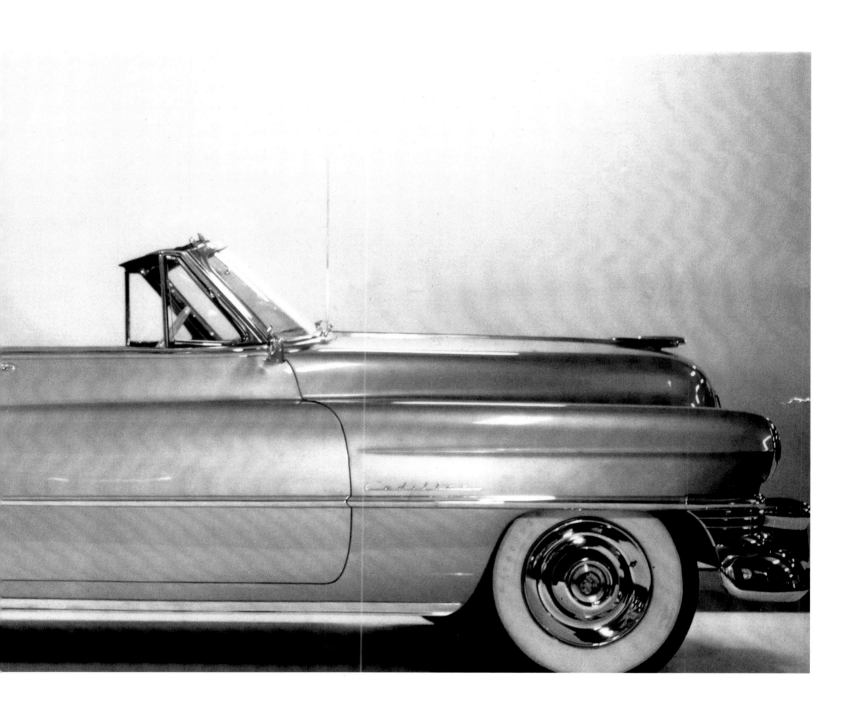

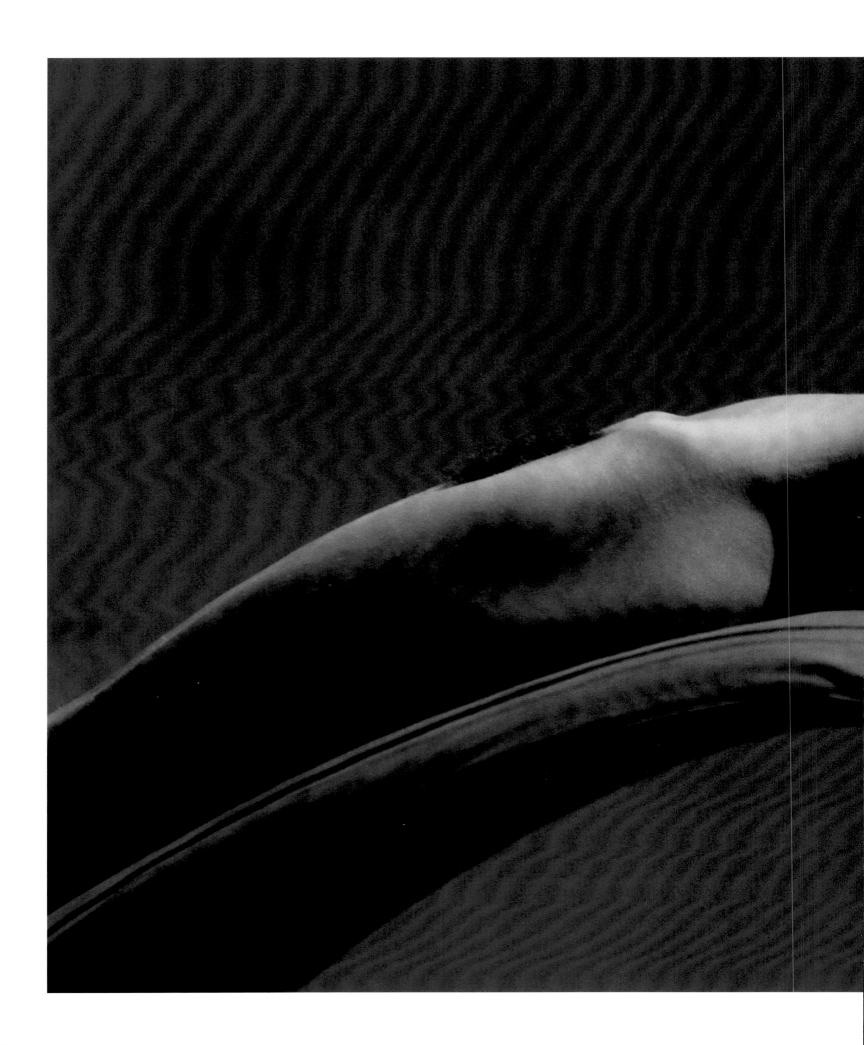

234

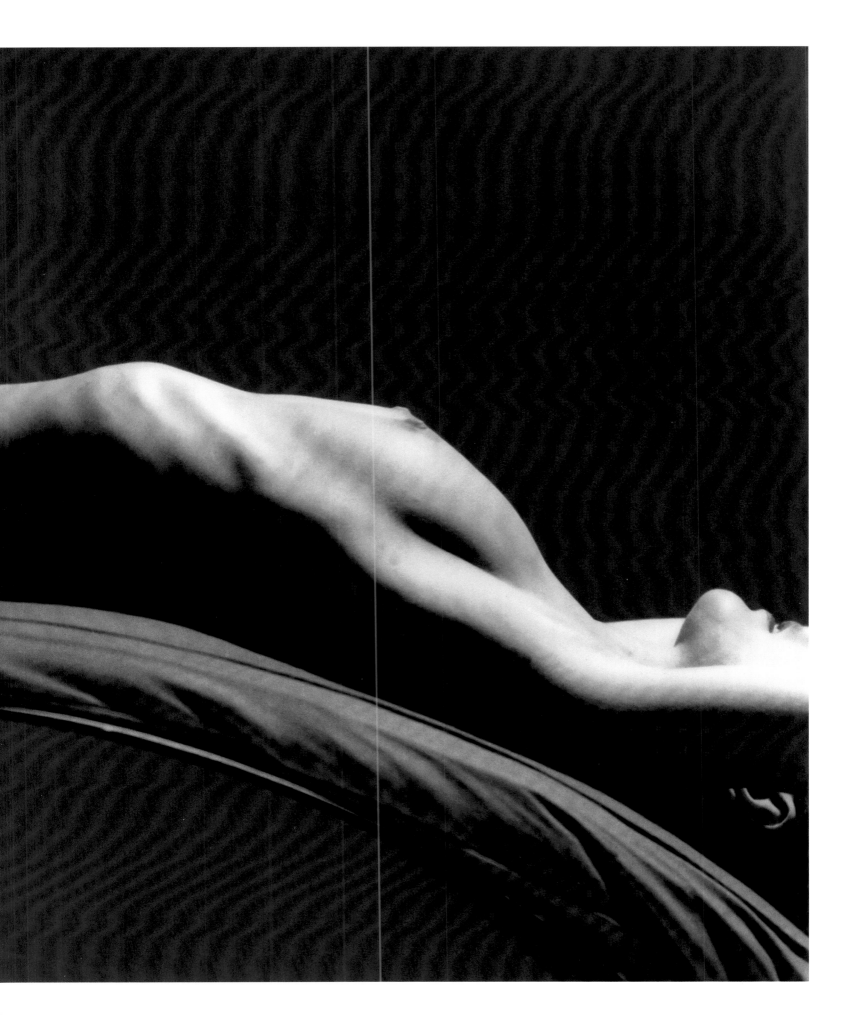

circa 1960

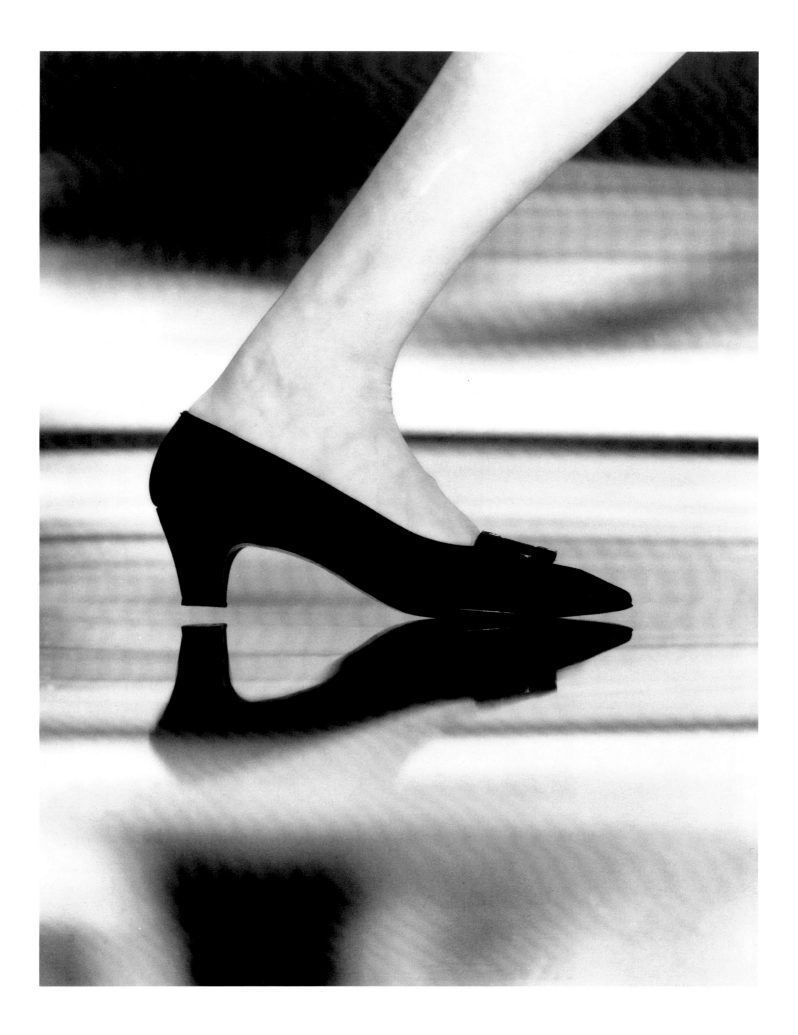

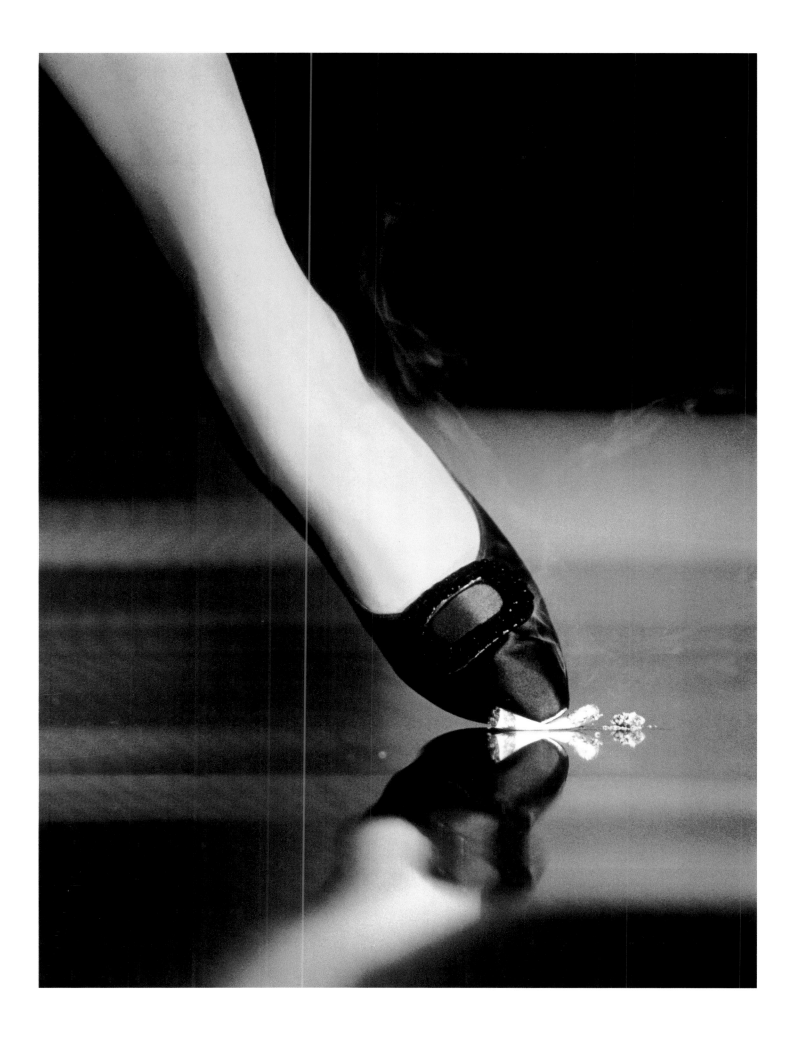

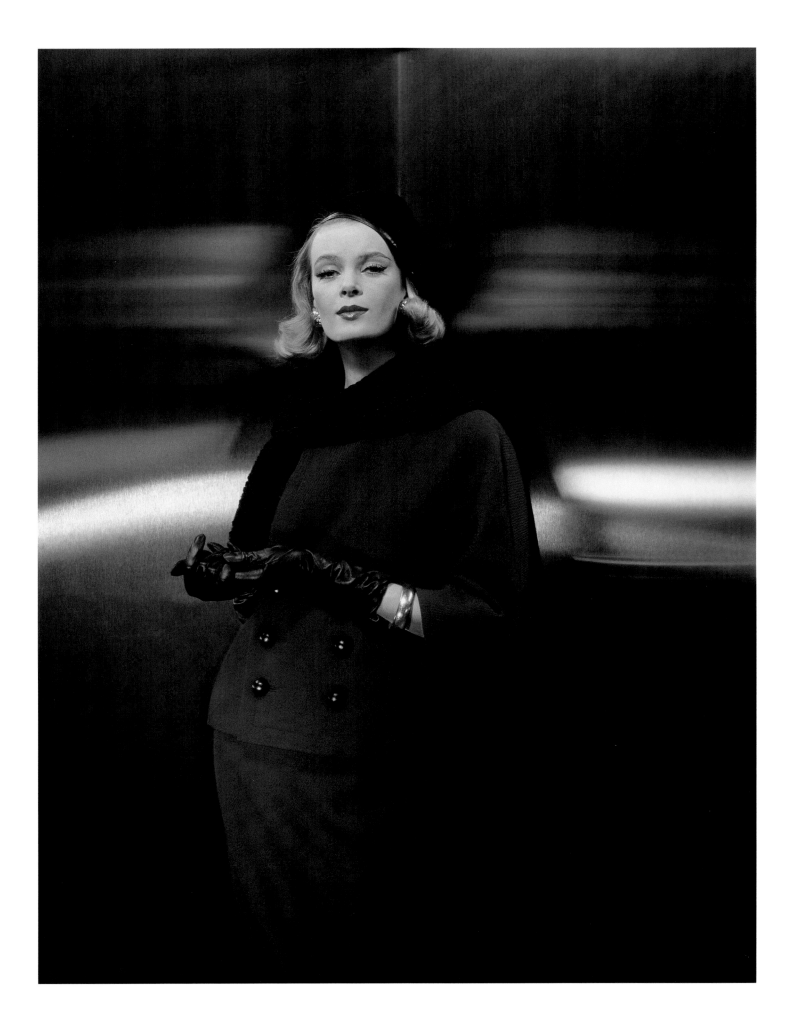

Nena von Schlebrügge, *Vogue*, circa 1961

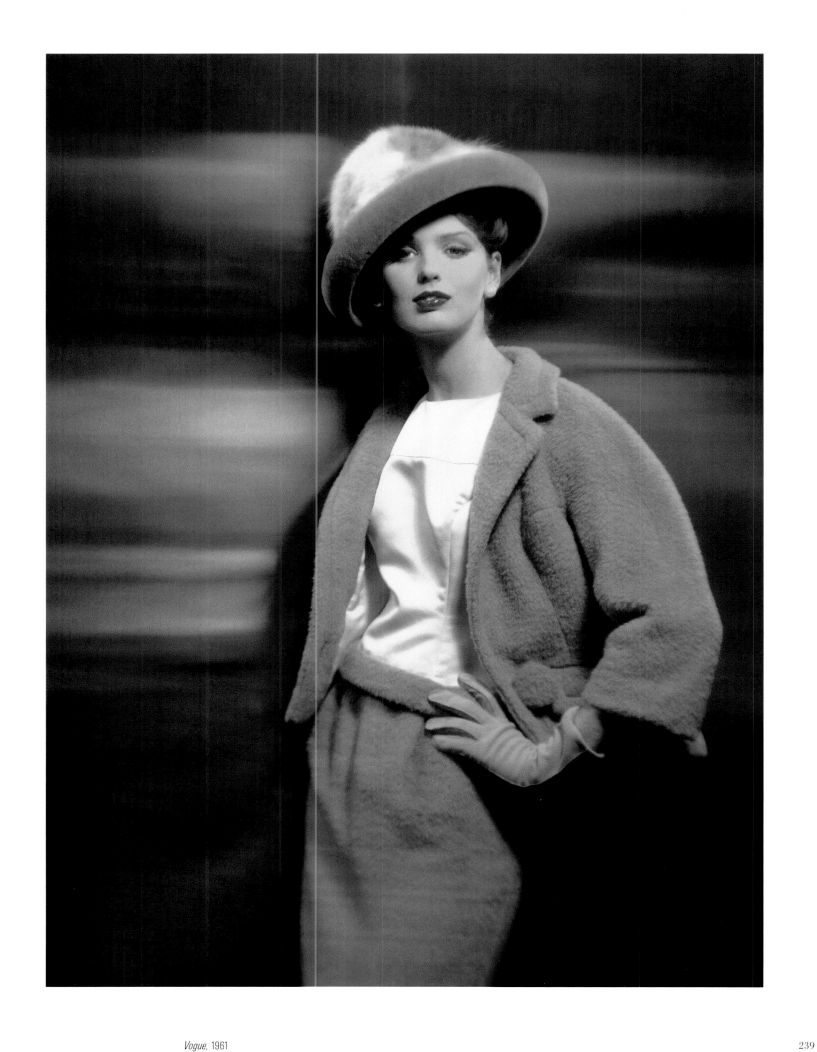

Nena von Schlebrügge, *Vogue*, November 1, 1961

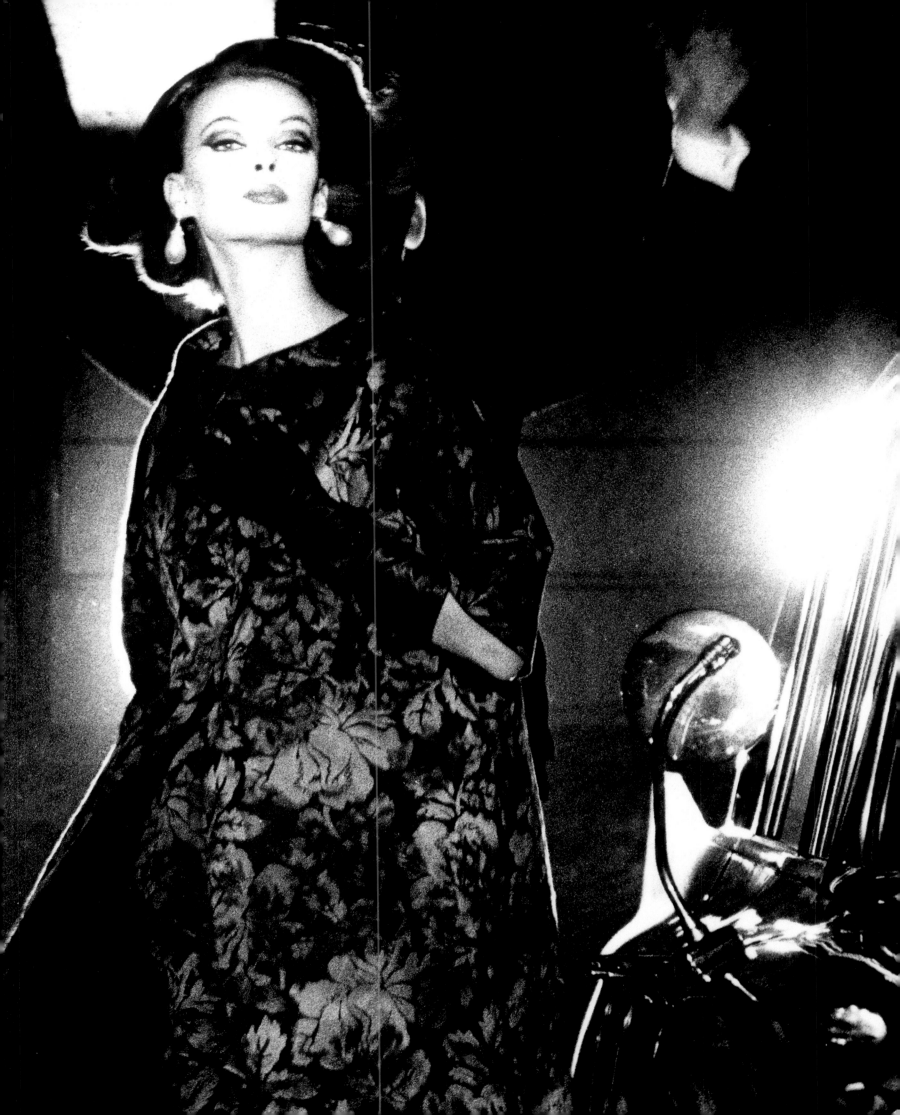

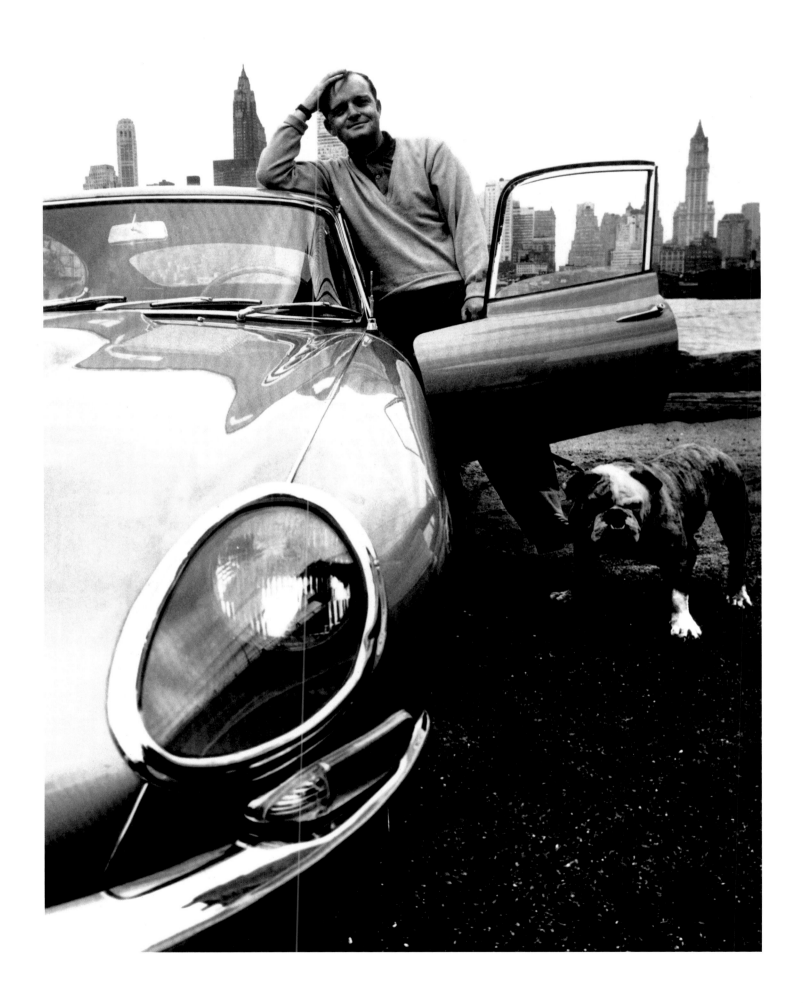

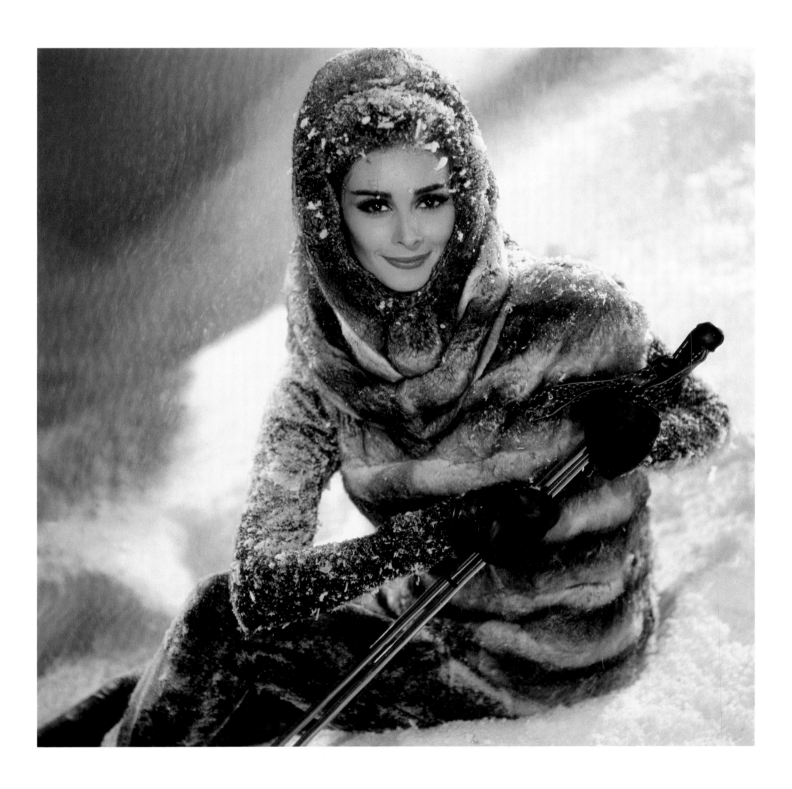

Wilhelmina, Ben Kahn Furs advertisement, December 15, 1962 Opposite: Wilhelmina, Ben Kahn Furs advertisement, May 25, 1964

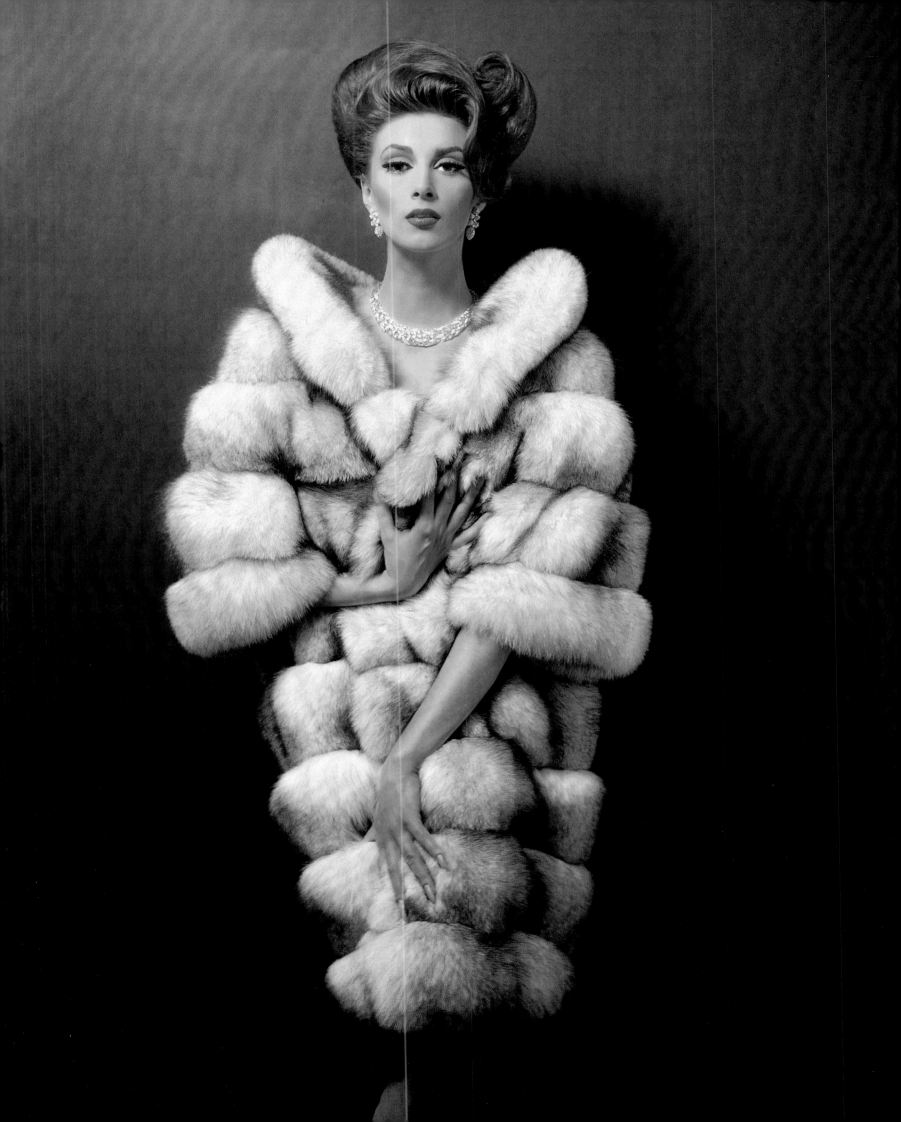

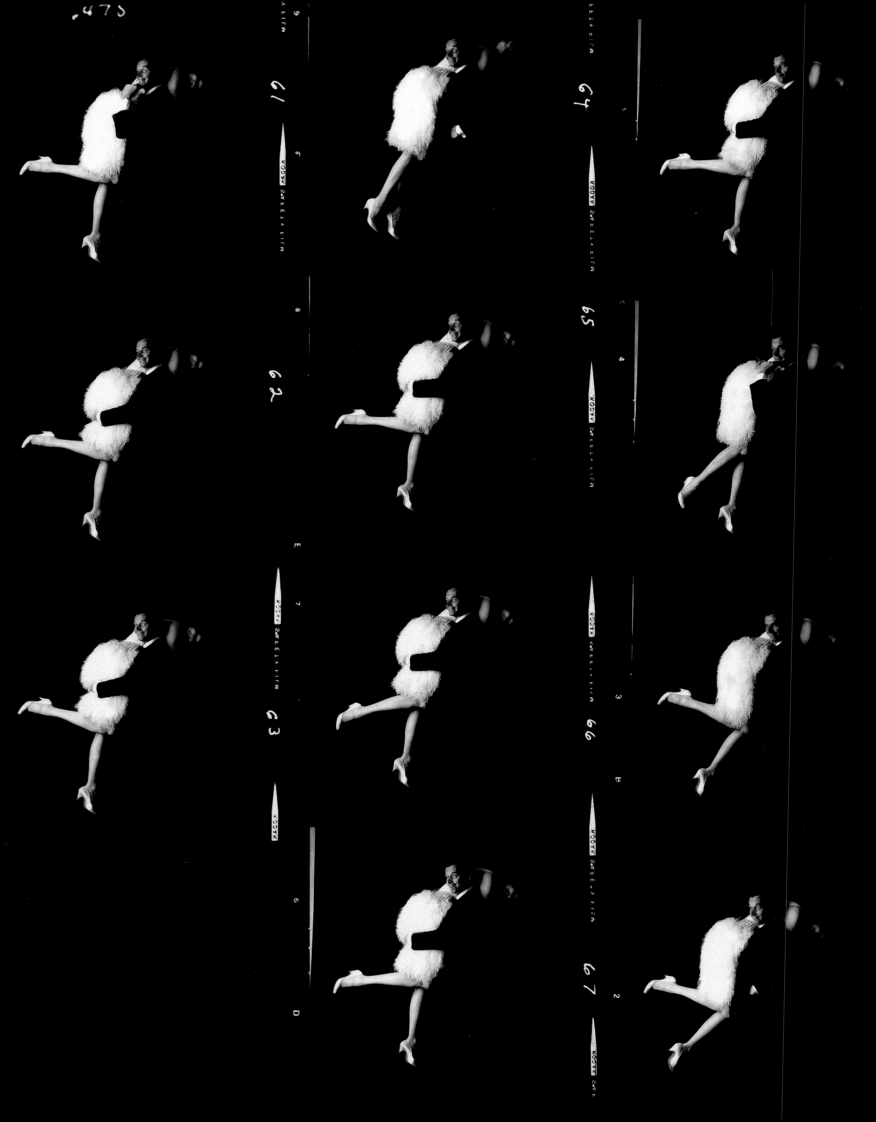

Hanes hosiery advertisement, 1964

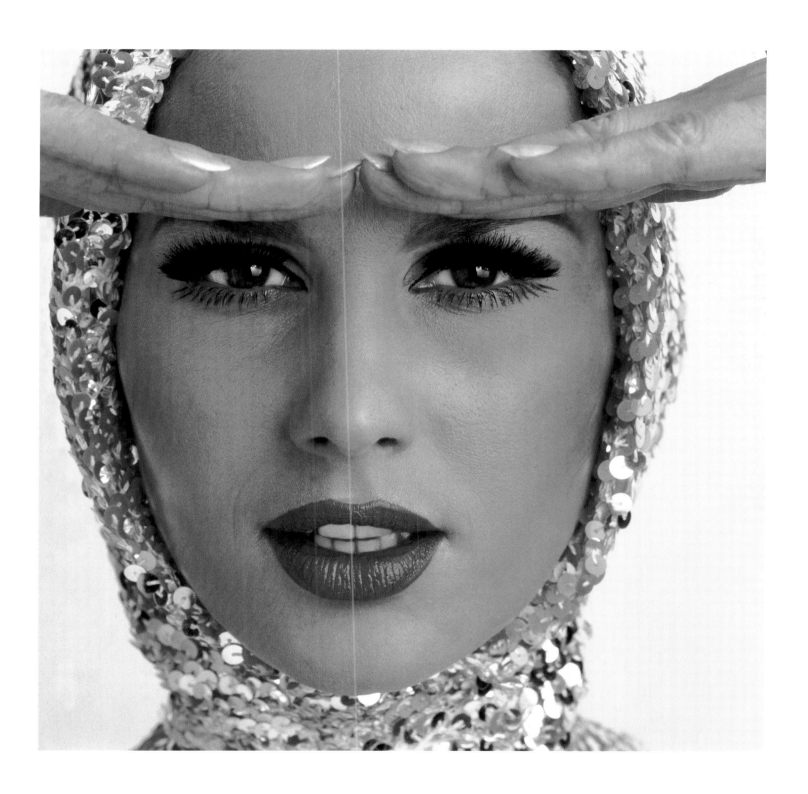

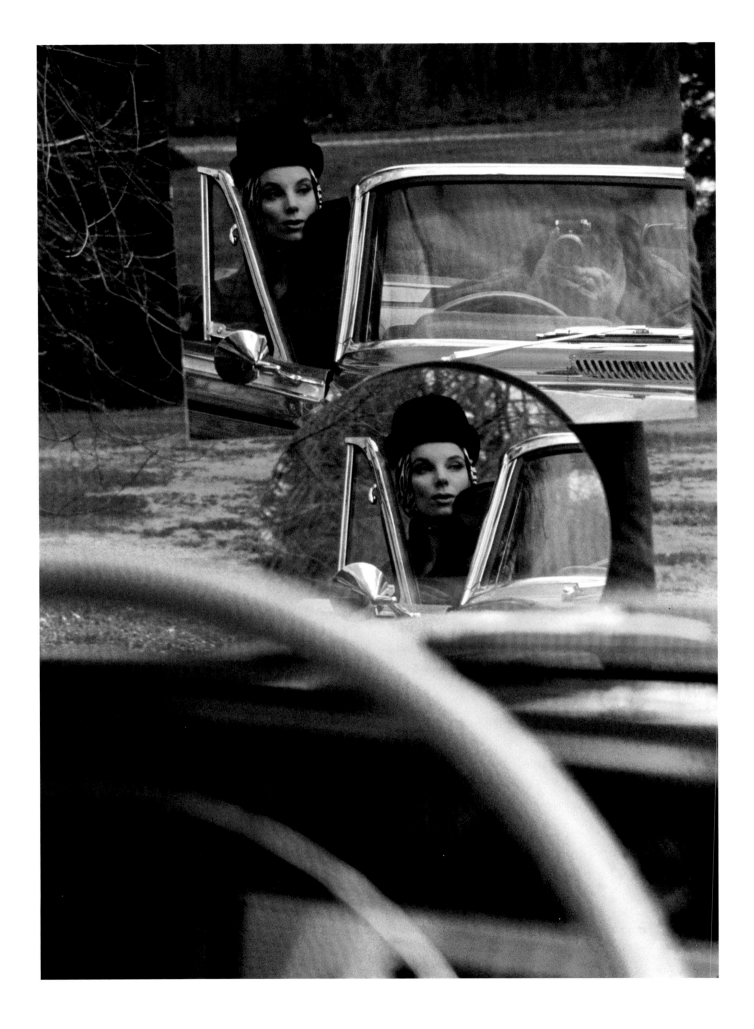

circa 1965

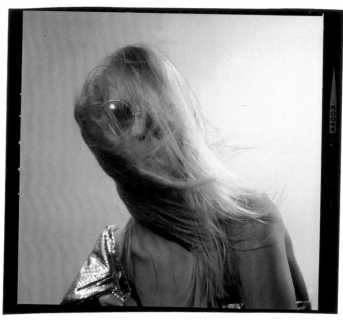
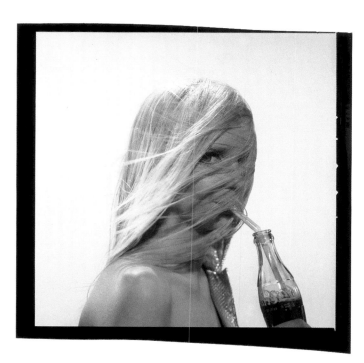
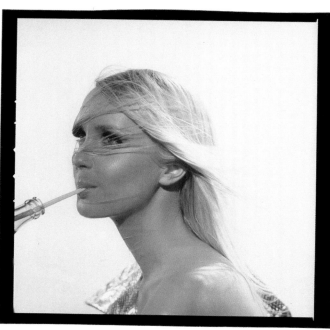
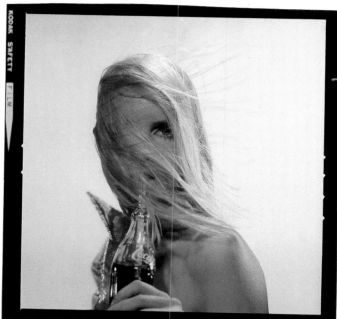

Birgitte, 1966

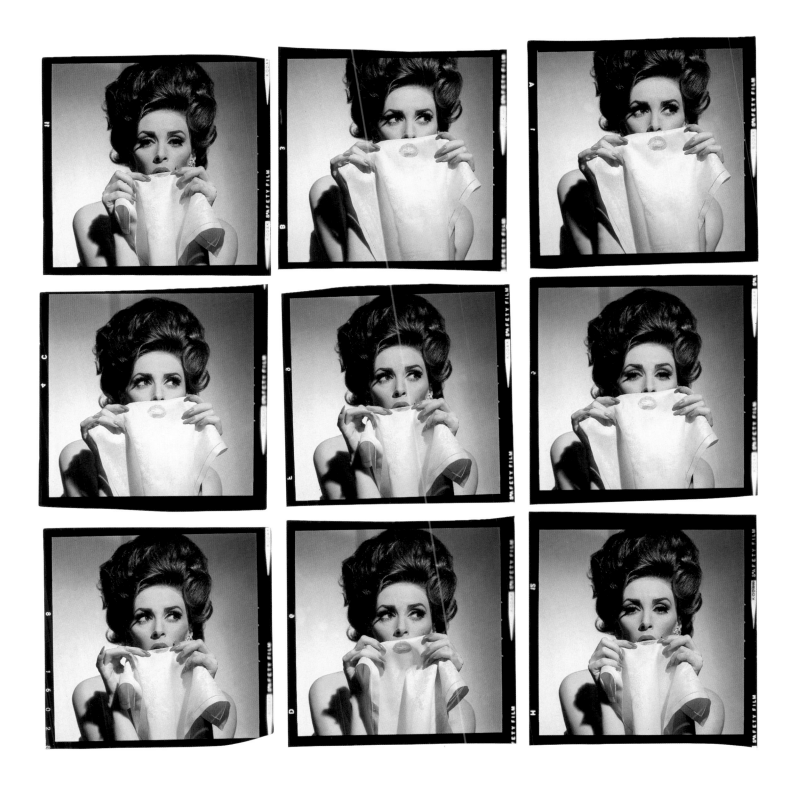

Wilhelmina, circa 1965

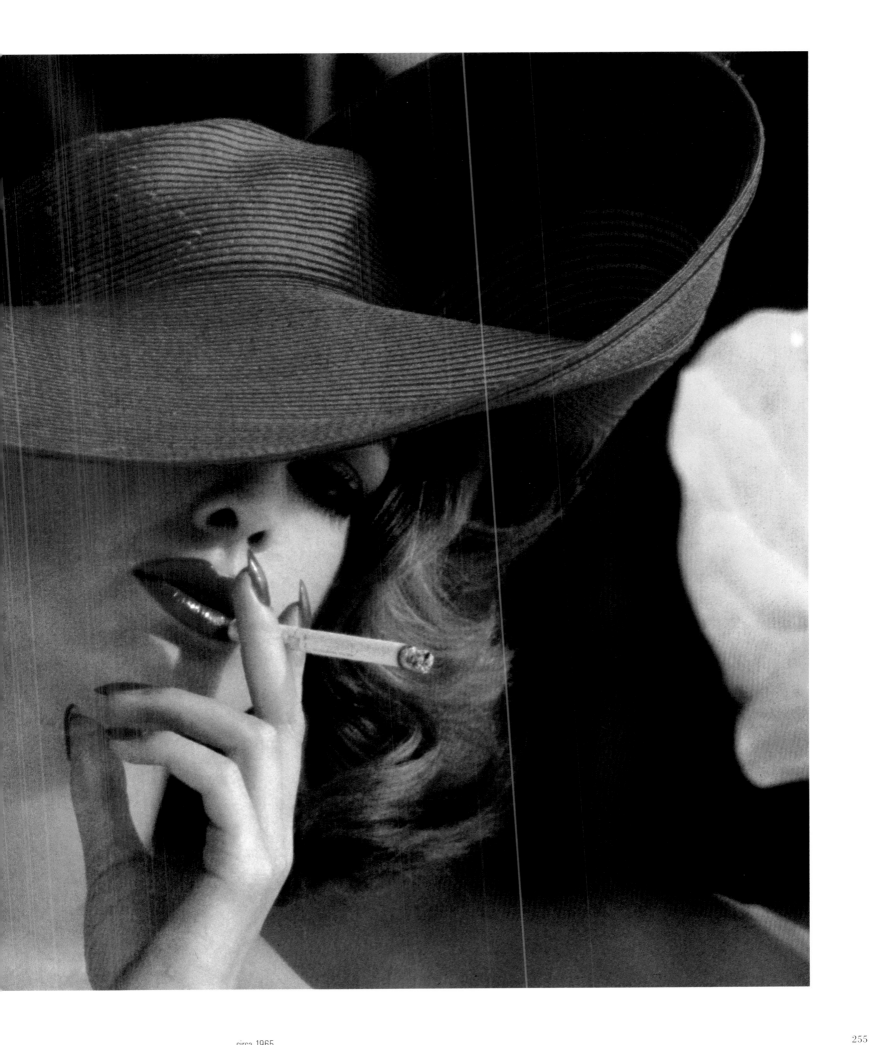

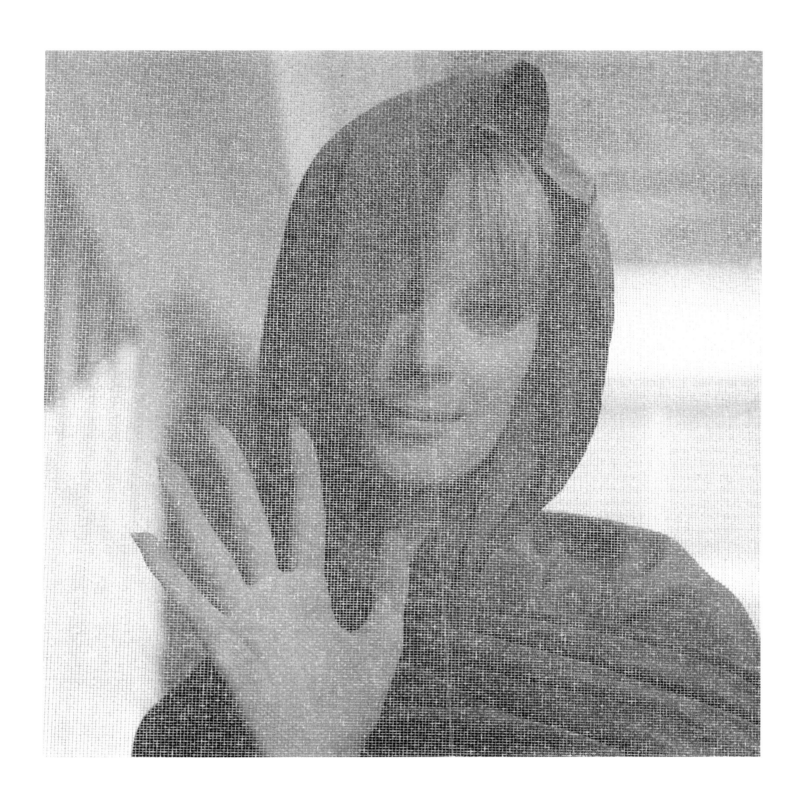

Nena von Schlebrügge, circa 1965

Dana Perfume advertisement, April 14, 1967

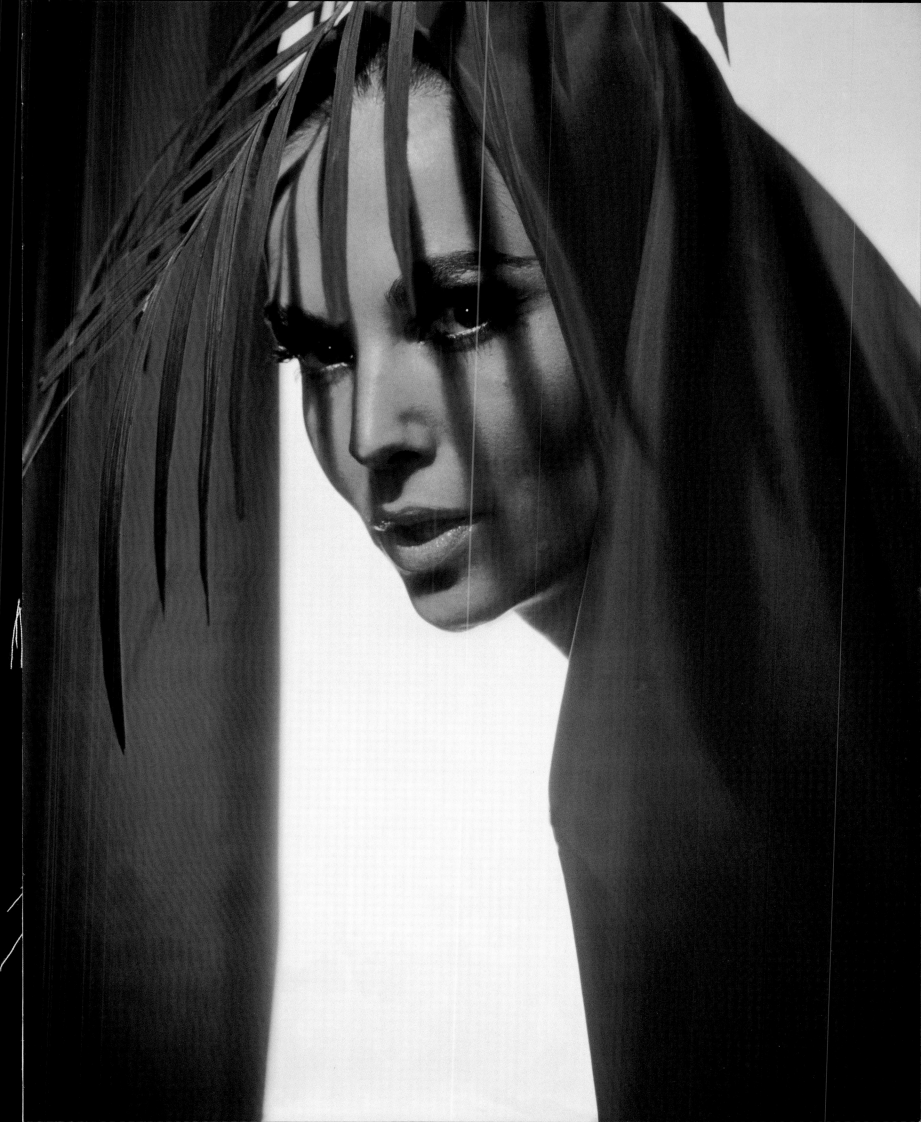

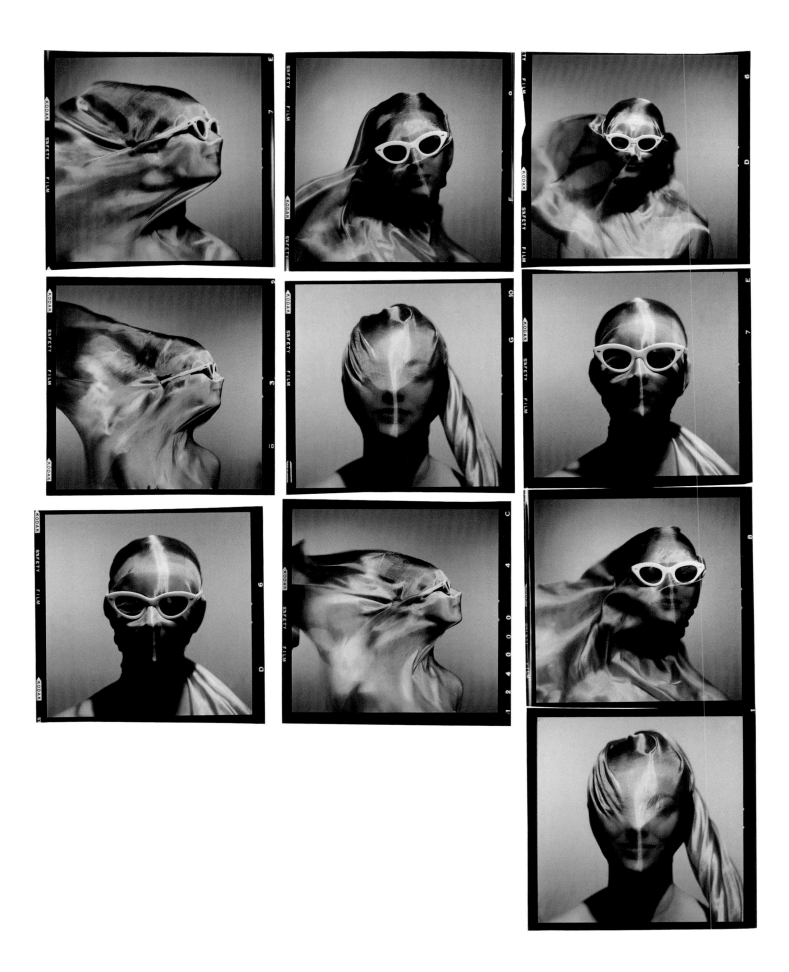

circa 1965

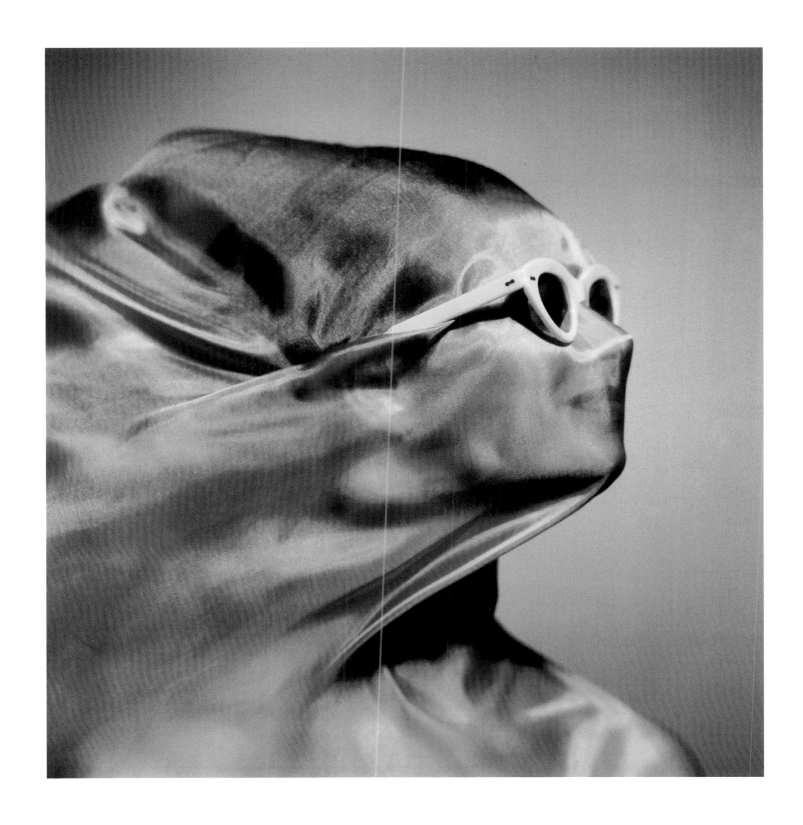

Revlon advertisement, circa 1965

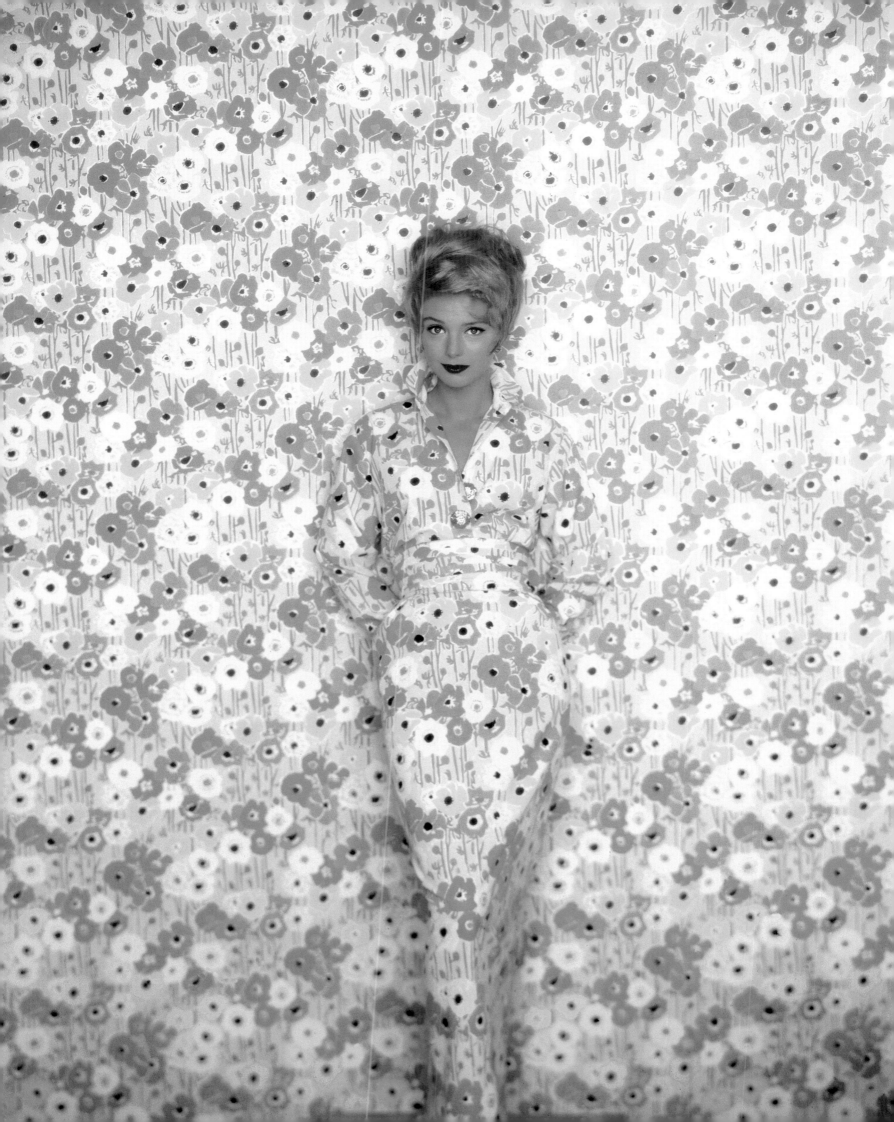

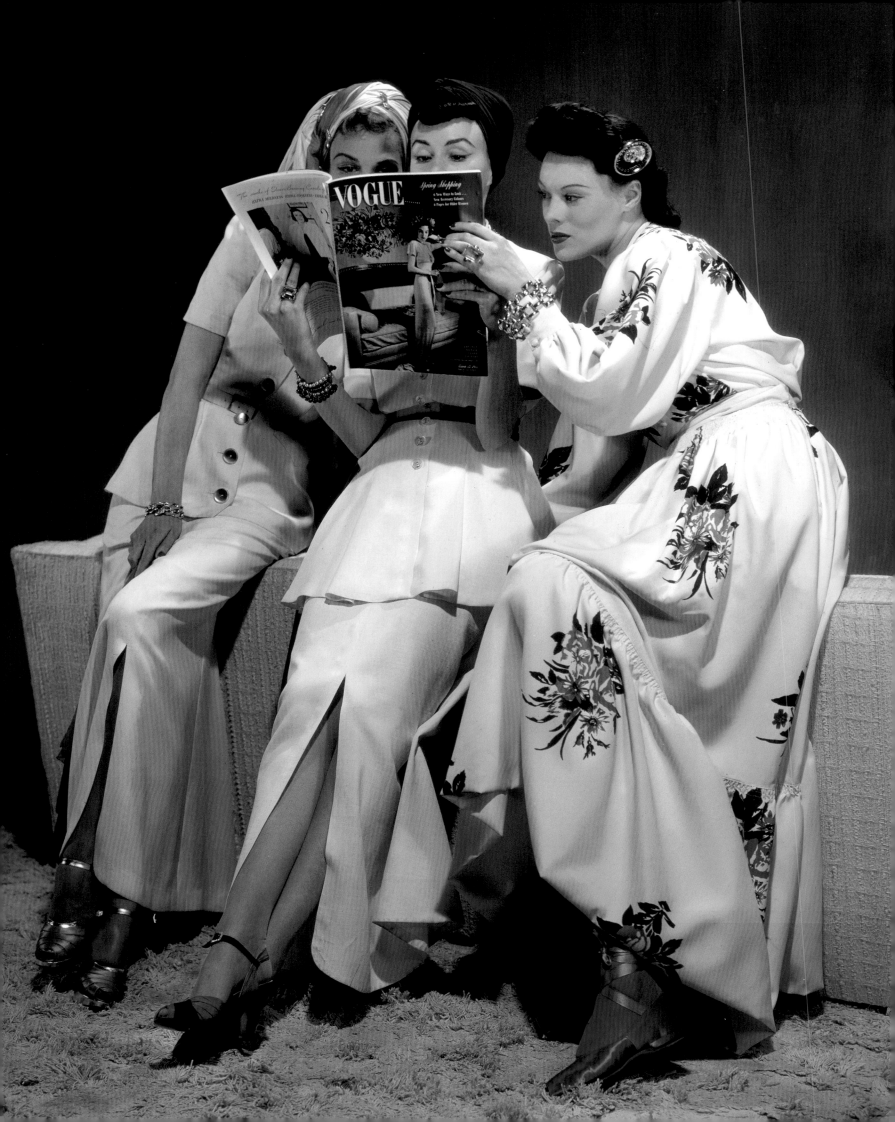

Acknowledgments

This book represents the unified generosity and collaborative efforts of the publisher and the two institutions whose mutual holdings form the nucleus of John Rawlings' oeuvre. The author would like to thank everyone at Condé Nast Publications, Arena Editions, and The Museum at the Fashion Institute of Technology, collectively and individually, for making this book possible.

Condé Nast Publications
Cynthia Cathcart
Tom Graf
Florence Palomo
Anthony Petrillose
Philip Reeser
Linda Rice
Charlie Scheips
Michael Stier
Susan Train
Anna Wintour
Ena Wojciechowski

The Museum at the Fashion Institute of Technology
Dorothy Twining-Globus
Sandy Shannon
Irving Solero
Valerie Steele
Jean West

Arena Editions
James Crump
Elsa Kendall

My most sincere gratitude to my research assistant and project manager, Carmela Spinelli Schauffler. Additional archival assistance and preparation, Karen Mauersberg and Andrea Valerio. Photography, Adam Reich. Archive coordination and additional photography, Irving Solero. Manuscript preparation, proofreading, and editing, Aaron Vlek and Peg Goldstein.

For sharing their memories, insights, secrets, and contacts that helped to bring John and Babs Rawlings's careers and personae to light: Adri, Peter Brown, Despina Messinesi, John Galliher, Amy Fine-Collins, George Trescher, Kenneth Jay Lane, Michale Vollbracht, Leonard Stanley, Carmen Dell'Orefice, Mary Jane Russell, Laird Borrelli, Dorian Leigh, Betty McLauchlen Dorso, Connie Wald, Babs Simpson, Dr. S. A. Hakim, and Robin Muir.

A very special thanks to the incomparable Suzy Parker (Mrs. Bradford Dillman) for being such a good sport in sharing letters, phone calls, and conversations about John Rawlings, his world, and the hitherto mysterious custom-rigged Rolleiflex.

For their early support and nods in the right direction: Marta Hallett and Ruth Peltason.

To Anna Wintour, Adri, Dorothy Twining-Globus, Charlie Scheips, James Crump, and Anthony Petrillose: Thank you for the support to move this project forward, thereby ensuring that John Rawlings's work will take its rightful place in the canon of twentieth-century photographic history.

Kohle Yohannan
December 1, 2000
New York

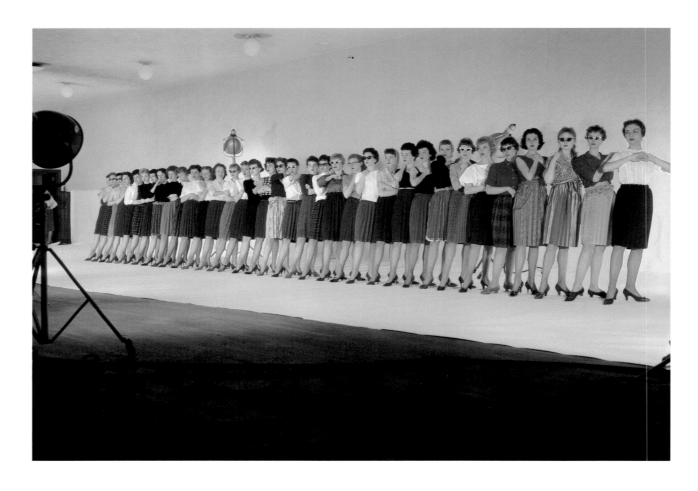

The Radio City Rockettes, August 15, 1959 Page 264: *Vogue*, June 1, 1941

Photographs at the Front

Page 3 Revlon advertisement, circa 1965

Page 5 *Vogue*, October 1, 1960

Page 7 Charles James evening gown, *Vogue*, December 15, 1944

Page 8 John Rawlings with Meg Mundy, circa 1940

Page 14 *Vogue*, October 15, 1941

First edition published by Arena Editions
P.O. Box 32101
Santa Fe, New Mexico 87594-2101 USA
Phone 505/986-9132 Fax 505/986-9138
www.arenaeditions.com

Publisher James Crump
Art Direction and Design Elsa Kendall
Design Assistance Freddy Cante

Printed by EBS – Verona, Italy

First edition, 2001
Library of Congress Control Number: 00-135861

ISBN 1-892041-38-3